Turning Pages

Turning Pages

*Reading and Writing
Women's Magazines
in Interwar Japan*

Sarah Frederick

University of Hawai'i Press
Honolulu

© 2006 University of Hawai'i Press
All rights reserved
Paperback edition 2017

Printed in the United States of America

22 21 20 19 18 17 6 5 4 3 2 1

Library of Congress Cataloging-in-Publication Data

Frederick, Sarah.
 Turning pages : reading and writing women's magazines in
interwar Japan / Sarah Frederick.
 p. cm.
 Includes bibliographical references and index.
 ISBN-13: 978-0-8248-2997-1 (hardcover : alk. paper)
 ISBN-10: 0-8248-2997-2 (hardcover : alk. paper)
 1. Women's periodicals, Japanese. 2. Women—Japan—
History—20th century. I. Title.
 PN5407.W6F74 2006
 059'.95608209041—dc22

 2006012667

ISBN 978-0-8248-6770-6 (pbk.)

University of Hawai'i Press books are printed on acid-free paper and
meet the guidelines for permanence and durability of the Council on
Library Resources.

Designed by Lucille C. Aono

Contents

Preface —— vii

Acknowledgments —— ix

1 Reading the Production and
Consumption of Women's Magazines —— 1

2 Serious Reading: Enlightening the
Modern Woman in *Ladies' Review* —— 26

3 Writing Home: Modern Life
in *The Housewife's Friend* —— 84

4 Women's Arts/Women's Masses:
Negotiating Literature and
Politics in *Women's Arts* —— 137

Epilogue —— 178

Notes —— 185

Bibliography —— 223

Index —— 241

Preface

While looking for a poem by the woman writer Hayashi Fumiko, I came across a reproduction of the magazine *Nyonin geijutsu* (Women's arts, 1928–1932). Years later, a search for the anarchist writings of feminist Takamure Itsue took me back. Run by a group that reads like a most-valuable-player list of Japanese women writers, filled with everything from debates on politics and literature to photographs of Soviet workers to department store advertisements, that publication brought to life an exciting and frightening time in Japan's history. My initial enthusiasm and sympathy for its goals of giving a voice to women writers in a manner both artistically and politically committed led me to write this book.

Nyonin geijutsu deserves a study of its own. But the more I examined the motivations and interests of its founders and contributors, the more I felt they were responding directly to the dramatic rise of mass-market women's magazines in the previous decade. *Nyonin geijutsu*'s sometimes abstract debates about commercialization of literature and the role of women and gender in Japanese society all played out more concretely in the texts and contexts of such publications as *Shufu no tomo* (The housewife's friend), *Fujin kurabu* (Ladies' club), *Fujin gahō* (Ladies' pictorial), and *Fujin kōron* (Ladies' review)—publications that predated and outlived *Nyonin geijutsu*'s short four years. These diverse periodicals, which over the course of the 1910s and 1920s formed that major category of Japanese publishing activity, "ladies' magazines" *(fujin zasshi)*, deserved a closer look.

It is hard to imagine a richer source for the culture of prewar Japan than monthly women's magazines; paging through year after year is an amazing experience to which it is difficult to do justice. Every issue has something for everyone: fiction by long-forgotten writers, unknown works by famous ones, commentary on Japanese "Miss" contests by illustrious intellectuals, cutting-edge commercial art, architectural plans, sewing patterns, and recipes; as well as lively and sophisticated debates on birth control, the proper age for marriage, national identity, education, and the economy. Over the decades,

VIII *Preface*

changes in urban life, economic structure, and political structure unfold month after month in a slow but visually dramatic way, as do related transformations in artistic movements, aesthetic tastes, and print technologies.

As I turned the pages of these magazines, I was intrigued by the range of lifestyles opening up to women, particularly in urban areas. These same images no doubt attracted many women who came from the countryside to the cities seeking, if not always finding, a better life. The extent to which magazines challenged the status quo, either in their polemical and fictional writings or their cover art and commercial images, is to a feminist reader, then or now, hopeful and energizing.

But one can easily get caught up in glitzy images of the "modern girl" or the polemics of anarchist feminists and overlook the less visually striking or politically radical content. Much of what was challenged here was also being created: the modern housewife, expectations about marriage and mothering, and women as shoppers, exploitable workers, or overly emotional and dangerously impressionable readers of fiction. The contradictory effects of capitalism and modernity on people's lives are sometimes clearest in representations of women, and are especially obvious in the pages of women's magazines. And nothing is more chilling than the wartime *Shufu no tomo*'s issues with foldout paintings of Yasukuni Shrine, industrial photography of women in factories and fields, and comic strips of soldiers in Southeast Asia. A purely affirmative view of these magazines might suggest lowered expectations of possibilities for women "way back then" or "over there" that are at heart condescending. I attempt here to convey both the vibrancy of women's print culture and the people who made it, while also considering its damaging side. Women's magazines are no more likely a locus of mediocrity than other forums for serialized fiction, but that does not mean I will not take up some works that are lacking in some ways, even when important and interesting in others. I hope not to dampen the reader's enthusiasm with what are sometimes negative evaluations of works of literature, editors' ideas, or images of women. But to these also the women of *Nyonin geijutsu* tried—not always successfully—to provide an alternative. Inspired by their efforts, I attempt in this book to negotiate between a respect for the writers and readers of women's magazines and a willingness to criticize what I find there.

Acknowledgments

The people and institutions who have contributed to the research and writing of this book are too numerous to detail, but I would like to thank some in particular.

My dissertation committee at the University of Chicago—Norma Field, William F. Sibley, and Kyeong Hee Choi—provided intellectual guidance and emotional support as I first muddled through this large body of disparate materials. I thank them for their patience and detailed comments, which remain thought provoking years later. Harry Harootunian also guided me in my earliest thinking about this topic.

At Waseda University, Anzai Kunio and all of the members of the Kingendaishi Japanese History Seminar helped me to clarify historical aspects of this research. Kano Masanao's classes were always inspiring and provided a model for committed and thoughtful research and teaching. Okamoto Kōichi tirelessly builds connections between North American and Japanese scholars and kindly gained me access to materials and obtained reproductions from Waseda's collection of the *Nyonin geijutsu* journal. Naitō Hisako, Koyanagi Akiko, Kawahara Aya, and I formed a reading group that was eclectic, fun, and useful. Hisako's research skills and help tracking down copyright holders were invaluable.

Tachi Kaoru and the Ochanomizu Women's University Gender Center hosted me for a year at a key point in my research. The members of the doctoral seminar provided excellent feedback on my ideas from the perspective of gender studies and Japanese women's history.

I thank the Kindai Josei Bunkashi Kenkyūkai in Tokyo for inviting me to their meetings and trips; it was a pleasure to share an interest in Japanese women's magazines across cultures and generations.

I used many library resources in Japan. I am particularly grateful to Kōno Masatoshi at Chūōkōronsha, the Ochanomizu library of Shufunotomosha, Waseda University libraries, and the Zasshi Kenkyū Center at Tokyo University.

I thank Jan Bardsley and the anonymous reviewers of this manuscript for their well-informed, detailed, and thoughtful comments. Although I have not done them full justice, their suggestions have made this a better book.

Financial support in both the United States and Japan has made various stages of this project possible. A Monbushō graduate fellowship through Waseda University supported the initial research, and I completed archival work with the help of a Fulbright-Hays Graduate Fellowship. The Center for East Asian Studies at the University of Chicago supported me during the writing of my dissertation, and the Humanities Foundation Junior Faculty Fellowship at Boston University granted me time and advice for my revisions. I would also like to thank the Reischauer Institute at Harvard for access to materials at the Yenching Library. I would also like to thank Pamela Kelley at the University of Hawai'i Press for her interest in this book, and Joanne Sandstrom for her meticulous editing of the manuscript.

Many people provided suggestions, motivation, and friendship. They include Melissa Wender, Amanda Seaman, Heather Bowen-Struyk, Carol Haney, Maryellen Griffin, Sarah Teasley, Alexis Dudden, Eve Zimmerman, Alisa Freedman, and Janine Schiavi.

My family, including Lancasters, Fredericks, Lehrichs, and Nagatas, have all lovingly supported me as I spoke abstractly for years about "working on my book."

Without Chris' love, conversation, eagle-eyed editing, and delicious cooking I could neither have finished a dissertation while planning a wedding nor finished a book manuscript while having a baby. Thank you for being the perfect partner in everything.

Finally, I must thank my son, Sam, for being patient enough about coming into this world for me to complete this manuscript and for the great joy he has brought with his arrival.

1 | Reading the Production and Consumption of Women's Magazines

> In the so-called women's press, we find survivals, superstitions, rituals, myths and modern mythology, formulated and systemized in accordance with new (and obscure) needs; and that in the fullness of the everyday, in a direct expression of the preoccupations and aspirations of the most immediately practical kind of everyday life. Moreover, this press represents an extraordinary sociological fact, which cries out to be analysed.... What does this enormous success mean? What new need does it reveal? Is it profound or superficial, valid or spurious? What structure of consciousness does it reveal? What contents?
> —Henri Lefebvre, *The Critique of Everyday Life*

In an early scene of Mizoguchi Kenji's film *Osaka Elegy* (*Naniwa eregii*, 1936), the telephone operator heroine Ayako reads a ladies' magazine on the job.[1] The camera cuts to a headline: "Woman Corrupted by Money." And as the plot unfolds, some combination of the power of the magazine's suggestion and filial piety leads her to become her boss's mistress and catch the "delinquent girl sickness" (*furyō shōjo byō*), alienating the very family she sought to help. By establishing Ayako this way, Mizoguchi's elegiac portrayal of the young woman tracks many of the controversies enveloping the "ladies' magazine" (*fujin zasshi*) in interwar Japan. Cultural critics complained that reading magazine narratives, whether confessions, serialized fiction, or advertisements, would lead young women down the wrong path, causing them to imagine the previously unimaginable.[2] In that context, Mizoguchi's close-up on the printed page foreshadows the inevitable downward spiral of his heroine. But in another sense, according to the logic of his story, the magazine merely reflects a world of greed and sexual objectification that already surrounds the woman and leads her to do what she does. In the final shots, she walks away with assured steps and an ambiguous facial expression, both sad and resolute; we sense that it is the very existence of the delinquent girl concept that she read about in the magazine that may ultimately allow her to move beyond the burden of her family's expectations. Just as the 1990s saw debates over whether the blame for schoolgirl prostitution or so-called

1

2 Chapter 1

compensated dating *(enjo kōsai)* fell on the men who sought the girls out, the media portrayals of such activities, or the overly successful promotion of designer handbags, so in the 1920s women's magazines were a focal point through which were articulated crises over consumer capitalism, gender roles, and national morality. Whatever the magazine article's final effect on Ayako, the camera cutting to its headline reproduces the prevailing view that women's print journalism contributed to the structure of modern Japanese life, whether as germ, symptom, or potential cure for its ailments.

From the midteens through the 1920s, an unprecedented number and variety of magazines aimed at women appeared in Japan. With them came a corresponding rise in the influence of their articles, advertisements, and images on intellectual discourse, the literary establishment, and daily life. These magazines included a wide range of publications: literary journals, organs of political movements, and popular magazines featuring fashion, beauty, or advice on household management. By the early 1920s, the ladies' magazine had become a distinct category of publication, one that numerous cultural critics debated and in which feminine roles such as housewife *(shufu)*, new woman *(atarashii onna)*, or girl *(shōjo)* were defined.[3] Feminists questioned those definitions even as they used this same forum to express their own views, often critical of those very categories. And writers of fiction worried that these readerships would compromise their artistic integrity even as they relied on women readers to launch or support their careers. Faced with these trends, writers, editors, and activists became self-conscious about both the potential of and the danger embedded in this emerging print culture aimed at women. They struggled to determine its political valence and critical capacity in a context where "woman" was becoming an increasingly complicated category in discussions of modernity.

This book introduces and analyzes the major women's magazines of the late 1910s through the 1930s. It argues that these publications are central to understanding not only women's literature and culture of the period but also the overall shape of modern Japanese literature and Japanese modernity. It also provides a methodology for analyzing this type of popular cultural material by considering together editorial aims, audience responses, and close readings of the texts themselves. It shows the ways that differences in editorial purpose and forms of financial support often transformed the way that literature was written and read, to an extent that is often overlooked in traditional literary scholarship.

Rather than give a thorough narrative history of interwar women's magazines or use magazines as a source to explore other issues in the social history of Japan, I take a broad approach in this book, looking at different types of

contemporary periodicals and a variety of texts within them. While chosen in part because they are major publications, the three magazines discussed in depth here also demonstrate a range of relationships to mass audiences, political goals, and artistic vision. Founders of *Fujin kōron* (Ladies' review, 1916–), discussed in chapter 2, expressed their aim as enlightening the modern Japanese woman by presenting her with high-quality material, including fiction, political debate, and domestic science, and avoiding as much as possible what might be seen as commercially corrupted material. Chapter 3 looks at *Shufu no tomo* (The housewife's friend, 1917–), a magazine that achieved tremendous commercial success, gaining a high circulation through practical advice, popular fiction, and skillful marketing techniques. The editors of *Shufu no tomo* focused on providing useful information and products and on keeping readers entertained. I will look at the types of reading practices and texts that were brought together as its editors sought out as wide a range of readers as possible. *Nyonin geijutsu* (Women's arts, 1928–1932), the subject of chapter 4, was intended to publish fiction and essays by women writers and participate in leftist political activism. It also was meant as an alternative to major commercial magazines, even as its organizers sought a level of financial stability themselves. At the same time, these characterizations often break down on examination, and a great many prolific writers contributed to all three of these very different publications.

Throughout, I will look at the modes of writing and visual imagery with which periodicals represented the emergence of women into public awareness, from their presence in advertisements, fiction, and articles to the way they were interpellated as audiences.[4] It would of course be possible to look more closely at either fictional material or journalistic writing published in these magazines, but this division between fiction and journalism was itself a central issue in magazine production, with editors and critics often asking whether fiction ought to be entertaining, political, or enlightening, and whether it should be visually separated from or intertwined with commercial or journalistic materials. These questions can best be considered by looking at the relationships among genres and styles of writing.

On one level, the argument of this book is simple: women's magazines played an important role in modern Japanese culture and Japanese literature. They tell us a great deal about women's lives. But I also want to make the larger claim that turning an analytical eye to women's magazines can transform how we view Japanese modernity and the course of modern literature. Japanese critic Maeda Ai's forceful argument to that effect several decades ago, which has recently appeared in English translation, makes my claim less bold than it might be. However, I take inspiration from his insight

about the unrecognized influence of the woman reader, an insight not yet fully explored despite some recent studies of aspects of women's magazine culture by Rebecca Copeland, Joan Ericson, Barbara Satō, and Jan Bardsley that have also worked to illuminate this question from different angles.[5] As Maeda shows, on an institutional level women's magazines provided the primary source of income for many writers by the second half of the 1920s, and the nature of this financial support had some effect on what people wrote and which writers succeeded in the profession. Perhaps more important, in the cultural sphere, the woman reader played a key role in a number of major struggles over literary value whose influences still echo in criticism of Japanese literature today: the categories of "popular" and "pure" literature *(taishū* and *jun bungaku)*, genre categories, canon formation, and the relationship between aesthetics and politics in evaluating literature. The institutional primacy of the woman's magazine meant that it was frequently at the center of these tensions. This centrality also extends to intellectual history, where women's magazines played a role in discussions of Japanese culture and everyday life, as has been shown in English by Harry Harootunian, Barbara Satō, and Miriam Silverberg.[6] In particular, women's magazines represented changes associated with Japanese modernity, including urbanization, consumer capitalism, Westernization, and transformation of gender roles; the same publications were, as we shall see, themselves products of and actors in those changes.

Maeda reveals the importance of women's magazines primarily through close analysis of particular serialized novels in women's magazines and debates among writers about popular literature. I turn my attention instead to the magazines themselves, both as institutions and as groups of texts (literary and otherwise), to help us understand their role as mediator between women readers and the world of cultural production. In doing so, I will expand upon Maeda's insights on the way the content of serialized fiction reflected the looming presence of the woman reader and will think more generally about the interaction between gender and genre, including the complex ways this interplay was informed by the publishing world and may have affected both literary production and the lives of real women.

In particular, I would argue, editors choosing what to print and contributors choosing where to submit their work tended to bring certain types of fiction to the pages of women's magazines, even as the texts found there are incredibly varied. On the whole, there is a historically situated feel to these works, perhaps because those selecting them felt the need to match text to readership by representing the present of Japanese daily life and women's place in it. We see such choices that are affected by gender in the serialized

romance fiction in a housewife's magazine and in both modernist and proletarian literature in a political literary journal. Because so often these works depicted the present, in a way more externalized than the interiority of the "I-novel" *(watakushi shōsetsu)*, women's-magazine fiction had a tendency to deal more directly with politicized topics, whether it dealt with them politically or not. Of course, male readers were also targeted according to economic class, age, region, and political affiliation; but most often the male reader was conceived of as just the reader in a more universal sense, the reader of the general-interest magazine *(sōgō zasshi)*. In such ways, the sex of the reader and, most important, the way it was imagined had, I will argue, a strong effect on the genres, styles, and subject matter of the fiction found in women's magazines—and, since writers relied on this venue for their livelihoods, on the landscape of Japanese fiction in general. I will show how this played out in three very different publications guided by equally different political aims.

I should note that, unlike in other recent studies of women's literary magazines, the focus here is not on women writers or feminist articles in particular. This is largely because in many cases these were not at all the focus or primary content of these publications—something that should not be surprising to any reader of contemporary popular women's magazines in Japan or the United States.[7] Such texts by women will be considered as they fit into, as they do in important ways, the broader landscape of modern Japanese literature and thought during this vibrant period of print capitalism, a landscape that I argue can be well understood only with full attention to gendered categories, whether we are dealing with writings by men or women.

Again, another goal of this book is methodological. It is difficult to analyze texts that contain such a disparate set of political positions, genres, and rhetorical styles; as the Japanese word for magazine *(zasshi,* or broken into its two Chinese characters, *zatsu* and *shi)* suggests, they are made up of varied or miscellaneous *(zatsu)* writings *(shi).* Taken as a whole, women's magazines provide a sweeping view of literature, culture, feminism, political events, and the daily lives of women during the period, the "fullness of the everyday" to which Lefebvre refers. At the same time, one should not assume that the texts are a "direct expression" of the desires of their readers even though they reveal so much about them. The very "fullness" and complexity of those "aspirations" and "desires" require a sensitivity to unpack and a close attention to the role of media in communicating them.

These publications pose difficulties in that they defy such standard divisions as literary criticism and history, literary studies and cultural studies, or

6 *Chapter 1*

popular culture and literature. My goal is in part to provide a model of what a literary critic, broadly defined, might bring to such materials, whether categorized as literature proper or not. Throughout, I will consider these texts from the perspective of both their producers (editors, writers, and capital backers) and their consumers (readers and subscribers), as well as examine the media technologies themselves. The focus here is on the very "magazineness" of these publications: how texts are edited, how they are categorized (as fictional, polemical, confessional, personal, or expert), how advertising is presented, and how each magazine itself is promoted. I suggest that the material limitations experienced by both producers and readers of these publications affect the form and reception of their texts, be they polemical, literary, or commercial.

As collections of mixed writings, magazines are by nature self-contradictory. And from a feminist perspective, they often produce a certain ambivalence: they defined women's roles—housewife, schoolgirl, mother—in newly restrictive ways, but they also generated new possibilities for different identities, whether through consumption of the products advertised there or by using the publications as vehicles for artistic creation or political activism. This ambivalence I will attempt to keep alive throughout my analysis, as this seems the most honest way to deal with the magazines' contradictory content—a product of the capitalism because of which women's magazines emerged, and after all what makes them so interesting.

The Emergence of Japanese Women's Magazines

The circulation figures of individual magazines alone express the magnitude of the changes in reading habits among Japanese women in the 1920s. Magazines such as *Shufu no tomo* and *Fujin kōron*, discussed here, had print runs in the tens of thousands of issues when they were founded in the late 1910s. By the mid-1920s, the circulation of *Shufu no tomo* was over 300,000 in many months, while *Fujin kōron* climbed over 100,000 around 1930.[8] Maeda Ai cites a rough calculation that 1.2 million issues in the category *fujin zasshi* were sold in January 1925.[9] Figures from the government censorship office in 1927 also show the approximate total circulation for all women's magazines to be about a million.[10] This increase was not simply a shift in market share from one publication to another but appears to represent a tenfold rise in total periodical consumption by women. Surveys of women taken between 1920 and 1934 show that 7 percent of so-called factory girls (*jokō*) read newspapers and 20 percent magazines; of working women (*shokugyō fujin*, a term that

refers primarily to white-collar workers) 85 percent read newspapers and 75 percent read magazines during this period. Among women students *(jogakusei)*, the rates for both were above 90 percent.[11] These figures suggest the importance of the interwar era for a discussion of women and mass culture in Japan. Men's magazines also saw higher circulation figures, with newer popular magazines such as *King (Kingu)* appearing (in 1925). However, the category of women's magazines accounted for the most dramatic expansion of the reading public.

This rise in women's magazines as a part of mass culture occasions my focus on the post–World War I era, but it is worth looking at precursors to the magazines discussed here. Japanese high school textbooks and popular histories sometimes take the beginning of Japanese women's magazines or journalism to be *Seitō* (Bluestocking, 1911–1916), because it was entirely run by women and was much talked about in contemporary newspapers. While this publication was important, *Seitō*'s originality as a ladies' magazine is often exaggerated; several publications in the Meiji period (1868–1912) were aimed at women audiences, most famously *Jogaku zasshi* (Women's education magazine, 1885–1904).[12] Edited by Iwamoto Yoshiharu (a Christian educator), Kondō Kenzō, and Ōba Sōkichi, *Jogaku zasshi* aimed to raise the status of Japanese women and solicited contributions by many important thinkers, including Christian socialist reformers such as Kitamura Tōkoku and women activists such as Kishida Toshiko. As Rebecca Copeland has shown, it also provided a forum for a number of important but insufficiently studied Meiji women writers, including Wakamatsu Shizuko and Shimizu Shikin. And finally, *Meiroku zasshi* (Meiji six journal, 1874–1875), although not likely read by many women and having a small circulation, also disseminated debates on women's issues, with discussions by intellectuals such as Fukuzawa Yūkichi and Mori Arinori.[13]

Although we might place the beginning of the modern ladies' magazine in the Meiji period, it is not true that Japanese women did not read before the 1880s or had never been targeted as readers. The activity of women writers during the Edo period (1600–1868) is also usually underestimated.[14] There were certainly many neo-Confucian texts aimed at women, and more-entertaining books often claimed to address women and children. Although not periodicals per se, some of these texts had similarities in terms of disposability and circulation that would be worth exploring in another study. There are also volumes of fictional works written by women during the seventeenth to early-nineteenth centuries, indicating that women with access to education continued to be both producers and audiences of literary works even during the periods when they had the fewest opportunities for literary

8 Chapter 1

production. In the Meiji period, the "small newspapers" *(koshinbun)*, a popular counterpart to the major or "large newspapers" *(ōshinbun)*, were commonly read by women.[15] Hirata Yumi has suggested that during the late 1870s and 1880s women, often geisha, regularly published letters in newspapers. She argues that their writings in feminine letter-writing style constituted a certain "woman's voice" later lost as journalism shifted from local dialects to standardized language. After that shift, women's literacy came to be represented, she argues, by the image of an enlightened schoolgirl or woman teacher who was tied to the state.[16] The writing of such women, educated in standardized language and modern *genbun itchi* (unification of speech and writing) style, was—or was presumed to be—better suited to publications aiming at a national audience, as standardized speech was increasingly a focus of national education.[17]

In this sense, *Jogaku zasshi* and other contemporary publications linked to antiprostitution and civil rights movements do provide one appropriate starting point for histories of modern Japanese women's magazines; they constitute a shift toward creating a public space where people would discuss the position of women in the Japanese nation, and in a way that included women in their anticipated audience.[18] However, their audiences were generally upper-class, urban men and a few women, although the frame of reference was "Japanese women." Many encouraged (and drew readership because of) essays by male intellectuals discussing women (known as *josei ron*). They often argued that raising the position of women in Japan would raise Japan's position in the world, either by making Japan part of international movements (such as suffrage or prohibition) or by incorporating the country into Western "civilization" through Christianity, education, or morality campaigns such as the antiprostitution movements. Meanwhile, standardization of national language in these journals meant that they participated in the formation of a national imaginary.

Magazines aimed at enlightening elite Meiji women were transformed into commercially successful enterprises by publishers such as Iwaya Sazanami's Hakubunkan, which created many popular magazines for women and children, including *Nihon no jogaku* (Japanese women's education, 1887–1889), *Fujo zasshi* (Women's magazine, 1891–1894), and *Jogaku sekai* (Women's education world, 1901–1925). These were followed by a stream of magazines, founded between the turn of the century and the end of the Meiji period in 1912, that aimed at a larger audience of upper-middle-class women. Several of these publications managed to expand their audience widely over time and still exist today, including two quite different publications, *Fujin*

gahō (Ladies' pictorial, 1905–) and *Fujin no tomo* (Ladies' companion, 1906–).[19]

Fujin gahō largely consisted of high-quality photographs and emphasized the lifestyle of elite women. *Fujin no tomo*, on the other hand, run by Hani Motoko, a liberal Christian woman who also started the Jiyū Gakuen school, emphasized education, rationalization of household tasks, and raising the status of women through promotion of middle-class ideals partly inspired by Christian liberal thought.[20] Although most cite Hiratsuka Raichō's *Seitō*, in part because it seems more radical and was cause for scandal, Hani's *Fujin no tomo* has the greater claim as the first major women's magazine run by a woman. Both magazines, along with socialist publications such as *Shin shin fujin* (The new true woman, 1913–1923), were part of the emergence of magazines run by women in the late-Meiji period. Many factors made that possible, but most obvious are the convergence of a rise in publications aimed at women, increased education for women, and a willingness on the part of other publications to print writings by women to a sufficient degree to encourage them to pursue careers as professional fiction writers and journalists.

Still, *Seitō* created the greatest stir. Compared to Hani's domestically oriented *Fujin no tomo*, which tended to advocate lifestyles befitting a genteel middle class, *Seitō*'s references to Western feminism, claims to female power (such as in Hiratsuka Raichō's opening words in the magazine, "In the beginning woman was the sun," in reference to the sun goddess Amaterasu, mythical progenitor of the imperial family), and representations of sexuality were more shocking to the public. The very claim that *Seitō* would be written entirely by women also invited attention. It is partly because of the various scandals surrounding its members that it is important for thinking about women in print culture. In *Seitō*'s years of publication, we see women becoming public figures because of their participation as active producers of print culture. Women's public political activity—whether explicitly political or not—tended to be transformed into scandal and sensation throughout 1920s print journalism.

These early magazines have been well covered by books on Meiji magazines, women writers, and feminist thought.[21] There is another whole set of studies on *Seitō* alone, including an excellent new volume that breathes new life into the topic with essays on such subjects as readership, visual texts, and lesbianism, issues not much discussed in the past.[22] A new volume in English by Jan Bardsley provides both analysis of *Seitō* and translations of important selections.[23]

The present study covers the subsequent period, beginning in the late 1910s, when we can begin to talk about a broad-based mass print culture aimed at women, reflected both in the volume of publications and the general consciousness of ladies' magazines as a category of Japanese culture and publication practice. The shift was not instantaneous but rather an accumulating quantitative shift that led to a qualitative one, such that by 1920, whether they embraced or were ambivalent about it, the producers and readers of all the publications analyzed here could not but see themselves as participants in a specific mass-marketed publishing category.

Along with the magazines discussed here—*Fujin kōron, Shufu no tomo,* and *Nyonin geijutsu*—there was a wide range of others during the same period. *Fujin kurabu* (Ladies' club, 1920–1945; 1946–1988) became a strong competitor to *Shufu no tomo* although it was not marketed so explicitly to married women. Its content tends to be more urban and fashionable than *Shufu no tomo*'s, with a greater percentage of articles on white-collar work, fashion, and romance; its mission statement said it was "not highbrow, and not lowbrow either, just a good-quality magazine."[24] In 1933 and 1934, *Fujin kurabu* and *Shufu no tomo* competed fiercely and battled to produce the most appealing special issues and extra inserts to attract more readers each month.

Josei (Woman, 1922–1928) was a publication that truly celebrated modernism and the image of women in it. The magazine covers featured art nouveau and art deco depictions of women in dramatic poses. This publication and its publisher, Puratonsha (Platonic publishers), had strong ties to Osaka and the Kansai region, having offices both there and in Tokyo, and were funded by the Club cosmetic company. The writings and layout conveyed a cosmopolitan and fashionable atmosphere through visual references to and translations of European literature and culture. The magazine started out running articles on women's issues, mostly by male intellectuals and journalists, similar to pieces in *Fujin kōron*, though it had a less political stance. It carried writers with progressive and socialist views, such as feminist Kamichika Ichiko and Marxist cultural critic Hirabayashi Hatsunosuke, along with much more conservative authors. Later, it put a greater emphasis on literary works. Some of the best-known authors published here were Tanizaki Jun'ichirō—the latter part of *A Fool's Love* (*Chijin no ai*, translated as *Naomi*) was published here—Izumi Kyōka, Akutagawa Ryūnosuke, and Nagai Kafū. Later, so-called new sensational writers such as Yokomitsu Riichi published here as well.

The more countrified *Ie no hikari* (The light of the family, 1925–) targeted rural women and their families. With fewer photographs and less use

of color than most women's magazines, it was reasonably priced. Its circulation reached 100,000 copies by 1931, one million by 1935, and in 1949, it began distribution to Japanese immigrants in Brazil.[25] *Ie no hikari* provided practical information on farming, illnesses, and child rearing, along with serialized fiction, but it also printed essays by major intellectuals interested in rural life such as Yanagida Kunio.[26] The reprints of this magazine would be worth a study in their own right for the insight they give into rural life in Japan.

Many magazines were devoted to more specialized topics, such as the little-known *Japanese Business Girls*, aimed at English-language typists, or the organs of political groups such as *Fusen* (Female suffrage), connected to Ichikawa Fusae's female suffrage organization, Fusen kakutoku dōmei.[27] Many writers and groups of writers also published literary journals and pamphlets on a smaller scale. For example, writer Yoshiya Nobuko produced her own "pamphlet" *Kuroshōbi* (Black rose, January–August 1925). She chose to call it a pamphlet *(panfuretto)* rather than a magazine so that it would not be subject to the same print journalism censorship regulations as magazines.[28] Uno Chiyo's ambitious fashion magazine *Sutairu* (Style) started in 1936.[29] Many of these might be considered precursors to today's important Japanese publication category of "minicommunications" *(mini komi)*.

Thankfully, the Fuji Publishing Company has reprinted many of these smaller-run publications and made them increasingly available to researchers. Unfortunately, longer-running popular women's magazines such as *Shufu no tomo* and *Fujin kōron* discussed here are too expensive to reprint in full and are difficult to find outside publishers' libraries and the National Diet Library. They usually were not purchased by academic libraries in Japan, and only a handful of issues of these publications can be found in North American libraries. My effort here is to introduce several major publications in detail rather than providing a survey, but there is clearly a rich body of material available for further study.

Print Technology, Publishing, and Entertainment Media

What was happening in the interwar period such that so many women's magazines could emerge and gain such importance and success? Several related factors came together at once to make national commercial magazines possible: changes in print technology and distribution in the publishing industry, changes in the economic and institutional structure of society that affected both women and print culture, and an increasing interest in women's

Chapter 1

issues as culturally important. When these factors, the perceived need for women to read more and enlighten themselves, and the sociological factors of education, labor, print technology, and urban life all came together, Japan saw its explosion of women's magazines.

Although there had been a lively commercial print culture in the Edo period, the scale of publishing increased markedly during the Meiji and early Taishō (1912–1926) eras.[30] The first newspapers produced by metallic movable type were published in the 1870s, but only ten years later did the technology become widespread and begin to expand distribution beyond the possibilities of woodblock printing.[31] Around 1887 postal systems became efficient enough to distribute mass-produced reading materials on a larger scale, and changes in the postal classifications for periodicals allowed magazines to be sent nationwide at a much lower price.[32] This wider distribution enabled broader professionalization of authors and journalists by the turn of the century, such that the leading writers came to be called a "new element of society."[33]

In the early 1920s, women's magazines, especially *Shufu no tomo*, were at the cutting edge in terms of printing techniques. A history of magazine advertising suggests that women's magazines in general and *Shufu no tomo* in particular were the most important in this area; for example, *Shufu no tomo* was one of the first to have both the front and back cover printed on the same high-quality paper and using the same number of colors, a practice that allowed for a high-end advertisement on the back cover.[34] Along with magazines, two important developments in publishing were the mass-produced anthology *(zenshū)* and the one-yen book *(enpon)*. The former collected major works of individual authors, characteristic works of particular genres, or canonical writings, as in the *Anthology of Contemporary Japanese Literature*, whose selection and marketing Edward Mack has analyzed in depth.[35] One-yen books marketed fiction and nonfiction in low-priced formats, mass produced on a large scale. Many critics in the 1920s suggested that women's magazines played a similar role among women as did the *enpon* among men: they were mass-produced objects that might be disposed of after reading.

Gender too became a key category in the marketing of fiction. Magazine categorizations of texts played a part in shaping the definition of literature and the place of gender (of both audience and writer) in determining the value and publication of certain writings. For example, Rebecca Copeland's analysis of *Jogaku zasshi*'s red-and-white covers—marking the intended readerships of different issues—and of the layout of the "Keishū sakka" (Lady writer) issue of *Bungei kurabu* (Literary club) demonstrates the importance of such layout in Meiji literature and the reception of women writers at the

turn of the century.[36] As we shall see, these practices continued particularly in the late 1910s in *Fujin kōron*, which also divided types of texts and printed special female writers editions. In the 1920s, such decisions became both more elaborate and less binary as commercial periodical publishers sought to create more diversified offerings to increase sales among readers of different genders, classes, ages, and regional status. Interestingly, they still found the category of ladies' magazine useful to do this.

The simultaneous development of other forms of media was also important to the success and nature of women's magazines. The emergence of film and radio enlivened Japan's culture industry and of course played a part in shaping ideas about the relationship between mass-produced entertainment technologies and audiences—a relationship that was usually gendered. Radio broadcasts began in 1924. Film technology came to Japan soon after it was developed, with Edison's Kinescope arriving in 1896 and the Lumière Cinematograph soon after. A large number of production companies emerged in the 1920s, and moviegoing became a part of everyday life and leisure culture. Just as certain types of magazine articles (such as "confessions" and "true stories") and works of serialized fiction came to be closely associated with female audiences, over the course of the 1920s women were increasingly seen as the major audience for cinema, and genre films aimed at them increased in number.[37] Together these new media forms interacted with the growing numbers of urban women to produce a strong awareness of women as an audience for mass culture.

Furthermore, the coexistence of these different media also encouraged a competition for visual prominence that raised the number of both visual materials and sensory-oriented writing in magazines. Magazines became a forum for radio- and film-related texts, such as radio dramas (or novels that would be adapted into that format) and stills, scenarios, and features on the everyday life of film actors. Those trends no doubt improved the appeal of the magazines themselves and increased their importance in women's culture. Print technology had its influences on the visual qualities of magazines as well, and in the late 1920s technological advances allowed for a larger number of photographs of higher quality at a lower price. The popularity of film and radio meant that magazines were at the same time motivated to increase their appeal to the senses in order to compete, and their increasingly brightly colored covers, graphic design, and photo spreads made them all the more alluring.[38] For example, a recent study of the popular magazine *King* (*Kingu*, 1925–1957), argues for the importance of the radio era and the talkie in forming the visual and rhetorical style of this very successful general-interest magazine.[39] During the 1920s a critic made the same connection,

Chapter 1

comparing efforts to draw audiences to popular film via an "encyclopedic, department-store-like" profusion of genres and styles to the sales efforts of thick periodicals such as *King*.[40]

Women and Modern Life

Where did these audiences of women come from? The most common image of the 1920s Japanese woman is the "modern girl" in Western dress and cloche hat walking the urban street, going to the moving pictures, or riding the ever-expanding network of trains and streetcars. Such a woman appears in a 1929 cartoon titled "Where Will Women's Magazines Lead Them?" (figure 1). The woman would be instantly recognizable as a modern girl, given her short skirt and bobbed hair, and the signposts represent much of what was negatively associated with the modern urban woman. The directional arrows list people, events, and moods linked with the bad influence of women's magazines: secret hotels, dancing, encouraging adultery, encouraging vanity, Valentino, cosmetics, unwed pregnancy, illnesses of the uterus, and the names of a number of individual fiction writers and women reporters associated with women's magazines and adultery scandals, including author Yamada Junko's relationships with artist Takehisa Yumeji and writer Tokuda Shūsei, and newspaper reporter Nakahira Fumiko's "Paris love triangle" that resulted in her husband's attempting to shoot her.[41] The admonitions clearly apply to more than just the reading material: they represent a number of anxieties about gender and modern life, namely, women's sexual desire and promiscuity (especially married women's) and the relationship of such behaviors to the writing and reading of fiction. While actual women looking like the one depicted here were very much in the minority, they stood for much wider ranging transformations in Japanese society, and real changes in the life courses of many women were certainly a major factor in creating a market for women's magazines. Meanwhile, the perception that there were new ways of living and that those were important—whether as positive or dangerous trends—provided much of the motivation for and content of those magazines. Thus, we must consider some of the actual transformations in women's lives as well as the imagined importance to the culture of new subjectivities and practices of women—and women readers—in the interwar period.

Women in large numbers moved to the cities, sometimes with parents, siblings, or spouses but often on their own. They frequently supported themselves and even family back in the countryside through their labor, commonly in manufacturing. From the turn of the century, women comprised about 80 percent of the workers in textile factories, arguably the cornerstone of Japanese

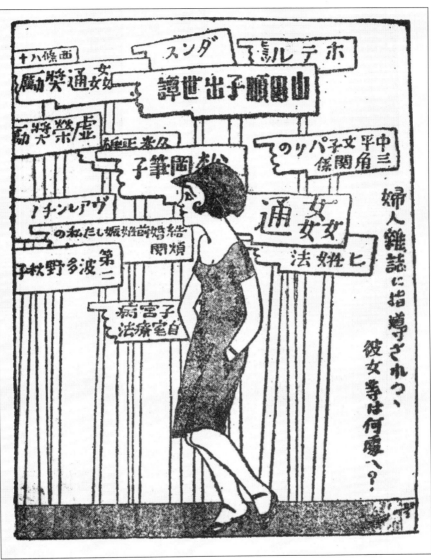

FIGURE 1. Cartoon, "Where Will Women's Magazines Lead Them?" by Shimokawa Ōten (1892–1973). From top right to bottom left, the signs read "secret hotels," "dancing," "Saijō Yaso," "encouraging adultery," "the debut of Yamada Junko," "Nakahira Fumiko's Paris love triangle," "Kume Masao," "encouraging vanity," "Matsuoka Fudeko" (Natsume Sōseki's daughter), "adultery," "Valentino," "cosmetics," "unwed pregnancy," "the next Hatano Akiko," "illnesses of the uterus," "hair removal methods." (From Shimokawa Ōten, *Hadaka no sesō to onna* [Tokyo: Chūō Bijitsusha, 1929]. Courtesy of the National Diet Library.)

economic growth. During World War I in particular, there was a high demand for Japanese textiles, and many women workers were hired through contracts whereby salaries were prepaid to their parents, usually poorer farm families. The working conditions were tough: factories ran two twelve-hour shifts per day, and the women lived in crowded, tuberculous dormitories. Certainly, many had no leisure time to read magazines or otherwise participate in such urban entertainments as moviegoing and shopping, but surveys show that 20–40 percent of women factory workers did in fact read magazines, often shared in the dormitories and factory lounges. Moreover, although they were paid low wages, for some the separation from direct parental supervision allowed greater freedom in how they spent what money they had.

Many middle-class women also entered newer jobs in the service industry and urban offices. This category of women increased steadily as the white-collar sector and retail industries grew during the 1910s and 1920s. This trend created new sorts of occupations such as English-language typists, elevator girls and mannequins for department stores, switchboard operators, and even "gasoline girls" *(gasorin gāru)*. Women in these occupations often lived away from family before marriage, especially if they moved to the city from elsewhere. Anecdotes in magazines themselves suggest that they read magazines and books at home, on the job (although one survey respondent complained that women were allowed to smoke or apply makeup but not read during breaks at her office), and while commuting by train or trolley.[42] Most women's magazine publishers put out special issues, series, and book publications on occupations for women; these often contained valuable details for women seeking employment—about salaries, necessary training, and methods for procuring these jobs; clearly, editors thought readers were interested in such labor. These same women sometimes continued working even after marriage, and in any case often continued to read periodicals. Some editors specifically conceived of articles on domestic management for housewives living away from the extended family who might formerly have taught them such skills.

Along with these sociological (if not neutral) categories of working women were the more scandalous feminine images of the era, most famously the "modern girl" or *moga* analyzed in some detail by Miriam Silverberg and Barbara Satō.[43] This flapper-like figure was very much a media phenomenon, as we have already seen in the cartoon, although she had as her referent real women, especially those who wore particularly outlandish Western clothing, employed certain kinds of heavy makeup, and used rough or masculine speech. The modern girl was joined as an object of scandal by the so-called delinquent girl *(furyō shōjo)*, the counterpart of the male delinquent boy. As

mentioned earlier, many criticisms of women's magazines blamed them for creating, fostering, or catering to problem women. What role magazines did play in these trends is complex, but it is clear that just as women's magazines increasingly provided guides to or admonitions about life in the city, they also played a part in making that life what it was. If women's magazines emerged from a market created by social changes, they also became agents of those changes by representing new identities, aspirations, and fears associated with the lives of modern women.

Along with transformations in the working lives of women, the success of women's magazines was conditioned by changes in compulsory education and increasing numbers of women attending school. The Secondary Girls' School Act, passed in 1899, required that prefectures provide girls' higher schools *(kōtō jogakkō)*, and by 1907 the compulsory education for boys and girls was determined at six years of elementary school, although there were both noncompliance and a lack of sufficient schools.[44] But as a result of economic factors and further government initiatives in 1918, the number of girls' higher schools tripled again between 1918 and 1928; the younger readers of the magazines analyzed in depth here would have been educated during that period.[45] The 10 percent of the high school–age population who enrolled in the higher schools, along with the large group that had attended elementary school, provided a large potential readership. Although there were few women in universities even in the late 1920s, publications such as *Shufu no tomo* were designed to be readable by elementary school graduates and, as was common, included phonetic readings for all kanji (Chinese characters) in parallel text *(sō rubi)*, making reading less difficult.[46] Women's magazines also creatively combined visual and written text to make reading easier. We see that magazines did not simply appear as a result of the increase in education and literacy level, but actively participated in fostering that audience and its reading ability.

Similarly, magazines both were enabled by and enabled the expansion of consumer capitalism, retailers, and advertising. The growth of women's magazine circulation paralleled that of the advertising industry. For example, the advertising research groups at Waseda University and Meiji University started in 1918 and 1920, and in 1925 Mannensha began publishing *Kōkoku nenkan* (Advertiser's annual), a journal of statistics and information on advertising. Advertising agencies began appearing about 1910 and slowly grew in complexity. Their main activities were to buy blocks of space in various publications, sell this space to advertisers, and act as advisers to advertisers.[47] It was in this capacity that they began to offer advice on the character of publications and their suitability for particular advertisers, and

18 Chapter 1

while this sort of research was less sophisticated than it is today, it did allow for a strong relationship between the new magazines and eager advertisers.

The rise of the middle-class family brought with it new sets of perceived needs for home products and leisure goods. The department store became a major symbol of this aspect of urban life.[48] Magazines themselves became one of those products and provided a major forum for the increasingly organized advertising industry. As many have noted, a key concept in the understanding of consumption in this period is "cultured life" *(bunka seikatsu)*. References to the cultured life at first appear in theoretical treatises by cultural critics describing what life should be, but increasingly the term denoted a lifestyle to which all middle-class couples had access, characterized by rationalized architecture and appliances, often—but not necessarily—Western or Americanized.[49]

The casual lifestyle of Jōji and Naomi in Tanizaki Jun'ichirō's *A Fool's Love* (or *Naomi*) is the classic fictional example of the cultured life: we note their Western house, lack of maid, frequent use of take-out meals and other urban conveniences, and interest in privacy.[50] But the term came to refer broadly to many aspects of modern life and sets of products that were advertised under its name. As Minami Hiroshi has argued in his seminal work on Taishō culture, the term "culture" *(bunka)* was also a key word for both the state and conservative public intellectuals who saw the concept, along with *shumi* (a difficult-to-translate concept that includes leisure, entertainment, taste, and hobbies), as a safer, less political goal for the middle class than the Meiji era's "civilization" *(bunmei)*.[51] Culture should be promoted, many argued, through both the fine arts and the improvement *(kōjō)* of the lower reaches of mass culture. The improvement of women's culture, like Meiji civilization, was essential to improving the nation, but this was often seen in negative terms: the lowest common denominator of popular culture—women's consumer culture—must be improved if Japan was to avoid social decay.

Magazines, then, had a particularly interesting relationship to that concept of culture, because their content could, on the one hand, be seen as fostering the best side of the cultured life. This lifestyle could be seen as stable and rational, and women's magazines as a way to participate in its improvement. Although they were profit-oriented, each commercial magazine discussed here also had in its mission statement an appeal to this idea of improving what women read or improving their daily lives through modernization and rationalization. On the other hand, as the "Where Will Women's Magazines Lead Them?" cartoon and Tanizaki's novel suggest, this proliferation of products and the new identities associated with them could be threatening. Moreover, in both instances it is a female figure—the woman reader, consumer, and sexual being—who represents the most

anxiety-producing aspects of this lifestyle; we will see women's magazine texts representing various perspectives on this tension.

As should be clear, this study is influenced by recent work in both literary and historical studies that seeks to reevaluate the place of women and gender in the categories of "modernism" and "modernity" and that has begun to show the ways in which the stories of modernity and modernism can look quite different when, to borrow the title of a recent volume on the subject, "women's experience of modernity" is taken into account.[52] In particular, the relationship between the "high art" associations of literary modernism (or the hard social-scientific connotations of "modernization") and everyday life quickly transform themselves when the story is retold from the perspective of female subjects. Interestingly, in some respects women have long been a salient feature in studies of Japanese modernity. This is in part due to the attention that major social scientists and cultural critics in the interwar era paid to the changes in women's lives as they related to broader social transformation. Through the studies by Harry Harootunian, Miriam Silverberg, and Barbara Satō, we see the ways that such thinkers as Aono Suekichi, Hirabayashi Hatsunosuke, and Kon Wajirō saw the effect of capitalism and mass culture on women's lives as central to Japan's understanding of its own modernity and national culture.[53]

Seen as representative of a whole range of potential and actual changes in society, "woman" was asked to stand for a great deal. In the context of nineteenth-century Europe, Andreas Huyssen notes that "a specific traditional male image of woman served as a receptacle for all kinds of projections, displaced fears, and anxieties (both personal and political), which were brought about by modernization and the new social conflicts."[54] As Rita Felski has argued, conceptions of "authentic femininity . . . positioned woman as an ineffable Other beyond the bounds of a masculine social and symbolic order."[55] In this context, women become the Other for a set of modern discourses that "obsessively genders mass culture and the masses as feminine, while high culture, whether traditional or modern, clearly remains the private realm of male activities."[56] These often contradictory attempts to use woman both as a receptacle for tradition and a symbol of mass culture can also be observed in Japan.

Contributors to women's magazines, and intellectuals in general, often used the term "woman" to stand for other issues they discussed: either as a symbol of traditional Japaneseness or, in the case of the new woman and modern girl, as emblems of how much was really changing. As Sharon Sievers has noted, women served as a "repository of the past" for many intellectuals, a stabilizing imaginary in the face of change.[57] At the same

20 *Chapter 1*

time, the radical transformations in the lifestyles of so many women as they moved to urban areas and worked in modern jobs in offices and factories necessitated a complete reimagining of that very category of "woman" for it to acquire any meaning. This is also one of the insights of Joan Ericson's work on women's writing and its categorization as *joryū bungaku* (women's-style writing): at the same time that women became more active in modern literature, there seemed to be a need for a stabilizing category to define their writing in terms of femininity. Thus the modernist style of Hayashi Fumiko's *Diary of a Vagabond* (*Hōrōki*, 1928) is often defined by critics in terms of femininity rather than modernism.[58] Journalists' interest in modern women's culture also often constituted a metonymic usage of women to represent the ills of modern consumer society and mass culture. And in the context of non-Western modernity, these changes were often represented as Westernization, with the changes in women's fashion and appearance standing in for a discussion of the influence of Western culture. This tendency often seems self-contradictory, with Westernization (and Americanization) simultaneously used to represent improved, rationalized domesticity and bad influences on women, as creators of the modern girl, new woman, and delinquent girl.[59]

Women's Magazines and Approaches to Popular Culture

Despite some assumptions one might have about a book about magazines, and women's magazines in particular, this is not a book about popular culture. More properly, such wording alone fails utterly to capture the controversial nature of such a concept as "popular" in interwar Japan. Nothing would more have horrified some of the journalists, editors, and fiction writers whom I will examine than to have their work labeled with any of the many Japanese terms translatable as "popular" or as "mass" culture, while at the same time at least one considered it her life's work to deserve that title.[60] Women's magazines were as much part of defining what John Guillory has analyzed as the "cultural capital" of literature as they were part of popular culture. In the 1920s and 1930s, print culture in general, including the broader range of literary journals, intellectual magazines, and popular magazines, along with *enpon* discount books and *zenshū* collections, played the central role in determining literary value.[61] As I examine the narrower topic of women's magazines, the broader issues at hand are those surrounding the creation of the now-familiar categories of mass *(taishū)* and pure *(jun)* literature, as they came to be known in Japanese literary criticism, and the broader effects of the emerging mass cultural forms in the interwar era on Japanese culture

Production and Consumption of Women's Magazines 21

more generally.[62] The relationship between gender and those categories was important but not simple.

In literary studies, there has been increased attention to the role of print culture and mass culture in the history of modern literature and literary modernism. It is now common for studies of modern literature to gesture to the role print culture played in its emergence; they seldom fail to mention the roles of magazine and newspaper distribution, serialization, and expanding readership. Too often, however, these honorable mentions remain only that, seldom examining that print media itself: the way such publications are put together, the concerns of editors who put them together, the type of people who read them. Recent exceptions in criticism of Japanese literature have tended to focus—and usefully so—on the role of mass culture in the thematic and formal qualities of modernist fiction writers.[63] I will do the same, but my emphasis is instead on the world of print culture itself.

In a broader sense, it is worth remembering that we tend to make value judgments of literature that stem in some way from the work's context and audience, even when that is not the primary focus of our criticism. How we might think about these relationships without being deterministic is a concern of this study. In considering literature in the context of categories such as "popular culture," it is important not simply to think of literature as a set of options from among the open marketplace but also to seek other ways of looking at the range of literary expression and its interaction with politics and the real lives of readers—something that can be seen in part through its modes of dissemination.

As mentioned earlier, women's magazines were an important forum for modern Japanese literature. Much critically acclaimed fiction by famous authors may be found serialized in women's magazines: Tanizaki Jun'ichirō's *A Fool's Love* and *The Makioka Sisters (Sasameyuki)*, Satō Haruo's *Melancholy in the City (Tokai no yū'utsu)*, Hayashi Fumiko's *Diary of a Vagabond*, and Kawabata Yasunari's *The Izu Dancer (Izu no odoriko)* to name only a few.[64] The origin of many of these famous works in women's magazines is often forgotten, and recalling it can lend insight to their critical reception. At the same time, to attempt to lend respectability to this topic via a list of names is as problematic as it is necessary. Both works accepted as great and others less acclaimed make women's periodicals important to modern literary criticism, as they all coexisted when pure fiction and popular literature—marked by such terms as *tsūzoku shōsetsu* (commonplace fiction, novels of manners) and *taishū bungaku* (mass or popular fiction)—were emerging. As Seiji Lippit discusses, the discourses on the Japanese I-novel theorized in the same period were "part of an attempt to define a 'pure' literature, which meant excluding

22 Chapter 1

both political issues and mass culture."[65] Women readers were crucial to both of these exclusions. They were important to an understanding of what mass culture and popular literature meant, of course, because they were the most rapidly growing audience for it. But also—and this is easily forgotten—many writers, intellectuals, and publishers defined high-quality modern literature based in part on what was printed in magazines such as *Fujin kōron* because that magazine attempted and claimed to determine good literature for women readers. Works by women also had a complex relationship to the I-novel because they were so often taken to be autobiographical romans à clef and valued when they expressed, as Joan Ericson has shown, a certain "womanliness" based on personal experience.[66] And yet, such works by women are not usually marked as part of the I-novel tradition.

Women's magazines also help us to think about this moment in the separation between literature and both popularity and politics. First of all, since women as a group became a focal point for thinking about the nature of modernity and its effect on culture, literature aimed at women (whether by its authors or the editors who chose to place it in publications with various expressions for "women" in the title) became invested with ideological significance. Even Kobayashi Hideo, often derogatory about ideological criticisms of literature, waxed moralistic on the fiction of the popular woman writer Yoshiya Nobuko and its inappropriateness for girls—and this when reviewing a novel aimed at *adult* women.[67] Second, as with any form of commercial publication, women's magazines brought together and revealed with particular salience the relationship between literary texts and consumer capitalism. The choice of which novels to serialize was affected, though never in simple ways, by financial concerns. Publishers might try to attract readers by choosing a popular author or novel with an alluring title, by avoiding or cutting works to avoid the financial disaster of postpublication censorship, or by formatting to combat accusations of commercialism in favor of an image of literary cultural capital. These manipulations become most apparent when we look at works in their context of publication, editorial business practices, and accompanying texts. Writers too showed ambivalence about the new professionalism or commercialism associated with their efforts, but at the same time were impressed with their ability to affect large audiences. As Maeda Ai argued, women's magazines, in part because of the big sums they paid, brought authors, sometimes unwittingly, into the debates on the effects of the "popularization" of literature.[68] By the late 1920s, intense arguments on the political role of art, surrounding but not limited to the proletarian literature movement and women writers and readers, played an important part in this discussion. The role of feminism and other political movements in

the work of women writers, along with the role of the woman factory or office worker as reader and writer, became central to questioning the relationship among reading, art, and activism.

In looking at consumer culture aimed at women, women's studies has sometimes worked to revalorize the study of women's popular culture, formerly denigrated as lowbrow or sentimental. In their less subtle manifestations, however, such criticisms unwittingly associate the popular with the feminine without historicizing that relationship. In other cases, they imply that the cultural history of gender can be found only in this realm, reinscribing the links between modern womanhood, mass culture, and popular literature, often without questioning these assumptions. Other scholars discuss the intellectual history of women's issues, feminism, or women authors through their "important" and "serious" discourses, preselected through such publishing practices as anthology and translation. While this is done out of convenience, it makes it difficult not only to contextualize those materials but also to see why they have been selected in the first place. Focusing on publishing itself thus helps reveal the values of editors in the past and scholars in the present.

The false binary between political action and consumption has also been thoroughly criticized. There are not only moments when readers resist a reading that is intended, but also where even a dominant reading might inspire political action that goes against it. Rita Felski ascribes a potential to fiction often dismissed as "melodramatic" or "escapist," pointing out that although there are "problems underlying any...automatic equation of the popular with the transgressive," "the politics of escapist forms is more complex than many critics have allowed, in that their negation of the everyday may hold a powerful appeal for disenfranchised groups."[69] Nan Enstad has shown some of the complex ways that reading popular novels enabled the participation of working-class women in labor movements in the United States. She clarifies that this is not an inherent property of the reading material itself, a stance that "would be to ascribe to popular culture *objects* a particular capacity for action and render working women passive."[70] It is rather that in some cases such fiction may provide some "utopian hope" necessary for political action in that, for instance, "a walkout is in part an imaginative process of coming to identify oneself as a striker as one takes dramatic public action."[71] Many of the mass-produced materials for women had potential to inspire utopian hope in some of their readers, whether in the form of intensified outrage at the exploitation of factory girls, identification with same-sex love, or affirmation of feminine culture—any of which might or might not have been politically inspiring for any given reader.[72] The fact that so many contemporary Japanese feminists have turned to this period for inspiration

24 Chapter 1

no doubt indicates this potential. But in the lively magazine culture, such opportunities, of understanding and imagining beyond everyday life, did not necessarily trump political and economic realities. Mizoguchi's film character Ayako and her counterparts could not so easily avoid economic obstacles, and the same print culture that might provide imaginative alternatives did foster new "needs" that might not benefit them, as well as new names to berate those who did not adopt them properly—*moga* (modern girl), *furyō* (delinquent)—or to praise those who needed in the right ways—*shufu* (housewife), *chūryū fujin* (middle-class lady).

By considering several magazines that intentionally but quite differently positioned themselves within the relationships among commercial goals, interests of women readers, and political action, I seek to shift attention from shallow questions about the lack or presence of potential for resistance. I ask what reading practices are encouraged by different texts and the conditions under which they are available to be read, keeping in mind that some publications are produced in forms that may encourage cultural transgression more than others and that editors and writers attempted with varying success to induce particular effects with their publications.

Miriam Silverberg's groundbreaking article about the discourse on the Japanese modern girl, "The Modern Girl as Militant," turns to the magazine *Nyonin geijutsu*, discussed in chapter 4, to consider whether there might be a female counterpart to the largely male discourse on the modern woman in the 1920s. She writes that *Nyonin geijutsu*'s "unabashed celebration of female creativity, sexuality and autonomy was a potent contribution to the process of representing and thereby defining" the modern girl.[73] A cursory reading might give the impression that Silverberg thinks definitions created by women are the most authentic—that therein might be found the real modern girl. But her use of the word "representing" reminds us that these self-representations are nonetheless representations, while her tantalizing suggestion that there might be a real "militant" to be found in this discourse on the "modern girl" is worth questioning further.[74] My methodology for this analysis involves looking at the forms and production of these magazines in order to consider what difference that might make in their effects, effects to which we cannot have direct access. Raymond Williams has argued that studies of "the effects" of such media are not often enough efforts to "understand right inside the productive process how these difficult modes of address and forms are actually constructed."[75] By considering directly the form and texture of Japanese women's magazines, I intend to present methods for reading such representations that allow us to interrogate with more specificity their potential militancy or lack thereof. It is only then that we can begin

to ask whether representations created by women were more feminist or culturally transgressive than those by men, whether commercially oriented publications were less or differently a part of women's political consciousness than explicitly activist ones. Nearly all representations of modern women can be read as having some sort of potential for a critical reading, and we can find room for resistance by readers and social critique by writers in almost any publication. Here, I would like to begin to sort out, through close reading of these texts and an attempt to "understand right inside the productive process," how these transgressions might differ from one another. We may not learn what made Mizoguchi's Ayako do what she did, but I hope to show enough of what the magazines she read were like to imagine an answer to that question.

2 | Serious Reading

Enlightening the Modern Woman in *Ladies' Review*

A December 1916 advertisement in the magazine *Chūō kōron* (Central review) celebrated the first anniversary of its offshoot magazine for women readers, *Fujin kōron*.[1] This new magazine, it claimed, covered "from every possible angle, though without sensationalism or ostentation, the various women's issues that have stirred up new social movements."[2] From the start, the publishers of *Fujin kōron* claimed to place the so-called woman problem (*fujin mondai*) within the context of broader social transformations associated with modernity and to produce reading material that would both improve the growing group of upper- and middle-class women readers in Japan and educate male and female readers about women's issues.[3] Of course, readers' interest in women's issues, and in reading this magazine at all, had a great deal to do with the sensationalism that already surrounded women's activities as reported in newspapers and magazines at the time, particularly the scandals connected to the women running *Seitō* and the "new women" who read it. It also arose from the growing awareness of the reality that women were becoming major consumers of print capitalism. *Fujin kōron* thus becomes a fascinating set of documents, its pages negotiating the tension between the goals of enlightenment (for both women and Japan) and profit. *Fujin kōron* was founded at a critical time in the history of the relationships among gender, the reception of cultural products, and the ambivalent position of women in Japanese modernity. My primary focus here will be the most textually unusual aspect of this publication, the explicit division of one mode of discourse from another through formatting. This format marshaled texts of different genres, visual appearance, and rhetorical styles to manage those relationships and stem the tide of Japanese commercial culture for women, even while being a product of it. While contradictory and unsustainable, this approach produced an important, if temporary, space for sophisticated discussions and representations of the effects of modernity on gender roles and Japanese life. I will argue that this method was used strategically as a response to the rise of mass culture and that the format had particular effects

26

on reading practices and, by extension, politics, thought, and lived reality. As a result, these editing practices altered the perception of the literary, cultural, and political values attached to the texts found within the magazine.

This sometimes dry and highbrow magazine might seem an odd starting point for a discussion of women's magazines, which we would usually think of as either the medium par excellence of women's popular and commercial culture or as a forum for women's self-expression. *Fujin kōron* is not the best example of either. While its publisher has since made several attempts to raise its circulation by making it more entertaining, as I will discuss later, its central message has always been that it is, as the leader of one of its active reader groups called it, high-level *(hai reberu)* reading material.[4] In its early years, *Fujin kōron* had decidedly drab covers and layout; it does not contain the most tantalizing images of women's popular culture, of which there are so many. There are better places to find rich images of modern girls or cutting-edge advertising.[5] Meanwhile, although it did print major writings by the most prominent feminists and women authors, the magazine has always been written and edited primarily by men, as one scholar has even shown through statistical analysis.[6] But it is also precisely for these reasons that it is interesting to begin here.

Fujin kōron created a place where the boundaries between popular and serious discourses aimed at women or written by women were explicitly discussed and where the commercial viability of highbrow materials was presumed. Associations between women readers and consumption of products and popular literature were in the air but not fixed, and contributors and editors constantly negotiated the issue of who (man or woman, intellectual, fiction author, journalist, reader) would represent the views of women. The magazine title itself referred to the "public": *kōron* means literally "public debate." The dry tone of some of the writings also stems from the effort to produce serious discussions that could hold their own in general public discussion. The publishers took seriously the idea that the category of "women's issues" or the "woman problem" could be part of the general public discourse (i.e., the community of readers and intellectuals who were not specifically female), and openly discussed the significance of women's literature, women writers, and women thinkers for public intellectual discourse.

In this endeavor, *Fujin kōron* stood at the heart of major tensions in Japanese modernity and its relationship to gender. *Fujin kōron*'s texts articulated stances on the role of cultural capital in creating better women and a better nation. The publishers' statements suggest that they were aware of women both as a new market and as beneficiaries of mass-produced print culture and that they brought together liberal thinkers and established fiction writers (albeit

28 Chapter 2

often controversial ones) to promote a sort of cosmopolitanism for women that would take advantage of their increased access to print culture. But this exposure to and in the public was recognized as a double-edged sword. Editors' efforts to link women and the nation, or women and the economy, and to debate those relationships were often in tension with their tendency to transform women into spectacles to represent the radical transformations in modern life, as women paralleled and were potentially symbolic of other changes in society. Because the market was already viewed as a danger to women, they tried to exclude and control its influence in the pages of the magazine.

In this chapter, I will first analyze the format of the magazine and then turn to a number of polemical columns and debates that explicitly discuss cultural value and its relationship to women, particularly the relationship between publishing and women readers. This is followed by analysis of some fictional works that do not specifically address these questions of gender and culture polemically, but whose publication in this context helps us to think about the intersections of gender, modern fiction, and mass-produced publications. Finally, I will consider the changes in the magazine in the late 1920s and 1930s as a way of reflecting on changed relationships between women and mass culture in the years just before the war.

Fujin kōron Today

Sometimes it lends perspective to begin at an ending. In March 1998, the magazine *Fujin kōron* discarded its small format and its simple covers of watercolor and pen-and-ink art that had echoed the original covers from the 1910s and 1920s. In the "Renewal" issue that look was abandoned in favor of a style used by many of the more successful contemporary weekly and bimonthly Japanese newsmagazines: a larger format with fewer pages and a glossier cover. Perhaps most surprising to those readers who have respected *Fujin kōron* for its role as a forum for important texts of Japanese feminism and literature was the choice to place the veritable queen of the Japanese scandal sheets, pop singer Matsuda Seiko, on the cover of this first issue (figure 2). The decision, likely requested by the new owner of the Chūōkōronsha publishing company, newspaper conglomerate Yomiuri, has drawn some scorn from those who have long respected this magazine.[7] Yet in another sense the scandal-ridden Matsuda, a 1990s answer to the 1920s modern girl media figure, was a fitting choice for a magazine that has grappled throughout its history with the question of the place of women in public discourse. Matsuda, who began her career as the quintessential adolescent idol singer in the 1980s, was transformed by the scandal sheets and

Serious Reading in *Ladies' Review* 29

Figure 2. Cover with Matsuda Seiko. *Fujin kōron*, March 1998.

daytime television news into a poster child for 1990s aspirations and anxieties: her alleged extramarital affairs with an African-American dancer and a foreign soccer player revealed the instability of racial, sexual, and national identities of globalized culture and economics; her U.S. release of a recording with New Kids on the Block singer Donnie Wahlburg emphasized questions of success for Japanese cultural products in America; and recently her divorce from popular actor Kanda Masaki could be taken to represent a trend in Japanese marriage practices.[8] *Fujin kōron*'s soft-focus photos of Matsuda in a pink camisole are accompanied by captions that emphasize not the scandals

30 *Chapter 2*

but the divorced Matsuda's sense of personal fulfillment as a middle-aged professional living in "[her] own utopia" in Santa Monica.[9]

This marketing appeal to a younger group of women readers than before has been seen as something of an end to *Fujin kōron*, which feminist Ishimoto (Katō) Shizue had called "the most progressive and popular women's magazine in Japan." But this shift also resonates with forces present throughout the magazine's history.[10] At the heart of essays in the first year—including "The Proper Age for Japanese Women to Marry" and Nitobe Inazō's "Marrying a Foreign Woman" in the series Homes of Interracial Marriages—was a similar conflict between the attempt to examine personal daily lives as explicitly political entities and the commercial temptation to use those lives as a spectacle for entertainment or a stand-in for other social anxieties about the transformations of modern society.[11] It was these same tensions that brought *Fujin kōron* to what was seen as its first decline in quality in 1929, when it lowered its price, changed cover styles, added a movie section, and increased advertisements to make its still very progressive message more salable.[12]

The central question in examining the tensions *Fujin kōron* faced is the possibility of making use of a mass-market magazine for either political or literary purposes. The early volumes of *Fujin kōron* hoped both to dissociate the magazine from mass-market journalism for women, which it called low-level *(teikyū)* journalism, and to be a commercially viable enterprise. This occurred at a moment in Japan when women were interacting in new ways with mass culture both as audiences of popular fiction and as consumers of leisure goods. Given its aim to appeal to women without the taint of commercial interest, how could a magazine represent women's relationship to mass culture and reflect upon its own part in that relationship? What forms of serious culture and literature were offered as alternatives to low-level magazines? Outside Japan as well, we continue to see new versions of this conflict in the marketing of news, periodicals, and contemporary fiction, from the coverage of Hollywood figures or fictional characters as bad examples to controversies over the so-called liberal media—all of which play off fears of social upheaval and how to get at the truth of it.

The Beginnings of the Magazine and Creation of an Audience

The Chūōkōronsha publishing company's choice to begin *Fujin kōron*, a women's version of their magazine *Chūō kōron*, grew in no small part out of the hubbub surrounding the feminist journal *Seitō* that preceded it. *Seitō* attracted attention not only because it was produced by a group of women

writers and feminist thinkers but also because of a number of media scandals; these included coverage of editor Hiratsuka Raichō's consumption of "five-colored liquor" and her visit with some other members to the Yoshiwara pleasure quarters to observe the lives of women there.[13] In the early years of the Taishō period, the publisher of the successful monthly general-interest magazine *Chūō kōron* did not overlook *Seitō*'s significance and the attention drawn by the concept of the new woman to which its activities had surreptitiously given birth. The sense of excitement surrounding this new woman was strong.[14] Signified by the loaded word "new," interest in the new woman came from both a sense of potential for aroused political sentiment and a fascination with sexual scandal associated with her. *Seitō*'s gradual move from an emphasis on fiction toward debate on women's issues, which came in response to spurious reports about its members and increased after the young poet and feminist Itō Noe assumed its editorship, revealed that there might be potential for a magazine devoted to such issues but aimed at a wider audience of educated readers. Taking advantage of that mood of potential transformation, *Chūō kōron*'s special edition on women's issues in July 1913 was published to test the waters, and the choice to start *Fujin kōron* followed close behind with its first issue in January 1916.[15]

Other historical and economic factors were equally important to the founding of *Fujin kōron* as was the precedent of *Seitō*.[16] *Fujin kōron* began two years after the start of World War I, the economic effect of which transformed women's circumstances dramatically. Japan's exports tripled in the period from the beginning of the war to its close in 1918.[17] The financial gain from these trends remained with industrialists in the areas that benefited most from the war, such as the weapons and textile industries, while rising prices for everyday necessities and low wages led to hardship for the working class.[18] Already a large portion of the textile workers since the late nineteenth century, women made up much of the workforce that expanded during World War I. Murakami Nobuko has also argued that it was during the early Taishō period that women's labor, which had been increasing during the Meiji period, came to be recognized by journalism and the government as a major social phenomenon that crossed class lines in its effect.[19] *Fujin kōron* also started in the same year as the famous labor group Yūaikai (Friendship society), the first women's organization to form within a labor union in Japan. Although it did not represent women's labor movements directly in its early years, *Fujin kōron* carried the series Investigation of Young Ladies' Occupations, which focused on new white-collar jobs for women, such as telephone operator, schoolteacher, and typist, that part of the expanding workforce of women most likely to be readers of *Fujin kōron*. Interestingly,

Chapter 2

it also included a few jobs such as geisha, warning readers about their poor working conditions and in fact critically questioning the applicability of the term "occupation" *(shokugyō)* for the job.[20] The editorial forces, who claimed to seek the improvement of women's status, were clearly aware of the rising importance of women in the labor force and in the labor movement as well. These influences reverberate in some of the abstract discussions of the relationship between women and politics in this magazine, as well as in arguments for the value of women's economic independence.

Shimanaka Yūsaku, a *Chūō kōron* editor who had overseen its special edition on women's issues or "the woman problem" in 1913, provided the idea to start *Fujin kōron*. He became interested in women's issues in his final years as a student at Waseda University under the influence of playwright Shimamura Hōgetsu, who was producing Ibsen's *A Doll's House* at the campus auditorium at that time; the play had as great a part in fueling debate over women's status in Japan as it did in Europe.[21] In his own recollections in 1935, Shimanaka describes his reasons for starting the women's magazine as the "relative success of the special edition," "the intriguing activities of *Seitō* members," the upturn in the economy in that year, and "the democratic thought that was taking the world by storm."[22]

The gender and class of the audience for the magazine was complex. Many women readers were first introduced through a father, partner, or brother who subscribed to *Chūō kōron* or through their own reading of that magazine, so a woman's class and her family or romantic relationships often determined whether she read it. In general, surveys show that the magazine was popular among upper-level schoolgirls and white-collar women workers in the late 1910s and 1920s, though it gained broader appeal in the early 1930s when it started to sell at a cheaper price and began to include both more visually striking material and coverage of popular topics.[23] Still, even in its early years, a certain number of readers were women working in factories, even if *Fujin kōron* was much less popular among them than adolescent girls' magazines.[24]

Although it was a major publication, the circulation of *Fujin kōron* was far lower than that of more popularly oriented and commercially successful women's magazines. For example, in 1927 the circulation was 25,000 copies, compared to 200,000 of *Shufu no tomo* and 120,000 of *Fujin kurabu*. *Fujin kōron*'s circulation was fairly similar to other high-end women's magazines, however. For example, *Josei*, the cosmopolitan magazine that carried articles by intellectual journalists and fiction, including Tanizaki's *A Fool's Love*, was recorded as having the same circulation of 25,000 in 1927. Hani Motoko's

Fujin no tomo, which was more household management–oriented than *Fujin kōron* but still aimed at an educated audience, had a circulation of 60,000 at that time.[25]

It is also important to note that men were almost as likely to read this enlightening material as were women. Surveys of magazine reading throughout the Taishō and early Showa periods have shown that men read many women's magazines; an early contributor to *Fujin kōron* was informed by the publisher that a third of the readers were men, and he should keep this in mind as he composed his article.[26] *Fujin kōron* served as a place for men to read up on women's issues and observe what positions the major liberal and socialist thinkers of the day were taking on them. It also carried fiction by well-known writers with no particular association with women readers. Thus this magazine, particularly in its early years, was not exclusively written for or read by women. While its promotional materials referred to the "advancement of women" through superior reading material, it indirectly targeted a broader audience.

This is particularly visible in the advertising, which was predominantly for books on feminism, translated philosophy, and literature. The earliest advertising would have suggested an anticipated audience rather than an actual one because although marketing research was beginning to develop as a social-scientific category at this time, there would not likely have been much research to predict statistically who would buy this magazine.[27] Some of the advertisements in the early issues such as promotions for hair dye or childcare products, depict women users. Ads for Mitsukoshi and other department stores sometimes feature women's fashion and cosmetics or refer to women shoppers. Just as often, however, they do not specify particular consumers, and indeed included men using the products. The majority of advertisements were placed by publishers of books on women's issues or books of literature, most of whom were also advertising in *Chūō kōron* but whose ads were here reworked to highlight the topic of women. For example, a Sōbunkaku advertisement used the rubric of "contemporary life and women" *(gendai seikatsu to fujin)* to advertise a number of its books, such as the novel *A Certain Woman (Aru onna)* by Arishima Takeo and writings by socialist Sakai Toshihiko.[28] The combination of advertisements suggests that there was some tension between expected audiences: one was defined by its interest in these new reading materials and ideas, the other by its consumption of products increasingly associated with women.

Fujin kōron's covers also reveal a great deal about how the editors hoped to place the magazine in relationship to gendered readers. During the late

1910s and most of the 1920s, the covers were different from most women's magazines of the same period in that they did not show a woman's face; not until late Taishō did the covers begin to feature the more typical "female beauty" *(bijin)* images (figure 3). The earliest covers were like those of *Chūō kōron*, which used a black box over a plain white background, but replaced the blank white with a flower pattern (figure 4). These choices suggest that the editors wanted to balance a feminine image with their awareness of male readers. Such covers also clearly distinguished *Fujin kōron* from other women's magazines' obvious attempt to attract readers with eye-catching covers of the sort we shall see *Shufu no tomo* using in the next chapter. The subtle floral background was thus the perfect choice, a culturally recognizable signal of femininity not particularly associated with commercialism. By not giving a visual representation of a woman on the cover, it did not define womanhood visually in the ways that "cover girl" representations did. Without romanticizing the publisher's motives, we may nevertheless read in this choice a certain emphasis on the intellectual, aesthetic, and practical

FIGURE 3. Cover by Tōgō Seiji. *Fujin kōron*, March 1931.

FIGURE 4. Cover for special issue "Beauties and Cosmetics." *Fujin kōron*, April 1919.

knowledge that the modern woman "should" seek, rather than beauty.[29] And there were always contradictions at work: the special issue shown in figure 4, though it does not have a cover girl, is titled "Beauties and Cosmetics."

Cultural Capital and Categorizing Texts

Turning past the cover does not mean somehow moving on to what is really important. The covers and historical context of *Fujin kōron* already are part of the magazine. More significant is that creating divisions among texts and contexts was part of the magazine's method, and the critic's method must include reconnecting them in order to understand the meaning of those divisions. Not all readers would have read these formats the same way, but the form of the magazine limited or enabled how it would be read by most readers. To begin to understand what effects—emotional, economic, or political—reading this magazine might have had on actual readers, this analysis will consider the sorts of reading practices encouraged by the form of the magazine itself. John

36 *Chapter 2*

Guillory's analysis of canon through Bourdieu's notion of "cultural capital" is helpful here. Guillory's focus is on the university as site for creating and negotiating distinctions among works, but periodical culture was a similarly important location in the first part of the twentieth century in Japan, as commercially published and self-published literary journals and magazines all took part in the selection, dissemination, and livelihood of writers of fiction and essays.[30] The part of commercial publications and manuscript fees in that process often became controversial, and the sectioning of *Fujin kōron* played a mitigating role. The division of "novels" *(shōsetsu)* and "creative works" *(sōsaku)* into a specialized section made certain implications about fiction's status as special cultural material that stood separate from the marketplace. This focus on cultural capital also went beyond literature in that nonfiction articles too emphasized a sort of cultured femininity (and as we shall see this was usually but not always a "Japanese" one) that should be cultivated in order to prevail over the appeal of either the desire to consume or to transform Japanese womanhood in directions considered dangerous or undesirable.

Fujin kōron appears unique among women's magazines in being divided into distinct sections, each separately paginated. Many aspects of the content and organization of the magazine mirrored the parent magazine, a formal parallel that presented it as *Chūō kōron* for women. The magazine started with three sections: Public Debate (Kōron), Essays (Setsuen), and Novels (Shōsetsu). The second year saw further subdivisions: a new Current Opinions (Jiron) section carried a monthly essay about a current event. The Setsuen section was split into two parts: Interests (Shumi, which also includes the sense of "taste" and "hobbies") and Knowledge (Chishiki); Shumi carried news about entertainers, travel reports, letters and writings on general social phenomena; Chishiki offered advice about household chores and health—generally information specific to the home, women's work, or the female body.[31] The section Novels was changed to Creative Works (Sōsaku) at the same time, apparently to better incorporate such genres as poetry and literary essays (especially works marked as *zuihitsu*). This organization suggested distinctions among the different types of knowledges the texts would communicate, divisions between informational and entertaining missions, and even relationships between reader and writer.

It is often hard to determine why a particular piece was placed in a given section. The Knowledge and Public Debate sections include similar articles on social movements, scientific discovery, and legal matters. The categorization suggests a difference between contentious writing and that which means to inform. The implication of this public debate category was that these noteworthy opinions were part of the public discourse, an important

Serious Reading in *Ladies' Review* 37

part of public debate rather than simply a source of information. The title Interests, on the other hand, implies that the section was intended to entertain rather than inform. By following the sectioning as a guide, readers could easily choose between light and serious texts and also between fiction and nonfiction. While the content of those sections did not always match this labeling in any simple sense, these categorizations likely affected the political valences with which they were read. In the Public Debate section, numerous conflicting texts explored and debated the motivations for the advancement of women. The fiction, meanwhile, was in a sense placed outside the context of public debate by being in an entirely different section. We see other magazines, such as *Nyonin geijutsu*, discussed in chapter 4, seeking to alter this tendency by integrating fictional texts and feminist debates in the same space. At the same time, *Fujin kōron*'s inclusion of "emotional" topics such as love in the Public Debate section meant that these could be marked as specifically political, whereas they had often been designated as light reading in other publications.

The categorizations also worked to emphasize certain texts as having different cultural capital from others and to literally divide literary cultural capital from capital. The advertisements in the magazine were placed near the front and back covers and never mixed in with these serialized novels. Thus, while the novels were being financially supported by the magazine medium, their format gave the fiction the look of being in book form. The separate sectioning presented the works as fiction that might stand alone, despite being part of this disposable medium, and the publisher's practice of subsequently publishing in book form the works found in their magazines, with little change in typesetting, emphasized a sense of fluidity between magazine and book. The separation of opinion and advice essays from interests and fiction worked to negotiate the relationship between entertainment and serious writing.

Commercial texts were physically separated from other writing, with most advertisements placed near the front and back covers. Indeed, the sheer rarity of advertisements in the first several years is surprising, and suggests that the magazine was supported by advertisements in the main *Chūō kōron* magazine. Given the number and type of advertisements found in other women's magazines at the time, the publisher of *Fujin kōron* seems to have avoided soliciting ads from cosmetic and department store companies in the early years to avoid tainting its serious image with explicitly feminine products, relying instead on the financial backing of the publisher's general-interest magazine.[32]

We will see that all of these categorizing practices worked in different ways to give the impression of integrating women into socially important public discourses, whether polemical or fictional, rather than those explicitly

38 Chapter 2

identified with forms of mass culture, but at the same time often needing to erase the taint of female readership altogether to do so.[33] By examining some specific examples of these categories of writing, the following sections will consider the significance of separating these discourses from one another.

The Kōron Section

Kōron literally means "public debate," and the section so titled was devoted to bringing a discussion of women into the public discourse. Here the magazine's contributors, readers, and advertisers contested the meanings of the woman problem and the significance of changes in women's lives. The effort to define *fujin mondai* was caught up closely with the relationship between women and conceptions of modernity or the modern nation. Many of the articles about women dealt with their place in the modern political or socioeconomic system: women in the workforce, welfare for mothers, and women's suffrage. This strand of issues placed women at the center of modern liberalism's discussions of rights and freedoms and viewed modernity as liberation or equality for women. In some cases, this argument also suggested that the status of women was as structurally integral to the status of the nation of Japan as had been the project of the men writing about women in *Meiroku zasshi* much earlier. And as leftist journalists increasingly contributed in the 1920s, articles sometimes argued that women's oppression was intricately connected to class struggle and economic transformation.

At the same time, the Kōron section dealt with topics previously identified as feminine, often because of their association with a domestic private sphere or with the psychological parallel of the private sphere: human emotion and psychology. The identification of such topics as potentially political, historical, and debatable has of course been a characteristic of modernity in the West as well; as Rita Felski writes, "The so-called private sphere...is shown to be radically implicated in patterns of modernization and processes of social change. The analysis of modern femininity brings with it a recognition of the profoundly historical nature of private feelings."[34] In *Fujin kōron*, articles dealing with love, marriage, divorce, motherhood, and suicide are not simply topics of interest to women, but matters of review, criticism, and debate, worthy of the attention of major intellectual figures and suitable for public intellectual discourse.

In fact, responses were sometimes published month after month in the Kōron section, producing a debate structure.[35] In contrast, placement of texts in the Knowledge section marked them as outside debate: women's health, sexuality, eugenics, the latest research in psychiatry, and domestic science. These

categorizations of knowledge then followed the ideology of modern science, with a science broadly defined and fixed in its view of sexual difference even as gender was debated elsewhere in the magazine. For example, while marriage practices or even government policy on birth control might be debated in the Kōron section, the physical realities of reproduction and related assumptions about female psychology or hysteria were taken as fixed.

The Taishō New Greater Learning for Women: Male Intellectuals and Modern Womanhood

The Taishō New *Greater Learning for Women* (Taishō shin *Onna daigaku*) series appeared in the Kōron section of *Fujin kōron*'s first nine issues. As a researcher I nearly skipped over this discussion because it is fairly conservative and not, apparently, the most exciting of the materials printed in women's magazines. It soon became clear, however, that these writings set forth nicely all of the major issues about the relationship between women and modernity that appear and reappear throughout the magazines with which this book deals. We see here the ways that writers were thinking about the modern and how it affected the relationship between women and daily-life practices, labor, politics, the nation, education, and scientific conceptions of the gendered body. As the first metadiscourse within the magazine on women's knowledge, the articles map out the range of issues and contradictions involved in this magazine's mission of writing to enlighten the modern woman and help define a new role for the public intellectual in writing about women's issues for an audience of women. We also see the types of rhetorical styles with which the woman problem was being discussed, many of which were rejected or transformed by other writers who went on to use the women's magazine as the means of dissemination for their writing.

The title of the series refers to the Confucian instructional text for women, *Greater Learning for Women (Onna daigaku)*, often attributed to the Edo intellectual Kaibara Ekken, a text that had been invoked and criticized throughout the Meiji period.[30] *Fujin kōron*'s version of *Onna daigaku* was written by nine different men who were regular *Chūō kōron* contributors and hailed by the editor's introduction as "top-level, prominent figures in modern society." Many of these figures are seldom mentioned now, but all were major intellectuals of the day. The first essayist, Miyake Setsurei (1860–1945), husband of Miyake Kaho (1868–1944), was best known as a critic of the Westernization of Japanese government and politics; he founded the magazine *Nihonjin* (The Japanese, later called *Nihon oyobi Nihonjin*, Japan and the Japanese). Major figures in women's education were included,

40 *Chapter 2*

such as Japan Women's University founder Naruse Jinzō (1858–1919) and Sawayanagi Masatarō (1865–1927), a Ministry of Education bureaucrat and university administrator who admitted the first woman into a college. A number of the columnists—such as Abe Isō (1865–1949), Yamaji Aizan (1864–1917), and Inoue Tetsujirō (1855–1944)—were Christian thinkers and educators, all people very much associated with the Meiji period who had made their names before 1900. By running this series in the first year of *Fujin kōron*, the magazine claimed prestige for itself and for the topic of women's education and learning.[37]

The editor of this series introduced it as a discussion of what "new morals" might replace the "old moral structure" that "has been lost."[38] It is important that although the arguments appear old-fashioned when compared to the more radical debates on women's issues that later took place in *Fujin kōron*, the contributors all claimed to participate in a new and modern outlook on women's position in society. Although somewhat pedantic, these articles, unlike most of the previous *Greater Learning for Women* revisions, were not simply didactic discourses on women in civilization but rather essays in a commercial periodical aimed at women readers. Although intellectuals had been writing about women's issues for some time, there begins here a stronger sense of women as a reading audience and as consumers of this media.

All of these essays in some way welcome the improvements in women's status that they see as breaks with tradition. For example, Keiō University president and later minister of education Kamata Eikichi writes that "equal rights" for men and women are necessary to accompany the "equality between the classes" that had been recognized with the "end of feudalism."[39] The authors encourage women's greater education and emergence into the workforce and urge them to participate in areas of society previously dominated by men. Claiming that they reject the "good wife, wise mother" *(ryōsai kenbo)* curriculum, all these writers see the significance of modernity for women to be these moves into public activity and rise in education levels. The effect of these changes, they argue, will be on women's consciousness (often expressed as *jikaku*), a consciousness of themselves and their place in their society and the world. Abe Isō in particular focuses on the importance of a wife's maintaining the same level of knowledge as her husband, and he enthusiastically praises some American adolescent girls who had the strength to correct him sharply while he was in the United States.[40]

At the same time, these thinkers explicitly distinguish their calls for "liberation" from the activities comonly associated with the new woman. The more radical images of the new woman are here attached to stereotypes of

feminine irrationality requiring control, which the authors of the series argue should be imposed by the same education system that they claim will liberate her. References, often in the form of asides, to the new woman in general and to *Seitō*'s Hiratsuka Raichō in particular, exhort women not to become overexcited by new ideological trends. They either position such women at the extremes of modern thought or in some way work to renaturalize their behavior; for example, Yamaji Aizan comments, "Certainly even Hiratsuka Raichō would never say that raising a child is only troublesome."[41] They generally urge discretion and restraint in following new ideas and call for the new woman to remember her "nature" and "duty" in order to help herself restrain her radical tendencies.

Yet many saw the same feminine nature as most prone to instigation by radical ideas. For example, Inoue Tetsujirō warns that women are "easily incited" and must try not to be overly swayed by the latest "abnormal changes" in thinking or the "new woman's" call to "free the flesh."[42] This admonition was supported by new notions of the influence of sexual difference on personality and behavior, information disseminated in *Fujin kōron* itself—in fact, articles on hysteria and instinctual jealousy appeared in the magazine during the same months as this series.[43] Pieces on delinquent girls and women criminals, with such titles as "Young Women's Road to Depravity," both intensified the suggestion that changes in women's lifestyles were dangerous and suggested that there were natural dangerous tendencies in the female sex that would be unleashed if traditional morality broke down.[44] In this context, the sober arguments for equality for women were intertwined with a reassertion of difference, newly aided by the popular representations of behavioral science and biology that accompanied them.

As a solution to the uncontrolled exploits of the new woman, these writers propose a combination of the more docile side of "feminine nature," "virtue," and practical knowledge.[45] They warn that freedoms and social change must be accompanied by a form of wisdom, often expressed as knowledge and virtue *(chitoku)*, that is itself part of the new but must also be its chaperone. Merely raising women's status and increasing their freedoms without polishing this *chitoku*, education bureaucrat Sawayanagi Masatarō argues, would be equal to giving freedoms to uneducated "barbarians" *(yabanjin)*.[46] Through this type of logic, the writers shifted the framework under which the new woman could be criticized by suggesting that the sense of danger linked to her was rooted not in her newness, but in her female sex. By associating women with irrationality (or as in Sawayanagi with barbarism), writers were able to criticize the new woman without criticizing modernity itself. By suggesting that her

activity was simply lacking in the civilizing influence of education or virtue and by calling on modern psychology, they designated their own discussion of women's issues as more modern and valuable because more rational.

For these writers, the primary source of the knowledge and virtue with which these ideal modern women should be guided was education. Their views of education for women may be divided into two main argument types: first, that women's improvement must operate in relation to modern domesticity; second, that women's education must serve society or the nation. This modern domesticity, as these writers see it, would work not on "instinct" but on scientific, practical knowledge: Takashima Heisaburō writes that because women have "many superstitions" they need the "new science" of "everyday knowledge" of "real things surrounding food, clothing, and shelter," such as why food spoils or why it is important to dry clothes and bedding in the sun.[47] In child rearing, he continues, women ought to learn about "the physical and psychological" aspects of children rather than merely following "instincts" without knowledge, the way "lower animals" raise their young.[48] The implication is that this publication, along with formal education, will provide the information to overcome these limitations.[49] In essence, these articles themselves claim to participate in the woman reader's education in this modern domestic life, and in this they diverge from the idea of good wife, wise mother education that sought to spread information through the schools alone. Interestingly, it was other publications such as *Shufu no tomo*, discussed in the next chapter, that most actively participated in domestic education through print culture.

These writers do not restrict their discussion to household science, and they all touch upon the importance of women's emergence into the public workforce, particularly in the new types of jobs in urban offices and stores. Many of the contributors to the Taishō New *Greater Learning for Women* series assert that working produces a new understanding of the world that will be useful in family life and society. Abe stresses "economic independence" as an important tool to avoid being "denigrated by men." The training and ability to work can also be called upon, he notes, if a woman's husband were to die or abandon her.[50] Such practical concerns were combined with glorification of work's power to impart "cultivation" *(shūyō)*, a concept that, as Barbara Hamill Satō has shown, became central for imagining women's work culture in post-Kanto-earthquake modernity.[51] These thinkers too emphasized the need for women to redirect what they had learned while working toward their "natural mission" of housekeeping and child rearing, albeit in new and scientific ways.[52] For Abe, *shūyō* is primarily a goal of premarital work activities whose benefits would be reaped after marriage:

he writes that a lack of knowledge and experience hurts relations between men and women, since the "level of their interests diverge" if she stays home while he "experiences the world." His example is a fiancé who goes abroad before his marriage: the man breaks the engagement, having seen that his fiancée pales in comparison to more socially experienced and cultured women in the United States. Education through work experience becomes key to "household harmony."[53]

Still there is worry that the same work might instead lead away from a virtuous domesticity. Inoue Tetsujirō writes that a woman must take care of household matters whatever else she does outside because without her in the home her husband "will not be able to act freely out in society."[54] Introducing the question of how their income would be used, Sawayanagi Masatarō writes, "Many jobs have been opened up to [women]. But this does not necessarily lead to their freedom or a new status. Some of them only use the skills and income they acquire for vain purposes."[55] Allowing participation in activities to which Kathy Peiss refers as "cheap amusements" in turn-of-the-century New York, new jobs for women afforded them disposable income to spend on leisure not entirely controlled by their families, a practice that they might even continue after marriage if turned into a habit.[56] Many intellectuals saw such leisured consumption as detrimental to women's attempts to liberate themselves from traditional morality, merely replacing it with an embrace of useless rather than socially significant activity, a worry that would come to be repeated later by socialist feminists.

The discussion of work also called upon ideas about the sexed body that were posed in modernist terms. The concept of division of labor *(bungyō)* is mentioned in many of the same articles in the Taishō New *Greater Learning* series as a call for women's expansion into the workforce.[57] While the series focuses on overcoming "irrational" exclusions of women from the workplace, it also reasserts new "scientific" ones related to supposed dangers and strength limitations. The argument that working would continue only until marriage could somehow seem consistent with goals of a conventional married life without appearing out of step with the times. Claiming to provide useful, scientific knowledge about work and women's bodies could thus diffuse this tension between work and marriage. Through this combination of messages the ideas become salable to some women who sought such cultivation through scientific knowledge and reliable information.

The improvement of women's status is seen as indicative of Japan's move into modernity or as the final step in completing that progression, establishing Japan's status as a modern democratic state. The thinkers emphasize that women's new freedoms should be channeled and disciplined

as activity in the service of that modernized nation. Although, as mentioned earlier, many of the thinkers emphasized gender difference, in this area they tended to use a rhetoric of equality; many opposed the idea that a woman should strive to be the good wife, wise mother that had been the ideal in the Meiji period, writing that she should focus rather on gaining equal education so that she might manipulate her new citizenship responsibly. Instead of women's education for women as women only, Sawayanagi writes that women must now be educated as humans *(ningen)* or little citizens *(shōkokumin)*. Interestingly, *shōkokumin* was also used to refer to children in Meiji and Taishō thought, indicating an overlap in thinking about women's and children's relationship to the nation—that is, as holding a partial or incomplete place in it. If Sawayanagi writes that women should learn about politics, economics, science, and "human spiritual production" so they can contribute to the development of society, the more openly nationalistic writer Yamaji Aizan urges them to become more enlightened in order to contribute to the "safety of the Japanese Empire."[58]

Inoue Tetsujirō makes the intriguing statement that discrimination against women had rendered Japanese society as if "paralyzed on one side of its body."[59] Inoue's remark emphasizes equality in the service of the nation, but it also recalls the ways that these discourses on personhood and citizenship were intertwined with a reemphasis on sexual difference; indeed, throughout the Taishō New *Greater Learning* series, the body and the nation are placed in a parallel relationship, as in Yamaji's statement that "a nation where women are merely baggage for men will not become strong."[60] Change in women's lives is connected symbolically with transformation of the nation on multiple levels. Images of the new woman and later the modern girl were—and remain—the most salient images of Japan's modernity in the 1910s and 1920s; this alternative discussion of the modern Japanese woman, then, works to put forth other less-shocking forms of altered womanhood to represent the nation.

In that vein, many of these writers refer to feminine virtue as an asset to modern Japanese society. Abe Isō refers to different sorts of obedience *(fukujū)* as essential elements of democracy, without which the people will not choose to follow the ruler. He parallels this with the need for women to be "in equal position" to but also pliant in their relations with men:

> What we want to emphasize in this new *Greater Learning for Women* is not women resisting men. What we really need is a new form of obedience. It is for women to stand in an equal position to men...but to be yielding....The more women raise their status and the more their

education progresses, the more they will be capable of a more beautiful form of obedience.[61]

Abe is in many ways the most ambitious in his hopes for women's education and place in society, calling for instance for female suffrage. He also speaks to the doubtful, saying that a more educated and privileged position for women will allow them to exhibit a "more beautiful form of obedience *(fukujū)*," more beautiful presumably than a more obsequious and weaker form. Although we should not attribute all notions of submissiveness to a "traditional" Japanese femininity—many such ideas as we think of them now were created in the Meiji period or even in the post-WWII era—in this context, with his comparisons to the United States, Abe's sense of *fukujū* seems to be a hybrid of his conception of democracy and what he thinks his audience will value as a Japanese feminine quality.

This hybridity works through the series in its understanding of the relationship between gender and modernity, and perhaps even represents through its view of this particular contradictory relationship anxieties about other contradictions associated with Japanese modernity. The definitions of womanhood discussed here are in many senses new, but at the same time they depend upon older views of feminine difference in combination with new views of physical and psychological difference. As Yamaji Aizan puts it, new values will neither "fall from the sky, nor bubble up from the earth."[62] Several of the other critics emphasize that new values for women would necessarily be based on what "had developed continuously, from far in the past up to the present."[63] By the 1920s, cultural critics would tend to focus on urban women as the ultimate in modern, with rural areas representing the "unevenness" of Japanese capitalism that many imagined would be overcome but would best maintain an element of cultural difference.[64] Here too the writers assume inferiority (of women) but argue that it can be lessened by improvement, education, or self-cultivation, leading women to move forward along a developmental model. Thus progress for women and natural difference weave tightly together. Gender difference is almost always assumed to extend beyond physical difference, although the dimensions of its domain are actively debated; that those differences can be debated, the writers imply, makes their discussion modern.

These articles certainly maintain a conservative outlook on progress for women. Nonetheless, simply to dismiss them as dull (as we might, given some of the more radical texts of the period) overlooks the significance of these men writing about this topic in this forum. These writers were likely solicited

to submit articles appropriate for a *Chūō kōron*–style magazine for women. Given that a quarter of the readership may have been male and many others would have been quite conservative women, it is not unlikely that the editor of these essays and the contributors had a sense of an audience who might be comforted by the cautionary tone; they may have strategically linked their calls for progressive changes in women's status to a lofty and circumspect tone. Because the writers tried earnestly to incorporate women's issues into their general visions of social change, and wrote at a level equal to what they would write for the well-respected *Chūō kōron*, they arguably transformed those social visions, at least for some of these intellectuals.[65] Their writings also provided a shared vocabulary and rhetoric about social change with which women readers and feminist contributors could put their ideas into conversation. Thus within a few years, *Fujin kōron* saw debates such as the famous motherhood protection debate *(bosei hogo ronsō)*, in which feminists discussed state welfare for mothers and grappled with the same issues of the state, physical difference, and self-reliance, in ways that engaged more deeply with other public discourses of the period than had articles in *Seitō*.

These writings can be seen as transitional from the type of Meiji writings on women that tended to ignore the possibility of women's forming their own public voice or even of an active readership who might apply the suggestions in an imaginative way. Typical of the series' mode were Yamaji's ten principles for women:

1. Listen to the information of the world and learn foreign languages.
2. [Remember that] the power of the world is in science.
3. Listen to debates of society . . . for the safety of the Japanese empire.
4. [Remember that] the husband should be the center of the family.
5. Try to get along with your in-laws.
6. Do not think you can be dependent on your husband or you are like a prostitute. . . . A nation where women are baggage for men will not be strong.
7. [Remember that] vanity is the product of a small heart.
8. [Remember that] women should go to temples, look at flowers, climb mountains—anything that will not damage their womanly kindness.
9. [Remember that] association with boys should be free and bold, but there should be a chaperone.
10. Be kind to all your relatives and friends.[66]

The style of writing, with its classical verb endings and weak imperatives vaguely reminiscent of neo-Confucian texts, lent a sense of seriousness to the rhetoric but seemed pompous in a commercial-market magazine intended to invite women readers. This didactic mode slowly dropped away in this magazine, and such lists as rhetorical devices became unimaginable even a year into publication. The debate also took a generally defensive stance against the new woman, speaking in a reactive rather than constructive voice. Neither the rhetorical style nor opinions in the New *Greater Learning* overtly capitalized on the excitement over the transformations of which the new woman was symbolic and that had driven the founding of *Fujin kōron*. The activities of *Seitō*'s editors in the previous years had helped to foster the idea that women should both produce and consume discourses on women and participate in promoting their own "learning." The fact that the editor moved toward new columns and special issues that featured women writers suggests that he and his staff may already have recognized this tension, as did Yamaji's preface to his article: "For me, a man, to write about the conduct of women is strange. No matter what the situation, morality is not something that one should advise for another. Female sexual virtue that is not willed by the woman herself is meaningless. . . . I will only write what comes to mind when imagining what I would do if I were born a woman."[67]

Women as Public Intellectuals

In the Kōron section, women writers were few. A researcher from an ongoing Tokyo workshop on women's cultural history has analyzed the exact percentages of male and female contributors in each section of *Fujin kōron* during the Taishō period and found that men outnumbered women in all cases.[68] The first indication that the editors were concerned about this was the choice to name the first special issue of *Fujin kōron* (October 1916) the "Lineup of Contemporary Women" (Gendai onna zoroi gō) and to limit printed articles to ones authored by women. The advertisement printed in the previous month's issue began, "People who do not read this magazine are not *today*'s women!!!" and promised contributions by such woman intellectuals as Hiratsuka Haruko (Raichō), Yosano Akiko, Nishikawa Fumiko, and Yamada Waka—all former participants in *Seitō*.[69] In women's magazines gender was often highlighted through layout practices, and here the advertisement neatly lined up the feminine *ko* suffix in the women's names at the bottom of the page. Even Yamada's name is written as Yamada "Wakako," though she was usually known as Yamada Waka, just as Hiratsuka Raichō is here given her legal name "Haruko."

48 Chapter 2

Although the magazine returned thereafter to printing a majority of articles by men, the October 1916 issue marked a certain group of women as important to the discourse on women's issues and established *Fujin kōron* as the major periodical forum for polemical pieces by women writers. Despite its predominantly male authorship, *Fujin kōron* was also the main place for feminists to publish their opinions, aside from independent journals focused on particular movements such as the suffrage movement. Many of these women also wrote occasional pieces on women in magazines and journals aimed mostly at men or at a general audience, but *Fujin kōron* was the dominant venue if an author wished to reach a large number of female and male readers who expressed an interest in such issues through their choice of magazine.

The significance is not simply that these articles reached a larger number of women readers; it also meant that the authors could assume enough interest and sympathy from readers that they need not dwell on defending their own importance and could take more contentious stances. This also gave feminists more room for clarificatory debate, which was rarely welcome in magazines on general politics or economics, where feminists thought they needed to present a more united front. For example, through the late 1910s and 1920s, socialist feminist Yamakawa Kikue contributed to both *Fujin kōron* and a number of leftist journals and economics magazines. In women's magazines, she was a strong critic of feminists who did not sufficiently address issues of class and economics. In journals of the largely male labor movement, however, she focused on arguing that motherhood, domestic labor, and marriage needed to be a part of their social vision because consideration of them, she argued, necessarily transformed the foundations of socioeconomic analysis.

Thus despite the numerical predominance of male contributors, *Fujin kōron* did end up the vehicle for many of the most sophisticated discussions of women's issues in twentieth-century Japanese feminism. Such discussions took advantage of the format of *Fujin kōron* and its marking of particular discourses as matters of debate. In particular, they could treat previously "feminine" topics that had been seen as matters of fact or nature, such as love or motherhood, as matters of opinion and politics. The already mentioned motherhood protection debate in 1918, for example, brought together a discussion of welfare for mothers with debate over the economic and emotional implications of working and raising a child at the same time.[70]

It is worth looking in depth at another important debate in *Fujin kōron*, Yamakawa Kikue and Takamure Itsue's so-called debate on love *(ren'ai ronsō)* of 1928. Their exchange combined a discussion of the movement toward a "love marriage" (rather than an arranged match) with a debate over anarchism and socialism.[71] Their sophisticated debate grappled with

issues intertwined with the production of the magazine itself: urban culture, consumption, representation of female beauty, and the meaning of political consciousness for modern women. They made use of the space of the Kōron section to examine in an unsensationalistic way matters often left in the Shumi or Chishiki sections, where they would be marked as entertainment or fact.

The debate was set off by Yamakawa's January 1928 essay "Women as Bargain Goods—Free Bonuses Included."[72] She begins by quoting newspaper advertisements for various products that tout their newness, quality, and good price, and shows the uncanny resemblance of these advertisements to those placed in newspapers describing the attributes of single women on the "marriage market." Such "advertisements" in the society pages pointed out "free bonuses" that would come along with each woman: skill at flower arranging or tea ceremony, high education level, good health, beauty, youthful qualities. Yamakawa then launches into a biting criticism of the commodification of women: "In this discount marketplace where land, houses, telephones, stores, poultry farms, hospitals, companies, typewriters, clothing, and furniture are all sold at 'special bargain prices,' it appears that truly the best buys are human beings—women."[73] Yamakawa specifically points out that the position of women in marriage relationships will not be transformed merely by swapping arranged marriages *(omiai)* for love marriages *(ren'ai kekkon)*. She insists that women must instead become conscious of the fact that they are being made into objects of exchange and seek a change in the economic relations in the society such that women would have financial independence. Yamakawa shows financial dependence to be clearly contradictory to true love *(jitsu no ren'ai)*, so there can be no real love marriages as long as economic inequality between the sexes exists; women who say they are entering love marriages are still commodities:

> Modern daughters instead of being bought and sold by their parents are now just selling themselves. The devotion to love that seems to be popular among young women today is like a bait set to attract the most profitable conditions and best customer to whom they can sell their whole lives, rather than any kind of celebration of pure, simple love between young men and women.[74]

Although Yamakawa does not specifically refer to the modern girl *(modan gāru)* of popular discourse as such, this piece is clearly a part of the discussion of that figure. The women Yamakawa describes as boasting a liberated approach toward love and marriage are related to the representation of modern girls as women who asserted their sexuality and their independence.[75]

50 Chapter 2

By arguing the shallowness of the turn by "modern daughters" toward "love marriages" she also questions the depth of the modern girl's resistance.

Yamakawa frequently uses clothing and cosmetics as both examples of and metaphors for the superficiality she perceives in these cultural phenomena.

> They say that young women today value love. But would it be fair to say that the value they place on it is not higher than that they place on new cosmetic techniques? Love that is only given the same weight as new cosmetic techniques to attract the highest bidder! Love to make yourself more attractive as a commodity! This skill of ornamentation for love, love techniques aimed at negotiating the best deal on the marriage market! These days what many young women are thinking of when they say "love marriage" is only a marriage—an exchange—based on these types of techniques.[76]

Yamakawa argues that so long as women cannot have lifelong financial independence, these changes in women's position will be less than skin deep: they are "just glossing everything over with 'love'" when "women's dependence on men" is the real issue. This, she writes, is "nothing more than exchanging the Japanese clothing the commodified woman is wearing for Western clothing; it is only modernization on the surface."[77] Of course, this is the image that much of the women's press at this time was selling: modern looks through cosmetics, clothing, and romantic love. It is also the criticism of the modern girl by many male intellectuals of the 1920s; Yamakawa's apparently condescending perspective is part of what Takamure criticizes in her response. But for such intellectuals the authentic presence behind the surface of the commodified woman tended to be female nature or Japanese femininity rather than some human truth revealed through the economic transformation of society and marriage institutions that Yamakawa seeks.

She finishes her essay on the commodification of women by expressing her concern that women are not "conscious enough of their status as commodities" and hoping that they will work to change the whole economic system of society instead of performing superficial acts of resistance.[78]

> A time needs to come when women are able to go without selling love and without having to rely on marriage to live—a time when they only live off doing earnest labor *(majime na rōdō)*. Women should not be satisfied with just being sex objects. If they do not feel any dissatisfaction and contempt at having to live off of sex, if they do not reject what is

essentially the occupation of prostitution, then they are sexual slaves and are no different from some kind of commodity.[79]

She imagines that, if this position of dependence ends, women and men can finally experience "true love" and "pure, simple love."

Four months later, Takamure Itsue published a piece titled "A Critique of Yamakawa Kikue's View of Love," also in *Fujin kōron*.[80] Her main criticism focuses on the question of whether a revolution of the economic system in itself will do enough to change the position of women. Stating that she is an anarchist, Takamure argues for a society of self-rule and cooperation based on physical labor and the values of the countryside; she posits these as opposed to the urban-centered, centralized world she imagines a "Marxist society" to be.[81] Takamure disagrees with the idea that economic dependence is the only obstacle to love; she says that what needs to be changed is that love is "based on a beauty that is selected by men" and specifically "leisure-class men."[82] She writes that, under capitalism, women have earned salaries and thereby gained some real independence; therefore, she says, "modern, independent free love" is not simply a detour on the way to dependence on men in the form of marriage, as Yamakawa argues, but "continues to reject that dependence."[83] Takamure had published "The Leaving Home Poem" (Ie de no shi) in response to the scandal caused when she temporarily left her husband in 1925. She wrote, "All the things I have done are / All the things that we women must do," referring to a rejection of the household system *(ie)*.[84] Takamure asserts that this type of defiance is a significant part of the process of developing women's consciousness and changing oppressive institutions, even if it does not deal with the problems of capitalism.

She does not, however, think that the kind of love most of the women with increased financial independence would practice is the "pure, simple love" that Yamakawa says will appear once women are free from such dependence, because it would still depend on "the leisure class's conception of female beauty."[85] It is Takamure's impression that although a Marxist revolution would try to dispose of the leisure class, it would not really change this "leisure-class beauty." She quotes "a famous Marxist" as saying to proletariat women that in a socialist world they will be able to wear "the pretty clothing they are too poor to afford now."[86] To ascribe such an opinion to Yamakawa is strange, but Takamure's critique of this potential line of reasoning is interesting:

So according to this person [a famous Marxist], even when it becomes a socialist world, there will not really be a change in beauty. It seems that

Chapter 2

the beauty created long ago by leisure-class men will even be carried over into socialism. The fashions of products put on to exaggerate one's body and attract sexual patrons will not be any different from what they are today, and some women, attracted by this type of beauty, will gradually come to dislike labor. Even if they call it something else, they will be led into the position of what is essentially a leisure class. Furthermore, most men will still despise ugly women and like beautiful ones.[87]

For her, such gender norms as conceptions of female beauty are related to economics, but are persistent and not transformable by economic change alone. She thinks that failing to change aesthetics would lead people back to capitalism even after a revolution in the economic system: men would still treat women according to leisure-class aesthetics, and women would still want to fulfill ideals that can be achieved only through having leisure time. She believes that if this concept of beauty does not change, the desires that drive capitalism will always reappear. Thus because Marxism as she reads it will not do enough to change these aesthetics or even to understand them, it cannot completely eradicate capitalism.

This exchange takes place in the columns of the capitalist press, in a popular women's magazine surrounded by advertisements for department stores and cosmetics, in the same place as the discourse on the modern girl is being published. The relationship between consumption of these items and those feminists' questioning of gender norms is especially important. Like Yamakawa, Takamure feels that the modern girl is not particularly successful at resisting social institutions because her criticism is superficial and coquettish rather than politically conscious. Like Yamakawa also, she misses the questioning of gender roles implied in descriptions of the modern woman or modern girl. Although she notes that many say the "new woman" is "masculine," she sees this merely as another way to say that she is unattractive.[88] Perhaps more than Yamakawa, however, she recognizes the danger that these women pose to patriarchal institutions. That they are labeled "ugly women" becomes a mark of how much they threaten certain social norms. Yamakawa believes that even women who refuse to marry men chosen by their parents are "no different from some sort of commodity," but Takamure suggests that speaking out does make them different. She seems aware that these resistances are still in danger of co-option by capitalism and are still not free of all the values of the leisure class. But because conceptions of female beauty, by which she means something not unlike socially constructed femininity, have involved being silent, attempts by new women to express

themselves begin work on the transformation of beauty that Takamure thinks crucial to any real escape from patriarchy and capitalism.

Yamakawa in her response to Takamure's critique does not fully deal with the questions about beauty and love that Takamure posed, however, preferring to focus on Takamure's misunderstanding of Marxism. Many historians writing about the debate have noted that although Yamakawa's arguments throughout were characteristically logical and careful, it was unfortunate that she did not confront these issues directly.[89] At the same time, Takamure's attack forces her to explain a Marxist vision of capitalism with clarity. And even as the response moves away from direct engagement with issues of capitalism and marriage practices, the debate structure and the setting in a magazine itself, one that included fiction and advertising that directly invoked those themes, keep those topics in play. Similarly, Takamure takes a combative tone in her final reply to Yamakawa, titled "The Trampled Dog Howls," and focuses on explaining both anarchist and eugenicist theories that she referred to indirectly in her first essay. Again, although this is somewhat less interesting than the first essay, the debate with Yamakawa forces her to state her opinions forcefully. She is much less clear and logical a thinker than Yamakawa, but her fiery argumentation and examples are compelling.[90]

It is interesting that these two women appear in the magazine as both intellectuals and personae. For example, in the same issue, a reporter comments on Takamure's "The Leaving Home Poem," and Yamakawa Kikue is featured as an important woman. Yamakawa is photographed; a page of messy handwriting from Takamure's poem stands in for her image. As they are both well aware, the two women were inextricably linked with the commercial press that they often criticized, both as subjects of representation and as professional writers.[91]

Although there are problems with both women's positions, this sophisticated debate might be seen as a pinnacle of what it was possible in this space for feminists to write—a space that marked their writings as part of the construction of public intellectual discourse in a commercial publication. Yamakawa and Takamure were both able to draw on the political and philosophical discourses within the magazine and to explore the topics of marriage and beauty that were also represented in a number of ways in the magazine, including advertising, how-to advice, scandal reporting, and intellectual discussion. The opportunity to debate the political significance of modern conceptions of beauty in the same space where cosmetics were advertised gave particular strength to their arguments and demonstrates one of the advantages of discussing capitalism in a commercial magazine. Meanwhile, the layout of

Fujin kōron did not present the debate as merely one of a group of competing voices, but as one that was more politically important than others. Perhaps this hid what was really happening commercially with the magazine, but it also allowed for a particularly visible stage on which to perform convincing criticisms of society and gender roles.

Besides incorporating famous women as writers in the debate section, the magazine also explored the possibility of its own readers becoming writers. The status of contributors to the Kōron section shifted most obviously when the editors began the Free Discussion (Jiyū rondan) column, to which any woman reader could contribute. Rules for submissions were printed at the right of each month's column:

> We open up the Free Discussion column to promote *freedom of speech* by our nation's women. We welcome submissions by anyone, so long as she is a woman. However, whether they are accepted or rejected shall be the decision of the column's editor. A necessary condition for contributions is that they shall be simple and clear.[92]

In this way, the relationship between reader and writer or editor became less divided, though as these guidelines suggest, there remained a wide gap between professional and amateur writers—certainly the more illustrious contributors were not held to this "simple and clear" rule. The Free Discussion column was even printed in smaller type than other articles, but the idea of ordinary women as not only readers but also participants altered the didactic tone of the magazine, and readers came to be seen on some level as legitimate voices in public discourse.

As the rules suggest, submissions were heavily edited or carefully selected. Printing reader letters was becoming common in Japanese magazines at this time, particularly women's magazines, partly under the influence of their American counterparts. But unlike the short, enthusiastic letters of praise for the magazine we will see in the discussion of *Shufu no tomo*, the typical Free Discussion article was relatively long and made a sustained argument about a specific problem or an article from a previous issue. Such letters used a variety of writing styles, invoking the forms of journalism, letters, and personal essays. The first printed submission, "Philanthropy or Hypocrisy," signed only An Admiring Reader, uses a humble voice, as if writing a letter to the author of the article to which she is responding. She starts out, "I read your exposition, Professor Kujibara, and one of your statements affected me quite intensely" *(Kujibara Kōjo sensei no osetsu o*

haiken itashimashite tsūsetsu ni kanjita koto ga gozaimasu).[93] She addresses the author deferentially as Kujibara Kōjo-sensei rather than using the more neutral *shi* suffix of address, and she refers to him with honorifics and herself with humble verbs. On the other hand, the third piece in the same column, signed with the full name Tominaga Misao, uses a strong polemical style to make an argument about the lack of respect for women schoolteachers in schools.[94] The neutral *de aru*–form verbs of written argument and strong conjunctions (many uses of *shikashi* and *shika mo* to focus the criticism) give the piece a strong tone. Tominaga's point is that women are not given freedom of expression in faculty meetings. Her final sentence uses the idea of women angrily speaking out as part of her rhetorical structure: "I want to cry out. To say: 'To begin with, women teachers are not asleep.' To say: 'I want men to begin to develop an understanding about us enlightened women teachers.'"[95] This content and rhetoric match well the column's guidelines, while also making use of styles employed by many of the famous intellectuals writing in the magazine.

Although these essays were highly packaged, framed by the editor's comments and guidelines, they did give room for lengthy arguments by women readers in a way that reader columns in more commercial magazines generally did not. Other reader columns often used the letters to promote the magazine by praising its content or to provide shocking or titillating personal confessions *(kokuhaku)* and true stories *(jitsuwa).* Although the Free Discussions were restricted to women with strong writing abilities and to topics of interest to the editor, at its best moments this column did create a space for some women readers to express their opinions in a forum that was presented as significant. Furthermore, these attempts to incorporate lesser-known women's voices into the Review section, even if they were simply gestures or experiments, involved a parallel, and maybe even related, tendency to bring a new set of topics and rhetorical style into this debate section.

Shumi: Opinion versus Entertainment

The Interests (Shumi) section printed topics presumed to be lighter than the opinions of illustrious authors and social thinkers in the other sections, suggesting that the serious reader might skip this section in favor of "more important" writings. And at the same time, its presence suggests that a women's magazine was thought to require this sort of entertaining material. Much of the content walked a line between the standard content of popular journalism, such as scandals and confessions, and the magazine's claim

56 Chapter 2

to present important topics and thinkers. High-end leisure activities such as travel were also discussed here, with many pleasant travel essays. As discussed earlier, many topics such as love and marriage, considered light reading by other magazines, were often discussed in the Kōron section, changing their valence to one of important opinion. The Shumi section had stories about the same sorts of topics but written in a less argumentative style. The chief difference was that the stories in Shumi were presented as interesting and entertaining rather than intellectual. As indicated in the following advertisement copy their usefulness for readers was meant to be derived from direct identification rather then analytical reading: "Discussions of women's tragic experiences, useful and interesting stories about various women—those who have asserted themselves and those who have degraded themselves—writings that any woman should read."[96] The Shumi section makes the same sorts of appeals to women readers as other publications do, but often with a thicker veneer of utility or significance. A common type of article is a discussion of a scandal involving a famous author, ostensibly glossed as important cultural news. The most productive way to look at the significance of this category is to examine one of the places that it overlapped and was in tension with the writings of other sections. Probably the most striking, where the themes of the Kōron, Shumi, and Sōsaku sections came together, was the coverage of the 1923 double suicide of author Arishima Takeo and *Fujin kōron* reporter Hatano Akiko.

Love Scandal and Literary Personae: The Arishima-Hatano Double Suicide

Scandal reporting grew with the emergence of the newspaper medium during the Meiji period. Late-Meiji scandals surrounding various new women were relatively common: indeed, the names of feminist figures and women writers were sometimes known as much for their association with various incidents as for their writings. The most publicized stories about *Seitō* were Hiratsuka Raichō's rumored consumption of a drink made with liqueurs of five different colors and the time that a number of members went to the Yoshiwara licensed prostitution area to see what it was like. These tales remained much better known than most of the writing in the journal itself, in part because the newspapers that covered them had high circulation, while the journal itself was not widely available. *Fujin kōron* was in an odd position in relation to such scandalmongering. On the one hand, it claimed to be serious and uninterested in such trivial matters: at the same time, as we have seen, the Kōron section also often implied that these sorts of incidents and activities

were in some sense political ones. Furthermore, it placed itself at the center of a circle of public intellectuals and literary figures, such that scandals about them appeared to be relevant.

Arishima Takeo and Hatano Akiko's double suicide in June of 1923 set off a flurry of articles in major newspapers and periodicals. Most of the articles in the August issue of *Fujin kōron*, like those in most other periodicals, were devoted to this event. As we have seen, *Fujin kōron* had considered the possibility that events related to love or male-female relations had a social significance they had not before been accorded. In general, this writing avoided the inflammatory tone of contemporary scandal sheets, focusing instead on gleaning the political significance of such events. But because the woman in question was a *Fujin kōron* reporter and the author was popular among the readers, coverage of the suicide walked a fine line between scandal and seriousness. The journalistic forces of eventfulness and spectacle threatened to overwhelm attempts to treat the double suicide as either an artistic or political issue.

Arishima's *A Certain Woman*, written from the perspective of a complex female character who might generally be considered a new woman, helped make him into a writer of interest to the intellectual women readers of *Fujin kōron*.[97] His frequent contributions of fiction and essays to the magazine kept him much in their purview, and his much-publicized efforts to raise his three children after his wife's premature death had made him a highly sympathetic figure. This suicide was covered heavily throughout the press and remains a stock trope of Japanese literary and popular culture from fiction to television.[98]

For readers of and contributors to this magazine, Hatano was also a well-known figure. She sometimes published essays of her own in *Fujin kōron*, and she regularly worked as an editor of others' work. Many of the illustrious contributors knew her from her contacts regarding their submissions. Although she was married, her job as a reporter also categorized her as one of the new working women whose participation in new sorts of careers drew great attention. She and Arishima apparently carried on an affair for some time before committing suicide together in the resort area of Karuizawa, but it was only in the wake of the suicides that the relationship became cause for speculation in the media.

The coverage of this suicide was in some ways reminiscent of the scandal surrounding the free-love relationships between anarchist Ōsugi Sakae (1885–1923) and three women: Hori Yasuko (his wife, 1883–1924), Kamichika Ichiko (a female reporter, 1888–1981), and Itō Noe (*Seitō* editor and writer of fiction and essays, 1895–1923). After Kamichika was driven to stab Ōsugi out of jealousy over his relationship with Itō, the women and Ōsugi chose, with

Chapter 2

some encouragement from a publisher, to write open letters in a women's magazine explaining their ideas about their unusual relationships. All three were in some way involved with journalism and magazine publishing (Itō had been the second editor of *Seitō* and Kamichika a successful reporter); they were very much aware of the dangers of encouraging greater press coverage. The very beginning of Itō's open letter (addressed to Yasunari Jirō, the editor of *Onna no sekai* [Women's world], who was publishing it) makes efforts to define the form of her "excuse" to the public on a formal level:

> Yasunari Jirō sama,
>
> As I tried to explain to you, albeit in a fragmented fashion, when we met, I was resolved to say nothing about these recent events. The array of emotions I have experienced and the way these events have unfolded are much more complicated than most people have made any effort to comprehend or any attempt to think about. Thus to discuss this in a fragmented way with others was impossible. So if I am to speak or to write about this now, I think it is necessary for me to recount, from A to Z, without omission, every detail of the ever-shifting circumstances of this affair as well as the fluctuations in my philosophy and emotions.[99]

In this way, Itō attempted to control how her scandal was presented in the press, by insisting on nothing "fragmented" and giving every detail of "fluctuations" in her thought. Without this explanation, Itō Noe might well have been depicted as yet another fan (of whom there were reportedly many) of the charming Ōsugi, rather than having strong ideas and feelings behind what she was doing. Having been an editor herself, she was well aware, it seems, of the effect of edited, excerpted, or sensationalized texts as opposed to sustained argument that allowed explications of the transformations in one's own thoughts rather than a snapshot of the moment. Kamichika, meanwhile, provided an essay for the more commercial and conservative magazine *Shufu no tomo* in 1920 titled (perhaps by the magazine editors rather than Kamichika) "The Confessions of a Victim of Free Love."[100] Her essay is in the voice of a contrite woman who has turned away from both free love and socialism.

The coverage of the Hatano-Arishima suicides was very much fragmented. Of course, the two could not explain themselves as Itō did. Well-known literati responded to the event in letters printed by *Fujin kōron* in a special column, and these are, for the most part, more incendiary than thoughtful, usually shorter than a paragraph. Akutagawa Ryūnosuke's (1892–1927) entire submission is, "I thought she was very clever. I also got the feeling

Serious Reading in *Ladies' Review* 59

that she was a little hysterical."[101] Murō Saisei (1889–1962) writes about her "iridescent eyes." Uno Kōji (1891–1961) says he was surprised by her "allure," so unlike what he expected from a woman reporter, and he wondered "what kind of family woman she could possibly be."[102] Tanizaki Jun'ichirō notes that she had "eyes so much like those of renowned geisha"; he has read in the newspaper that she was rather "androgynous," but he disagrees, saying that she had a certain sort of "feminine delicacy" common among the Edokko (old Tokyo families).[103] Even Itō Noe participated, claiming to have held "antipathy and contempt" toward her, but thinks she was beautiful, with "the kind of eyes that fascinate other women."[104] In these writings, Hatano is described almost entirely in terms of her appearance (and especially her eyes) or relationship to Arishima. The very brevity of the responses even suggests some editorial hand in that image: few of the writers are provided much space to comment on the matter, but each response is given a headline, taken from the comment itself. These generally highlight the sorts of observations about her appearance quoted above, even where the details of the texts are slightly more reflective on the significance of her death.

What seems strangest is that despite the fact that she was a writer for the magazine, there is no mention of her work or opinions. Even in the longer piece by Shimanaka Yūsaku, the editor in chief, who knew her well, there is little discussion of her articles. He dwells on the last time he saw her and his vague impressions about her affair with Arishima and her marital relations.[105] Unable to come to her own defense, Hatano became a symbol of the modern woman and even the woman fiction reader and fan. The newspaper cartoon described in the introduction to this book—"Where Will Women's Magazines Lead Them?"—included among the destinations "the next Hatano Akiko" (see figure 1 on page 15).

By contrast, the articles about Arishima reflect at great length upon his philosophy and what political and emotional forces might have led him to commit suicide. The submission by poet and journalist Yanagisawa Ken (1889–1953) summarized others' views on the suicide, noting that "the right wing views it as a sign of decadence, the left wing as a bourgeois act of a man who never succeeded in becoming a proletarian writer." Yanagisawa interprets the suicide as being about the relationship between "the individual" and "the collective."[106] Meanwhile, Hatano was depicted merely as another of Arishima's swooning female fans. A cartoon in 1923 depicts a woman student holding the small literary magazine run by Arishima, *Izumi* (Spring), and saying, "That Hatano is so lucky. If only I had known that Mr. Arishima so wanted to commit love suicide I would have submitted an application

60 Chapter 2

to volunteer myself"[107] (figure 5). In the picture, the woman is not even reading the magazine but crying into it, and this was the image of Hatano: an overemotional fan rather than a reader of literature—or the active writer that she herself was.

An interesting twist is that some of the writings on the suicide were not in the Shumi section but in the Kōron section. It is likely that because of Arishima's cultural status as a respected writer of fiction, his suicide could be treated simultaneously as a scandal and as a cultural event. Furthermore, the topics of suicide and love suicide were available for treatment as social problems that went beyond the sensation of this particular case. We see how the sectioning negotiated the mixed nature of such an event that bridged the worlds of highbrow and lowbrow culture and could be interpreted as having a combination of literary, social, and entertainment value.

Despite the interest seen in the Kōron section in considering the political nature of topics such as love, suicide, sexuality, and marriage as they relate to women's lives, in the Shumi section of the magazine, women's experiences of such events are subject to analysis only as they have the power to shock, surprise, or titillate the reader. As we turn to the fictional texts of this magazine, we will continue to see this tendency for ideas about women as low-level readers—a characterization suggested by the magazine itself even in its claims to improve them—to affect the choice of texts and authors.

Sōsaku: The Creative Works Section and Imagining the Woman Reader

Many Japanese authors were deeply affected by their encounter with female audiences and the publishers aiming at them, though the manner of that engagement varied widely depending on the type of publication involved. *Fujin kōron* wanted to connect serious writers to women readers. When publishers aimed wholeheartedly at achieving mass appeal, authors often tried to write fiction to support themselves while also trying to keep the other foot in the highbrow literary establishment. In trying to lead this double life, authors were compelled to think more about the entire relationship between their art and this mass audience. Such thought often led to crises in how they would relate to movements such as the proletarian literature movement in the late 1920s and generally forced them to think about mass culture vis-à-vis their own sense of their artistry.

The editors' choice to divide the Creative Works from the Public Debate section severed the relationship between public political discourse and literature, even as many other authors of the day weighed in on political

Serious Reading in *Ladies' Review* 61

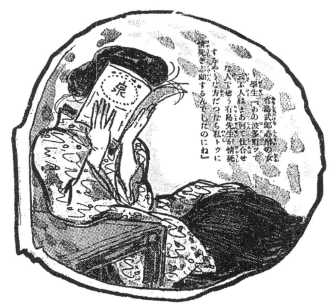

FIGURE 5. Cartoon. "Girl Student Infatuated with Arishima Takeo," author unknown. Caption reads "That Hatano is so lucky. If only I had known that Mr. Arishima was looking to commit love suicide, I would have volunteered to die with him myself." *Jiji manga*, July 22, 1923.

views. While other women's magazines emphasized that their fiction was entertaining, *Fujin kōron* represented the fiction section as highbrow leisure-reading material. An early advertisement for *Fujin kōron* claimed that the magazine would "improve" the tastes of women who had unfortunately been corrupted by the "low-level" literature found in other women's magazines and adolescent girls' magazines.[108] The writers found here were certainly highly regarded ones: Satō Haruo, Tanizaki Jun'ichirō, Tokuda Shūsei, and Tayama Katai, to name only a few. These writers might have been found in any magazine of the day, though often the pieces chosen for this magazine treated topics seen to relate in some way to women, either with prominent women characters or supposedly feminine topics such as love or even cosmetics.[109] But when these works have resurfaced in anthologies they have also been further distanced from these origins, as if to perpetuate the logic of *Fujin kōron*'s ambivalence about their readership into the present.

The fiction section, unlike other sections of the magazine, was devoid of advertising, and this practice served to distinguish cultural value from

commercial texts. Still, the fiction was what attracted certain audiences, and the publishers were not averse to using such advertising devices as tantalizing teasers for the serialized fiction. For example, an ad for the New Year's issue of the second year reads,

> At last the novel *Abandoned Child* is approaching its climax: what turns of fate will lead this tragic tale to its conclusion? We left Yoneko, the main character of the full-length play *Jealousy*, at a moment of surprise. How will this develop in the third act?...The top author of the literary world, Masamune Hakuchō, has written a novel especially for this magazine. How will he capture the interests of our readers? Just thinking about it now makes the heart dance.[110]

Multiple images of women readers circulated in the press at this time. Essays printed in the magazine emphasize the enlightening and "cultivating" nature of reading and what it might add to women's lives. In a column called Ladies' Reading (Fujin no dokusho), woman writer Miyake Kaho suggests that even a couple of hours of reading broadly each day would add a great deal to the erudition of the average housewife and prevent her from having a "meaningless life" made up only of "the many odd tasks" she is forced to do. She notes that if each of the well-dressed wives she sees around Tokyo were to give up one *obi* to buy books, she would benefit greatly. She hopes that rather than joining "the throng of people at a sale at the Mitsukoshi department store fighting as if overcome by sheer madness over one kimono," women will realize "that reading any one of the books [at the nearby Maruzen bookstore] closely would be as inspiring as any gold brocade."[111] Although she presents reading as superior to shopping, she is also suggesting the ways that they were already linked in people's minds. Significantly, she suggests buying books, not disposable magazine fiction, although much of her own work was disseminated by the *Jogaku zasshi* periodical, as Rebecca Copeland has shown.[112] Perhaps the fact that her own critical reception was weak and that she was "forever defined by her relationships with men" made her especially interested in gaining for women readers and writers alike a higher level of respectability, dissociated from consumption.[113] Like many critics, she attempted to divide women and the consumption of disposable or unnecessary goods.

There were many similar columns on women and reading, and many of the suggestions were more or less timeless classics. They tended to argue that cultivating women readers was best achieved with traditional works— Japanese literature and philosophy such as early women's diaries and neo-

Confucian tracts rather than modern fiction. Although the suggestions are for younger women, a series of submissions by illustrious intellectuals, authors, and journalists for a column titled What Should a Young Lady Read? are revealing about attitudes toward women's reading. Along with Japanese classics they mention translations of Western works ranging from Tolstoy to Emerson. One critic discouraged works by Swedish feminist Ellen Key, Nietzsche, Guy de Maupassant, and Gabriele D'Annunzio, although he admits they are what he reads.[114] But most of the warnings in this series mention novels of manners (fūzoku shōsetsu), decadent fiction (daraku shōsetsu), and novels that deal with the topic of love.[115] Several even specifically criticize magazines; Noma Gozō writes, "What I would especially not recommend is low-level magazines and novels."[116] As we saw in the discussion of Hatano Akiko's double suicide with Arishima Takeo, women readers were depicted as especially susceptible to fascination with literary gossip and moral corruption and magazines as the vehicle for such materials.

In the following sections, we will look at three novels by established male writers printed in *Fujin kōron* and consider what effect the awareness of women readers as a potential audience might have had on the writing and reception of novels in the early years of the magazine. These should not necessarily be considered representative, as the works found in magazines are by definition varied. They do represent a reasonable sample of the relationships between fictional works and women's magazines that we might find, however. I have chosen works by Satō Haruo and Tanizaki Jun'ichirō in part because of their fame and familiarity to readers of Japanese literature in English; Hirotsu Kazuo is a less well known figure, but his literary production was closely associated with mass print culture.

An Actress Wife and One-Yen Novels: Satō Haruo's Melancholy in the City

One of the most important novels printed in *Fujin kōron* is Satō Haruo's *Melancholy in the City (Tokai no yū'utsu)*, serialized from January to December in 1922. Satō (1892–1964) was an important poet and novelist most successful in the late 1910s and 1920s. This novel, one of his most renowned, followed its precursor *Melancholy in the Country (Den'en no yū'utsu*, 1918).[117] That novel, in its first draft, was titled *The Sick Rose* in reference to the William Blake poem beginning "O' rose thou art sick." The protagonist, referred to throughout as "he," is an author living with his actress wife in a house in a rural area connected to Tokyo by train—a sort of refuge near but separated from the city in a farming area gradually becoming suburban. The novel is

64 Chapter 2

affecting in its depiction of this "gloom" or "melancholy" of the title. In this rural refuge the relationships between the main character and other people, and even with the plants in his garden, are mediated only through art.

Satō Haruo first published *Melancholy in the Country* in the small magazines *Kokuchō* and *Chūgai*, but when greeted with strong critical acclaim by other writers it was published in book form. In the following years, his works came to be published in major magazines. Why, then, was *Melancholy in the City*, which reads as a sort of sequel, printed in *Fujin kōron?* There is some anecdotal evidence suggesting that Satō had agreed to serialize it there before finishing his writing. It also seems that the placement of the work affected critical reception at the time. Hirasawa Seiji, a *Fujin kōron* reporter, recalls,

> *Tokai no yu'utsu* was introduced over the course of one year in *Fujin kōron*. But this was not because of an effort to match that readership with a somehow "dumbed down" *(chōshi wo oroshita)* work. I knew that this longer work had been eyed for a long time by someone at Chūōkōron publishing house, and as a reporter for *Fujin kōron* I pressured Mr. Satō and got him to give us the manuscript.[118]

Satō himself recalls that Hirasawa played a role in the completion of the work: "The *Fujin kōron* reporter Hirasawa came all the way to my house more than a hundred times over the course of the year to get me to finish writing this work, and listened to my whining more than twice as many times."[119]

Hirasawa's story demonstrates the connections that were common between the publishing industry, magazines, and literary establishment at the time. There was a great deal of debate over which *Melancholy* novel was better, and many were disappointed that the *City* version was not like the first: Satō remarked that he would not want to write the same work twice "simply because the first one was good."[120] Critics found *City* naturalistic and easier to understand, both of which characteristics they linked to the *Fujin kōron* readership.[121] Both this assumption and Hirasawa's clarification that the work was not "dumbed down" for women readers suggest that the work's critical reception was affected by its place of publication.

Whether Satō's writing was in some way influenced by knowledge of where the work would be published can only be speculative. But it is interesting that the character of the wife, Yumiko, now seldom commented on in scholarship, is much more developed in the *City* sequel. Whether this was part of the author's intention or not, I would argue that it played a part in the work's success with women readers and certainly resonated with topics such as the modern theater that were of interest to women magazine readers of the era. What we can consider most directly is how reading the work in

the context of women's magazines helps our understanding of that character and the work as a whole. (For convenience I will sometimes refer to the wife by her given name, Yumiko, and Ozawa by his family name. They are rarely called by name in the book: usually the third-person narrator calls them "he" and "his wife." Yumiko also appears as Segawa Ruriko, her stage name.)

Satō's *Melancholy* novels have become classics of the category "Taishō-period fiction." Seiji Lippit describes the handling of space in works of the era in relation to emerging modernism in the late 1920s and 1930s:

> Against the dominant topographies of Taishō-period (1912–1926) fiction, which tended to focus on enclosed, interior spaces, modernism moves out onto the streets, beyond the boundaries of the private and domestic worlds and onto the fluidity of city space. These urban landscapes, situated both in Tokyo and at the borders of the nation-state, stage a certain disturbance or unsettlement in the experience of Japanese modernity.[122]

In Satō's series, as it moves from the *Country* (really the suburban "garden city," *den'en*) to the *City*, Yumiko becomes a bridge between the "enclosed" world of the narrator and the world "out onto the streets" in her roles as actress, wife, and reader of fiction.

Again, Yumiko's character may be one of the reasons the novel was placed in *Fujin kōron*. Although critical analysis has focused on Satō's important concept of "melancholy" or "gloom" *(yu'utsu)* and its relationship to modernity, and the urban and country settings of the two segments, the figure of the wife who works in a suburban theater while he stays at home trying, rather unsuccessfully, to write, is one of the most interesting characters in both books. In *Melancholy in the City* the couple has moved to Tokyo to be closer to her work, with hopes that it will also inspire his writing. Their house is on a back street, blocked from the sun by other buildings, so that each day the sun steals into the house only briefly. He spends most days at home in this dark and suffocating house while his actress wife goes to the theater. This living situation, his distance from the activities of his wife out in the theater, and his fragile mental state are the focus of the novel. He begins to think his wife might be having an affair, although it seems this may be a product of his own imagination. The narration of the novel centers on him, but the wife's character is the main way his alienation from society is developed.

In the first extended description of his actress wife in this second installment, he reflects on how much housework she does even after she returns from work, while he has been idly thinking "about various unproductive things" at the house all day:

> His wife was home. The lively young woman, cheeks brushed and reddened by the cold wind, squatted down briskly, facing the brazier, and spread her hands in their black gloves before the fire, without, however, saying anything in particular about the cold. At once she began to talk rapidly and laugh noisily about one or two silly things that had happened that day out there on the streetcar or backstage. She pulled off her gloves and the long white scarf that hung down to the floor. Reaching out one hand, she opened the shoji door behind her, picked up the copper kettle of boiling water, and took it to the kitchen. There she quickly cleaned up the dirty dishes on the dining table that had been shoved idly from the kitchen into a corner of the sitting room, and, when she had finished washing the dirty bowls, she put them back in the sitting room. . . . He—uncommonly cold and idle as he was—watched with astonishment at how his wife managed things so quickly and nonchalantly after returning from a full day's work. She did come home late at night; was that why she managed so diligently? he wondered, as he watched attentively. He had to feel tender toward her.[123]

In the passage, the only signs of her slightly glamorous life are the black gloves and long white scarf. Her gloves come to seem practical for keeping her hands warm and not fancy enough to try to keep clean as she indelicately "squat[s]" to warm her hands in front of the brazier. And the white scarf soon comes off and the gloved hands busy themselves washing dishes.

Just as in many works of popular fiction, not to mention magazine scandal stories, the image of a working woman, especially one working at a very modern job—here, as an actress—is called forth in this novel. The actress was at this time particularly visible in magazine culture because of the suicide of actress Matsui Sumako in 1919. She had played the lead in major productions, usually the debuts of Japanese versions of Western plays, most famously Nora of *A Doll's House* and Katusha of Tolstoy's *Resurrection*—the two quintessential new women in 1910s Japanese culture. Other articles mentioned actresses as generic figures to attract attention to a story. One feature, called Victims of the Popular Arts, included confessional essays such as "One Dancer's Downfall" and "My Life as a Cabaret Actress."[124] Working actresses were common characters in popular novels, which often used them as atmospheric signals of the modern, sexuality, or public activity by women, without needing to develop the characters in more depth. They work to provide an atmosphere of the modern that permeates the text.

What happens here, however, is a look at the actress not only when she is portraying an image of public activity in the theater, but also when she is at

home, boiling water and washing dishes, where she has taken off her fancy scarf and is no longer visually striking or a symbol of anything—or of anything obvious. The focus is instead on her hard work and his inability to express his thanks or to communicate to her how he experiences being a man staying at home while she works. Thus although the actress is not the center of the story, not made into a heroine, and certainly not given any sort of interiority, his reflections on her activities provide a powerful exploration of this gender role reversal and how his activities as an unsuccessful professional writer affect his masculinity.

The dilemma of this modern couple is explored further through the main character as he wonders what sort of "jealousy" he might feel toward her:

> Yet he was for now oddly and inexplicably dejected. The gloom assailed him often when he faced his high-spirited wife on her return late at night, or when morning after morning he watched blankly, half asleep but wakened by the little noises of her dressing quietly, careful as possible not to wake him and then leaving lightheartedly, or when he watched her sleeping soundly and snugly beside him as he lay sleepless night after night. Among the feelings he had thus far experienced this was most akin to jealousy. It was not a common kind of jealousy—not once had he fancied that feeling about his wife. Yet as a feeling resembling jealousy grew a bit each day, he thought he began, little by little, to understand the likely cause. He saw it was a kind of jealousy after all. A person with nothing to do, a person who does not know what he wants to do, a person who seems unable to do anything—when that person watches someone near to him who has a job or a profession attack that job with joy and zeal, then you have jealousy. In other words, the jealousy of one who has no livelihood for the one who does, isn't that it?[125]

Even though Yumiko is sleeping and has no voice, this passage could imaginably have an appeal to the woman reader with its insight into this new family scenario. This passage would be equally compelling to the husband of a career woman (then or now) and of interest to just the sort of man who made up one-quarter of *Fujin kōron*'s readership.

Whether or not it is intended, Satō's novel does not simply produce an alternative to the working-women tropes of a certain genre of popular fiction and magazine scandal story, but also a critique of them. Even the opening lines set up the book in relation to literary gossip:

> People in the neighborhood looked at the house and thought it strange. Two people only—a young husband and wife lived there with their two

dogs. The wife went out every day in the morning. Her gaudy clothing was no common form of dress. The wife looked to be about twenty. Once she had left, the house to all appearances was vacant.... But the house was not vacant—he lived there.[126]

This "he," alone writing in the house while his wife goes out in her "gaudy" clothing and thought odd by "people in the neighborhood," might be the stuff of novels that focused on literary gossip. This life with the dilapidated house and unusual wife even leads one of his neighbors to comment, "Life in your house is like a novel, isn't it?"[127] And in fact, Satō was married to an actress. But the novel generally refuses to exploit this modern lifestyle career to much effect, focusing more on how the main character realizes he does not want to have his life be "like a novel."

The plot wanders with the protagonist's indecision here, but one of its main thrusts is that the author is trying to be a professional writer but does not produce enough to make a living. He is under constant pressure from his parents and in-laws to find a way to make enough money to live without their support. At one point, he applies for a job at a newspaper, but it is instantly clear in the interview that his social awkwardness and complete lack of interest in that kind of writing make him a laughable candidate. His friend suggests that he write a "cheap novel" to improve his finances, taking a mediocre Western adventure novel and doing a loose translation or simply stealing the plot. But he cannot even bring himself to do this, fobbing it off on another author friend who reads foreign languages better. This friend, Shozan, a skilled writer whose literary fashion is slightly behind the times, eventually ends up in the hospital. He has, while sick, forced out a chunk of this pirate story one-yen novel so he can pay his medical bills, painting a rather grim picture of the professional literary scene. Ozawa himself does briefly come up with ideas for something to write that might sell. Early in the book he was worried that he "was a literary youth with no talent and no accomplishment.... No, he was husband to a minor actress in a suburban theater."[128]

This phrase, "husband of an actress," reappears later:

His wife's facial expressions when they began to quarrel were indescribably disagreeable to him. Her words were all like lines recited on a stage, and from her facial expressions and bearing emanated a terrible seriousness that one could not imagine coming from a real face and body. When he suddenly recalled the looks of his wife at those times, he became acutely aware of the words "husband of an actress." And certainly he could write that—he thought all this, as he threw the completely burned-out cigarette stub into the ashtray.[129]

The key phrase in this passage is "he could write that." Just as the pirate stories would sell well in a popular magazine for boys or general readers, a story called "The Husband of an Actress" would be perfect to sell to a certain set of popular women's magazines of the day. Although this passage at first seems to be, and on one level is, a criticism of the artifice of his wife's manner, it ultimately suggests a parallel between the meaninglessness of her facial expressions and his repeated image: "husband of an actress." Where in *Melancholy in the Country* the allusions and texts that separate the writer from his surroundings are European, Japanese, and Chinese literature, here in the *City* they are the tropes of popular media and the pressures of dime-novel publishing. "His wife" represents a connection between the interior world of his mind and the public world, his wife's world out "on the stage" or in novels that "he could write"—not in the self-absorbed style of the I-novel but in the form of a magazine novel with the eye-catching topic of urban life as the husband of a modern woman.

Her words like "lines recited on a stage" also suggest that a link between women and simplistic and mimetic readings of art is being made here. This theme first appears in *Melancholy in the Country*. At one moment she can think of her husband only through the eyes of a novel she has just read:

> His wife recalled *Spring*, a novel by Shimazaki Tōson that she had finished reading five or six days ago. In her simple head, without questioning her husband's nature, she saw one of the characters step out of the novel to become her husband in front of her eyes, alive beside her. . . . Did he really want to waste away his life in the country, abandon everything, and forget the artistic work that he seemed so much to believe in? What wonderful dream was he seeking?[130]

The reader of Satō's novel is presented with the sense that her husband thinks she fails to see his psychological state, in part blinded by her filtering of his life through Tōson's novel. Thus even as parts of this story appeal to women readers in the depiction of a working woman, and its sequel is printed in a magazine aimed at women readers, it also reinforces the image of the superficial woman reader. Still, her "simple head" is not utterly so, as she is able to interpret his life through the fiction she reads, just as he does as a professional writer, and to consider the "wonderful dream" he seeks. If we imagine the average readers of these novels as women from a world more like his wife's than his, somehow her powers of imagination and ambition for him look rather different. She is a very practical character and in a sense more aware than he of the ways they are embedded inextricably in an urban capitalist economy that requires him to be a paid writer (as Satō

certainly was). As the character suffering from melancholia, he is alienated from his artistic work, and there is a sense that it is her ties to the city and the outside world, as an actress and as a reader, that may bring him back to his writing—even as it brings him dangerously close to its commercialization.

I can only hypothesize about the relationship between the critical reception of this work in relation to its publication in *Fujin kōron*. It does continue to be less widely read than *Melancholy in the Country*, except when they are brought together as in the English translation. The aspects of urban life in 1920s Tokyo that are more salient in the *City* sequel may tend to situate the work as historically rather than artistically interesting and as more in the realm of what was called commonplace or popular *(tsūzoku)* fiction, a category of literature Satō was more likely to criticize than attempt to write, rather than a more universal sort of novel that might be better seen as high fiction. This reception itself is not tied to publication in a women's magazine—there is not some sort of sexual discrimination against such texts, for example—but the tendency to choose works that seemed to have some identifiable appeal to their readers tended to bring forth works in genres or styles that are less readily located in the world of Japanese pure literature so often characterized by a focus on the narrator's interiority rather than social forces. The playful, I-novelesque self-referencing of a novelist writing in a women's magazine about an author's angst over whether or not to write a novel about life as the husband of an actress is lost when we do not consider that it was serialized in *Fujin kōron*. But bringing *Melancholy in the City* back to its publishing origins helps bring to life both its historical and artistic interest.

Genre and Gender Play:
Tanizaki's The Sacred Woman

Tanizaki Jun'ichirō published many of his most famous novels in women's magazines, and many made a strategic use of the women's magazine format, both to print longer novels than literary journals allowed and to play with gender and genre conventions. Tanizaki's best-known encounter with women's magazines was in 1924–1925, when his novel *A Fool's Love*, which was being serialized in the *Osaka Asahi* newspaper, was pulled out midpublication because of complaints by readers about its racy content. The remainder of the novel was published in the magazine *Josei*. We can see here as well that a women-oriented magazine provided a space for him to work with themes not as welcome as in other venues. From September 1917 through July 1918 his novel *The Sacred Woman (Nyonin shinsei)* was published in *Fujin kōron*, an

earlier experience with women's magazines that may well have influenced his later writings in both women's magazines and more generally.[131]

The Sacred Woman is an odd romance story. It tells the tale of a brother, Yūtarō, and his sister, Yūko, after their father dies and their mother has to rely on relatives and friends to help support them. They begin as young adolescents, and it is a sort of coming-of-age story. Yūtarō is a feminine-looking teenager, and in the first sections he works to polish his feminine beauty, envious of his sister for being able to wear more beautiful clothing. He is pursued romantically by a brawnier boy from school, so in the first part of the story it seems as if he might be the "sacred woman" of the title. He later turns to women, however, first a geisha and then the teenage girl at their foster home. His sister meanwhile develops a romance with the foster brother. These relationships progress with various ups and downs until eventually Yūtarō is accused of being after the girl's inheritance.

All of these plot twists are similar to those seen in domestic novels in magazines of the period. In the Japanese *katei shōsetsu* (domestic novel) developed around the turn of the century, several plot forms familiar to readers and viewers of modern melodrama anywhere were common: a loss of innocence or sexual awakening, the sudden revelation of secrets about kinship, conflict over inheritance.[132] *The Sacred Woman* also has elements of other romances of the period, where one pair of siblings intermarries with another.[133] But was Tanizaki writing a typical work of popular domestic fiction for this women's magazine, or attempting something quite other?

What is most striking is that even as these events that are so common in romance fiction occur, they are presented with little melodramatic tension. The ending is entirely anticlimactic. Yūtarō suddenly gives up his passionate pursuit of the woman he loves, commenting blithely, "As long as there are women someone will take me in," belying all the expectations of domestic novels resolved by marriage or death. Throughout the novel there are scenes that start to set up dramatic tension and then move to anticlimax. In one, Yūko seems about to be the victim of her lecherous foster uncle, who may force her into being his maid and lover. He suddenly offers to pay girls' school tuition for her, however, and the whole scene is interrupted when her mother and aunt walk in, breaking the tension. "Yūko wondered if it had all been a dream."[134] Tanizaki also suggests taboo topics such as incest, which can often provide melodramatic interest, by lightly mentioning how attractive a married couple the brother and sister would make. These remarks become playful rather than moralizing, however, and mock the tension-building devices of the romance novel while keeping their enticing effect.

Chapter 2

Such domestic drama stories generally relied on polar opposites between sexes and good and bad characters, as will be discussed in the work of Yoshiya Nobuko in the next chapter. But Tanizaki's focus on Yūtarō's gender ambivalence and a same-sex romance side plot undermine the sister-and-brother rubric he sets up at the beginning. Gender is presented as an act or performance, with references throughout to Yūtarō's actorlike qualities. In a tough situation he seeks sympathy from his sister:

> And as he was wont to do he burst into tears. Yūtarō, who had always counted as one of women's beautiful qualities the ability to shed sweet tears while wooing someone, always adored crying. Now that he was in this funk, just a single kind word from whomever he talked to, whether enemy or ally, brought him suddenly to tears. While he was talking to his sister, he completely forgot all shame, and letting that effeminate pathos *(memeshii awareppoi kanjō)* take over, he threw himself into it and sobbed openly in front of her. Rather than feeling that he was revealing his own ugliness by doing so, he came to think that he was embracing his own feminine *(onnarashii)* beauty.[135]

The coming-of-age story does not lead to the happy marriage one might expect, but rather to personal gender tragedy for Yūtarō:

> In short, Yūtarō's body gradually had lost its womanly beauty. Painfully he watched as bit by bit, from beneath what had been the willowy, gentle curve of his figure, emerged the strong, well-muscled build of "brawny masculinity." For Yūtarō this was unbearable. When no one was around, he would look furtively in the mirror, and see that his formerly soft, slender noseline had, over the course of time, grown thicker and harder, and become strangely angular. Furthermore, from his cheeks, which were plump as if molded around his lips like plasticine, slowly appeared bits of disgusting stubble. To top it off, the flesh of his palms, which had been as tender as fresh leaves in June when sunlight passes through them, grew thick and tough, while the ligaments in his soft fingers became gnarled. His silhouette came to look the very image of his father, approaching the appearance of an adult man.... "Why has my own body become so ugly and coarse? Look at my little sister: her nose, her cheeks, even the ligaments in her hands, are like those of another race, so refined and alluring—their appearance has not deteriorated at all." Yūtarō did not even realize that the biological changes he was currently experiencing were phenomena that all youths experience. Rather, he felt

that his own flesh was like a piece of soft silk clothing being taken off in order to be replaced with a cotton robe—that perhaps its quality was gradually deteriorating.[136]

We see here early signs of Tanizaki's interests in race and in the transformation of the body as a physical and psychological experience.[137] Gender and appearance are also tied to class and economic status: Yūtarō has been wearing a silk kimono from the days when his family had more money, but he must now pass it to his sister, who needs to dress more elegantly as an adolescent. When she does so, people remark, "Oh, you look just like your older brother!" His family's history has been told as one of ephemeral waves of wealth and poverty, where the quality of housing, clothing, and jewelry has marked its rises and falls. So when Yūtarō's coming of age and of masculinity is told as the decline in fabric quality, it becomes mapped on to the parallel story of such products. Yūtarō worships the "elegance" of that "race" of femininity that is enabled by consumer goods. He does not want to become a dirty and masculine speculator like his father but to stay associated with the decorated side of his family who use cosmetics and receive diamond rings; he prefers to be an elegant consumer rather than earn money. All of this becomes more meaningful when we think of it in terms of women's magazine culture and its association with women's consumption. And Takamure Itsue's analysis of the relationship between conceptions of feminine beauty, urban capitalism, and biology sheds light on Yūtarō's outlook.[138]

Ultimately this novel does not work terribly well as a melodramatic page-turner, nor is it completely successful as a biting parody of one. But rather than treating it as a lesser work, one can, by reading it with the genre of family novel in mind, observe the beginnings of Tanizaki's play with popular women's genres. Tanizaki used this venue to toy with the conventions of traditionally women-audience-oriented genres less common in literary journals, as well as with themes of sexuality that were less welcome in newspaper serialization. This was indeed something that he called on in his later works as he polished his ability to mock various genres. In *A Fool's Love*, what starts in the voice of an I-novel ("I'm going to relate the facts of our relationship as man and wife just as they happened, as honestly and frankly as I can") quickly turns back on the confessing narrator; even more striking is the way the novel takes the figure of the modern urban woman or modern girl of popular fiction to create a darker work that criticizes the male lover as much as the modern girl Naomi.[139] *Spring Snow* (*Sasameyuki*; published in part in *Fujin kōron* and in English as *The Makioka Sisters*) follows many of the story lines of *katei shō-*

74 *Chapter 2*

setsu, but the sprawling novel ends, devastatingly and grotesquely, as the young daughter who has finally managed to find someone to marry after much searching experiences major gastrointestinal distress on the train going to her wedding.[140] The effect is much darker and more powerful than Yūtarō's shift to bravado and indifference in *The Sacred Woman*. It is also true that literary magazines tended to encourage shorter works, and most of Tanizaki's earlier works are short stories and novellas. The women's magazine serialization format encouraged a longer work, allowing or forcing Tanizaki to write in the novel form, a form that eventually produced the likes of *Sasemeyuki*.[141] In combination with his interest in film, which has garnered some scholarly attention, these examples suggest that Tanizaki's lesser-known women's magazine fiction, and the women's magazine origins of more famous ones, should be considered important moments in his career and oeuvre, particularly his interaction with mass culture and play with genre.[142]

Publishers, "Models," and Serialization:
Hirotsu Kazuo's Café Waitress

In a few cases, there is evidence of direct influence on the writing of a novel by the publishers as it was being serialized. One of the clearest examples is *Café Waitress (Jokyū)*, a novel by Hirotsu Kazuo (1891–1968) serialized in *Fujin kōron* between September 1930 and February 1932.[143] The novel is amusing in its own right, but its publication history tells us quite a bit about the networks of professional writers and editors that developed over the course of the 1910s to 1930s and increasingly shaped Japanese fiction. Hirotsu, a well-known author and critic, became a writer while immersed in the atmosphere of print culture. His father was a judge for reader submissions to the magazine *Joshi bundan* (Ladies' literary world), in what Kōno Kensuke calls the "reader submission fever" that was a "sign of the mania for speculation and homogeneity [in literature] that came with capitalism," and Hirotsu himself began publishing with a reader submission.[144] Financial factors appeared to have played a major role in his becoming a novelist at all, having started as a critic. He writes,

> My art criticism was relatively well received, and there were requests from all over. But the length of those pieces was usually only ten to fifteen pages, and everyone's royalties per manuscript page were set at 50 yen. No matter how much I wrote, I could not make a living out of it. I could do translations, but I was in the habit of going out and

wandering around outside, and so could not move myself to stay inside thumbing a dictionary. So I thought there's no other way for me to make a living than to get started writing novels.[145]

Café Waitress, one of the novels he penned to make a living, tells us a great deal about some of the more direct relationships between the conditions of publication and the form or content of 1930s Japanese fiction.

Hirotsu wrote his *Fujin kōron* novel in the voice of a café waitress, supposedly one whom he met at an inn.[146] Hirotsu claimed that Shimanaka Yūsaku (then the *Chūō kōron* editor) asked him to submit a story for *Fujin kōron*; Shimanaka and he had been friends at Waseda University, where they often played catch together. It took him some time to fulfill the request, but he eventually wrote *Café Waitress* after talking to a café waitress who was staying at his same boarding house, and sent it to Shimanaka. Shimanaka claimed to like the "simple title," which was most likely also appealing for this magazine because it marked the text as being about a modern woman.[147]

Café waitress (*jokyū*) was one of the new urban occupations associated with the modern woman.[148] The cafés in question often served alcohol along with coffee and food, and were common hangouts for men in the city. The job often became sexualized and represented a range of activities. Some café waitresses became involved in sexual relationships with their customers, sometimes engaging in prostitution. At the same time, it was not an uncommon job for aspiring women writers, as the case of Hayashi Fumiko demonstrates. It seems that although she had some unpleasant experiences in the job, Hayashi also made connections with literary men there who helped in her efforts to publish poetry.

The novel recounts the trials and tribulations of Sayoko, a café waitress from Hokkaidō who works in a Ginza café (Café T) to support her baby son, who was born out of wedlock. The story is most interesting because of its descriptions of life inside the café; these vividly display aspects of modern Tokyo nightlife, something that few women readers other than café waitresses themselves would encounter. Sayoko's feminine, conversational voice is very convincing. Sayoko's hard work for her child elicits sympathy, as does her attempt to steal a baby rattle from Department Store M when she has no money to buy toys for her baby. Work in the night entertainment world for one's relatives was a common theme in women's films as well, as we see in Ozu's *Woman of Tokyo (Tokyo no onna*, 1933), about an older sister secretly working in the shady nightlife to pay for her brother's tuition (her brother is so upset when he learns of her activities that he commits suicide).[149] The plot of *Café*

Waitress involves various men who help Sayoko deal with her sad fate. Sagara, a married office worker, pursues her aggressively, to the point of leaving his wife and proposing marriage. Unsure of his intentions, she avoids him and goes to visit her baby, whom she has entrusted to her parents in Hokkaido. Upset with her evasion, he attempts suicide, making her the object of scandal and ridicule at home. Returning to Tokyo, she reunites with an old customer, Yoshimizu, an author who stops in at her new place of employment, Chat Noir. In the beginning, he is depicted as unattractive, and she avoids and manipulates his advances toward her. But midway through the novel another waitress colleague captures his interest, inciting her jealousy. This leads to a rivalry between the Purple, Green, and Red teams of waitresses, which have been urged to compete by the café's supercapitalistic managers. Having given up on Sayoko, Yoshimizu puts a diamond ring on the finger of a rival team's waitress, leaving Sayoko longing after him. As further punishment for her mistake, Sagara charges her with marriage fraud.

The character of Yoshimizu became controversial in the press. Various clues suggested, and eventually the author Hirotsu himself admitted, that the character was based on popular author and literary magazine publisher Kikuchi Kan.[150] Hirotsu claims that he meant this "caricature" of his friend to be a joke that Kikuchi would enjoy. But the publishers of *Fujin kōron* picked up on the reference and without consulting Hirotsu placed a huge advertisement in a major newspaper touting the novel as having "A Literary Establishment Big Shot" as its "model."[151] Kikuchi became so angry at this advertisement that he went to the publishing headquarters to demand a meeting. He ended up punching a fiction editor in the face (apparently only because he could not reach across the table to the editor Shimanaka himself).[152] The company tried to prosecute Kikuchi for assault. Shimanaka was at this point president of the whole Chūōkōronsha organization and said, probably with exaggeration, that he was willing to risk both *Fujin kōron* and *Chūō kōron* magazines to seek retribution for his editor. Kikuchi noted that although he had his own venue if these two giant magazines collapsed, he knew that many of the literati would suffer badly and therefore showed some willingness to cooperate.[153] Hirotsu acted as an intermediary, forcing both sides to sign apologies. Notably, it is in the monthly installments following this dispute that the café waitress Sayoko suddenly does take a romantic interest in the character Yoshimizu and has a fight, rather out of place in the rest of the novel, with a young rival waitress over him.[154] Hirotsu was vague about this in his accounts, but he wrote that if one read his novel through to the end, he would see that he was not being malicious toward Kikuchi, presumably because he gets the girl's attention in the end.[155]

It has been common to read works such as this only in their anthologized form and without regard to their publishing history. The textual history of *Café Waitress* suggests that, given the close-knit relationship among individual writers and publishers in the literary world, attention to these sorts of connections alters the ways in which we look at such fiction, including the process of its production and the conditions of its reception. Here the rich voice of Sayoko, who narrates the novel in a conversational style, well suited to a woman of her background, suddenly becomes unbelievable as she turns from being practically minded about the relationship to pathetically wistful. Fortunately, the novel does pick up at the end with a wonderful scene where the waitress, having successfully defended her actions as nobler than those of the men who have become obsessed with her while she was just trying to make a living, dances the Charleston through the halls of the police station.

Women Authors and Fujin kōron

Although female writers were heavily represented in the nonfiction sections of *Fujin kōron*, commenting on all manner of issues relating to women, few were printed in the fiction section. Tamura Toshiko's story "Tsuyako no ie de" (Tsuyako runs away from home) was found in the very first issue, and interestingly reflects on one woman's experiencing independence through reading (Russian novels and her friend's letters) while her friend seeks it through running away from home.[156] But aside from a number of early short stories of this sort, primarily in the special issues for women writers, women did not contribute regularly to the literature section until well into the 1920s, even compared to what was found in general-audience magazines of a similar level and *Chūō kōron* itself. Several comments suggest that many women writers did not want their works published here. Miyamoto Yuriko was rejected here at first, reportedly because her writing was too difficult for its readers, a fact she proudly recalls: she claims to be flattered by women's magazines' noninterest in her work as proof of her literary seriousness.[157] Her pride reflects a frustration on the part of many women writers with the narrow expectations for how a woman writer should write. In this period, the concept of "feminine writing" (*joryū*), the idea that women naturally wrote in a style different from that of men, had already gained prevalence in Japan. Furthermore, especially after the journalistic scandals about women writers involved in *Seitō*, there was a sense that the personal lives of women authors would overshadow any serious consideration of their literature. Like the actress and the café waitress, the woman-style writer (*joryū sakka*) was an

overdetermined figure, used in the press and novels to stand for myriad anxieties about social change. Joan Ericson has shown how this category worked in the literary critical community and literary press.[158] I would argue furthermore that the woman writer was often a problem figure in general, just like the new woman or modern girl. Even *Fujin kōron*, with its claims to seriousness, called on those images in their advertisements and in the way they marked their articles as being by "woman author X." This magazine's apparent adoption of this stereotype of woman-style writer repelled many women writers who might otherwise have published fiction there. It was also, I suggest, part of the impetus for them to form alternative journals where they could control how this image of woman author was deployed, as with *Nyonin geijutsu* (Women's arts), discussed in chapter 4.

Another successful woman writer of the day, Nogami Yaeko, wrote in a *Fujin kōron* article titled "What Young Ladies Should Read." "Among the things I would not recommend for young ladies the worst would have to be the flowery sentences published each month in women's magazines. Similarly, even the novels printed in *Fujin kōron* would fall into this category."[159] We see here that even with the magazine's rhetoric of "serious reading," these women writers considered it dangerous to associate with the taint of women readers. Given the gendered expectations for the style of writing in women's magazines that Nogami herself expresses, it is not surprising that women writers were self-conscious about publishing in any women's magazine. As a result of that tendency, women could not so easily take the opportunity to play with mass audience genres in the way we saw Tanizaki doing. A few turned to full-blown popular fiction, as did Yoshiya Nobuko, who certainly did write "flowery sentences."[160] More turned to literary journals and private publications, which afforded them neither the financial advantages nor wide audience of women's magazines. In early *Fujin kōron*, they limited themselves to polemical pieces, where they were not expected to have feminine writing styles.

From the mid-1920s and early 1930s, women writers begin to appear more often in *Fujin kōron*, including such authors as Uno Chiyo, Ozaki Midori, and Okamoto Kanoko. Still, it is interesting that even as more women were contributing to *Chūō kōron* and other general-interest magazines and newspapers, *Fujin kōron* published a relatively small number of works by women and did not become, in the prewar period at least, a primary forum for women writers. Both Uno and Okamoto published major works in *Chūō kōron* while publishing only occasionally in the women's version, but they were not as resistant to *Fujin kōron* as someone like Miyamoto Yuriko. Uno and Okamoto were more comfortable with a modern girl image and with being associated with the characters in their own fiction.[161] Ozaki too was more celebra-

Serious Reading in *Ladies' Review* 79

tory of new media and mass culture as a part of modernist fiction, as we shall see in the analysis of her "Random Jottings on Film" in chapter 4.[102] *Fujin kōron* also changed to incorporate more images of women's sexuality, the body, and freedoms associated with consumption in the late 1920s and 1930s. Some women writers interested in embracing that set of images can thus be found here. Women writers also developed closer associations with the modernist and proletarian movements that were both in vogue, and under these auspices contributed more frequently to both *Chūō kōron* and its feminine counterpart. Those movements were more concerned with the role of mass culture in politics or with potential overlaps between writing styles and the modes of depiction with new representational technologies I will hold off discussion of modernist fiction, mass culture, and politics for chapter 4 and my analysis of *Nyonin geijutsu*, but it is important to note that much of the same productive mix of political criticism and celebration of a mixed media context for art was found in *Fujin kōron* as well.

Embracing Mass Culture: Editorial Changes in *Fujin kōron*

Before turning to other magazines, it is worth looking at *Fujin kōron* in the late 1920s and early 1930s. At this time, it lost some of its particularities and became more like other women's and general-interest magazines on the market, so I will devote less space to this period despite its interest. In 1927 Shimanaka Yūsaku was tapped to become the editor of the parent magazine, *Chūō kōron*, and his position at *Fujin kōron* was taken by former editor of *Fujin sekai* (Ladies' world) Takanobu Kyōsui. This is often seen as the reason that *Fujin kōron* moved toward a more popular format, introducing representations of women on the cover (see figure 3), more advertisements and photographs, biographies of movie actresses, and treatment of romantic topics. These changes eliminated many of the formal qualities that have been discussed here, including the separate sections for different genres of writing. Just as many people mourned the postwar changes in *Fujin kōron*, and the 1998 "Renewal" issue sporting Matsuda Seiko on its cover, contemporaries complained that *Fujin kōron* had become like other women's magazines, just another *fujin zasshi*. Commercial success and increasingly commingled visual, commercial, and artistic texts did, however, produce an increased range of images of women (written and visual) and a less controlled sort of vision of modernity for women than the New *Greater Learning for Women* series advocated. This was a mixed blessing, as those multiplying images were increasingly commodified and less frequently criticized.

A typical photo series from this era can be found in the front section of the September 1933 issue (figure 6). The series, titled "Sounds" (Hibiki), consisted of photographs of women in connection with sounds and in garb ranging from Western dress (both flapper and churchgoer) to a Kyoto *maiko* (geisha in training). Especially interesting is the effort to represent sound in print, which was achieved using a combination of titles, light descriptive text, photographic clues, and a graphic of concentric circles suggesting sound waves. This use of photography, dramatic layout, and mix of word and image was characteristic of the magazine during the 1930s. The bringing together of the usual tools of the print media with a suggestion of what other media might provide—sound and a sense of movement—was increasingly common. In terms of content, the photo essay's representation of women showed a shift from the idea of enlightening women into a form of upper-middle-class respectability toward multiple identities and fashions of a modern woman

FIGURE 6. "Sounds" (Hibiki). Photo essay by Yama Rokurō, Imamura Torashi, and Murai Gaikōji. *Fujin kōron*, September 1933.

FIGURE 7. Photographic fiction (shashin shōsetsu), "A Young Wife's Melancholy" (Waka tsuma no yū'utsu), by Okada Saburō. Fujin kōron, March 1931, 43.

that might include "Japanese" style (a national identity of which people were becoming increasingly aware) or "Western" style in any number of variations (although not seen in this case, "Chinese" style appears as well).

As with all magazines, the influence of cinema culture became stronger, and bold graphic design and photography interacted more closely with fiction. Of the texts discussed thus far, it was Hirotsu's *Café Waitress* that was published at a point well into those transformations, and indicates the sort of media-savvy writer who increasingly published here. As Kōno Kensuke remarks, Hirotsu Kazuo was representative of the new era of literature in the "age of vibrant media."[163] Similarly, Okada Saburō's piece of "photographic fiction" (shashin shōsetsu) "A Young Wife's Melancholy" (Waka tsuma no yū'utsu) in 1931 is a wonderful example of the interaction between media and print culture (figure 7).[164] Okada (1890–1954) is rarely mentioned today but was extremely popular at the time for works such as *Paris* (Pari, 1924) and

Chapter 2

his Japanese short stories inspired by the French *contes* he encountered during his two years in France.[165] In what is described on the cover (see figure 3) as a "novel you can see / movie you can read," film stills are combined with typed narration.

The story is of a newlywed, Fuyuko, married to a Western-style painter, Jūji. Although this was a marriage based on romantic love, blossoming when she posed on his studio couch in a green kimono, she is quickly ignored by her husband in favor of the models he paints in his atelier. The story is written from her perspective, and in it she never sees them in the studio. The photograph shows what she imagines might be going on in her husband's studio in the middle of the afternoon when she hears dancing followed by an odd silence. The prose version, which is in fact on a previous page with no photo, reads, "Fuyuko remembered the scene *(bamen)* of herself sitting in on that sofa and accepting Jūji's kiss—she could now imagine that woman model sitting there in her place. And that was not all. She painted a mental picture of wild scenes, even scenes showing so much more than kissing."[166] We can see how the prose portion makes use of visual vocabulary: she imagines in the form of scenes and considers what is or is not shown. Meanwhile, although it might seem that the purpose of using photographs here is to show what is "really" happening, based on visual conventions, the use of the out-of-focus framing around the studio part of the image formally marks it as an image of her imagination. According to the words, the identification is between her and the model and is more about her own desire and memories of pleasure than her husband's. The composition of the photograph, on the other hand, turns the gaze upon the model, who occupies the central position in that frame and is the object of the artist's gaze. In terms of who is looking at whom and who is identifying with whom, the interplay of text and image in some sense denaturalizes the reception of the photograph and of the relationship between the other woman and the wife. At the same time, to see this side of the story, it is necessary for the reader to read the quantity of text provided rather than following it primarily through the photographs to fully comprehend the plot, which is both decipherable on a basic level through the images alone and incomplete in itself. Ultimately, the written text seems to allow for a different reading of the housewife's desire than would the conventions of the pictorial narrative.

The photos here also provide a visual guide to Western-style clothing and furniture, the cosmopolitan lifestyle of an artist, and the accoutrements of the so-called cultured life of upper-middle-class Japanese life in the 1930s, not accessible to all the readers directly. For example, the story contains episodes set at Christmas in Fuyuko's husband's Westernized family's house and at a

Ginza club. Especially for readers with no access to these lifestyles, this story provides a way of imagining these scenes visually: what a big leather chair or a Christmas tree would look like in a trendy upper-middle-class home or a Ginza club. The work spans those worlds, from housewife to film heroine and from housework to life at a Ginza club. This amusing but on some levels dark story (Fuyuko is pregnant but has an adulterous husband; her friend Harumi turns to paid dancing and prostitution) presents a range of lifestyles for the modern woman and makes them visually appealing. At the same time, the short length in some senses domesticates more anxiety-producing material about women in the movie culture of the same time, an anxiety that often drives the tension and plot in longer feature films or novels.[167] Okada's story and its layout were still much more oriented toward the art world than the equivalent works of photographic fiction in *Shufu no tomo*, which had straightforward family dramas with layout that emphasized realism over style. The emphasis on high-level culture that had always been a part of *Fujin kōron*'s ethos continued, I would argue, to affect the way it interacted with what was considered low-level entertainment, even as it increasingly included such materials itself.

Many rued both that explicit interaction of the serious magazine with mass culture and the sense that it was an increasingly unexamined relationship. The new layout meant that articles of the public debate variety became more and more difficult to notice among the other vibrant texts that surrounded them. The abandonment of the magazine sectioning meant that no text was privileged: each just became one of the products available for reading. Of course, possibilities for cultural critique and gender norms were encouraged by the fresh combinations to be found in this publication, which continued its concern with modern life and cultural change, along with the infusion of visual imagery and discussion of mass culture that came with the new editorial stance. *Fujin kōron* always really was a *fujin zasshi* in the eyes of most readers, and attempts to disguise its connection to the market or to gender had always been a bit false, as we have seen. But it is also worth considering the real loss of a very different set of spaces within magazine culture for women that the early *Fujin kōron* had created through its efforts to formally mark the artistic and political values of its high-level reading materials.

3 | Writing Home

Modern Life in *The Housewife's Friend*

Using one of the buzzwords of the day, Ishikawa Takeyoshi, the editor and founder of *Shufu no tomo* (The housewife's friend), said that "women who are not yet married do not yet have anything you can call a way of life *(seikatsu)*."[1] The magazine's famous slogan, "Once you're married, it's *Shufu no tomo*" (*Kekkon shitara "Shufu no tomo"*), touts the publication itself as an essential component in a married woman's life, and reading it a way to learn to live—and want to live—a certain type of life. In approaching *Shufu no tomo*, it is necessary to confront the insidious nature of Ishikawa's words. It is also necessary, however, to reconcile these words with the incredibly alluring and varied nature of its texts and with the fact that they did improve the lives of many readers. Whether reading the magazine allowed readers to imagine different ways of earning a living or alternative sexualities, or helped them prevent a pregnancy or a child's death from tuberculosis, these are part of the significance of this publication, even as they do not make its stifling prescriptions for women's lives or its wholehearted support of Japanese fascism any less disturbing. The minor *Shufu no tomo* boom that has occurred among people from scholars to used-book buyers no doubt stems from the impression that this publication represents directly the everyday life of prewar and wartime Japan in a particularly rich way, a richness that I suspect was experienced, if differently, by its contemporary readers. And, of course, we must not forget that the greatest riches of all were probably reaped by the publisher himself. These contradictions are those of the magazine's moment, when capitalism and the growth of mass-market publishing brought with them both new freedoms and new constraints.

Shufu no tomo put its first issue on the shelves in March 1917. Directed primarily at urban, middle-class, married women, this new publication was exceptionally successful at capturing the growing audience of women readers, and it came to embody and, to a large extent, shape the commercial possibilities of the women-oriented press and of periodicals in general. While intellectual contributors to *Fujin kōron* turned their attention to the libera-

tory aspects of modernity for women and the attendant changes in gender roles, the publishers of *Shufu no tomo* examined instead the rationalization of domestic consumption and use of time as the primary benefits of modern capitalism to women. Sometimes using the expression "cultured life," articles, poems, pictures, and stories theorized, romanticized, parodied, and sold ways of living to its readers. Although often pulling in contradictory directions, the texts of this magazine generally dealt with desires and aspirations for a better life along with related fears and curiosities toward lives different from readers' own or different from those they were meant to idealize. These desires and fears, expressed in modes ranging from scientific logic to sensationalism, from derision to elegy, vied for readerly attention and were enormously successful in attracting it, garnering one of the largest circulations in Japanese publishing by the 1920s and surviving to this day.[2]

The icons of prewar Japanese modernity have long been the new woman, the modern girl, and the café waitress. When looking at these figures associated with life on the urban streets or participation in public life, often forgotten is the differently modern figure more associated with the domestic sphere: the housewife. The *shufu*'s rationalized domesticity was as important to conceptions of the modern woman and her connection to consumer culture as was the extradomestic consumption associated with figures like the modern girl, and *Shufu no tomo* was one of the *shufu*'s first champions. The founder, Ishikawa, noticed that married couples were increasingly living away from their parents and could no longer learn how to keep house directly from them. They were also residing, or aspiring to reside, in new living spaces in urban Japan. Ishikawa felt that this new modern life was best learned and overseen by the housewife, and her education about how to live could no longer be gained from her parents as with women before her, nor, he felt, should it be learned from the street as in the case of the modern girl or the café waitress. Instead, women could learn from this nationally (and internationally) distributed periodical, from this "friend."

The transformation in daily life and living in interwar-era Japan was of great interest not only to the publishers of popular magazines, of course, but also to major intellectuals of the period. As Harry Harootunian has shown, many intellectuals saw political potential in the differences created by modern life from within which an "escape from a binding past" and a "hope for a better future" could arise, even as they recognized that this life was "colonized by the commodity form and its effects."[3] Scholarship on the "cultured house" and "cultured life" shows the multivalent and overdetermined quality of these concepts: "culture" gestured in different contexts to efficient and scientific ways of life, mass-commodity culture, transformations

in gender and class identities, or the creation of new subject positions.[4] In *Shufu no tomo*, we see a representation of the same transformations in people's lives that interested these thinkers but in a way that was restrained about celebrating living that took place on the street or away from the office or the home. While the texts of the magazine taken as whole touted the rationality and efficiency of modern life, they did not emphasize related changes in subject positions or gender identities. While the modern girl, woman office worker, or delinquent girl might appear here, they were not part of the way of life ultimately promoted: they appeared as topics of serialized fiction, confessors in confession columns, main characters in humor and caricature sketches, and visual content of layout, cover designs, and advertising graphics, but they were a source of entertainment or anxiety and not an ideal. Many readers may well have seen potential for a more thoroughly different set of lifestyles through reading even these cautionary tales and simply encountering their representation, but the magazine's controlling editor, Ishikawa Takeyoshi, emphasized modernization in ways of living more limited to the domestic sphere and anchored by media-disseminated notions of gendered and national identities—a community of housewife friends (an imagined one) who were readers and consumers of this more fixed idea of daily domestic life.[5]

Magazines are not unified texts with a single argument, of course, and in Japanese they are literally "varied texts" *(zatsu shi* or *zasshi)*. *Shufu no tomo* was certainly on the cutting edge of emphasizing this variety, what one observer called a "media mix," combining a range of written and visual styles.[6] As Ishikawa's magazine went about representing what he saw as the true *seikatsu* that only a married woman could have, it used a whole spectrum of voices, from sober to emotional and from realistic to hyperbolic; readers would certainly have identified differently based on the aesthetic qualities, entertainment appeal, or emotional intensity of what they read as well as their own experiences. Here I will focus on these multiple modes and multimedia aspects of print culture for women as a means of getting at the messy problem of how popular texts and the ideologies of their producers seeped into and shaped the real lives of readers, as multiple and varied as those effects must have been.[7] I will examine this popular magazine and the ways it represented and defined a way of living through a variety of textual and visual strategies in articles, photographs, serialized fiction, comic strips, and advertisements. Reading the pages of *Shufu no tomo*—whether they inspired laughter, identification, fear, or excess spending—did in fact become a part of living for millions of Japanese people, and here I will explore what it may have been like to read about a *Shufu no tomo* way of life.

Corporate Culture for a Cultured Life

The editorial side of any publication does not have a transparent or determinative relationship to the product, and information about the production simply as background as such is not necessarily useful. In the case of *Shufu no tomo*, however, the editor's presence (or persona) was very strong in the published text itself. His appearances in the magazine were part of the very construction of the publication as friend to the reader. His journalism and corporate philosophies had an overwhelming influence on the magazine's content, and the fact that he regularly published pieces in the magazine discussing his management practices and philosophy meant that the production side of the magazine revealed itself saliently in each issue. Compared to attempts by *Fujin kōron* to keep its sources of income in the background by eliminating advertising from the fiction section, *Shufu no tomo* was generally unabashed about its entrepreneurial origins and commercial success, suggesting that it should be a model for the success of its readers, or of their sons and husbands.

The narrative of Ishikawa's success was presented in corporate histories and his autobiographies in an inspirational tone. Indeed, by the mid-1920s, when such histories began to appear, *Shufu no tomo* was the crowning glory of the emerging popular women's press, and Ishikawa had emerged as the king of mass-circulation women's magazines. His shrewd business sense, combined with his mission to promote respect for the position of the middle-class housewife, brought him unrivaled success in the periodical publishing world. Although he was officially the editor in chief and president of the publishing company, his greatest importance may have lain in his other roles of entrepreneur, advertising salesman, and constant contributor.

Ishikawa entered the publishing world at a young age when his Tokyo landlords introduced him to a job with an education publisher. In 1910, his employer started the magazine *Fujokai* (Women's world, 1910–1950). One of Ishikawa's colleagues there was Hani Yoshikazu, husband of Hani Motoko, the woman who ran *Fujin no tomo*, another successful women's magazine.[8] *Fujokai* failed at first, primarily because the editors misgauged how many copies of a given issue to print in each press run. After Ishikawa and Hani Yoshikazu helped *Fujokai* rebound, they left together to work at *Fujin no tomo*, and soon Ishikawa began planning to start his own women's magazine, getting it off the ground in February of 1917.[9]

In terms of the contemporary economic situation, Ishikawa's timing was not coincidental. *Shufu no tomo* was launched during a period of intensified Taylorization of factories, which sought to improve production to meet the export demands of World War I and remain competitive after it.[10] World

War I brought Japan increased demand for certain exports and brought instant wealth to people in some industries, particularly shipping and textiles. Aside from successful industrialists and entrepreneurs, known as the wartime nouveau riche *(sensō narikin)*, however, the war did not have many beneficiaries. The prices of food and other imports rose while many wages fell.[11] These trends culminated most dramatically in the rice riots of 1918, soon after *Shufu no tomo* began publication. Government programs sought to stave off this sort of protest with campaigns—including the Life Reform Movement (Seikatsu kaizen undō)—to encourage thriftiness, hard work, and personal savings.[12] Gender was extremely important in the rice riot: the protesters were primarily women (it was referred to in newspaper coverage as the *nyōbō ikki* or wife's uprising), and countermeasures often focused on promoting other less contentious aspects of Japanese womanhood.[13] *Shufu no tomo* soon presented itself as a generous assistant to the housewife attempting to make do during this inflationary economy. Articles about saving money used such words as thrifty *(setsuyakuteki)* and inexpensive *(anka)* in their headlines. Meanwhile, pages of floor plans for model houses claimed to provide effective use of space, improved sanitation, and increased convenience.[14] This vision of home life insisted that the housewife would control the modern managed household through careful household bookkeeping and budget-conscious cooking.

Meanwhile, Ishikawa's guidance to his journalists emphasized suppression of contemporary economic circumstances. Articles made little or no mention of basic events related to these hardships, even the rice riots themselves, thus masking the circumstances upon which the magazine's mission was predicated. They particularly avoided any debates and arguments about this economic situation; the corporate history celebrates this omission: "*Shufu no tomo* is not argumentative *(rikutsu o iwanai)*. It does not debate. Working together with its own readers, it polishes life skills, promotes technologies and knowledge for a new lifestyle, and aims to give sympathy, encouragement, and enjoyment to its readers."[15]

Whereas *Fujin kōron* often categorized modern daily-life issues as matter of debate, *Shufu no tomo* focused on stasis and comfort. Neither does it see the types of debates over welfare for mothers, suffrage, birth control, and women's labor that appeared in *Fujin kōron*. Such issues were of course never truly absent from *Shufu no tomo* or other such popular women's magazines of the period, but they emerged in fundamentally different ways within the practical, entertainment-oriented publication that avoided "argumentative" rhetoric. Within this format, figures such as the woman worker, the suffragette, or the modern girl shifted from discourses categorized as opinion and debate to those of entertainment, melodrama, or information.

Modern Life in *The Housewife's Friend* 89

The first publication of what would become Shufunotomo publishing company operated fully in the realm of practicality. The volume on household economics published in 1916, *Daily Life Strategies for Saving Money (Chokin no dekiru seikatsuhō)*, both prescribed and practiced thrift by cannibalizing reader submissions that *Fujokai* had rejected. This publication, along with a late-1916 book of economical recipes also culled from *Fujokai*'s leftovers, provided enough capital to start *Shufu no tomo* the following March.[16] Although it came to be combined with lighter subjects, this same theme of budgeting and frugality continues to be part of the appeal of the magazine today, and it has long been a valuable source of information on cheap meal preparation (such as "100-yen dishes") and household account keeping *(kakeibo)*. Good planning through record keeping and market research was also key to the publisher's success; since newsstands could return unsold copies to the publisher for a refund, Ishikawa worked to assess purchasing trends with increasing accuracy to gauge how many copies to print in a given press run. This seems obvious as a business practice, but many aspects of management culture were less solidified than today, and what might be considered basic management practices were not necessarily followed. Ishikawa Takeyoshi's was in fact one model that others came to follow in Japan; indeed, the Shufunotomo Corporation depicts Ishikawa, through a series of Shufunotomo-published autobiographies and essays, as a sort of capitalist hero building up from these cobbled-together publications and recovering from various financial hardships.[17] The company's buildings were also destroyed by the earthquake of 1923, and it had to rebuild its finances and facilities, but within a few years it had constructed a major building in the Surugadai neighborhood of Tokyo that took the form of a publishing and cultural center. In the narratives of this rebuilding, Ishikawa and the company became models of post-earthquake cultured life and the company office of the cultured house of the same sort that the articles promised to the housewife if she lived skillfully. Representation of his own success aided by everyday office practices paralleled the magazine's depiction of how daily household practices could lead to the housewife's own success. Rather than emphasizing the magazine's huge marketing accomplishments, this representation constructed the magazine and even its publishing corporation as friends to the reader.

Narratives about the lives of women sometimes paralleled these success stories. Written in an inspirational and melodramatic tone, they took time-management themes and showed how they worked in some extreme case of poverty and misfortune. One common form involved a strong mother who overcomes all odds despite her unfortunate circumstances. Just as Ishikawa's narratives about running the magazine served as a model of capitalist enter-

prise, these stories showed, in exaggerated form, how one might integrate the magazine's principles into domestic management. The first issue carried the story "The Struggles of the Widow Who Raised Three PhDs."[18] In 1919, a four-part series titled The Millionaire's Mother Who Raised Five Sons Out of Poverty covered in excruciating detail the life of Yamamoto Hisako, who held a family together despite her husband's drunkenness and poor business sense.[19] The biography begins, "A woman's strength! a woman's strength! After hearing her story, I realized that a women's strength can be truly superior and great. But that strength cannot be weighed on any scale. We cannot measure that strength in meters." The article goes on in this same weighty vein for almost two pages. It describes the "bravery" of "saplings growing in a dry forest" under the protection of "a woman as brave and steadfast as a mountain spring" that "neither runs dry nor overflows its banks," before finally introducing Yamamoto and her story of sacrificing and skimping for her children's needs throughout her life. Her husband's business failures and heavy drinking have left her with few resources for raising her children, the reporter tells us, but she has managed to make do for her children by pawning some of her own belongings, teaching her sons frugality and ambition, and working hard in the small shop she has opened. Having discovered that "time is money," she started sleeping only two to four hours a night so she would have time to manage the business well enough to pay both her husband's alcohol expenses and her sons' tuition. In fact, a mother raising a family without support of a husband was one of the most financially difficult situations a woman could endure, given the low wages for women workers. The rhetoric of heroism used to describe this woman's hardship and efforts would clearly have appealed to other struggling housewives among the readership. But of course few would come to raise a millionaire.

Most discussions of the discourse on motherhood around 1919 examine the issue through the motherhood protection debates that were going on at the same time among feminists Yosano Akiko, Hiratsuka Raichō, Yamakawa Kikue, and Yamada Waka in *Fujin kōron* magazine. Their debate focused on issues surrounding the possibility of state financial support for mothers, issues of economic independence versus "dependency-ism" *(iraishugi)* on either the state or a husband, and the relationship between gender and radical social transformation.[20] The rhetoric of the mother-heroine stories in *Shufu no tomo* has a special power to mask these issues of contention between Hiratsuka, Yosano, and Yamakawa. The successes of Yamamoto are clearly extraordinary, but the rhetoric presents her primarily as an ordinary woman with ordinary hopes for her children. The mothering techniques that are said to lead to her sons' successes are the very same time- and domestic-

Modern Life in *The Housewife's Friend* 91

finance management practices that *Shufu no tomo* had been formulating as the everyday tasks of the successful housewife and mother. The whole genre of the women's magazine success story relies on the "it could happen to you" message for its appeal to the housewife reader. While calling on a very real set of anxieties about what would happen if a husband died or failed to provide any income, and calling on the sympathies of the readers, these stories suggest that hard work and frugality will make everything turn out well. In these Horatio Alger–of-motherhood stories in the pages of *Shufu no tomo*, the melodramatic format serves to mask the true singularity of such positive scenarios.

Ishikawa's vision of his own management culture advocated a balance between hard-nosed financial practicality and the comforts of daily interpersonal rituals that mimicked or modeled those that should be practiced in a modern home. Minami Hiroshi has made the point that Ishikawa established himself as a fatherly type of company president with "paternalistic" office practices.[21] His office rules detailed every aspect of the day-to-day workings of the company, with numbered rules proclaiming such items as "Give a hearty greeting in the morning" and "To be late is shameful."[22] His Editor's Diary column claimed that his was the first company to make workers do daily calisthenics on company premises, an activity that became an icon of Japanese business practice in the postwar era.[23] The articles and the column suggest that both the home and the office should strive for rationalization, with etiquette and moral uprightness mixed in to soften the efficiency that should guide one's daily motions, from answering the office phone to getting up early to see one's husband off to work. In the company as in the home, there was also a strong sense of separately gendered spheres of activity, even though there were many women reporters on the staff. Male and female reporters met separately.[24] The company guidelines stress the value of women's contributions as workers but emphasize their distinct roles, just as Ishikawa felt that the *shufu* herself ought to be revered for her special contribution. And despite these parallels, Ishikawa emphasized that ultimately "the biggest mistake in Japan is to confuse the home with the office"; for example, one should dispense with lengthy pleasantries for company visitors and quickly determine their purpose for coming; in home life, meanwhile, such pleasantries are indispensable.[25] Home life should always maintain a feeling of domesticity, and the modern home, while efficient, should nonetheless always provide shelter from modern office stress.

The relationship between Shufunotomo corporate life and the home life the magazine advocates is boldly stated at the end of a several-page discussion of restroom etiquette written in 1944:

Chapter 3

> In the home and in the office a dirty restroom is regrettable and a clean one to be celebrated. A person who can be happy about cleaning a bathroom is a person who can succeed in this world. ... *Shufu no tomo*'s job is akin to cleaning up society, and making the world a sanitary place to live is *Shufu no tomo*'s mission. We who aim at good sanitation in society must start with our workplaces, and especially that area which soils most easily.[26]

It also noted that failure to do so was part of the obstacle to Japan's becoming a "first-rate nation," a comment that I think Ishikawa would have made even if it were not 1944. His "first principle" in a 1926 list of employee guidelines was "Make your whereabouts clear"; employees should either be in the office or at home and should never pursue a "method of living where one's whereabouts are unknown."[27] Home and office living should be clean and not involve wandering the modern city streets, with its cafés, or having contact with lifestyles not guided by hygiene and punctuality. Ishikawa's comments about corporate etiquette ascribe a tremendous symbolic weight to daily behavior that intertwines concerns about corporate success, home life, and national life. They suggest that such work and home practices that inform each other in their efficiency can protect the employee or the family member from the corrupting influences of the capitalism that one might encounter in whereabouts unknown.

The Production of Readers and Writers

The publishers pursued a readership on two levels. On one level was the imagined community of readers based on a metaphor of friendship. This fictional community of housewife reader-friends shared an interest in the lifestyle represented there and were, by implication at least, Japanese. The magazine's texts—including its title, topics, and reader column—emphasized this image of a group of *Shufu no tomo* readers being entertained and assisted by the publication and having some identification with "housewife" as a label for their present or future selves. Articles making contrasts to American housewives, or recommendations that Japanese wives should aspire to their practices, served to emphasize the Japaneseness of the readership. On another level, however, this magazine could never have been so successful and long-lived if it did not appeal to a much broader range of readers of various ages, classes, and regions of the country, and even to male readers and readers living abroad. The financial goals of the publisher both allowed and required a variety that could not be contained by the more rigid definitions of men's and women's lives found within.

Modern Life in *The Housewife's Friend* 93

It was in the face of much criticism that Ishikawa chose a title for the magazine that so narrowly targeted the housewife rather than women in general. When friends pressured him about this rather homely *(nukamiso kusai)* name that used the word "housewife," Ishikawa insisted that his publication would emphasize not the unfashionable image of the house-bound woman, but its literal meaning as the "main woman," counterpart to "the main person" *(shujin,* i.e., the husband). He felt this would encourage people to see that the wife was centrally important to the workings of the household and its economy. "Rather than targeting the vague category of 'women,' I want to do editorial planning that focuses on the lives of middle-class *(chūryū)* housewives."[28] As a result, he became one of the first major periodical publishers in Japan to target a group of readers so narrowly by creating a division in readerships finer than those between men and women or adults and children that had guided most popular magazine titles in the past.

Ishikawa's choice was to increase readership by zooming in on a very specific lifestyle and representing it with a respectful tone that might inspire reader loyalty among this smaller group. At the same time, it targeted a broader audience than the more intellectual *Fujin kōron* or the ostensibly higher-class *Fujin gahō* in terms of class and education level. The simple prose and broad range of quotidian topics incorporated the lower- to middle-class reading public of women as Ishikawa and his staff gauged it. Ishikawa's comments about his vision of the housewife suggest that these were not only marketing choices but also part of his ideology about how women should live their lives, with hopes that they would make the magazine into a companion for that lifestyle.

Of course, this category of "housewife" that was both defined and interpellated by the magazine does not directly represent who actually read it, and *Shufu no tomo* would never have succeeded as well financially with that readership alone. By 1927 the circulation was recorded as 200,000 by the government office in charge of censorship, as compared to *Fujin kōron*'s 25,000 or that of the other two most highly circulated women's magazines, *Fujokai* (155,000) and *Fujin kurabu* (120,000).[29] By the 1930s the numbers were approaching a million, and readership easily exceeded official numbers because it was common to share magazines in communities and offices. This success came in part because the publisher combined his ideas about domestic life with a group of well-coordinated promotional techniques that often crossed beyond the boundaries of the nuclear family's threshold. For example, he cleverly added booklets and inserts treating topics of interest for both the married audience and other potential readers. Some months carried inserts on household skills such as sewing, flower arranging, or home economics, and others on trendier topics

94 Chapter 3

including romance, fashionable Western dresses, or film stars (figure 8). By the 1920s almost every other month saw a special issue whose topics would cycle through those aimed at married and unmarried women, mixing up issues such as "Motherhood" with "Friends of the Opposite Sex" and "Love and Marriage." Advertising and articles also ranged beyond the likely needs of the purported audience to reach the other potential ones.

As a result, this magazine came to have a strong readership among unmarried working women.[30] Although the distinction is problematic, most prewar discussions of women's labor divided working women into two groups: *shokugyō fujin* (literally, "women with occupations" or "employed women") and *jokō* (women factory workers, often translated as "factory girls"), with the former generally denoting women in nonmanufacturing jobs, particularly new occupations, such as typists and department-store clerks, or jobs requiring high levels of education, such as teachers. The activities of both groups of women were heavily surveyed by metropolitan agencies, and surveys in Tokyo, Nagoya, Hiroshima, and Kyoto taken between 1922 and 1930 show *Shufu no tomo* to be among the top four magazines that *shokugyō fujin* read.[31] The same surveys show that these women tended to be younger unmarried women, although a few were working after marriage.[32] Although we cannot know for certain what interested them in the publication, it seems likely that serialized fiction and articles that did not focus solely on household life, whether gossip or health information, would have been more appealing than parenting and household accounting. As awareness of this readership grew over the course of the 1920s and the competition from more general magazines such as *Fujin kurabu* intensified, the number of features unrelated to married life increased, even as Ishikawa's monthly Editor's Diary continued to address married women as the primary audience. In this way, the editors' strategies based on financial goals for audience expansion stretched the effects of the publication beyond the publisher's own stated intentions. As part of modern consumer capitalism, *Shufu no tomo* marketed a variety of texts such that it would capture a broad range of readers who might hold differing aspirations and identities that might not include marriage or other aspects of idealized femininity. It was variety within the magazine, and the lack of such a variety of choices in publications for women in general, that made it possible to do so, even under the rubric of the "housewife."[33]

This is not to say it did not make a difference that they were reading *Shufu no tomo* instead of (or along with) a magazine such as *Fujin kōron* that often had articles contesting the whole institution of marriage, for example. In the popular imagination, the expected life course for these nonmanufacturing working women was to continue their jobs until marriage and then move into

Modern Life in *The Housewife's Friend* 95

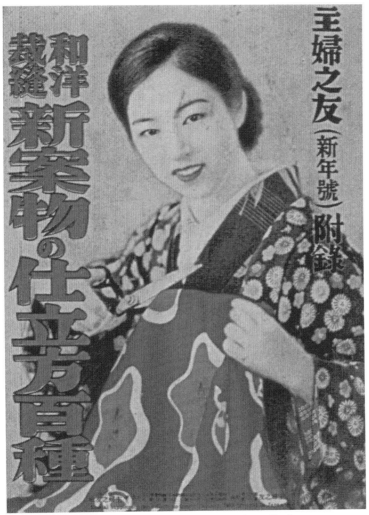

FIGURE 8. Cover of special supplement on sewing. *Shufu no tomo*, January 1933.

the role of housewife. As Barbara Satō's sophisticated analysis of surveys and letters from these women demonstrates, a variety of aims, both personal and financial, drove their working lives. While in actuality most who worked had strong economic reasons to do so, the surveys and popular discourses on *shoku-gyō fujin* show that women often expected and were expected to use this work to provide valuable training for married life. The term "cultivation" *(shūyō)*

96 *Chapter 3*

was often used in this context.[34] In my readings of the surveys, when individual readers used the term it usually referred to self-cultivation and improvement. Articles in *Shufu no tomo*, however, also often suggest that it was really about preparation for marriage that could be gleaned from work life, especially if combined with readings of educational materials and etiquette lessons. The overwhelming message was that the proper life course for these increasing numbers of women with larger incomes of their own should be a period of self-cultivation followed by a rationalized married lifestyle that would draw on the skills learned in the workplace. Many of the articles explicitly argued that such skills could then be retooled and used in their proper feminine sphere. Although articles on how to keep a house account book may have seemed like useful information for a future married life, women likely found something else of appeal here to read in such numbers. Ruptures in the domestic self-discipline the magazine promoted provided space for them to enjoy the magazine. At the same time, the driving message was that their own lives could be integrated, in the future, to a domestically oriented cultured life. So while a successful serialized novel about romance such as Kume Masao's *Shipwreck* (*Hasen*, 1922) might have drawn a given woman into the readership, the magazine's emphasis on ways of living after marriage and the importance of marriage itself would likely have a strong effect on her, one different from the effect of a different magazine or the book *Shipwreck* itself. Because so many of the magazine texts laid out before a woman such a life in an unrelenting way, married life appears as a permanent lifestyle in contrast to the other temporary options that appear in some of the magazine writings.

Besides providing a wide variety of subjects to appeal to diverse ages and lifestyles, the magazine's producers worked hard to modulate the tone and the difficulty of the language in which it was written for the sake of reader relations and reading ability. This is likely how the more rural and less educated audience were courted. Although not uncommon in magazines of the day, *furigana* glosses providing pronunciation of Chinese characters were used consistently throughout the magazine. At least before the proletarian literature movement, most magazines categorized as literary magazines *(bungeishi or bungaku zasshi)* usually glossed only difficult characters or glossed characters for artistic effect, although general-interest and women's magazines commonly provided pronunciation for all characters. Improved print technology, namely the creation of movable type that included the necessary pronunciations together with the character, saved typesetting time and space in the magazine.[35] Because of these efforts, it was said that elementary school graduates could read most of *Shufu no tomo*, and these practices brought that within the realm of possibility.

Ishikawa is said to have laid down specific policies for making the reading material easy and interesting. He posted five rules:

1. Never write a single line if it is not for the sake of the readers.
2. Never write a single line that is merely to show off your own knowledge or to promote yourself.
3. Never pretend to know something you do not.
4. Never write negatively of others. Make every effort to write positive things.
5. Do not write of anything unconfirmed. Write only after having investigated the facts.[36]

Besides emphasizing responsible journalism, these rules suggest a concern that articles not patronize or show an air of superiority toward the audience. As one reads through the magazine, these policies are apparent. For example, articles contributed by doctors, professors at elite universities, or famous educators are surprisingly clear and simple. This is in large part because most of them were not taken directly from the writers' manuscripts; Ishikawa or one of his reporters would often entirely rewrite the text in simpler terms or go to interview the contributor and ghost the article based on the oral exchange. These techniques made the writer's style more accessible to the reader, but at the same time highlighted each writer's elite status. Professionals' titles were always included next to the article headlines, while readers' contributions were often marked by smaller type or the contributor's given name only; this was probably done to protect the contributors' anonymity, but the practice also served to emphasize their status as regular women. The leveling effect of the textual style was always supplemented by the second message: these were authoritative writers even if they wrote (or were written up) in an easy style. Meanwhile, the practice of picturing these contributors with their own families and in their own houses heightened the message that these were ideal practitioners of the advice provided and that they were living lives and speaking a language not entirely unlike the lives and languages of their reader "friends."[37]

One significant effect of this simple style is that many readers chose this magazine on the basis of their education level rather than identification as housewife or middle-class housewife. Although fewer women factory workers (categorized by the surveys as *jokō*) included reading as a pastime than did men earning similar wages, the majority should have been able to read *Shufu no tomo*—and many did. According to surveys of women workers, it became quite popular by 1921, especially among the Tokyo area *jokō*, among whom it was the second most popular after *Fujin sekai*.[38] Throughout the 1920s and

98 Chapter 3

early 1930s, it seems to have continued to compete for this audience against magazines aimed specifically at girls and general-entertainment magazines such as *Kingu* and *Kōdan kurabu* (Story club).[39] On some level, girls who worked under contracts that kept them in virtual indentured servitude may not have had much interest in reading about household budgeting during their breaks at the factory. While there is no way of knowing, we might suppose that the effort to appeal to housewife readers by providing a variety of entertaining texts as well as useful health information, such as ways to mitigate the effects of tuberculosis or eat well enough to maintain a regular menstrual cycle, would have helped to extend the circle of readers to other women, including those who were not married and were far from gaining access to a bourgeois cultured life in their own homes (or factory dormitories). Ultimately, this was an inexpensive way of reading many works of fiction or, as was possible later, seeing the story line and images from movies without going to the theater.[40] It provided a window on to a world to which many women might not have financial or geographic access. And from the factory floor, a fantasy of clean, well-run homes might have been an appealing distraction from the factory girls' surroundings to which those girls might aspire.

As mentioned earlier, the production side of the magazine often appeared explicitly in the magazine through Ishikawa's Editor Diary columns. The consumption side was also represented by reader submissions such as personal narratives, confessions, and reader letters, which were solicited in addition to professional feature articles. While these do on the one hand give some sense of reader reactions, they are also highly mediated texts. The magazine encouraged such contributions: most issues carried a call for submissions on various topics such as young women's ideals for marriage, how I changed my luck, or women who overcame infertility. These would normally appear as special article series or be categorized as confessions *(kokuhaku)*. Every issue also had several pages of readers' letters in the Magazine Club column (Shijō kurabu). The letters chosen tended to mention successes enjoyed by writers who had followed *Shufu no tomo*'s advice or the comfort they had felt from reading about another reader's or reporter's analogous life experiences in a previous issue. *Shufu no tomo* claimed in this way to provide authentic information from real women, frequently using only the reader's first name to convey familiarity. These practices gave the impression that any reader could also be a writer for this magazine. When the magazine's circulation was in the hundreds of thousands, with constant calls and promises of rewards for submissions, the majority of submissions were rejected, but the format of the magazine always emphasized an atmosphere of reader participation despite

its increasing unlikeliness. The magazine's layout suggested that with a little household rationalization, interior decorating, and good mothering (advice about all of which *Shufu no tomo* provided) any woman could create the same kind of household as any of these elites. The motherhood success stories suggested that there was no class difference that could not be overcome with *Shufu no tomo*'s practical advice.

Creating the appearance of a community of readers was also a project of creating a national imaginary. Although readers were primarily urban, published readers' letters came from women from all over Japan, the colonies, and emigration destinations (including California, Taiwan, Korea, Manchuria, Brazil, Peru, New York, and France). Such diversity is not likely to have been coincidental, given that most readers were in urban centers of Honshū. This practice created the sense that its readers were united in their Japaneseness, defined more by country of origin, race, and language than by the boundaries of the nation-state. Regular exhibits, readers' meetings, concerts, and lectures organized as national tours by the Shufunotomo Corporation helped to expand the loyal audience, provided a place to sell related books and products, and allowed it to sign up new subscribers. Although it proved too costly to continue, the publisher also experimented for nine months in 1926 with a localized section in the back of the magazine targeted at five different areas: Kantō, Kansai, Chūbu, Tōhoku, and Seibu.[41] Interestingly, this section included *manga* that were the same in all editions even as there were local feature articles. Sazanami Iwaya's efforts to organize the telling of children's stories around mainland Japan, Taiwan, Manchuria, and Korea in conjunction with his children's magazines *Shōnen sekai* (Boys' world) and *Shōjo sekai* (Girls' world) and the affiliated Otogi Club of storytellers helped to encourage standardized language usage; similarly, *Shufu no tomo* exhibitions created a sense of national readership participating in the same set of household rituals around the country.[42] Even though most products were for household use, these trips to cities throughout Japan and even more rural areas brought urban Tokyo culture to those places in a way that was no doubt intriguing, even perhaps to women who were not running a household at all. Photographs of these exhibitions and the visitors would appear in the magazine itself, meaning attendees could see themselves in print and imagine themselves seen by women across Japan. These attempts to make readers present in the magazine helped to define a sense of community despite absences in whom they represented directly. Readers' letters suggested a wide geographic diversity, but the activities described in the magazine never referred to such variation explicitly;

Chapter 3

this focus tended to suggest a unified set of practices being followed by the "Japanese housewife" whether she lived in Los Angeles, Seoul, Tokyo, or Niigata.

The metaphor of friend chosen for the title, which several periodicals in Japan chose to use, is an interesting one because it came into popularity just as the possibility of readers' becoming literal friends (with each other or the magazine producers) grew increasingly unlikely. The title called on a community of readers who shared some common interests and needs. Compared to real friends, however, the reader community would be less truly helpful and, at the same time, perhaps less disciplining than a real community of acquaintances, family members, or neighbors might be. On the one hand, as with women's magazines everywhere, the anonymity allowed readers to view birth control advertisements or sexual advice columns away from prying eyes. On the other, the increasingly commercial relationship was masked by the sense that this magazine was part of a community of readers to whom it played the role of sympathetic interlocutor. The further emphasis on a voice that provides advice and emotional support rather than criticism or argument meant that the political implications of its messages (whether housekeeping advice or representation of a community of "Japanese" readers) always remained neutralized.

Finally, the title of this magazine worked to smooth over the contradictory projects of rationalizing and disciplining the lives of its readers while urging them to spend time and money on the magazine itself and the often unnecessary products advertised there. Its group of reader "friends" was presumed in need of time-management skills but also to have time for reading the publication; their finances required frugality but also had leeway for less rational purchases from the magazine's advertisers.[43] Through its tone and content, the reader-to-magazine relationship was remade into one between living or shopping companions, rather than between consumer and marketer. Women's magazine culture played a part in associating consumption of commercial products and reading material with women, and the written and visual texts of this magazine connected women with consumption, both the frugal consumption of daily household goods and the less frugal consumption of entertaining reading material. Unlike the image of woman as a political actor in the Japanese public sphere promoted by *Fujin kōron*, *Shufu no tomo* emphasized identification with home life (whether present or future), with the magazine as a friend who would enable its readers to rationalize their daily lives and at the same time provide entertaining breaks in that very life as it became more routinized. This image of community,

Modern Life in *The Housewife's Friend* 101

of friendship, helped to negotiate the apparent contradiction between the magazine's disciplining messages of frugality and its more entertaining or commercial writings. Formal elements, from writing style to visual layout, fostered a sense of connection between reader and writer, despite distances in place and privilege. In both *Fujin kōron* and *Nyonin geijutsu*, discussed in other chapters, participation of female readers was considered by many of the editors to be a politically positive goal. And this is an even stronger assumption in a place like contemporary America where editorials, essays by "regular people," or callers to radio talk shows are thought to add to political debate through expression of their "voices" in the media. Precisely at this time when mass-market magazines were expanding their audiences, this artificial "friendly" community of audiences and professional writers, buyers, and sellers became especially appealing.

Cover Girls

Shufu no tomo covers commonly appear as illustrations in books about interwar-era Japan and have become iconic of women's culture of the period. Generally speaking, these were not the modern girl–type images ones sees on the covers of more explicitly modernist magazines such as *Josei*, and so it is sometimes surprising that these paintings of housewives are looked back on as interesting and somehow modern images of the 1920s. What was most modern about *Shufu no tomo* covers was their printing quality and the use of highly skilled painters to produce what was essentially commercial and promotional art.[44] As the circulation and advertising revenue increased, the quality of the painting and the printing increased such that they become a visible and tangible representation of the nexus between new print technologies, such as three-color offset printing from intaglio plates, and the growing importance of women consumers and readers. Given the success of this magazine, and the extent to which people do judge magazines by their covers, these seem to have worked. Covers no doubt inspired some form of identification and aspiration in readers that we might glean from reading them closely, keeping their promotional purpose in mind at the same time. The covers also indicate in a broader sense the importance of the advancing print technology and what it brought visually to all aspects of magazine printing in a way that spilled beyond the covers into the visual and written styles found throughout such publications.

The December 1919 cover shows a woman carrying a parcel in a *furoshiki* (a cloth used to wrap and carry items) that matches the backdrop of a forest

green and the outline of a tree (figure 9). Her clothing also suggests that she is outdoors, ostensibly delivering or bringing home whatever is in the packet. The wisps of hair around her face and the uneven way the pink lining of her kimono lies show that this is not a formal pose but a woman in daily activity. At the same time the landscape of the background is abstract, typical of most *Shufu no tomo* covers. It suggests an undefined location, and the reader living anywhere can identify with this woman carrying an unspecified package to an unspecified place. It is not a busy city or street scene, where such an errand would likely occur, and the relaxed appearance of her facial expression, achieved through the eyes looking slightly away and the way her eyebrows arch downward into her hairline, suggests a placid environment. While she is apparently doing the sort of activity discussed in the articles inside the magazine, the cover's mood gives a jarringly different impression from that given by the almost frenetic and tedious chores advocated within.

The complexity of this image, and of many of the covers, might best be understood through the ambiguity of the woman's parcel. Her package could be a luxury purchase, an obligatory gift, or a practical item. The vivid colors and aesthetic appeal of these covers show that the cultural messages of women's magazines did not match neatly the ideologies of state frugality campaigns. Instead, they encouraged a complicated desire for an abstract, yet idealized, feminine lifestyle, an ambition that might involve a combination of practical errands with luxury purchases of cosmetics and clothing, as well as of magazines themselves. The covers also presented images of women engaged in hobbies; many showed women painting, arranging flowers, or reading. The women sometimes wore opulent but usually simple clothing and jewelry that were never threatening to gender differences, sexual mores, or economic common sense in the way that images of the modern girl, such as those pictured on magazines such as *Josei*, had been.

The paintings of women adorning *Shufu no tomo* covers indicated visually that this was a magazine specifically for and about women, a fact less obvious in some women's magazines, particularly those claiming to focus on the highbrow, as we saw in the case of *Fujin kōron*. The title words "Housewife's Friend" printed next to these portraits implied, of course, that they depicted housewives. Images of women in traditional kimono patterns were the norm, but women who suggested modernness in appearance (either in Western dress or placed next to objects suggesting contemporary life) were used sparingly, and to great effect. By a skillful mix of fashionably dressed women appealing to a younger readership with images of women who looked like they could be housewives active in domestic work, *Shufu no tomo*

Modern Life in *The Housewife's Friend* 103

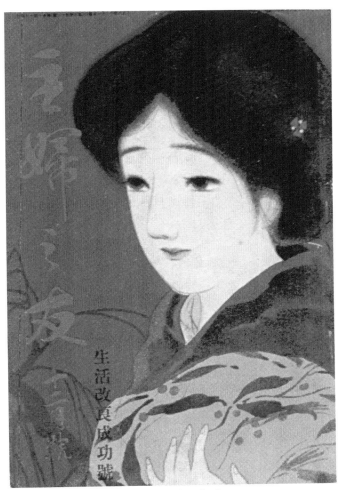

FIGURE 9. Cover by Morita Hisashi. *Shufu no tomo*, December 1919.

appealed to a broad range of readers. One cover artist's recollections confirm this mission to attract the readers without rupturing the ability to identify:

> Mr. Ishikawa's wishes for a cover image included that one would not tire of gazing at it by the end of the month, that the figure would not be excessively refined, and that she would be a "young lady" *(musume-san)* or "young wife" *(wakafujin)* to whom the average lady could relate closely.[45]

The resulting covers were all lithographs or oil paintings until the late 1950s, when photographs were introduced. The quality of the color print was remarkably high for a midpriced magazine, and many of the paintings could stand on their own as interesting compositions. The first issue came out in March, the month of the Doll Festival, and carried a lithograph by Ishii Tekisui: a woman's face in a circle in the center with two paper bride and groom dolls painted on the peach-colored background surrounding her. The first year and a half had covers by the same artist, whose painting style fits in the category of modern *Nihonga* (Japanese-style painting); most of the first four years of covers fall into this genre, and most were printed through lithography. Many include a small child with an adult woman or a woman performing a household chore; such women wear simple kimono

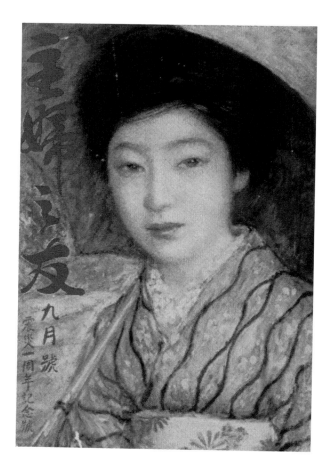

FIGURE 10. Cover by Hasegawa Noboru. *Shufu no tomo*, September 1924.

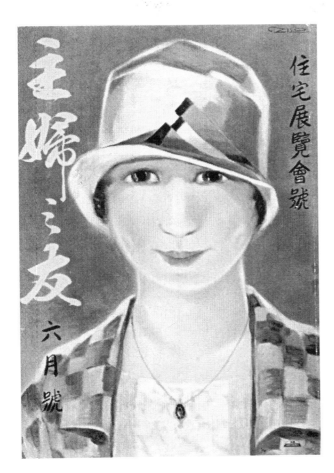

FIGURE 11. Cover by Yoshimura Jirō. *Shufu no tomo*, June 1929.

worn loosely, appropriate for doing housework. In the early 1920s the artists used impressionism-influenced brush techniques and increased the variety of colors for skin, hair, eyes, and mouth. They increasingly followed the conventions of Western painting more than those of *Nihonga* (figure 10).[46] In the late 1920s, depiction became more abstract, with rougher facial features, as in the covers from January to June 1929 by Yoshimura Jirō (figure 11). In the mid-1920s, many modern painters of *Yōga* (Western-style painting) who were already well established in the Meiji period, such as Hakubakai members Okada Saburōsuke and Fujishima Takeji, contributed covers regularly.[47] More significant is that there was a move away from any direct representation of household tasks on the covers in the 1920s. This no doubt allowed for a broader identification with the women on the covers, but it also

106 Chapter 3

attached an image of leisure that diverged from the life depicted within the magazines. As such, the impression conveyed was that if she managed her time and money as instructed by the magazine, the reader might achieve the beauty and leisure depicted on its cover.

Although the painting styles and artists move dramatically from the pale faces of *Nihonga* to the unusual coloring of the *Yōga* schools, and the content of the illustration reflects historical changes, a common feature throughout is that the women's appearance is informal. Covers reflect changing fashion but usually show outfits suited to housework, shopping, or informal socializing. Most of the women wear simple kimono, sometimes with an apron cover. An exception is the covers that showed bathing suits to decorate issues with articles about sewing swimsuits and planning summer vacations (August 1924 and July 1925). The Western clothing shown in one or two covers a year tended to be fashionable but within the range of what a younger upper-middle-class woman going shopping in the city might wear, but by 1930 more full-blown modern girl types began to appear. In general, the faces seem to be those of women in their late twenties and early thirties. They express calm and contentment, and appear to have been chosen for conveying emotions appropriate to a married woman. Although not uniform, they all could be considered paintings of beauties *(bijinga)*, but beauties living an everyday life. As a whole they make up a set of aestheticized depictions of daily life for women in a partial variety that captures certain values about middle-class living and gender roles and articulates them through the sufficiently, but not completely, subdued beauties on the covers.

On a few significant occasions, the magazine did not use a woman on the cover. These exceptions in a sense best show the representational weight attached to the *bijin* covers. The first was the October 1923 "Great Kantō Earthquake Pictorial" issue that carried a dramatic oil painting by Okada Saburōsuke, "The Asakusa Twelve-Story Building in Flames" (Moetsutsuaru Asakusa no jūni). The painting was primarily of flames in red and yellow with the vague outlines of the famous Asakusa twelve-story building burning in the earthquake-related fires. This October issue was completely redone from the one scheduled to go to press the day after the earthquake, and the new version's content was primarily about the disaster.[48] The choice to use this cover was, of course, partly a marketing decision to promote the fact that the issue contained extensive drawings and photojournalism of the earthquake's destruction. At the same time, the editors must have considered the potential disjunction between an image of a beautiful housewife and her rationally maintained household and the irrationality of the earthquake's destruction of such homes. The science of household management, so highly touted here,

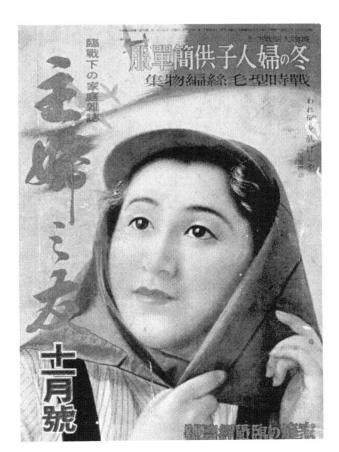

FIGURE 12. Cover by Okuzawa Jirō. *Shufu no tomo*, November 1941.

failed to account for these terrible scenes. When femininity had come to represent a warm, beautiful household produced through consumption of its products and following its practice, it was out of place where so many households had been destroyed. Especially when so much carnage and destruction had resulted from the bad timing in the late morning, when many women had just turned on their gas burners to cook lunch, the image of the contented and efficient housewife seemed out of place.

The second time that the housewife-beauty was eliminated from the cover was the period after the Pacific War in 1945. Cover artists remained the same from 1941 until 1947, painting wartime pictures of women working in factories, fishing, farming, and mothering for the war effort. These images borrowed the style of their contemporary movie posters in photograph-based color images (figure 12), and such paintings

continued even as the covers had to be printed in black and white in the last three months of the war; but at the time of surrender, we see a sudden shift to a series of persimmon trees, birds, fish, onions, Christmas trees, children, and dogs (figure 13). No picture of an adult woman was shown on the cover for almost two years. The covers of this period indicate that

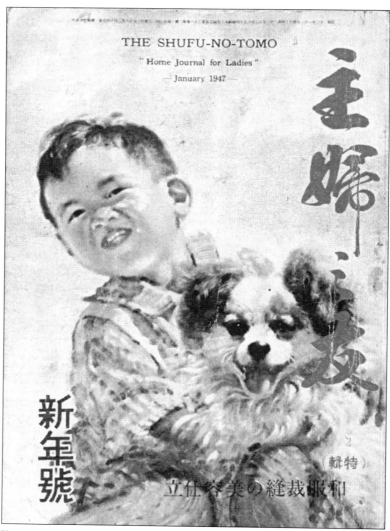

FIGURE 13. Cover by Miyamoto Saburō, *Shufu no tomo*, January 1947.

the women on these covers had become so strongly associated with the war effort and the image of imperial Japan that it was impossible to continue representing the Japanese woman here, even if, paradoxically, more works by the familiar artist Kinoshita Takanori continued to appear in the front sections of the magazine. A cover-woman image would have been reminiscent of the propaganda role the magazine had played when it showed women, mobilized for the war effort, looking like movie stars, their activities visually beautiful. Because of this past, the magazine's publishers seem to have been at a loss as to how to depict the housewife or woman in early postwar Japan. This confusion suggests how much was at stake in depicting her at all.

Although it is outside the period addressed here, the move to photography on the 1964 issue is significant. When photographs were introduced, the women used were actresses and models (the first was actress Sakuma Ryōko). Previous covers had been representations of "a typical beauty of the time"; even when depicted in the style of movie posters, they had not been representative of specific actresses.[49] Identifications with vague housewife figures or generic Japanese beauties were transformed through the shift to star identification. The reader knows who the cover woman is because the realist photographs claim truth in representation, and it is clearer in some senses that it is not the reader herself. It is at this moment that the reader's longing must shift from "I want to be her" to "I want to be like her." Even if famous women of the target reader age group are used, it is obvious that these women do not live as the readers do: who would be less likely to try to cook 100-yen meals or be interested in information on vacuum cleaners than a famous actress? Of course, new forms of star identification develop: an identification shift occurs when realist modes, similar to film posters, are employed in wartime and again with the shift in medium to photography.

After 1993, the cover model switches once more, as the marketing is even more finely tuned. Shufunotomo Corporation now publishes many magazines aimed at different ages. *Shufu no tomo* itself was narrowed to its practical, frugal elements, and the cover now has headlines and photos of cheap meals, lunch boxes, and household crafts rather than a person. *Shufu no tomo* has struggled to keep its old niche as other magazines more successfully do what it originally set out to do: teach younger women living away from parents how to keep house for the first time. The glossy recipe magazines *Orange Page* and *Lettuce Club*, for example, have done much better among college students, single working twenty-somethings, and

young housewives skirting the line between the fashionable and the domestic, as have similar magazines that focus on home decorating. *Shufu no tomo* had targeted a variety of identities within the magazine itself, but it now seeks to do so through providing a variety of magazines from its publishing house. This tactic reflects changes in costs of production of separate magazines that are allowed by new technologies and the increase in percentage of pages to advertising. But it also suggests the ways in which *shufu* came to exclude those who do not identify as housewives, either because they are not housewives or because they did find the label homely after all. As this market segmentation takes place, the choice of a cover model becomes more difficult. Rather than using a single image, the December 2002 issue instead uses photographs of nine people tied to different stories. They include such images as a casually dressed young woman, who we are told is a twenty-eight-year-old mother of one who worked in a clothing store before marrying her college sweetheart, and a woman in a sweatshirt, calculator in hand, trying to reduce her household expenses. Because the range of lifestyles depicted no longer includes those to which an ambitious family might only aspire, the idea that an actress cover model can sell guidebooks about careful home accounting starts to make less sense and must be replaced by photographs of "real" housewives. Of course, being a full-time housewife is something that many families cannot afford. Such families are in fact included in *Shufu no tomo* articles, but the title and most articles promote frugality as a way to make being a full-time housewife a possibility, especially for mothers. For example, one article in the December 2002 issue depicts a family of five who face major debt after buying a house, charting their way out through frugality and refinancing. Interestingly, the father's face is blurred out in all photographs in the feature.[50]

To return to the interwar era—rather than emphasizing longing toward the upper class and high fashion as some of the pictorials such as *Fujin gahō* had done, *Shufu no tomo* focused on the image of a middle-class housewife in a beautified form suited to a particular magazine issue. This had the visual effect of both elevating and defining the "ordinary housewife" this magazine claimed to represent. These figures then seemed to be within the community that comprised the imagined audience, but with sufficient beauty and attractive clothing that they might be friends—envied friends at once objects of identification and of longing. Although the self-discipline advocated inside the covers did not always read as enjoyable, the covers depicted an imagined feminine and beautiful product of that daily lifestyle at its most successful.

Home Shopping: Advertising and Layout

In *Window Shopping*, Ann Friedberg observes that department stores use architectural techniques to move the shopper through the store as store designers work to "effectively mobilize the shopper's gaze through the commercial machine" by encouraging "loitering in association with consumption."[51] *Shufu no tomo*'s layout and advertising strategies suggest an analogous project. In the 1920s, advertising firms and magazine editors increasingly considered the interactions of advertising, article text, and fiction, and *Shufu no tomo* devised some of the least subtle—yet most intricate—linkages. In many issues around 1930, humorous short stories were literally written into the margins of advertisements along the one-inch space between the ad and the binding and ran continuously, three lines at a time, through the entire twenty- to thirty-page advertising section.[52] Entertaining reading was important to advertising sales and also worked visually to lead the reader's eyes from one place to another, prompting "loitering" among the products advertised there.

The use of ads on the pages of the text of a story also indicates the powerful role of literary texts in the magazine. Many readers would buy the magazine to follow a serialized story, and the promotions interspersed through the stories presented ads to readers that they might otherwise not notice. Although this is common practice today, it was still a new technique in the early 1920s. Short stories by lesser-known writers were often printed with one paragraph and an illustration of the written text on each page, mixed in with nonfiction articles on an unrelated topic. The stories would be divided into sections and scattered over about thirty pages, each paragraph-long section numbered like a monthly installment of a serialized novel. Although *Fujin kōron* clearly marked literary texts by placing them in the separately paginated Shōsetsu (later, Sōsaku) section, *Shufu no tomo* mixed the fiction through the whole magazine, making it more difficult for a reader to ignore the ads and nonfiction pieces. It used the anticipatory aspect of the serialized novel not only to encourage readers to purchase the magazine each month but also to transform the way that they read the magazine as a whole.

Shufu no tomo's first issues coincided with a period of changes in the advertising industry, the beginnings of scientific marketing research, and an increase in the visual aspects of advertising. Initially, written text dominated the ads. The visual techniques for attracting attention were simple, consisting primarily of different font sizes, lines of various thicknesses, well-placed drawings or symbols, and black background rather than words. Some ads simply used arrows pointing to important messages and pictures. One Novem-

ber 1919 promotion for Pompeian beauty powder and massage cream uses one arrow going down the right side of the page and another up the left side (figure 14). This has the effect of moving the eyes of the reader up and down the page, sometimes in the opposite flow of the up to down, right to left text. It also elicits a pause before the reader turns the page because the arrows point in opposite directions.

Advertising often drew on modern art, using such techniques as increased abstraction, particularly of the human form, and strong diagonal lines to fix attention on the product. This trend paralleled a simultaneous one in American advertising where aspects of modern art such as harsh edges, off-center layout, and futurist techniques to depict a sense of motion were used to attract reader attention to print ads.[53] In Japan, representations of women depicted them

FIGURE 14. Advertisement for Pompeian beauty powder, facial massage cream, and hair massage cream manufactured in Cleveland. *Shufu no tomo*, December 1919.

Modern Life in *The Housewife's Friend* 113

FIGURE 15. Advertisement for "soft flannel" and "smooth and silky serge" fabrics from Ikuchi Shōten. *Shufu no tomo*, September 1923.

as a part of these changing modern design styles, interwoven into transformations in style and landscape (figure 15). The caricatured depiction of women in many cosmetics ads placed women's modern appearance in a metonymic relationship with general cultural transformation. Meanwhile, other advertisements placed them more literally in modern or Western-looking settings. Compared to a magazine such as *Josei*, which was more connected with modernist writers, and even competitors such as *Fujin kurabu*, which courted the modern girl type, *Shufu no tomo* had less in its layout and commercial texts of the modernist graphic arts such as those that Gennifer Weisenfeld has described.[54] Still, there are stunning examples of abstraction and use of latest trends in graphic design to an extent that often went beyond the image of the staid housewife. To some extent, these were probably meant to appeal

to the younger readers and the modern girl–type, although arguably they were of the greatest interest to the graphic design community itself. At the same time, they were also no doubt effective in bringing even the housewife into the modern by associating the accepted themes of hygiene and domestic rationality (or even high-quality cosmetics and other luxury products) with the up-to-date look of modernist aesthetics.

Shufu no tomo's more surprising advertisements were not in fact the most glossy or visually stunning. Unique were the many small, inexpensive ads in the back for products that could be procured either from the manufacturer or through *Shufu no tomo*'s sales agency using a perforated order form inserted in the magazine (figure 16). These ads, primarily text with a small picture, tended to be placed by smaller medicine companies or makers of household tools. The price for *Shufu no tomo*'s full-page ads was high: 214 yen in 1927, as compared to 120 at *Fujin kōron* or 160 at *Fujin kurabu*. These small advertisements were only 10 yen, however, making them accessible to very small businesses.[55] In all likelihood, a further charge was made on sales conducted through *Shufu no tomo*, but the risk for the companies would be small.

This technique of advertising and direct marketing through the back pages of *Shufu no tomo* narrowed the gap between informing and selling, just as the proximity of ads and serialized fiction linked reading to shopping. The editors strongly emphasized the informative aspects of advertising, and some editorial essays suggested that the readers use them as such. As the July 1925 issue stated, "Those households who carefully read advertisements will have progress, economic success, and happiness."[56] The March issue of the same year urged rural readers, who would not have been able to afford the prices of most items advertised in the magazine, to read them as a source of information.[57] The dense layout gave this section the visual feel of practical articles rather than advertisements, a point emphasized by its title, Important Household Product News.

Advertisers too presented their advertisements as education about modern lifestyles. Because *Shufu no tomo* often introduced new home products, particularly those associated with cultured life, such products often had to appear in their context or required narrative explanation. While items such as whitening face powder needed little visual explanation (and would be difficult to represent in black-and-white line drawings), appliances were often shown in use. A 1921 ad for water heating appliances shows a man with a toddler in the bathtub and a woman tending to the kitchen (figure 17). Labels mark the hot-water system, the electric pot to heat drinking water, and the cooking range. The drawing indicates what sort of evening rituals these would permit: the wife rather relaxed as she oversees the appliances

Figure 16. Mail order catalog page. "Guide to Beneficial Home Products." Tear marks on the binding show where order form has been removed by a reader of this copy. *Shufu no tomo*, September 1923.

Figure 17. Advertisement for water heating appliances made by Tomoe Shōkai. *Shufu no tomo*, August 1922.

116 *Chapter 3*

cooking dinner while the father bathes the child. Light-bulb advertisements were common and usually showed the eating or reading that the lights would make possible (it is worth remembering that for many readers, particularly in rural areas, such conveniences were not yet widespread).[58] This genre of advertising showed how products could be integrated into a new lifestyle or, conversely, how one could create such a lifestyle by using the products.

Readers were somewhat suspicious of the reliability of products advertised in major magazines. *Shufu no tomo*'s catalog-sales division was often checked by the police because readers were nervous about paying in advance.[59] The constant repetition that these products were "all reliable" suggests that there was a great deal of doubt about advertised products. Sometimes advertisers used techniques from other writings in the magazine, especially user testimonials, similar in format to the titillating genre of confessions. Giving the name, and sometimes portrait, of a doctor was a common promotional technique used for medicines. The advertisers of the Radio Wave Machine claimed to be treating illnesses in the imperial household and in important families throughout Europe and America.[60] These marks of expert, high-status, or Western opinion, as well as *Shufu no tomo*'s own mark of assurance—rather like the *Good Housekeeping* Seal (of Approval)—helped make the transition between familiar local products and new mass-produced ones by suggesting a science and rationality of buying based on national or international standard. In fact, inasmuch as the *Good Housekeeping* Seal was instituted in 1909 and Ishikawa paid close attention to American women's magazines, it is not inconceivable that the idea was taken directly from that publication.

Department-store retailers realized that if a large number of consumers passed through the store, a certain percentage would buy and make it commercially successful. *Shufu no tomo* was sustained by a large audience who bought a wide range of differently priced products.[61] If the Mitsukoshi department store believed that a small percentage of readers of *Shufu no tomo* might do their high-end shopping there, the store would continue to buy high-profile advertising space, even when the bulk of purchases by readers were everyday household goods, foods, and mail-order items. Other readers simply bought the magazine and none of the advertised products, but this overall combination sufficed to support the magazine.

Just as department stores developed new spaces and techniques that transformed the visual qualities of the experience of buying, so too did *Shufu no tomo*. Their methods for promoting direct-market shopping were quite different, however. The ads presented products in a visually unimpressive way, and the shopping took place in the home. *Shufu no tomo*'s slick covers and other sophisticated printing and design suggest that its use of the simple

catalog ads did not stem from lack of good graphic designers or printing houses. Instead, editors speculated that this sort of restrained marketing had an attraction for the housewife audience. The very simplicity of these ads was congruent with the magazine's strong themes of household economics and frugality, while still encouraging spending on household products. *Shufu no tomo*'s drab sales techniques emphasized self-restraint while suggesting that women should buy these products. Although less visually spectacular than methods for selling powders and colognes, the magazine's way of acting as agents to sell brooms, health tonics, and toothbrushes was just as new and no less a part of consumer culture. The messages of restraint and consumption worked in tandem even as the latter was in a sense suppressed. Arguably, a set of ideas about families' daily lives smoothed over these contradictions of consumer capitalism. The magazine presented the product choices as regulated through the science of home economics (i.e., the knowledge the magazine provided), so that buying them could still be part of frugality and responsibility. The choices to consume are presented as rational ones of biological necessity or daily need. Luxury purchases, meanwhile, are presented as incidental, with an occasional reader choosing them after glancing at the department-store ads as she reads about how to save her money. These relationships—relationships between concepts of selling and frugality and between the production, manipulation, or articulation of desire—were thus negotiated through formal choices.

Popular Fiction for Women and the Literary Establishment

The woman reader came to be recognized as a primary audience for popular fiction in the 1920s. Ōya Sōichi famously remarked that women readers were "like a new colony for journalism":

> The remarkable phenomenon of the increase in women readers in recent years has influenced popular writing in much the same way that the discovery of a vast colony might influence the country. The sudden development of women's magazines had an effect on the literary establishment *(bundan)* not unlike that which the growth of the spinning industry's targeting of the China market has had on Japan's financial system. Similarly, popular writers' incomes have risen in proportion to the development of women's magazines.[62]

Many critics associated these trends with the proliferation of inferior reading material for women, an association that led to the move to improve women's

magazines *(fujin zasshi kaizen undō)* in the late 1920s.[63] With her usual clarity, socialist feminist Yamakawa Kikue maps out the factors involved in "Just Another Form of Commercialism." She poses the question of whether magazines caused women to follow the vagaries of fashion or whether they simply spoke to preexisting materialism: "Low-level *(teikyū)* women's magazines exist in part because there are so many low-level readers. But at the same time, the second-rate articles also help to produce low-level readers, to expand second-rate interests." She ultimately indicts most severely the "fundamental commercialism" of society.[64] The serialized fiction of *Shufu no tomo* helps to unpack these questions of cause and effect.

Maeda Ai's discussion of the ways women's magazines related to the *bundan* in terms of remuneration complicates the question of links between Yamakawa's "commercialism" and fiction. Women's magazines were a primary financial force behind the development of Taishō popular literature or what was referred to as commonplace fiction *(tsūzoku shōsetsu)*, and *Shufu no tomo* was a dominant forum for this popular serialized literature.[65] A major motivation for many of the authors was the high price paid for their submissions, much higher than that for general-interest and literary magazines or newspapers. Frequent contributors of longer works throughout the 1920s and early 1930s included Kume Masao, Okamoto Kidō, Watanabe Katei, Ikuta Chōsuke, and Mikami Otokichi, authors who eventually benefited from the *enpon* publishing phenomenon.[66] Many of the works published here became best sellers of the era and the basis for popular films of the 1930s. In fact, Mikami's profits in popular fiction and film adaptations provided financial backing to his wife for *Nyonin geijutsu*, the journal discussed in chapter 4. Tanizaki Jun'ichirō submitted some pieces, although his work was more commonly found in such highbrow women's magazines as *Fujin kōron* and *Josei*. Kume Masao's *Hasen* received a 10,000-yen contract from *Shufu no tomo*, equivalent to fourteen yen for a *genkōyōshi* manuscript page.[67] Of course, this was in part because it was a high-profile novel that was rumored to be based on the marriage of Natsume Sōseki's daughter Fudeko to one of Sōseki's students, Matsuoka Yuzuru; nevertheless, major general magazines such as *Chūō kōron* offered only one yen per *genkōyōshi*, and the average was half that. It was common for women's magazines to be offering four or five times the general rate at the end of the Taishō period.[68] Sasaki Kuni, an English-literature professor who was not originally a writer but a translator, was reportedly enticed by Ishikawa to write humorous stories for *Shufu no tomo* when Sasaki's domesticated duck flew into Ishikawa's yard.[69] At first simply elated by the pay of one yen per page, plus additional money when the circulation was higher, Sasaki became a major writer of humorous magazine

Modern Life in *The Housewife's Friend* 119

fiction and one of the most frequent contributors of original and translated stories to this magazine and other women's magazines.[70] Thus there are clear cases where the financial clout of women's magazines was creating writers.

In 1921, *Shufu no tomo* even solicited novels from the general public by offering a 10,000-yen contract to the winner. This offer became controversial because there were numerous accusations in the newspapers that such a high sum must indicate fraud.[71] Ishikawa responded directly to the accusations in the January 1922 issue, where the first installment of the award winner Yuasa Kenkichi's story was published. The high price paid for all of these manuscripts reflected the growing circulations of women's magazines and their resulting ability to outbid others for popular authors. The flip side of this, as Maeda Ai notes, is that "this demonstrates how highly women's magazine editors valued the power of commonplace fiction to mobilize readers."[72]

For magazines such as *Shufu no tomo*, a famous author's name alone was usually insufficient to draw readership. A successful serial needed to work well in that format, with a story that built anticipation from month to month. Those who established a reputation in this genre (irrespective of their writings in the literary journals) could publish repeatedly, though they might also be replaced if a particular novel did not draw enough praise or fan letters. Yamakawa, highlighting the status of writers as laborers, noted that if these writers went on "strike," refusing to write material without artistic merit, "they would suffer but the magazines would not."[73] The financial success of popular magazines led to a situation where many writers maintained their status in the *bundan* by writing for literary magazines while being financially supported by fiction written for popular reception. Maeda notes that around 1926 it was common for writers to publish short pieces in the genre of I-novels, considered pure literature, in literary and general journals while simultaneously publishing popular fiction in women's magazines.[74] This meant that the *bundan* itself could temporarily ignore the implications of the commercial success of popular fiction by its own complicity in that success. Maeda argues that in time, leading this sort of double life forced the literary establishment to confront the question of "mass" literature, and this confrontation in turn became a key term in the proletarian literature movement that guided the magazine *Nyonin geijutsu* (discussed in chapter 4).[75]

What can we make of this connection, initially repressed, between highbrow I-novels and the melodramatic writing of popular women's magazines? Kume, a figure in whom the split was most obvious, wrote that the I-novel "should become the main path, the basis and essence of the art of prose. To use others as a means of expressing the self is, after all, to reduce art to the commonplace *(tsūzoku).*"[76] In his debate with Nakamura Murao on the

"authentic novel" versus the "novel of the mental state." Kume does not consider consumption of either genre by the reader. Neither does he address the tendency of the mass media to commodify his own fiction and life, obfuscating it with an emphasis on artistic merit. Kume's disdain for this commercial banality is apparent, but he does not directly critique this system of which he is so much a part, turning his attention to the personal, which he admits might sometimes be equally commonplace. Just as contemporary Hollywood movie actors often try to avoid looking too commercial or artistically compromised by refusing to appear in advertisements, these authors only maintain an apparent separation from a system of exchange that supports them financially.[77]

It is clear that writers often tried to quarantine their middlebrow publications, especially those in women's magazines, to protect their more artistic works from the taint of commercialism. Nevertheless, this hygienic distinction did not make their writing any less part of the commercial press. As Tomi Suzuki has pointed out, the I-novel was not so much defined with reference to a certain body of works in the *bundan*, but in a "consensus institutionalized by the expanded mass media about a particular mode of reading and about the newly perceived social function of the novelist."[78] Women's magazines both provided financial backing for writers and played a role in creating the personae that helped define how their confessional works would be read: making public the lives of writers, manufacturing scandals, and constructing connections between those scandals and writers' work. As critic Katakami Noboru noted in 1926, any piece of published fiction was now a commodity even if writers were not as conscious of the fact as when they wrote *tsūzoku shōsetsu*.[79] Increased emphasis on distinguishing the popular novel from the artistic novel *(geijutsuteki shōsetsu)* only reveals more starkly the extent to which the I-novel and *tsūzoku shōsetsu* genres were similar in their relationship to popular periodicals. This association of popularity—the commonplace—and the commercial with the feminine must transform the way we understand this relationship.

The developing consciousness of a split between mass and elite readerships, between popular and pure literature, has been discussed at length by Maeda and others, but the factor of gender has been understated, even in Maeda's work, which is incisive enough to foreground the role of women's magazines in these trends.[80] What an early advertisement for *Fujin kōron* termed the "second-rate interests of women" (a phrase echoed by Yamakawa's article), particularly associated with popular women's magazines, was an overdetermined category representing a broader discomfort with mass culture and 1920s capitalism. The efforts by writers to dissociate their artistic

novels and confessional novels from the presumed inferior desires of this audience was thus just as complicated in its relationship to gender. In effect, the attempt to divorce artistic writing from popular writing for women was an attempt to separate art from the commercial. This is the suppressed side of the various debates among authors in the late 1920s and 1930s over the relationship between literature and politics, and it all too often remains hidden in both modernist and proletarian critiques of mass culture *(taishū bunka)*.

Serialized Fiction and Media Mix

When examined as a whole, the fiction of *Shufu no tomo* might be described in terms of its variety. Although it touted well-liked authors when their novels were published, the magazine also satisfied readers through a range of genres and celebration of the multimedia aspects of 1920s life. Rather than keeping fiction elevated and separate from commercial and "light" texts, as in *Fujin kōron*, *Shufu no tomo* has a leveling quality, from the table of contents, which deemphasizes differences among styles of texts, to the mixture of images and texts themselves. Fiction is implicitly another of Ishikawa's "interesting" reading materials, distinguished only from the equally broad category of the "useful."

Humorous fiction, much of it written by Sasaki Kuni, often pokes fun at the daily lives of the middle class. For example, *Culture Village Comedy (Bunkamura no kigeki)* starts the first chapter, "A Declaration," with the self-deception of suburban commuting:

> "It's only ten minutes from the station. It's very close"—This is what everyone says, but in fact it's quite far. Yamagishi tried timing it many times during the construction of his house, and unless he broke into a jog it always took fifteen minutes, and so he settled on the idea that, for the sake of exercise, it was better this way anyway. For his wife it took twenty minutes.... The great lie was that this would be shorter when more roads were constructed, even though no one had any idea when that would happen.... But he never spoke with others about the inconveniences in hopes that by exaggerating the good points more people would set down roots out here. Even if that didn't result in more conveniences, at least his share of the inconvenience would be spread more widely.[81]

This lively novel depicts the daily life of a couple trying to convince themselves that it is better to live among the rice paddies, now labeled "culture village"

in anticipation of its future development, than in Tokyo. While it undercuts romantic notions about efficiency and modernization, the story's humor relies on assumptions about the interaction between husbands and wives. Ultimately the tone would be comforting to a couple trying the culture village in that there is a sense that the experience is in fact shared, the foibles of its community "spread more widely."

Comic strips also tended to focus on everyday life. The November 1919 issue on men and women working together featured an illustrated comic tanka (kyōka) called "Tomokasegi" (Double-income couples).[82] While examining their finances, a couple realizes they are coming up short, so she goes out to work in an office. The next frame shows her husband eating cold rice before she comes home. She and her husband do piecework together because prices are still rising while their salaries have stagnated. Another image shows that a request by workers to raise piecework wages has been rejected. She has so many children that she cannot keep up with the work anyway—the children are shown piled on top of her. The final frames show how the husband and children have spent the money while the bills pile up. The husband's new suit is marked on each side as the "part the husband paid for" and the "part the wife paid for." It concludes that maybe a peasant's life is more carefree since no matter how much you work to save, you cannot save enough. In the same issue another comic strip had an installment "a Married Couple's Miseries of Misunderstanding." Having torn up her flower bed to plant herbal medicines for profit, the wife also starts making celluloid dolls. These are so strange looking that she and her maid pass the time by imagining that one of them might become the maid's future husband. The son distracts them, however, so the mother gives him the day's profit to entertain himself. He goes out to buy a sparrow trap (a sticky wooden plank), but, bored when he catches nothing, he decides instead to make the dolls into an army. While chasing him the maid is caught on the sparrow trap, and when she keeps running she tramples the herb garden, for an overall financial loss for the day.[83]

As so often humor does, these stories play out particular anxieties, here about women's working and child care. Women readers who are mothers currently working in the home, whether doing piecework or not, would likely recognize these scenes of children interfering in their work as familiar. But the stories also mirror harsher critics of women who were not able to spend as much time with their children because of work. As Kathleen Uno has shown, lower-class working women were often criticized for letting their children run loose in the streets rather than monitoring them closely.[84] Meanwhile, a torn-up request for a raise among the plastic dolls is a jab at employers. At

the same time, the jovial and harmless nature of these stories could have been soothing, not inconsistent with government frugality campaigns suggesting that men and women might need to work together to overcome economic difficulties. The comic tanka about double-earning couples ends with a begging monk, a vision suggesting uneasiness about whether having more money will really make for a better life.[85] These comics reveal a great deal about prevailing anxieties and expectations, yet they do so in a way that entertains without threatening the largest portion of the readership. In general, they rely for their humor on the assumption that these trials are temporary situations, produced by irregular economic necessity. They are amusing because they disrupt the normative vision of everyday modern middle-class life—a lifestyle only just being defined and represented, often within this same magazine—in which the flower bed is normally intact, the rice for dinner hot, and no paid work occurs inside the house. We see how a number of media work together with the magazine's ideology, not to dupe women readers in some way, but to communicate and encourage them to laugh at their own anxieties while naturalizing this conception of everyday life.

The magazine made increasing use of such comics, illustrations, photographs, and color plates. By the late 1920s, film had become one of the most interesting presences in this mix. Popular films from both Hollywood and Japan would be summarized in so-called film stories *(eiga monogatari)*, combining stills with plot summaries and often running over several pages of the magazine. Expanding this form further, some original stories never made into movies were staged as photographic fiction, as we saw in the *Fujin kōron* item "A Young Wife's Melancholy," which used studio actors posed for photographs resembling film stills with a running textual narrative. Some of these were written by regularly featured serial fiction writers, such as Yoshiya Nobuko, who wrote a piece of photographic fiction called "The Girl Next Door" (Tonari no musume).[86] These types of works increased both the emphasis on visuality in the publications and the connection to the increasingly popular world of the movies.

Shufu no tomo strengthened this association and the atmosphere of reader participation by holding film story contests, including one where the winner's film was actually made by Shōchiku Productions and the filming covered in the magazine. The January 1925 issue covered the winner of the film story contest, Miki Ruiko, and her winning entry, "The Twin-Flowered Primrose" (Niwa no yukiwarisō). The issue also contained photographs and an article by a script editor about the production of the film, which debuted at the Denkikan in Asakusa on March 3, 1925. The film, directed by

Shōchiku's Tsutami Takeo, featured major actors and filmmakers, including Hanabusa Yuriko, who later played O-Yuki in Naruse Mikio's *Wife Be like a Rose* (*Tsuma yo bara no yō ni*, 1935).[87] Such cooperation was mutually beneficial for the magazine and film studios, providing promotion for both media. In the same issue as "Twin-Flowered Primrose" was a lengthy article by Nakano Seiji, the *manga* reporter (who illustrated text with comic-strip-style drawings), on the inner workings of Nikkatsu Studios, called "Inside the Studio: The Mischievous Lives of Movie Actresses," with drawings of actresses in everyday activities at the studio.[88] Satō Takumi has shown in his recent study of *Kingu* that writing styles were affected by film in what he calls the "talkie-fication" *(tōkika)* of the magazine.[89] Of parallel importance are the direct relationships between film and magazine industries: not only did *Shufu no tomo* work as a mediator between the film world and the textual reading public, but it also suggested that readers could participate in the productive side of that world even without having any technical skills or even physical proximity to film studios.

Comics became more and more common in *Shufu no tomo* over the course of the 1920s. These ranged from social commentaries aimed at adult women to amusements that were clearly aimed at children. In general, these are not difficult cartoons in terms of reading level, and they may well have allowed less able readers to enjoy the magazine through its visual signs. The comics often also targeted a children's readership, a group highlighted increasingly during the late 1930s when a full children's insert was added, with adventure stories for boys often included in comic-strip form.

The line between fiction and nonfiction was not blurred only in the case of those forms usually considered less literary or lowbrow, nor was the increased use of illustrations necessarily associated with mass culture. For a magazine generally taken to represent the more ordinary tastes of 1920s Japan, there are many surprising finds in *Shufu no tomo*. For example, in what might seem like the very accessible form of the pictorial story *(kaiga monogatari)*, modernist drawings illustrate a mysterious story that spins off from Baudelaire's reflections on time in "Be Drunk": "It is time to be drunk! So as not to be the martyred slaves of time, be drunk, be continually drunk! On wine, on poetry or on virtue as you wish."[90] While articles often emphasized simplicity and efficiency, or on the flip side negative (but fun-to-read) examples of human behavior, fictional texts were chosen to be entertaining and up-to-date in their tone, look, and content. In this *kaiga* novel, the disorienting illustrations and reflections on time—which would hardly go with the image of women studying to become early-rising

housewives—were likely chosen for their gestures at modern atmosphere and eye-catching qualities.

Most works of serialized fiction printed in women's magazines were categorized as domestic novels *(katei shōsetsu)* or romance novels *(ren'ai shōsetsu)*, along with some historical *(jidai shōsetsu)* and detective novels *(tantei shōsetsu)*. Common *katei shōsetsu* plots elaborated the intricacies of family secrets and scandals, revelations of which led either to resolution of family ties or to tragedy. A common type of *ren'ai shōsetsu* story line traced the adventures and misadventures of women office workers, modern girls, or other such icons of modern womanhood.[91] Like many of the articles, much of the fiction in *Shufu no tomo* mapped transformations in lifestyles: new careers, new living spaces, changing family relations. The fictional depictions ranged from tragedy to comedy as their plots pursued changes in landscapes and identities, and they often attached sexual experiences to such situations, with scenes of attempted seduction played out in spaces generally outside the type of family life that *Shufu no tomo*'s nonfiction articles idealized.

The essay "Women's Literary and Social Desires," by 1920s literary critic Aono Suekichi, claims that these themes represent "women's literary desires."[92] Aono suggested that these narratives of modern-girl figures, which explore their adventures and tragedies in modern urban life, were appealing to middle-class women who were unable to participate in such unconventional activities in their everyday lives and thus sought to imagine liberation on this fictional level. He argues that this fictional escape prevented them from seeking real transformations in their lives. His observation that readers usually had limited resources to incorporate the sorts of nonconformist actions represented in the fiction they read into their own lives is an important one, and a point often forgotten by literary scholars today when they detail the "subversive" moments in texts. Aono's choice to place the focus of his criticism of popular literature on the apolitical nature of women's "desire," however, fails to take into account that both the ways these texts helped to form that desire and the ways women's reading of them have reworked them were also political. It merely repeats the association of women with consumption, common both to many socialist critiques of capitalism and to right-wing concerns about women's being corrupted by this low-level reading material and leisure activity, and leaves unexamined the extent to which women readers as a category were being used as icons of larger social trends as we saw in the discussion of such readers in *Fujin kōron*. A look at Yoshiya Nobuko's fiction and fandom helps us gain a different perspective on these issues.

126 Chapter 3

Yoshiya Nobuko and the Pleasure of Excess

Yoshiya Nobuko had nearly unparalleled success as a writer of serialized fiction for the women's magazine and newspaper markets beginning in the late 1920s and remained popular well into the postwar period.[93] Unlike many magazine authors, she did not divide her career between literary magazines and popular media. Although well connected and supportive of her contemporary women writers and feminists, she was not usually seen as part of the group of literary women categorized as feminine writers (joryū sakka), famous for their participation in the journal Seitō or for their recognition by the literary establishment, and who published primarily in literary magazines, newspapers, and general-interest magazines.[94] Instead, Yoshiya's success was located almost entirely in the popular press, and many of her works appeared in publications for women or children.[95] One of Yoshiya's earliest works, Flower Stories (Hana monogatari, 1916–1924, 1925–1926), by most accounts created the genre of shōjo shōsetsu (girls' fiction).[96] It was in the late 1920s that she began writing for periodicals aimed at adult women rather than primarily the shōjo zasshi (girls' magazine) audience; her first serialized novel in an adult women's magazine was To the Yonder Edge of the Sky (Sora no kanata e, May 1927–April 1928), which ran in Shufu no tomo.

Yoshiya intended To the Yonder Edge of the Sky specifically for the women's periodical audience. By her own account, she wrote the story to break into the women's magazine scene and sent it unsolicited to Shufu no tomo.[97] It is worth noting that girls who had been fans of Flower Stories when it was first published would by this time have been the right age to start reading a housekeeping magazine like Shufu no tomo, and this concurrence probably contributed to Yoshiya's immediate popularity in that market.

Yoshiya's writing is often described as flowery and highly ornamental (often described in Japanese as bibun). Her purple prose makes extensive use of exclamation points, English alphabetic text, and exotic words or images, all shaped into a rhetoric of hyperbole and sentimentality. In To the Yonder Edge of the Sky, foreign place names and Christian images create an exotic atmosphere that combines with up-to-date details of Tokyo life, from fashion to recent events such as the Kantō earthquake, to build a world that is at the same time comprehensible and exciting to a wide range of readers. The novel's popularity probably owed much to its calling simultaneously upon so many of these forms of identification and desire while also remaining relatively unthreatening to readers' assumptions.

Modern Life in *The Housewife's Friend* 127

This novel, serialized from 1927 to 1928 and later published in paperback, was made into movies in 1928 and 1939, but it is no longer well known and is untranslated.[98] The story is set in the very recent past, spanning the years around the 1923 Kantō earthquake. Its main characters are three sisters from a Nagasaki Catholic family who now live with their mother in the Ichigaya neighborhood of Tokyo. Their father, a curio dealer, has died from a venereal disease contracted while entertaining his business associates in the Yoshiwara prostitution district. The schematically named Hatsuko, Nakako, and Sueko (literally, "first," "middle," and "final" child) and their mother make up an "isle of women" *(nyogo no shima)* living in an outbuilding on the compound of a wealthy, military family made up of three sons and their strict father. The oldest daughter, Hatsuko, is the responsible one, a devout Catholic schoolteacher who tries to provide for the rest of her family so that their mother, who has heart disease, need not work. The second daughter (Nakako), a white-collar office worker (referred to as a *shokugyō fujin*) working in the famous Marunouchi Building near Tokyo Station, is the immoderate sister, going to movies and eating sushi after work. She has no interest in her sister's religion, with its "unscientific" ideas like the virgin birth, and instead focuses most of her attention on newspaper department store advertisements. The youngest (Sueko) is the sympathetic innocent: born blind, probably because of her father's disease, she learns to play the violin in hopes of becoming skilled enough to play her beloved oldest sister's favorite, "Ave Maria."

The novel is split into three books: "Love" (Ren'ai hen), "Suffering" (or "The Passion") (Junanhen), and "Resurrection" (Fukkatsu hen).[99] "Love" tells of the sisters' first romances and sexual experiences. "The Passion" shows the conflicts that develop as a result, ending with Hatsuko's resolution to persevere and "hold on to love in her heart," rejecting options such as marrying a good man from work or suicide, and to travel on "to the yonder edge of the sky." "Resurrection" depicts the Kantō earthquake and then the resolutions of various difficult relationships, including Hatsuko's tragic death in the earthquake. The novel ends with a vision of Hatsuko appearing as the blind Sueko plays "Ave Maria" at her grave, a "rebirth" that solidifies the Christ / Mary image of the virtuous Hatsuko.

In the beginning of the novel, Hatsuko and the boy-next-door figure, Shigeru, begin to have romantic feelings. They read novels together, especially Tolstoy and Dostoevsky. They also read Swedish feminist Ellen Key, and he later passes his declaration of love to her hidden in the leaves of a book by South African feminist Olive Schreiner. His father, however, has plans for

Chapter 3

his son to be a successful military man and sends him off to the mountains for the summer to develop his body and to grow up; and although he prefers Hatsuko's "feminine love" to his father's love, and reading feminism to physical activity, he is forced to go off on the trip.[100] Hatsuko waits for him, patiently knitting him a sweater. When he returns, having conquered both the Japanese alps and a number of women, he has developed a more aggressive sexuality. In the chapter titled "On Manliness" (Danseiteki naru mono), he pushes her to consummate their relationship. She spurns him, saying they must wait and pursue their "pure love."[101] Shigeru is transformed from a sensitive boy to a man who is overbearing when aroused, with masculine sexuality invading the quiet, warm world of feminine connections of virtue and purity.

In the meantime, Nakako has become obsessed with buying patterned cloth that she has seen in a newspaper department store advertisement. She finds what she likes but cannot afford it. In a scene reminiscent of Zola's *Au bonheur des dames,* Nakako goes to look at the cloth in the department store on a crowded day, and while surrounded by a crowd of women, she is mistaken for a shoplifter by a rich mother and daughter. In an analysis of Zola's work, Rita Felski notes the multiple classes represented in the crowd, which is nonetheless characterized by "fluidity" and "chaos":

> Class distinctions are blurred by the women's shared instincts and passions.... Yet, if class difference is minimized in the promiscuity of the crowd, gender difference is accentuated; the nervous and isolated men squeezed among the compress of excited female bodies do not share, yet are unable to escape the feverish delirium that envelops and threatens to suffocate them. Masculinity is hemmed in and restrained from all sides by female passion.[102]

Similarly, Jinno Yuki discusses the development of conceptions of feminine consumption, department stores, and taste in Japan.[103] But here in Yoshiya, the chaos and threat of "female passion" are reined in when Nakako's desire to buy is both fulfilled and exploited. In a dramatic coincidence, she happens to run into Mutsumi, the son of her company president, described as "masculine, with a husky voice *(sabita koe),*" who discovers her crying and buys the cloth for her; he tells her to disregard those "petty bourgeoises" who have mocked her.[104] She sleeps with him in return, and he offers to set up a house near Osaka for him to visit her when he likes. She agrees because she is too embarrassed to be around her sisters and mother after having lost her virginity, although this shame, the narrator argues, is merely proof of her abiding "virginal character *(shojosei).*"[105] This lingering virtue is paralleled by her own uneasiness with her status as a kept woman:

Mutsumi took her to the prepared hideaway, dressed her up beautifully and taught her all sorts of luxuries that she had never known. But her soul was not so completely sullied that she would blend into and be satisfied by this strange new lifestyle. So she felt a gnawing uneasiness, sorrowful fear, shame, and guilty self-condemnation that sometimes cast a shadow over her beautifully made-up face and which made Mutsumi oddly anxious.[106]

These feelings of shame and nagging conscience mark her as a sympathetic character through the subsequent events.

Later, she accompanies this man on his trip to Kyushu, and when alone just happens to run into Shigeru, who, sexually rejected, is on his way to Pusan to seek his fortune. After this unlikely chance meeting, a stock device of the romance novel, he and Nakako drink together and she seduces him, not knowing of his romance with her older sister. Feeling guilty, he promises to marry her, and, touched by his kindness, she agrees. Nakako returns to Tokyo and tells her sister of her planned marriage. "The Passion" is taken up largely by Hatsuko's shock at this incident and her sacrifice of her love for the sake of her sister. She goes so far as to order Shigeru to marry her sister Nakako.

Escaping the uncomfortable situation at home, Nakako and Shigeru go to Pusan together, where she transforms herself into his frugal housewife. In the section On Womanliness (Joseiteki naru mono), femininity is defined as incarnate in the reformed Nakako. She has pawned all her fancy clothing to buy cooking utensils and suits for Shigeru to wear at work, and she tries to make ends meet through housewifely frugality very much of the type advocated by *Shufu no tomo*. But Shigeru loses sexual interest in her now that she is no longer "a beauty living a cheap and dissolute life as a man's toy." A didactic aside in the narrative tells us that men "[are] made drunk with pleasure only by the low-class plaything of a woman's white powder and lipstick rather than the beauty, devotion, and sacrifice that characterize a woman's true heart."[107] He turns to wasteful spending and drinking in the cafes of Pusan. Nakako's sympathetic position in the novel in part derives from her virtuous attempts to set up house in the style of *Shufu no tomo* guidelines. But at the same time Nakako was interesting in the first part of the novel because of the contrast with her two saintly sisters; her misguided adventurousness, her fashionable wardrobe and career, and her tragic weakness to sexual advances made for reading excitement. That her turn to domesticity has made her sexually unappealing to her husband, leading to his dissolution, forms a much darker picture of *Shufu no tomo*'s idealized single-earner nuclear family, one that readers may find less worthy of aspiration and investment.

130 Chapter 3

Eventually Nakako flees Shigeru one night, setting off with the intention of going back to Tokyo alone. This flight sends her out into the streets of the city, where she becomes lonely and disoriented. She is only there for a few hours before Shigeru comes after her, but these hours are disturbing to her. Nakako and Shigeru's household in Pusan is depicted as a protected area that is both feminine and Japanese within the space of the colony; the separation of her domestic life has left her oblivious to her impoverished surroundings. Her happiness in Pusan is at its peak when she has purchased a rice cooker and Shigeru shaves bonito flakes for her with his knife. But her wider surroundings in Pusan, never described as long as she stayed within the domestic space she and Shigeru had created, suddenly emerge into her consciousness and into the narrative for the first time when she leaves the house. She finds the colony desolate and vaguely threatening in contrast to her short-lived domestic bliss. She accepts that her problem-ridden relations with Shigeru remain imperfect like most *danjo seikatsu* (life shared between a man and a woman). But she never tries to leave again.[108]

This gives us an unusual view into a moment of a domesticity (in both the national and familial sense) imagined as at once very Japanese and ac[u]lturally rational, and projects Japanese femininity into that colonial space. Certainly this episode would have operated in complex ways among both *Shufu no tomo* readers living in Korea and those on the mainland. In either case, it presented an anxiety about whether it would be possible to set up house there, or whether to do so it is necessary—as it eventually is for Nakako and Shigeru—to return to the Japanese mainland *(naichi)*. The reader community is more troubled and troubling in this representation, as it can be disintegrated by crises in both national identity and sexual relationships. Conversely, these very everyday problems of sexual relations, frugality, and setting up house have become essential to the colonialist project: there must be a home of the *Shufu no tomo* variety away from home. The fact that Shigeru is also in contact with local Korean café waitresses while Nakako waits at home suggests the importance of the relationship between gender and cultural identity in thinking about this form of domesticity promoted in *Shufu no tomo*. That said, Yoshiya's novel does not simply reflect or espouse those ideals, but instead develops her own view of the relations between the sexes and femininity. In this fiction, for example, the characters have based their warm home on a lie and act of treachery (toward Hatsuko), suggesting a bleak vision of that possibility.

In the end, the novel sets up a not very subtle contrast between men, driven by sexual desire, unreliable, wasteful, and incapable of a pure kind of love, and women, who ideally are devoted (to their relatives, lover, God,

virginity), self-sacrificing, and frugal, albeit at times weak to temptation. Of course, this is not a didactic text but a novel that uses exaggerated contrasts and familiar conflicts to create a suspenseful story, one that is moving in both a melodramatic and sexual sense. It achieves its effects to a large extent by playing off, whether in a way that affirms or transforms, the modes of discourse and assumed values of frugality and sexual control according to which the magazine operates.

In *To the Yonder Edge of the Sky*, women's desire for material goods (Nakako's department store experiences and moviegoing) is opposed to frugality (Nakako as housewife and Hatsuko's hard work to support her sister and mother). If relations with commerce are one axis of the story, the other is sexuality, played out in terms of whether a character rebuffs or makes sexual advances. These themes of sexual and consumer restraint or liberality are closely related to the articles in *Shufu no tomo*, where the themes of frugal home finances were linked to a sort of sexual self-management. In the pages of the magazine, these literary representations of excess desire were presented not only to criticize but also, of course, to entertain.

In the chapter "First Kiss!" the scene between Hatsuko and Shigeru was so explicit that seven lines of it were censored from the magazine version. This kept the readers of the original from witnessing, for example, Shigeru using his "strong arms," "pulling himself alongside her on the floor," and "pressing his lips against Hatsuko's crimson maidenly lips."[109] Instead they would read,

> "But, but, I still have not yet really made you mine, Hatsuko—I…I…"
> xxxxxxxxxxxxxxxxxxxx, xxxxxxxxxxxxxxxxxxxxxxxxxxx—xxxxxxxxxxx.
> xxxxxxxxxxxxxxxxxx, xxxxxxxxxxxxx, xxxxxxxxxx, xxxxxxxxxxxxxxxxxxxx.
> xxxxxxx! xxxxxxxxxxxxxxxxxxxx, xxxxxxxxxxxxxxxxxxxx—xx.
> xxxxxxxxxx—it was a single kiss that would hold no value for someone impure. But it being a virgin's first kiss, Hatsuko could not help but be stirred.[110]

The surrounding description and sheer quantity of fully punctuated x's are perhaps more titillating than the removed text. The conventions of the confession articles at the time would have made filling in the blanks even easier. Hatsuko's refusals also follow standard bodice-ripper conventions before returning to emphasizing her "pure love" stance. Though it is her purity and Virgin Mary–like status that make her the heroine of this novel, it is the threats to it that would have registered the most reading excitement.

Despite, or rather because of, the narrational insistence that women are by nature self-sacrificing and frugal, there is considerable enjoyment in watching Nakako fulfill her frustrated desire to consume. Similarly, the

132 Chapter 3

demands of advertisers meant that despite its home frugality stance, *Shufu no tomo* needed to represent the pleasures of consumption. *Shufu no tomo*'s stock characters—the readers who wrote confessions about spending and saving or heroines of articles—are played out in the novel. Nakako's exaggerated character transformation explores the contradictory experiences of a housewife skimping as her husband wastes her carefully planned-out spending money and her pleasure in buying fashionable clothing. Yoshiya represents this spending in a mode very different from that found in articles and advertising. Bringing together the cautionary tone of articles with the pleasures of consuming, neither is made appealing, and the true heroine becomes Hatsuko, with her perseverance in neither marrying nor committing suicide, living a simple and single life as a schoolteacher based on her true love rather than duty to the institution of marriage.

We can have some sense of reader identification with the sisters through the reader letters that were published after each installment in *Shufu no tomo*. Of course, as discussed earlier, such letters are mediated texts, not a scientific survey, but they do give a sense of the imagined relationship between the readers and the novel. Many focus on Hatsuko as romantic lead. One writes, "please" not to let Shigeru marry Nakako, to "make Hatsuko be happy."[111] When another teacher at her school offers to marry Hatsuko after Shigeru has moved to Pusan with Nakako, a woman from Osaka writes, "Shigeru and Hatsuko's love is exactly like situations we experience. No matter what sorts of defamation you face, please don't be weak like us [i.e., marry unhappily] but live out your true love forever."[112] Of course, Hatsuko does not fulfill the expected role of heroine who marries her love, suffers tragically, or commits suicide—the options most commonly expected in this genre. The main character's eternal virgin status puts a new spin on these expectations. Other types of identification depend more on her independent attitude or her devotion to her sisters. One reader writes, "What beautiful writing about sisterly love this is. Kind to her little sister at home but strong when going out into the world—this is a model for us women."[113] In the same issue a woman from Hokkaido writes of an almost identical set of experiences, with a sister of similar personality to Nakako and a loved one "far away in South America."[114]

Yoshiya herself was aware of her fans and of how her image was developing in magazine culture. Her posed pictures, while possibly accurate depictions of her everyday lifestyle, reveal her willingness to show openly her Western-style house, her modern clothing, and her hairstyle choices to her audience. Like many of the elite intellectuals such as educators and doctors publishing in *Shufu no tomo*, she allowed pictures to be taken of her living and

Modern Life in *The Housewife's Friend* 133

work spaces. The difference was that this lifestyle did not at all match that proposed for women by the magazine's articles: Yoshiya was an unmarried adult woman whose life partner was another woman (Monma Chiyo).[115] As the letters show, many of her fans saw her as a sympathetic friend, although one entirely unlike the ideal housewife friend represented by the magazine to which she was formally attached.

Many other letters focus on Yoshiya herself, often projecting reader expectations on her. Some of them imagine her to be holding strong against male discrimination. One reader writes that she has always imagined Yoshiya in a "cement office building" "working, a woman alone among oppressive men."[116] Another mimics Yoshiya's own penchant for the exclamation point: "Oh, waiting for the April issue! Nobuko-sensei! Nobuko-sensei! Long live *(banzai) Shufu no tomo*! Long live Nobuko-sensei!" Interestingly, the letter writer uses Yoshiya's given name as a form of intimacy together with "sensei" to represent her deferential distance.[117] It is clear that even this early in her career, her persona and writing style are well known. One letter asks, "Do you, as I hear, live in a 'cultured house' in Ochiai?"—a clear demonstration of the fan's familiarity with Yoshiya's personal life.[118] Others suggest a crushlike and even erotic attraction for the author: "Miss K" from Tokyo writes, "I love Yoshiya's *To the Yonder Edge of the Sky* so much I can't stand it. Perhaps it is because Sensei's pure beautiful spirit is thrown into it, and so when I read the work I feel like she is right in front of me, kindly comforting me. 'Yoshiya'—just seeing the name makes my heart race."[119]

Critics and fans have read Yoshiya as a writer of lesbian fiction and as having feminist possibilities, and those final letters open the question of whether there is room for those readings in this story itself.[120] Obvious readings of same-sex desire are difficult to find among the characters since almost all characters of the same sex are siblings. Hatsuko's and Nakako's triangular relationship with Shigeru leads to an intense emotional situation between the two sisters, and the connections between the women occur on this hyperbolic and also nonphysical level. Female sexuality is at its ideal when lacking, with the eternal virgin presented as heroine. At the same time the experience of reading the more sexually charged scenes and erotic identification with the Mary figure herself likely had complicated implications. Crushlike relationships between women living together in dorms or students and teachers were common themes both in Yoshiya's earlier book for young girls, *Hana monogatari*, and in the general media at this time.[121] From the reader letters it seems that the most obvious mode of female-to-female desire (though many sorts are potentially here) is that by the readers for Hatsuko or the readers for Yoshiya herself.

Chapter 3

Although Yoshiya's text leaves unquestioned the idea that feminine sexuality is most natural when it is "pure, clean love," she reworks other formulae of heterosexual romances. Hatsuko rejects the two most common resolutions. First, she refuses the proposition to marry another teacher from her school even though he is religious and responsible. The go-between's argument that men and women are "meant by God to marry" is questioned: Hatsuko points out that, like her sister's blindness, not all things that exist or are practiced are necessarily good. Second, she refuses to mourn for literary figure "A-shi" after his double suicide (clearly a reference to Arishima Takeo's and Hatano Akiko's double suicide discussed in the previous chapter). She rejects suicide as a solution and insists that she will live "beyond romantic love" and its loss by taking care of her blind sister. The heroine in this text thus protects her virtue not to save herself for some future "true love" but rather to preserve her own "pure" sexuality and her intimacy with other women.

These references to and rejections of the typical romance and marriage plots were no doubt among the reasons for Yoshiya's instant popularity among many of *Shufu no tomo*'s typical middle-class readers, allowing and constructing the possibility of life without marriage or participation in public institutions. The novel also presents the possibility for women to participate in public life in a way that did not threaten cultural images of femininity (something that remains an issue in contemporary feminism in Japan and elsewhere) or devotion to love and family. With obvious connections to be made with feminists' wartime roles in state enterprise, Hatsuko is described as a "public servant" who, devoted to the service of education, has given up her sexuality. This role prefigures both feminist activities in wartime Japan, where feminist organizations were often retooled as patriotic women's associations, and Yoshiya's own role as a PEN writer and collaborative reporter on the colonies.[122] Because *To the Yonder Edge of the Sky* questions the inevitability of marriage and explores female self-sufficiency without questioning imagined female or familial bonds, it was probably less threatening than the examples set by women who were seen as more radical feminists. Figures such as Itō Noe, whose free-love relationship with anarchist Ōsugi Sakae was upsetting to popular family values, were less palatable than a model such as Hatsuko, whose modes of independence seemed grounded in more accepted views of feminine sexual virtue.

An obvious question would be whether Yoshiya's fiction is subversive in any sense. Like other writers of formulaic mass-market fiction, Yoshiya demarcates sharp sex differences between characters and the gendered personalities, sexualities, and moralities associated with them, and she uses these to create the conflicts and resolutions that drive plot. Expectations based on

Modern Life in *The Housewife's Friend* 135

such types become all-important, particularly in serialized formats where successful publications usually play off gendered roles to build anticipation or surprise. These categories appeal to expectations about women's experiences, even if they may break them for entertainment or shock purposes.

At the same time, readers identify in complex ways and across genders. This may have been particularly true in the case of Yoshiya Nobuko. On the one hand her plots often revolve around heterosexual scenarios and emphasize clear definitions of femininity and masculinity. On the other, Yoshiya's own unfeminine appearance—she often wore androgynous clothing in magazine photo sessions—and the fact that she lived and traveled with another woman were already fairly well known. Through her own nonfiction essay submissions and public appearances, she carefully crafted a vaguely transgressive persona. This stance no doubt encouraged other forms of reader and fan identification, forms that do not neatly fit the models of womanhood we have seen *Shufu no tomo*'s texts and management otherwise idealizing and that also complicate Aono's vision of women's literary desires.

In the end, Yoshiya's writing presents messages consistent with the magazine's. Furthermore, irrespective of the content of her fiction or her magazine image, the publishing format presented her stories as simply entertaining breaks from quotidian chores. The letters might be read at many levels, but they were part of the creation of an imagined community of readers, a community that the magazine helped to produce, primarily to sell more magazines. Of course, we must not assume that all readers accepted all these messages, or that they were completely fooled by this artifice. The pleasure in imagining connections or similarities to strangers, even knowing quite well they are distant, should not be discounted. Melodramatic accounts provide reading pleasure at least partly because they are unrealistic and extreme, inviting readers to extend beyond their material limits to imagine something else. In this sense, Yoshiya's fiction must have created a real excitement for many of her readers. Her over-the-top texts could well have been read as ironic by savvy readers, and may even have been intended that way. The fan letters are only one of the many suggestions that readers and fans were neither all housewives nor necessarily accepting of the values promoted in the magazine. To suggest that readers were entirely passive or that certain readings were foreclosed by the form or content would be to ignore many of the useful lessons of both feminism and cultural studies.

At the same time, we should not discount the extent to which the format and the socioeconomic circumstances under which the novel was read limited its possibilities. Readers also must have experienced very real limits in their ability to act on excitement they felt while reading such works of

136 Chapter 3

fiction. Hatsuko is able to spurn the second marriage offer she receives (and thus retain her virginal honor) by being a schoolteacher, but this route would not have been open to most readers. It would have been both socially and economically difficult to live on an "isle of women," given both the low wages for women and the dominant ideologies about marriage. And, as I have argued, the working of the magazine itself did not actively encourage women to behave unconventionally outside fictional worlds, even if it provided some texts that enabled such a possibility. As we have seen, the repetition of quotidian rituals as the content of women's lives by the texts of *Shufu no tomo* suggested that the consumption of literature was only temporary. The insistence that entertainment was, by definition, neither debate nor logic suggested that when the entertaining novel was finished, the reader should come back to an ineluctable reality. It also claimed that the various readerships—schoolgirl, office worker, factory worker—should or simply would eventually grow up and become a part of the community of housewives. The message left was that, after giving up their jobs or putting down the novel, women should begin, or return to, the true *seikatsu* that the editor claimed only a housewife really has.

Conclusion

Shufu no tomo brought together a variety of texts to target a broad range of lifestyles and market groups. This strategic and studied variety allowed for a broad readership that might be consistent with the possibility for multiple forms of identity and an opening up to possible new definitions of womanhood to match that variety. But the fact that this range of choices for women was combined so successfully with directed marketing at specific (if multiple) "ideal" women and a certain way of living as the ideal middle-class housewife ultimately tended to limit the range of possibilities that it presented to readers; we cannot so easily view this proliferation of multiple feminine ideals as a positive aspect of modernity, but also must see in it a set of choices not always available or helpful to readers who were moved by the magazine to seek them.

4 | Women's Arts/Women's Masses

Negotiating Literature and Politics in *Women's Arts*

The covers of *Nyonin geijutsu* (Women's arts) tell a dramatic story. Over the course of only five years, images of flowers, girls, and dolls give way to spare red, white, and black graphics suggestive of a modernist, radical culture, and then again to the yellow and red of communism that adorned photographs of laborers worldwide. Lastly come a changed name and a drab newsprint broadside publication. I was inspired to embark on this project based on my first encounter with the sensory impact of these covers and my resulting curiosity about the artistic and political energies and historical forces that led to these rapid and drastic editorial choices. The covers articulate in a material and aesthetic way the tensions between gender and class identities and between politics and art that took place.

From 1928 to 1932, a group of Japanese women issued *Nyonin geijutsu* under the direction of playwright Hasegawa Shigure, funded by her husband's serialized fiction. As the title suggests, the publication featured art and literature by women. This short-lived and seemingly obscure publication launched the careers of many of twentieth-century Japan's most important women writers, including Hayashi Fumiko, Sata Ineko, and Enchi Fumiko, and it is for this that it is now best known. Women translators also introduced works by authors from Edgar Allan Poe to Alexandra Kollontai.[1] At the same time, the magazine developed into a major forum for leftist feminists who saw it as a potential way to reach out to women workers through proletarian fiction and practical information or to debate issues such as the role of art in revolution. Both readers and contributors often perceived these goals as in conflict, even as some felt they could be complementary efforts. Throughout its four and a half years of publication, critical essays, roundtable discussions, and letters from readers debated the magazine's diverse internal goals, and one can

observe on its pages a series of ongoing discussions of relationships between art and politics, gender and class, theory and practice.

These discussions did not, of course, arise in a vacuum. They are very much of the early Showa period (the late 1920s and early 1930s), when both the literary and working worlds were busy with politics, proletarian culture, strikes, and revolution. Many scholars who mention this journal in passing refer to its more political fiction as reflecting the "mood of the times" and the trendiness of the proletarian literature movement as somehow overtaking its artistic goals. But this position diverts attention from the vibrancy and importance of the magazine's efforts as well as the important connections between politics and 1930s modernism more generally, connections that are often ignored. Any look through the collected works of writers active at this time reveals that no part of the Japanese literary community was untouched by the proletarian literature movement, and most writers felt a need to address the question of politics and art, whatever stance they might take on the question.[2] The pressures of the looming conflict in China and increasing state oppression lent intensity to these concerns. *Nyonin geijutsu* emerged from this moment, and it is no surprise that its contributors engaged with these intellectual trends.

There is at the same time, however, another set of questions about media that intertwines with and informs the contributors' aesthetic and political concerns. A general savvy about publishing and representation marked the efforts of these women, who were after all creating a medium for their own work.[3] The previous chapters of this book have treated with some criticism the commercial women's magazines of the 1920s and some aspects of mass culture more generally. The women who ran *Nyonin geijutsu*, who formed the Women's Arts League (Nyonin geijutsu dōmei), were responding to a similar dissatisfaction with such publications, in which most of them had published work. While aware of financial limitations, the people working on *Nyonin geijutsu* talked about it as an alternative, for both contributors and readers, to such highly profitable women's magazines as *Shufu no tomo*. They often tried to distance and distinguish their writings from the type of materials about delinquent girls and marriage problems found in that magazine. They believed they could improve upon the way writings were organized and chosen by the mass-market publications, both because they did not seek such high profit and because they were women, although of course these factors often came to be in tension. Meanwhile, as the magazine increasingly pursued women workers and sought to raise political consciousness, the writers, like many members of the proletarian literature movement, considered the

question of audience, including their own abilities to appeal to readers of the same publications from which they had sought to distance themselves.

Perhaps less obviously, the writings exude a fascination with transformations in human sensation in a world both rich with new media (including mass-market magazines, talkies, popular music, and radio) and new lifestyles in urban housing, cafés, or factories. It is often through these interests in representation and physical experience that the debates about or creative engagement with feminism, Marxism, and aesthetics were articulated, and this concern links the seemingly disparate texts that range from playful to didactic.

As we look back on *Nyonin geijutsu* today, many of the arguments about aesthetics and politics or the problematic relationship between mass culture and politics seem naïve, resting too strongly on binaries that might now be rejected. The moments when contributors fully embrace Stalinism or the idea that Japanese-occupied Manchuria could be a utopian place can be painful to read in retrospect. And many of the stories and poems chock-full of jargon are not to some people's taste today. At the same time, some of these criticisms cannot be directed so lightly. The people involved in this project took seriously the significance of providing an alternative to highly profitable magazines while being savvy about the difficulty in doing so in a way that was not so naïve after all. They aimed to have greater political and artistic effect by constructing a politically active popular audience, seeking in a sense both to criticize commercial mass culture's products for and about women and to produce popular culture by and for women, in the sense of culture of and for the good of "the people." The creators aimed to produce writing that was both political and artful, which many of them never imagined to be mutually exclusive. The most important scholar of *Nyonin geijutsu*, Ogata Akiko, said to me that after working on this magazine for so long she ultimately felt that "isms and literature don't mix," but I am unsatisfied with that answer to the issues *Nyonin geijutsu* raises.[4] It has been my contention throughout this study that the material functioning of a magazine is relevant to understanding its effects, and it is here that we can examine whether the degree of financial independence or the political consciousness of this magazine may have produced a different reading experience for its audiences, whether it inspired them to political activity, to personal insight, or even to awe. As we consider its texts in detail, it is worth invoking the magazine's own questions of whether one could really speak to all women across class and education levels and whether artistic value, fuzzy concept though that is, could survive or even flourish in the face of such passion for these other goals.

Hayashi Fumiko's *Hōrōki*
and *Nyonin geijutsu*

By far the most famous work of fiction ever published in *Nyonin geijutsu* was Hayashi's *Diary of a Vagabond*, and before beginning an analysis of the magazine I should mention this legacy.[5] The novel's textual history, the author's statements about its publication, and its critical reception all reveal a troubled and complex relationship with *Nyonin geijutsu*. The author herself later eschewed its origins in *Nyonin geijutsu*, and a common narrative of this publication history (based on Hayashi's own) has her pulling it from the journal because of the journal's increasingly political leanings. Ogata and others note that it is "ironic" that this problem work ended up being the magazine's greatest legacy, with the implication that it was Hayashi's lack of interest in the magazine's politics that allowed her to create a great work of fiction.[6] In fact, most of the original first volume was published in *Nyonin geijutsu* and in many senses blended in with its surroundings.

This work has been analyzed thoroughly in recent work by Seiji Lippit, William O. Gardner, Joan Ericson, and Susanna Fessler, and is skillfully translated by Ericson; although I will return to this text later in the chapter, I will not duplicate their efforts.[7] My aim is rather to suggest through analysis of other works of fiction and criticism in the magazine the ways in which this text looks different and makes sense in new ways when considered in the context of its first publication. Especially as new criticism, particularly by Gardner and Lippit, places Hayashi's novel as a key text of Japanese literary modernism and uses it to demonstrate the importance of mass culture to that movement, it is worth considering how the novel's place in *Nyonin geijutsu* helps us to think about these broader areas of Japanese literary history. I will return briefly to the case of Hayashi after providing a better sense of this publication.

"I Don't Need No Diamond Ring":
The Founding of *Nyonin geijutsu*
and Sources of Print Capital

Even as a seemingly radical enterprise, the journal was not free of the concerns of commercial publishers, and the Women's Arts League sought some degree of independence in a way that was not entirely romantic. League members knew that they needed to negotiate and strategize in the face of financial limitations and government pressures of censorship. Its founding,

Literature and Politics in *Women's Arts* 141

like *Seitō*'s nearly two decades earlier, was based on the general idea of a magazine written and edited by women only. However, even a cursory look at the magazine suggests how much had changed.[8] The idea of women writing for their own magazines was no longer shocking, and these women (some of them in fact members of Seitōsha, which published *Seitō*) were now seasoned journalists, fiction writers, and publishers of independent magazines.[9] They were self-conscious about how to both represent and comment upon what one of them called the "lifestyle feeling" *(seikatsu kanjō)* of the times and had sophisticated ideas about what visual layouts and combinations of journalism, fiction, and political argument were best suited to this project.[10]

In its funding, *Nyonin geijutsu* was explicitly tied to the commercial press. Hasegawa Shigure's husband, Mikami Otokichi, was a popular serial fiction writer who benefited greatly from the *enpon* boom and the growth of magazine readership in the 1920s. As the royalties poured in, he offered to buy Hasegawa a diamond ring. She reportedly responded that she had no use for one and would prefer that he give her 20,000 yen to start a magazine for women writers and artists.[11] He agreed, and so this magazine was then funded by the success of popular serialized fiction such as Mikami's *Hiaburi*, a novel about the romantic adventures of a woman office worker that was originally printed in *Shufu no tomo*. The film version of that same novel was advertised in *Nyonin geijutsu* and benefited its enterprise. Hasegawa and other women helping with the project held their meetings and did copyediting in the upstairs room in Mikami and Hasegawa's house, and in this way too they relied on the two writers' previous successes in publishing and theater.[12] Sugawa Kinuko, who acted as editor for the first several issues, came from the major publisher Shinchōsha, where she had worked on the literary journal *Bunshō kurabu* (Composition club) and came to *Nyonin geijutsu* because it was a "magazine run by women." Author Ikuta Hanayo also came to do publicity based on her good connections with other women writers.[13]

Hasegawa and the women she recruited were not particularly interested in creating another of the independent literary journals (so-called *dōjin zasshi*) that were so common in the literary establishment at the time and that certainly would have allowed for full control over the content and almost complete disregard of the censors. Whether they wanted to showcase the artistic talent of women or cause a revolution, all the writers seemed to want to touch an audience broader than the usual readership for a literary magazine; instead they sought a magazine that would be sold at general bookstores and newsstands but remain under more personal control than large-scale publications. The previous chapters discussed the fact that male writers of the

Chapter 4

literary establishment sometimes wrote serialized fiction for popular women's magazines; for respected literary magazines they wrote confessional works, which they thought more important. *Nyonin geijutsu* differs from this type of highbrow alternative to the opportunities commercial magazines provided for women writers. Instead, the editors sought to make explicit the financial relationships of print culture fiction through their comments on other magazines, their roundtables, and their editorial notes. In other words, they sought to maintain a reflexive tension with mass culture and discussion of the magazine's relationship to consumer culture.

Even the promotion of the magazine reflected this tension and self-awareness. Women such as Hayashi Fumiko (who was still working as a café waitress at the time) handed out leaflets in the busy area of Shinjuku while wearing thick makeup and fashionable clothing.[14] These types of techniques were criticized in the magazine itself by members and readers, but Hasegawa regarded them as useful activities that recognized the images of women already in the public and made strategic use of them. She and some of her cohorts felt that certain texts and activities had the potential to transform and expand the ways women were viewed; they felt that they should recognize that working urban women would be interested in both fashion ads and pieces about the women's labor movement because they lived in both of those worlds.

At the same time as the women adopted practices from mass-market magazines, they also engaged in constant criticism and analysis of journalism. The first issue alone makes direct references to magazines ranging from the "Women's Edition" of *Worker and Farmer (Rōnō)*, to articles on China in the U.S. magazine *The Nation*, to major Japanese women's magazines. A piece notes that important intellectuals are criticizing most women's magazines and summarizes some reports on the subject from general-interest magazines such as *Chūō kōron* and *Kaizō*. The author comments on the "policy of aggressive selling, which has now reached absurd heights" and gives statistics on what she views as an excess of articles on sexual topics and advertisements about sexual diseases.[15]

A more substantial feature article marks the downfall of the magazine *Josei*, which had emphasized cosmopolitanism and cultivation *(shūyō)*.[16] Rather than taking the expected position of reporting the event as one related to women, the commentator Ōki discusses the larger issue of neutralism *(mushugi)* in journalism, in particular its connection with the women's movement. She criticizes *Josei* for failing to develop a guiding logic *(shidō riron)* beyond its highbrow *(haikara)* and literary *(bungakuteki)* character.

Although "such guiding logic is much despised in the world of journalism," she writes, the ideal of neutralism is driven by the marketing forces of "capitalist journalism that want to have as many readers as possible."[17] This "vacillation-ism" *(hiyorimishugi)* means that readers can "enjoy low-level reactionary magazines alongside magazines with socialist leanings" without noticing any contradictions and is "a sign of the perverse development of Japanese capitalism."[18] Just having a magazine named *Woman* with good literature but "lacking any concern for the position of Japanese women themselves" was a mistake, she argued, and ultimately the magazine folded despite the great fiction published there precisely because it did not take a strong position on issues such as the women's suffrage movement through which it could have "gained the support of progressive and enterprising women."[19] Her points, which remain appropriate to twenty-first-century journalism, are just a taste of the sort of sophisticated criticism of journalism and gender found in the nonfiction articles in this magazine.

"Autobiographical Love Fiction" Issue

This same degree of criticism came to be leveled by participants toward *Nyonin geijutsu* itself, especially surrounding the March 1929 "Autobiographical Love Fiction" issue (Jidenteki ren'ai shōsetsu gō). This volume contained more than twenty short stories with erotic or romantic subjects, poetry, and essays by most of the major *Nyonin geijutsu* contributors including Hayashi Fumiko, Sata Ineko, Nakamoto Takako, and Takamure Itsue. Hasegawa's Editor's Postscript declared her goal in molding the issue:

> The spring streets are adorned with the pink of cherry blossoms
> and green grass. Much of the love that has been taken up by women
> writers is similarly cute, all light peaches and grassy greens....But this
> "Autobiographical Love Fiction" issue is not all playing at the doll
> festival, but tries to show a more authentic view of women....This is
> not the usual sort of decorative trick. It is the honest crying out of minds
> from which veils have been lifted.[20]

The importance and quality of the fiction in this issue is attested to in part by the fact that even though little pre–World War II fiction by Japanese women has been translated, two of those stories have been translated into English. Nakamoto Takako's "The Female Bell-Cricket" (Suzumushi no mesu) is found in Yukiko Tanaka's *To Live and to Write* anthology, and

Chapter 4

Ozaki Midori's "Osmanthus" has been translated by Miriam Silverberg for *Manoa*.[21] From its cover—a depiction of Leda and the swan (figure 18)—to the attention-grabbing title, it was also one of the most controversial and best-selling issues. Accused of being a publicity stunt and using exploitative and erotic packaging of the personae of women writers, it was commented on by major newspapers and in subsequent issues of *Nyonin geijutsu* itself. Meanwhile, Hasegawa's own statements suggest that she saw it as an opportunity for women writers to express a more honest, and also less benign, view of sexuality and romance than could be found in writing about love elsewhere. The stories analyzed in the following section were found in the "Autobiographical Love Fiction" issue and are representative of early *Nyonin geijutsu* fiction. Although varied, they express similar concerns with sexual desire, truth, and media representation. After analysis of the stories, I will turn to some of the debates the special issue produced.

Matsui Teiko's "Riddle of the Dolmen"

The most unabashed descriptions of sexual desire in the special issue are found in "The Riddle of the Dolmen" (Dorumen no nazo), a story by the young author Matsui Teiko.[22] In this somewhat confusing story, the narrator, Ms. S (S-ko),[23] describes her sexual feelings over the course of her life during her days as a cashier at a rice shop, a brief marriage, and then her experience as the lover of a proletarian writer. The story certainly fits Hasegawa's goal of avoiding adornment with its matter-of-fact descriptions of sexual activity, dull work, and illness.

S-ko describes her "special method for pleasure," which she had developed before her marriage but in which she continues to indulge:

> I would wait for my husband to go out on an errand and leave me home alone. Then I would call to mind the faces of writers whom I like and enjoy xxx. xxxxx. My husband and I were together for four months, but it was just me watching his pleasure, while not even once was I able to achieve xxx, so I ran away.[24]

Such direct description of autoeroticism and orgasm not surprisingly invited controversy and these self-censorial *x*'s. Given the types of censorship practices at the time, it is likely that this blank type *(fuseji)* was placed by the author or *Nyonin geijutsu* editors to avert postpublication censures, which could forbid distribution of a periodical and cause a total loss on printing costs. Of course,

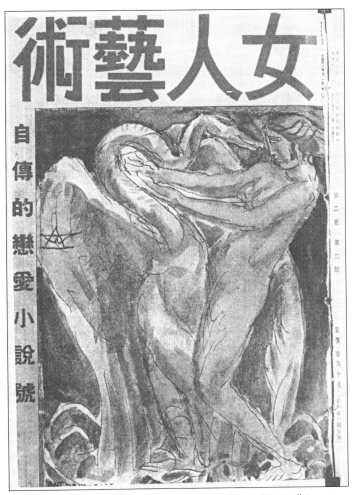

Figure 18. Cover of the "Autobiographical Love Fiction" issue. Artist not attributed. *Nyonin geijutsu*, March 1929. (Courtesy of Waseda University.)

by placing these marks cleverly, writers could communicate what would be considered "immoral content" or "dangerous thought" without using certain controversial words.[25] In an even cleverer case, a *Nyonin geijutsu* poet avoids the frequently censored red flag *(akai hata)* of communism by writing a *senryū* (a seventeen-syllable traditional poetic form that is often satirical): "Suppression that lurks behind blank type on newsprint / A flag dyed the same

146 Chapter 4

color as the human heart."[26] Until 1939, galleys were rarely examined; censorship was implemented by forbidding the sale of an issue. Writers and editors could largely avoid such censure, which sought out certain words and topics, by replacing certain political and sexual words with *fuseji* (*x*'s, *o*'s, and commas); it was hard for censors to defend censoring nonwords, and postpublication reading did not allow for the kind of close examination of the contexts of those *fuseji* that would determine their implied meanings. In the end, careful placement of *fuseji* could in fact draw more attention to the passages, and as each mark could replace one character, it was often easy to figure out for what each stood. Postcensorship filling in of the blanks by writers or editors for the purpose of later anthologies does not really recover the original, especially in the case of self-censorship. As Heather Bowen-Struyk has argued, the literary critic should view these blanks as part of the fictional work rather than seeking a "pristine, pure text" existing "prior to self-censorship."[27]

This story goes beyond this shock value to reflect on the relationship between concepts of feminine beauty and class. Just as anarchist Takamure Itsue (who also published a story in this issue) argued that conceptions of female beauty were based on upper-class and urban values (see chapter 2), the narrator of the story comments that she is "too poor to pursue ideal love."[28] S-ko recalls that early in her life "with face powder, kimono, and a little bit of cultivation [she] worked in vain to attract men, and in the process became a little more beautiful."[29] This echoes Takamure's "Theory of Feminine Beauty" (Bijinron), where she argues that the atmosphere of "urban capitalism" is characterized by "makeup and kimono competitions," which can be pursued only by those with leisure time and money.[30] In each relationship S-ko has, her conception of beauty develops. In her affair with a working-class man named Isamitsu, who was the "essence of male beauty" and "just like Charles Rogers,"[31] with "a splendid body and black belt in Judo," she is disappointed by his "ignorance" as exhibited in his treatment of women: "There was one quality that precluded him from being the one I love. It is that he is ugly. And that is because he is ignorant.... Because of his ignorance Isamitsu was convinced that as long as a woman was beautiful, he could xxx without limitations."[32] His abnormal *(abnōmaru)* view of women is confirmed when he enjoys how beautiful she has become after being severely ill.[33]

The final relationship, with the proletarian writer, is based in part on her own enlightenment through reading Marx while working in the rice shop. Now her conception of beauty is based on economic relations; as she comments, "The great capitalists, the bourgeoisie, and the dissipated will make themselves ugly with money."[34] But although the proletarian fiction

writer (Mr. H) seems to be the perfect partner for this newly politically conscious young woman, he too is unable to see her as an equal because of her sex. He insults her lovemaking style (if this is what is meant by "xx-ing") and tells her to consult a gynecologist before she marries someone. He notes that after their sexual relationship began she was "transformed" and now has a "very feminine sort of beauty." "Mr. H seemed elated and pleased with himself, but I was such a fool."[35] This awkward but devastating ending suggests that even with the knowledge of political theory that this proletarian writer might be expected to have, he could still humiliate women in the movement around him; his "ugliness," embodied in a final smirk at S-ko, comes not from lack of education or political consciousness but from a form of sexism.

Although the stir this story created had much to do with its shock value, it did suggest that a story about explicit sexual experience could engage with the relationships between feminism and Marxism so hotly debated in the late 1920s. What is difficult to assess is the question of this story's quality as literature. Of the many works and writers published here, Matsui is one who never became a major player in the literary world, and somehow that is not surprising to most readers of this story. The reasons for the sense that it is not "artful" are intangible, although they may have to do with its lack of subtlety and rare use of metaphor or imagery. This is one example of the value in analyzing *Nyonin geijutsu* fiction in the context of its publication, where its significance comes in part from its surroundings and its settings in a strongly political and feminist journal and by the 1930s in a tumultuous Japanese society on the verge of war. The story's avoidance of what Hasegawa called "adornment" meant that it fulfilled many of the ideals espoused by the most radical of the proletarian fiction theorists writing here and forces one to deal with the implications of their theories of art. It is unsatisfying to conclude immediately that they were wrong about the possibilities for powerful writing that is not focused on aesthetic qualities. It would also be a mistake to say that its impact derives only from being somehow sexually liberated for its times or from some notional sociological significance. The shock it elicits is partly due to formal literary qualities—Matsui's (or her editor's) use of *x*'s: the directness and almost didactic use of logic; its depiction of objects and body parts absent from the fiction of more ladylike women writers. It also comes from the contrast with those who would not or could not write something so personal as "autobiography" for fear of reprisals from family or the public. The visceral force that the story holds is real even now and even to those who might not choose it as a favorite work of literature.

148 Chapter 4

Kubokawa (Sata) Ineko's "Self-Introduction"

The ending of "Self-Introduction" (Jikoshōkai), the contribution by Kubokawa Ineko (who would become Sata Ineko) to the "Autobiographical Love Fiction" issue, presented a feminist criticism of proletarian activists.[36] Most of the story is taken up with the self-introduction of the narrator, Mineko, to members of a political group who are campaigning for a Communist candidate for district representative. She tells of her experiences working as a factory girl at thirteen, later as a maid, as a waitress in a restaurant, and then as a salesclerk in a bookstore. She mentions in passing that she has recently begun to think about "social issues" after reading the "same books as Shimoda." Another man there asks, "Now Mineko, you have told us many of your experiences in your self-introduction....But what I want to hear more about is how you, wily old Mineko, were able to get Mr. Shimoda."[37] Apparently Mineko is having a relationship with another campaigner named Shimoda, and this is known by the questioner, E-san. She realizes then that her life experiences are being reduced to her relationship with this man.

> "Wily." The description sounded so whorish. Did E see my relationship
> that way? The thought made me a bit gloomy. No doubt this was
> another sign of my petty bourgeois disposition, so I tried to brush
> aside the feeling. Still, if I could have added just one more thing to
> my self-introduction it would be this: I have been through all sorts of
> experiences in my life, but I have never been part of a male-female
> relationship, never part of a romance before Shimoda—I wish I could
> just have added that....If life experience is what helps us predict the
> sorts of problems that emerge from male-female relationships, my own
> was still lacking.[38]

The story also criticizes the activist E-san who, when listening to a woman activist, focuses on gossip about romance rather than her experiences of labor and poverty. Thus even this story in the "love" issue is critical of the obsession with the romantic ties of women activists.

This story also brings us to the question of packaging fiction, particularly as autobiography. Many elements of the character Mineko's life as described in her self-introduction match Ineko's own experience: working in a candy factory, moving to Tokyo with her father, and almost becoming a geisha so her grandmother would not have to work. It is unclear who Shimoda would

Literature and Politics in *Women's Arts* 149

be, and this is where the autobiographical model breaks down. Shimoda's status as a well-known activist suggests that he may be Kubokawa Tsurujirō, a proletarian poet and critic in Nakano Shigeharu's circle and Ineko's husband at the time she wrote this.[39] It is also said that she was criticized by some Party members for her *Caramel Factory* (1928) because it was too weak in its social criticism, and perhaps that is reflected in her story. But Mineko says she has never been involved with another man, while Ineko had by that time been married to another man already. So while this story contained enough of Ineko's autobiography to be suggestive, it refused to satisfy the prurient interests of audiences who, like Mr. E, were blind to any story besides confession.

This story was noted by people such as the author Hirabayashi Taiko as an example of one that did not need to be packaged with such a sensationalist magazine title in order to be interesting.[40] More important, the story itself complicated the meaning of how a "true" story might be read. Sata (Kubokawa) questions why the experiences of a young woman seem to be reduced to her romantic experiences and why even the most seemingly politically conscious audiences tend to follow the lead of Mr. E in fetishizing the gossip surrounding the personae of women activists. By casting light on the ways interpretations of life experiences were gendered, she criticizes this blind side of many Marxist movements even as she supports their broader goals and turns on its head the packaging of fiction by women to encourage gossip. More broadly, her story cleverly parodies the obsession we have seen in all of these magazines with the lives of women journalists and writers, such as Hatano Akiko and her suicide with Arishima Takeo.

Sata's later work *Scarlet (Kurenai)*, serialized in *Fujin kōron* in 1936, suggests that Sata chose not to hide from that packaging but to face it directly. The implied references to her own marriage in this novel, whose protagonists are a proletarian woman writer and her husband, were clear. *Kurenai* explores the conflicts that arise among daily household life, love, and activism, and reflects throughout on the effect of public opinion on such a marriage. In the final scene, the wife feels the pressure of the public *(seken)* that knows of their relationship through writings and gossip: "Ah, we will be swept away, Akiko thought as she felt the waves of society crashing into the gap between the two of them."[41] Sata in *Kurenai* continued to confront head-on these difficulties facing the woman writer and activist through her nuanced examination of the emotional and political experiences of both writing and marriage. "Self-Introduction" remains as an earlier exploration of the nature of female self-representation in literature and its political implications.

150 *Chapter 4*

Nakamoto Takako's
"The Female Bell-Cricket"

The most critically acclaimed story published in this issue was Nakamoto Takako's "The Female Bell-Cricket" (Suzumushi no mesu).[42] Renowned author Satō Haruo wrote on March 27 in the *Asahi Newspaper* that although he had first purchased the magazine issue "dutifully because of a promise he had made to Hasegawa Shigure to read it," he was extremely impressed by this first story by Nakamoto Takako for its terrifying description of "a woman's cruelty" achieved through "the cumulative effect of Chinese character compounds" in her prose that "create a mysteriously grotesque flavor."[43] Indeed, this is a haunting and more vivid work than either Sata's or Matsui's, and it is questionable whether packaging it as autobiographical added to its power.

The main character, Tomoko, begins the story riding home on a train excited and "breathless" amidst the many men packed into the car; but she "scolded herself for being helplessly attracted to men, even after Akita, her common-law husband, had betrayed and left her." She is returning from a final encounter with this Akita, who will soon marry another woman. She goes to the house, "shabby as a small paper box," where she lives with a doting struggling author named Miki. This man is willing to spend the entirety of his scant earnings from writing stories and trite poetry to "decorate stationery, intended to move the peach-colored hearts of naïve teenage girls," to feed Tomoko,[44] and when that is not enough, he sells his belongings:

> He had only a few books left; his violin had been exchanged long
> ago for rice and charcoal. His cloak had flown away like a butterfly,
> transformed into a piece of steak, into hot chicken with rice, into
> colorful salads. . . . The money earned was quickly changed into meat and
> vegetables; the only trace of his labors was the faint smell of fat at the
> bottom of a cooking pan.[45]

As she fattens up on these steaks and cutlets, he becomes increasingly pale and sickly. Feeling disgust at her own dependency on him and her attraction for other men, she reflects on her relationship with him:

> Tomoko felt dried up, like a scab on an old wound. She had no desire
> to work; respectable jobs all seemed absurd, and any effort of a
> philosophical nature she considered useless. (Look at the way people
> live in this big city, she thought: they flourish like cryptogamous plants;
> they conceal strange bacteria as they live day to day.) She spent her days

observing the man gasping beside her, indifferent to what she saw; she could have been watching a plastic doll. Sometimes she stared at his fine Roman nose, thinking that she would some day kill this man and eat him, just as the female bell-cricket devours her mate.[46]

In the ending, he coughs up a clot of blood, no doubt having developed tuberculosis as she was devouring steaks; she sits coolly by, smoking a cigarette.

Although the story is sexually graphic, with references to men's and women's body parts, semen, pubic hair, and the main character's sexual aggressiveness (some of which are only implied, replaced by x's), the erotic is always framed by the "intimidating" concrete city, which she blames for "altering and engulfing" her lover's personality—the smell of "sour alcohol" on the train, the insect-infested house in which she stays with a tubercular man. One of the bits of x's is the sentence "In the desert of sheets, one strand xxx had fallen (she thought, I should just modestly wrap that in a piece of tissue) and she held xx in her palm and examined it in the light, letting out a sigh as long as a comet's tail."[47] At the moment when Miki first looks at her lustfully, Tomoko is hunting for the fleas that are jumping around inside her faded pink underwear. In this setting, sexual desire is overshadowed by desire for money and food. Although their bodies and sexual organs are described, the characters never explicitly consummate their attraction for each other in the story, as she encourages him to ignore her body and his violent coughing to write more of his mediocre poetry or to go ask for an advance. She essentially prostitutes herself one night to a "pug-nosed bourgeois" to repay him, but also partially because of her bitterness over the former lover's wedding announcement in the paper. The part of the money she gives Miki (one-fifth of the amount she has received), he in turn takes to pay a prostitute in jealousy over what she has done. In this way, Miki and Tomoko's sexual and romantic relations are subordinated to their financial ones, and they come to relate to each other only through money and food. The story becomes a comment on the frustrations and perversions of desires in urban life. The bell-cricket metaphor is used to imply the perversity of a sexual and economic relationship between a man and woman by implying that it is as cruel as the bell-cricket's eating her mate. Tomoko also compares her "bourgeois" lover Akio and his new wife in their newspaper wedding announcement to "butterfly specimens," as visions of the typical elite couple.[48]

As in many writings in *Nyonin geijutsu*, a reference is made to the relationship between entertainment media and emotionally or physically real experience. Here the comparison is made as a way of describing a deeper sense of alienation: "Ever since losing Akita to another woman, Tomoko

Chapter 4

felt like a movie screen: after the film of her metaphysical life was finished, the screen reflected only an empty reality. No matter who tried to project an image onto the screen, no matter who tried to stir up a physical sensation, the screen remained blank, empty."[49] As her character tries to understand her romantic and sexual relationships through film metaphors, cheap poetry, and a newspaper wedding announcement, Nakamoto's story, like many in *Nyonin geijutsu*, reflects on the role of media in the experience of modern life and the alienating tension between mediated and physical sensations.

While Kubokawa's story "Self-Introduction" pushed the "autobiography" assignment given by the editors, Nakamoto's story seems the most out of place. I do not know whether it resembles aspects of Nakamoto's life, but its rich use of this grotesque insect metaphor does not gain much through association with the author's life, and the possibility of the real-life models only distracts from the story's haunting hyperrealistic quality.

It is worth noting that Nakamoto later turned away from this style of writing, which was linked somewhat with the new sensation school *(shinankanku-ha)* most closely associated with writers Yokomitsu Ri'ichi and Kawabata Yasunari. Nakamoto denounced her earlier fiction in "the style of the petit-bourgeois *shinkankaku* school" in favor of writing more explicitly tied to labor activism. I think it is worth taking her rejection seriously, but her use of the grotesque and vivid imagery associated with the *shinkankaku-ha* already made a powerful comment on the dehumanizing qualities of poverty and relationships of exchange in the capitalist economy in ways not inconsistent with her later work. In her later writings, which she labeled as proletarian fiction, she also continued to make use of this type of description of anger and physical sensation even as she mixed it with more explicit use of Marxist terminology. These changes are arguably in part reflective of a willful transformation of her own autobiography when she moved to a working-class neighborhood and participated in movements at the Tōyō Muslin Factory and other work for the Communist Party, leading in turn to multiple imprisonments, harsh interrogations, and resulting time in a mental hospital. Her novel about the muslin factory strike, *Tōyō Muslin, Number Two Factory (Tō-mosu Daini kōjo)* was serialized in *Nyonin geijutsu* in 1931 and 1932. Nakamoto Takako always casts doubt on an overly social scientific approach to social problems, criticizing something that might be translated as a "statistical" or "inspectional" and by implication quantitative *(chōsakengakuteki)* perspective: a view of social transformation that can gauge change in the structure of society only by quantitative methods. She calls for hands-on "bloody" struggle as part of the transformation of ideas.[50]

And her reflection back on her own move to "Muslin Alley" to "see with my own eyes, hear with my ears, and experience this [exploitation and oppression of factory workers] directly through my skin and through my muscles" seems not so distant from the bodily sensations through which Tomoko and her lover Miki experience hunger, sickness, jealousy, and love.[51]

Ozaki Midori's "Osmanthus"

Ozaki Midori has recently been rediscovered through the reprinting of her collected works, and in English through Miriam Silverberg's translation of the story "Osmanthus" (Mokusei) and Livia Monnet's brilliant analysis of one of her novels.[52] She is generally considered part of Japanese literary modernism, and not associated with the proletarian fiction movements. Ozaki contributed fiction and a series of essays on film to *Nyonin geijutsu*, and helped with editorial work as well. "Osmanthus" playfully depicts a woman living in Tokyo who falls in love with the Charlie Chaplin of *Gold Rush* as a sort of stand-in for a man, N, she has just decided not to marry.

Again, this story plays with the autobiography concept and refuses to be fodder for gossip, at least of any usual kind. Her relationship with N could be based on Ozaki's life, but their interaction is banal and unrevealing. She simply forgets to "make fun of his tie," refuses to marry him, and lets him go back to his "ranch where the cows are." It is through her fan relationship with Chaplin that her desire emerges. Technically, this is a relationship to which any moviegoer anywhere in the world could have access—a connection to him in the bits and pieces she see on the screen: "Charlie's shoulders are lonely, just like my heart. His hat is also lonely. His cane is also lonely. And his laughter is also lonely. His moustache. His pants. His rope shoe. His whole body is lonely."—these bits that flicker on the screen. But the story is about how a woman living alone as "a piece of moss" in a Tokyo rented attic apartment makes her connection with Charlie her own.[53] She goes out to talk to him and walks with him in the street, even with piano accompaniment, and Charlie helps her talk through why she did not want to marry N, even though the mother she writes to at the end of the story may have wanted her to.

The narrator is taking a different path by not marrying him and finding a "happy ending," just as she views the movie in a way completely different from that of her fellow audience members:

> In the course of trying to spread laughter throughout the world, he
> was instead spreading only loneliness. But the audience in the theater,
> those in work jackets, and guys in hunting hats, and old grandmothers

and their grandchildren, and young girls, too, kept on laughing just as Charlie wished. My heart was the only abnormally twisted one after all.[54]

The narrator sees the gap between the meaning of Charlie for her and for this audience (or her friend who has eyes only for Valentino). Seeking solace for her "starved heart," she depicts the way creativity, and perhaps her activity as a writer itself, even if it is only making "waste paper," can transform the reception of laughter that is meant to be the same "throughout the world." She notices too that her immediate physical surroundings, the very material conditions of the viewing, transform the viewing of her dreamboat: "Charlie's shoulders, blurred by the rain of the old print, were shaking in the blizzard. Enveloped in the smell of varnish or paint and of the toilet, I had to search for Charlie's shoulders."[55]

Ozaki Midori's column on film for *Nyonin geijutsu* echoes this desire for different and unofficial perspectives on mass culture. In the first installment of this series, "Random Jottings on Film" (Eiga mansō), she explains the "psychology" of the "random jotter's" desultory writings, which are distinct from the newspaper reviews by experts:

> "Random jottings" refers to those involuntary musings that occur while the curtain is up on a given day, those thoughts that occur to the viewer, that disappear or move from topic to topic, that might be compared to clouds, smoke in the morning sun, or perhaps fog, shadows, sea foam, or frost. At any rate, they are far from the transparent and definite perspective of film criticism. In other words the "random jotter" is a species lacking the scientist's perspective on the movie screen. You might say the workings of his own heart when confronted with the picture is itself as if made into a movie.... His heart is engulfed by the world of shadows flickering on the screen.[56]

Ozaki explores the possibility of unfixed and even confused experiences of identification and desire that can be felt by the untrained observer. Ozaki is described by Ogata Akiko as a lone "humorous" voice "in the midst of the increasingly leftist writings" of *Nyonin geijutsu*.[57] This characterization perhaps minimizes the extent to which her broader goal of interacting with a popular audience, with regular readers and viewers who might be untrained and unscientific in their perspective on culture, shaped her sense of humor. Just as the goal of proletarian literature writers was often to help proletarian readers who felt too engulfed by their daily lives and even physical needs to

Literature and Politics in *Women's Arts* 155

pull back and see clearly the systems that oppressed them, her film criticism explored the necessarily mediated but direct interaction with characters on the screen. The debates within the proletarian literature movement about the role of literature in depicting the workings of the worker's heart—a heart that might not yet be enlightened about its own situation—and the nonproletariat writer's role are echoed in Ozaki's perspective on film criticism.

Debates on the "Autobiographical Love Fiction" Issue

Participants in the June 1929 roundtable discussion on the first anniversary of the magazine discussed the "Autobiographical Love Fiction" issue at length. Some were critical of the sheer intensity of having so many stories on this theme in one issue of the magazine. Hayashi Fumiko, who contributed her story "Ears" (Mimi) to the issue, commented, "If the individual stories are separated out, they are extremely good, but when gathered all together like that, don't you think the fragrance becomes too overpowering? Perhaps the title 'autobiographical love' was the problem."[58] It was not uncommon for popular magazines such as *Shufu no tomo* to print "true stories" with titles such as "A Woman Weeps over Her Disastrous Love Marriage" (October 1919); "Women Who Found Success through Studying: From Ignorant Factory Girl to Elementary School Teacher" (September 1923); and others by mothers of delinquent girls and members of love triangles. Although some claimed that authors knew the theme of the issue, members of the Women's Arts League criticized the association of the authors' art with sensationalist "true stories" that the title suggested.[59] Many warned that the publication had "gotten too carried away with eroticism"[60] or that this was at least strategically unwise since "it is very easy for a new women's magazine to be misunderstood."[61] Others such as Hirabayashi Taiko felt that it undercut the real feminist and class concerns of the journal by focusing on "gossip about famous women"; for Hirabayashi this was also an artistic problem suggesting that the fiction was gossip rather than written "seriously."[62] Some felt that although the stories themselves were good, using a marketing strategy in the form of a suggestive title and the depiction on the cover of Leda and the swan was too much.[63] But while most agreed that the special issue should not have been used as a publicity stunt, many noted that they needed to have some popular issues if they were to keep the journal afloat. The discussions of romance, which sold so well, might hide, for example, the realities of the woman factory worker. The images of the assertive, attractive woman touted

in some of the stories, some felt, were easily commodified and incorporated into the advertisements by which they were framed (figure 19). The Mitsukoshi department store's ad in this issue was for children's clothing, which some felt undercut the effort to represent love and sex as an attempt to critique bourgeois love. Much was also made of the cover and its use of an image of rape for an issue on love.

It is clear that the cover and title of the issue were in some sense commodifying female sexuality as a publicity stunt and that sometimes this packaging detracted from the fiction. As we have seen, however, much of the fiction works with that assignment but confuses the concept of the personal story. Furthermore, the discourses by which these and other pieces of fiction on sex and love were surrounded, as well as the content of the fiction itself, help to problematize that commodification. For example, the first major article in the issue, which is otherwise made up of love stories, is about Proletarian Women's Day, with a picture of Moscow representatives of women proletarian groups from different countries in drab dress.[64] They work to remind readers of the disparate economic conditions under which the authors are representing sexuality.

This same disparity was present in the other magazines we have seen, but in a way that was managed by means of magazine layout. Here the entire issue is marked with the title Shōsetsu, meaning that the literature is not sequestered to a separate section to be enjoyed irrespective of its surroundings; as we saw in *Fujin kōron*, for example, the plight of factory girls and women strikers might be covered in articles, but any connection between them and serialized fiction would be severed by its formal separation into the Shōsetsu section. In *Shufu no tomo*, stories related to the proletarian movement tended to be written as confessions or romantic stories about young female factory workers that often seemed as unreal as the melodramatic fiction in the same issue. This is not meant to suggest, of course, that the poignancy of factory girl stories made them inherently apolitical; they no doubt inspired sympathy and occasionally action on the part of readers. Those predisposed to ignore, however, could easily blur them together with tragic fiction and relegate any social message to obscurity. Here in *Nyonin geijutsu*, it was the nonfiction pieces that did not relate to love or invoke emotions at all; for example, the short news story with photos about a Proletarian Women's Day march in Russia, or current events summaries. As a result, rather than discussing love through journalistic and philosophical writings or sexological reports, opinion of love and sexuality grew out of the fictional texts themselves.

Commentators also raised questions about art and truth. Hirabayashi Taiko wrote of the issue of autobiographical fiction.

Literature and Politics in *Women's Arts* 157

FIGURE 19.
Advertisement,
Ōki Clothing
Store. *Nyonin geijutsu*, March 1929, unpaginated. (Courtesy of Waseda University.)

A person cannot really write an autobiographical love story just because she wants to, if fiction can be called any kind of art. That is, if what I want is to spread gossip about myself I can do that easily enough. When faced with writing fiction, though, anyone takes the task seriously. In that sense, this was not "women's art" *(nyonin geijutsu)*. Though perhaps there is something interesting in gossip about famous women.[65]

She continues: "What I am saying is that it is strange simply to tell your own romantic interests to people and call that fiction."[66] Yagi Akiko also addressed the question of truth and the special issue: "Hasegawa planned this issue out of the desire that women writers in this age of truth reveal the full reality of themselves, showing images that are confrontational, honest, and raw. She intended for this to give the fiction significance for the period

158 Chapter 4

in which we live."[67] These quotes also suggest that this move for "truth" is a strategy suited for the present: this "age of truth" where fiction should have "significance for the period we live in." This does not simply refer to a vague relevance for the times but rather entails a belief in the possibility of improving current social conditions through direct representation. The critics meanwhile were concerned about how easily salable was that version of the present state of women's love and sex experiences. They also disagreed over whether it was the present situation of women that should be depicted, some thinking that instead they should write of a desired future set of conditions based on a combination of feminist and Marxist ideals. These were of course some of the quandaries of the proletarian literature movement, which sought to show the truth of the present to bring about change. These same questions emerged more as the magazine shifted some of its efforts from fiction by professional writers to "true stories" by lesser-known writers and reader submissions, often from the workers themselves.

True Stories

The discussion of truth in proletarian fiction, and fiction in general, reflected a hotly debated issue throughout the literary world during the proletarian literature movement. Yet we see that this discussion took on a different character when it came into connection with specifically feminist objectives, as it did on the pages of *Nyonin geijutsu*. In particular, the concerns over self-representation appear particularly urgent, and this because many of the participants worried that women were simultaneously being used as the icons par excellence both for commercialism (as readers, consumers, and subjects of representation in journalism) and for the labor movement in the form of the factory girl. Observing the extent to which women and female categories had become larger-than-life representatives of the perception of social change, the editors and contributors to *Nyonin geijutsu* struggled with how best to be activists without simply reproducing those categories. They presented what they thought had tremendous political potential, the realistic stories of women working, while trying to not simply reinforce loaded images of the working woman.

Jitsuwa of a very different sort from those about being cured of diseases or being seduced that were found in *Shufu no tomo* began.

> Shizuoka is an old-fashioned town. Through a tiny window near the ceiling, a thin ray of sunlight peeked in, and you could hear the machines and, over the humming of the belts, the footsteps and voices

of the people, who were black with oil. This small workplace, seeming almost ready to burst with all these things stuffed into it, was dark, so you couldn't walk around normally. Just to go do an errand, you had to walk stealthily with your eyes wide open until they adjusted to the dark. It was worse than being in solitary confinement. (To be honest I haven't experienced solitary confinement or even prison, but that's what it seems like.) That was how I felt when I first arrived here. After working every day, I no longer feel that it is like a prison cell, and since it's where I have work I just came to think of it as my true workplace.[68]

This "true story," which continues with the narrator's becoming involved with a proletarian newspaper, is one of more than fifty such stories printed in *Nyonin geijutsu*, including a special issue in October 1930 called the "True Story Exposé" issue (Bakuro jitsuwa gō)—with "Don't be fooled!" (*Damasareru na!*) splashed boldly across the cover.

The women running *Nyonin geijutsu* placed calls like this one for *jitsuwa* manuscripts: "Calling for Manuscripts! For the True Stories, Cries from the Workplace, and other columns, send them in. Even if your sentences are bad, your Chinese characters poorly written, if it is a genuine crying out (*sakebi*) send it in!"[69] This call for personal "true story" writings explicitly targeted unpublished readers of the magazine rather than the set of women who were known as writers; by implication, *Nyonin geijutsu* sought women of the proletariat. Invitations for reader participation and a sense of collective interests characterized commercial magazine *jitsuwa* as well, given that such a huge percentage of readers of magazines such as *Shufu no tomo* were factory girls and other working women. The effect on certain groups of readers likely overlapped. At the same time, *Shufu no tomo jitsuwa* were framed by melodramatic texts both fictional and "true" that followed similar trajectories but where the resolution was manifested in newfound financial success (through marriage or hard work). There is also a sense in which those stories were being presented as much for the voyeuristic pleasure of middle-class housewives as for factory girls. The broadside-like character of this call for submissions in *Nyonin geijutsu* suggests a somewhat different meaning in a strongly Marxist magazine: while similar questions about the gap between the average reader of the magazine and the situation of workers should be asked, the tension is more about the role of the intellectual in workers' movements.

To give a sense of the *jitsuwa*, I will describe a few found in the "Exposé" issue. "A Woman Brought Up according to Class" (Kaikyū de sodaterareta onna) describes a seaside village girl's experiences as she finishes compulsory education in a school with girls of mixed class backgrounds.[70] She foregrounds

the contradiction between her teachers' lectures about patriotism and required marching with the Japanese flag and the gaps among girls who were allowed to wear kimono to school and those in uniform. She notes that they were not given the same equipment with which to complete their schoolwork despite ideals of uniform national education. She is especially poor because her father died when crushed between rollers at a local factory. In the end, she leaves school to live in a textile-factory dormitory where she works to support her mother, but there she receives a letter that the corpse of her mother, who had been left living alone, was found eight days after she died with a rotten apple still in her mouth. "Hold on Tight" (Te o nigiri shimete) is in diary form.[71] A woman describes her life working a sewing machine from 7 AM to 11 PM for sixty sen per day. As she sews scarves that "an elegant, aristocratic woman will likely drape around her thin neck," she thinks of the man who broke off his engagement to her when he learned that she was burdened with a grandmother to take care of. The most disturbing story in this particular issue is no doubt "Selling a Dead Baby" (Shiji o uru), in which a woman's baby is stillborn because of malnutrition and her imprisonment after participating in a strike at her factory. When the dead baby turns out to have a rare mutation, a doctor asks to buy the body for experimentation. Despite her understandable uneasiness, the woman decides to sell it as her "only property" in order to fund her continued work in the labor movement.[72]

These stories are not driven by crafted plots or filled with figurative language. They are rough but powerful in their use of physical sensation or emotional trauma. They are highly personal stories, but they also call on a set of standard themes from the labor movement and proletarian literature movement to resonate beyond the individual experience such as the factory floor and class conflict. A number of such tropes are highly gendered ones as well, those associated with the factory girl or other young working women: the dormitory, loss or separation from parents, desire or disdain for material finery (the scarves in "Hold on Tight," for example).

Some of the stories also dealt with figures less traditionally associated with the proletarian literature movement. The prostitute in particular always had a troubled relationship with the proletarian literature movement and its politics because of the type of labor and associations with moral decay. Heather Bowen-Struyk has analyzed Hayama Yoshiki's "The Prostitute" (Inbaifu), where we see the prostitute through the male worker as her body becomes a site for reflecting on his political consciousness.[73] In *Nyonin geijutsu*, the prostitute is reintegrated into proletarian writing not through the perspective of a male worker but in her own narrative voice. In "Diary from a Whorehouse" (Kuruwa nikki) a prostitute has a charming activist customer whom she

rather likes: "He thought that reading *Senki* and wearing workmen's clothing and a hat made him a socialist; it was rather cute." He uses some Marxist jargon and calls her "comrade." The full irony of a man's doing this while frequenting a whorehouse and asking for more saké is not lost on her, and she notes that it is "outrageous" even though he is fun to talk to. She finds him likable and charming but senses a disturbing gap between his analysis and his action. She is not merely cynical, however, and continues to cheer on the women strikers that she has read about in his issue of *Senki*.[74]

Jitsuwa is a journalistic classification rather than any particular writing style, so it is hard to characterize generally. Most of the *jitsuwa* here were not written in the first person, but there was usually (but not always) a female protagonist and a female author's name (a real name or something along the lines of X-ko). At the same time, the protagonists' names are often different from the authors', and many episodes are told through surprisingly indirect narration. For example, many of the *jitsuwa* use a diary format or epistolary form in which a letter to a relative or husband tells most of the story. These forms call attention to how mediated the stories are. Although some of the stories in *Nyonin geijutsu* are not much different from the sad stories of factory girls found in *Shufu no tomo*, others defy the image of the pitiable young girl. The fierce stance of the woman who confidently declares that she will sell her baby's corpse in order to eat while participating in the next strike is not one found in popular ladies' magazines, of course, but it would hardly be common in general proletarian literature magazines either.

The most sustained response to this *jitsuwa* issue was by Gotō Katsuko in "A Brief Review of the Exposé True Story Issue."[75] Gotō questions, first of all, whether these stories really expose anything of capitalism inasmuch as they are too sentimental and "lack the interest that comes from an effectual veracity *(kōkateki shinjitsu mi no omoshirosa)*. This is because they are written too much from a creative standpoint and fictionalize the incidents they are relating."[76] In other words they are not real enough—not because they are untrue, but because of how they are written up and the alterations that are made, not in fact but in perspective. She writes,

> xx [censored, but probably "dictatorship"] of the proletariat does
> come through revealing class conflict. . . . However, it is not necessary to
> force ourselves to create animosity when there is none, to exaggerate it
> as if we were actors. Let's aggressively expose the conflict that exists.
> But displaying *non-existent* conflict is not necessary. Looking at this
> magazine lately, I read all of this made-up class conflict and ideology; it
> feels like I am looking at a close-up shot of a film actor.[77]

162 *Chapter 4*

Just as a close-up shot reveals the constructedness of an image because it is created using a photographic device even as it shows reality better by making it easier to see, the true story can fail to ring true if it exaggerates the current state of class conflict. Interestingly, Gotō thinks that showing the present reality larger than life-size also entails showing things sooner than real time, since she does believe in the inevitability of class conflict—just that it is not occurring so much in the present. She is also referring to something like stereotyping in representation, whether it be the close-up of an actor or a typical "model proletariat": "Just as each struggle is different depending on life pattern and economic situation, so too today's proletarian fiction must write more and more truthfully *(shinjitsuteki ni)* so that the particularities of each life pattern and economic situation...will be revealed."[78]

Although we might expect from Gotō's demand for representation of things as they are that she would advocate a direct documentary style of writing without close-ups, she thinks nonliteral representation and good writing are important:

> An earnest tone that reaches out is more likely to move people, and we have to remember that.... We need to learn to think more about figures of speech and forms of expression. A sense of the right expression and finesse with language. Shouldn't that ultimately be the first consideration for someone who picks up a pen to write?[79]

The analogy between film close-ups and writing seems odd, but the implication is that skillful use of language can represent the specificity of a given person's experience of proletarian life effectively, while a camera representing an actor shows only a type, a person distilled as a character, rather than one situated in real social and economic relationships. It is clear that "realistic" for her does not mean some notion of transparent writing but rather representing something "true" in the sense of conveying material reality.

A reader who identifies herself as a member of the proletariat and responds to the magazine is similarly concerned with issues of language:

> The sentences mimic the style of upper-class ladies, or maybe it is petit-bourgeois ladies, but *de arimasu, na no desu,* and so on are not necessary. I want to see the proletarian writers use a proletarian-like strong *de aru,...de wa nai ka!* ... What have value are reports from the workplace that are direct, clear, and correct and show our proletarians' lives as they really are so that people who read it will be moved...and given class consciousness and spirit of struggle.[80]

Here it is not the content but the style of the writing that she thinks needs to represent truthfully. The reader criticizes language that is feminine and that is upper class not because it fails to represent the conversations that working women have—they probably would say *na no desu*—but because it is not the written style appropriate to express the determined stance of an activist. This reader is pushing for writing that has a quality of "true" political consciousness. Ultimately, even the whole category of "true story" comes under fire from Gotō. "I read this 'true stories' issue with great interest. But I wonder whether we as others *(tanin)* are able to really say anything about those documents once they are marked as 'true stories.'"[81]

If we look at the whole essay, which I have discussed much of in order to give a sense of the texture of such arguments, it is clear that the reader is not criticizing the practice of soliciting and printing so-called true stories but rather their classification as such in print media. If they are "marked as 'true stories,'" that places them outside the realm of critical discussion. Magazines such as *Shufu no tomo* solicited "real experiences" and "true stories" but printed them as "confessions," imposing a particular spin on their content by marking them as presumed authentic expressions of reader interiority but not part of political debate. This strategy occasioned discomfort in *Nyonin geijutsu* as we have also seen in the case of the "Autobiographical Love Fiction" issue. Would doing the same with workers' "true stories" make it impossible to criticize how they are written or even their political implications, since they were already marked as true? This argument about the levels of potential truths mediated by layers of language usage and media packaging attempts to hold on to the idea of self-representation on the part of individual women in different situations for political purposes while trying to complicate the understanding of how such stories might be expressed and published, and the different effects those choices might produce.

Interestingly, it does seem that the "true story" was indeed read differently from traditional fictional forms and perceived as more dangerous to the status quo; at the least, it made all the difference for one powerful group of readers: the censors. If we look at the incidents when women's magazines were pulled from the shelves, we see that *jitsuwa* and *kokuhaku* played a major role. A *Shufu no tomo* seduction-story *kokuhaku* was occasion for its first censored issue, and *Nyonin geijutsu*'s Marxist *jitsuwa* provoked the censors to forbid sales of an issue more than once. Neither was taken off the market for any work of "literature" *(bungei, sōsaku, shōsetsu,* etc.), despite some very sexually and politically explicit fiction in both publications. Perhaps, in a reverse way, we can see that these self-described nonfiction forms rang true.

164 Chapter 4

Autobiographical Narrative and Hayashi's *Hōrōki*

It is with the "Autobiographical Love Fiction" issue and "true stories" in mind that I would like to return briefly to Hayashi Fumiko's famous work *Hōrōki*. This work has a complex textual history, covered in detail by Imagawa Hideko and in Joan Ericson's study.[82] Part of that story involves its original publication in *Nyonin geijutsu* beginning in October 1928, where it was apparently given the *Hōrōki* title by Mikami when he encouraged Hasegawa to publish it.[83]

The order of the diary-like entries in *Nyonin geijutsu* and the form it took in the book from Kaizōsha were quite different. The first entry that appeared in *Nyonin geijutsu* was called "Autumn Has Come!" (Aki ga kitan da!) and begins,

> The month of October x day
> Gazing up at the four-by-four skylight, I saw the sky lit up in a clear lavender for the first time. Autumn has come! Sitting and eating my meal in the cook's quarters, I so longed for autumns back in the countryside far from here.
> Autumn is wonderful....
> Today a woman came. White like a marshmallow, a rather curious looking woman. I'm so tired of this. Why do I miss certain people's faces?
> Maybe because of that, every customer's face looks like merchandise; every customer's face is tired. It doesn't matter, so I just pretend to read a magazine and think about various things. I just can't go on.
> I've got to do something or I'm just going to rot away.[84]

This passage has many of the commonly described aspects of Hayashi's writing, including the sense of yearning for home or past friends and the use of concrete and unusual imagery. Although still very much Hayashi's style, when we think of other *Nyonin geijutsu* writings we have seen, it is not as unusual as one might expect, either in imagery or theme. The "marshmallow"-like woman and lavender sky are not unlike the modernism of early Nakamoto and Ozaki Midori. Meanwhile, images of sunlight through cramped urban windows and tired faces are very much those of the proletarian women writers in *Nyonin geijutsu*, as were comments about human beings as "merchandise." Although Hayashi later belittled the role of *Nyonin geijutsu* in her career, despite the break it gave her, I suggest that she found it a

Literature and Politics in *Women's Arts* 165

fitting forum for publishing her work until she was insulted by criticisms of insufficient political consciousness.

After some months in *Nyonin geijutsu*, Hayashi published "*Hōrōki izen*" (Before *Diary of a Vagabond*), a preface to *Hōrōki*, in the magazine *Kaizō*; this preface was then added to the book version from that publisher and to future book versions of the work. It is too long to quote here in full, but it begins with her childhood in Kyushu in an autobiographical mode:

> At a certain grammar school in Kita-Kyushu I learned a song that went something like this:
>
>> Under the darkening autumn evening, a traveler's sky
>> Worried and alone with my thoughts
>> Longing for my hometown, missing my father and mother.
>> I am destined to be a wanderer.
>> I have no home *(furusato)*.
>> I am a crossbreed, a mongrel.[85]

Further passages describe many of her childhood experiences living with her down-and-out parents, working in a millet-processing plant, peddling food in a mining town, and beginning to read books and see movies. "I am destined to be a wanderer. I have no home" became the most famous lines of this entire work, and the inclusion of the preface arguably changed the history of the novel. Although the preface contains elements of Hayashi's fragmented style and, as Gardner has shown, creative use of both mass cultural languages and a hybrid style, it also transforms Hayashi's fragmented pieces of writing into a personal narrative in a way that it was not in *Nyonin geijutsu*, where the work began without explanation or self-identification. It is not surprising that only recent critics have reconsidered *Hōrōki* as part of the history of Japanese modernism, as the reception of its autobiographical preface long marked it as women's writing rather than modernism, and domesticated its wild narrative paths. Meanwhile, although I think Hayashi's work would have remained a beloved one in either case, its popularity and longtime sentimental charm has had much to do with this framing through her preface and its reception, which linked the author and narrator (despite inconsistencies that arise in the process).[86] This is the precise issue that the critics of the "Autobiographical Love Fiction" issue had been so concerned about: the packaging of women's stories as personal and salable narratives. We do not know how Hayashi felt about this, but the political implications of her *Kaizō* version were not likely lost on some of her keener cohorts at *Nyonin geijutsu*, and may help make

166 Chapter 4

sense of the attacks on her that have always been read as uncharitable and overly dogmatic. When we consider this textual alteration in the context of *Nyonin geijutsu* debates, it becomes clearer what sorts of issues about truth, political commitment, and autobiography were at stake and the ways that their significance has been ignored by the postwar reception of her work.

Mass Transformations: Debating Directions for *Nyonin geijutsu*

After February 1930, when a number of its anarchist contributors such as Takamure Itsue, Mochizuki Yuriko, and Yagi Akiko broke off to form their own journal *Fujin sensen* (Ladies' front) following an anarchist-Bolshevik debate *(ana-boru ronsō)*, there was a near-consensus that the general slant of *Nyonin geijutsu* should be socialist. A few less politically motivated writers, including Hayashi Fumiko, continued to publish fiction here, despite some disagreement with those politics.[87] Hasegawa herself was not particularly interested in that movement but was open to letting the interests of the women involved determine the content of the journal. Hasegawa did contribute some poems to *Nyonin geijutsu* that might be considered proletarian literature, such as "High Noon" (Hizakari), written in the voice of a man working in a glass factory: "There's no thermometer here / If there were, it would be illegal to make us work they say! / The inside of a person's head might melt / Ayaa! The glass factory / Where working boys live naked / Hisssss, blood is burning / Like a beefsteak, not human flesh."[88] Like Hasegawa Shigure, most of the contributors were open to trying their hands at political art, including many like Shigure who are not associated with those movements and whose legacies lie elsewhere, such as Enchi Fumiko and Ōta Yōko.[89] Along with the transformations in fiction and poetry, many of the major changes responding to these tendencies occurred in appearance and format rather than content of writings per se.

Cover Art

As discussed in this chapter's introduction, the most visually obvious transformation of this magazine is in its covers. It was so striking that the censorship office's one-paragraph report on the magazine devoted much of its own description of the publication to the move from oil paintings to bold red-and-black graphics.[90] The covers that had shown artwork, often representations of women or still lifes (figure 20), moved to red-and-black graphics (figure 21). Finally, covers went to yellow and red as they fully

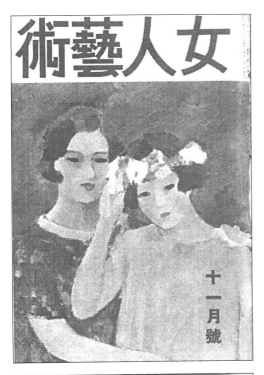

FIGURE 20. Cover by Fukazawa Kōko, titled "Crown of Flowers." *Nyonin geijutsu*, November 1928. (Courtesy of Waseda University.)

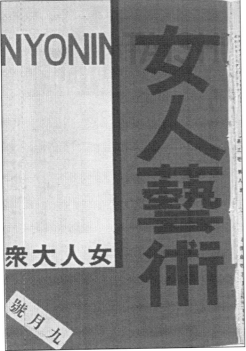

FIGURE 21. Typical red-and-black cover from early 1930s *Nyonin geijutsu*. The vertical type carries the magazine title, *Nyonin geijutsu*, while the horizontal characters read the same as the romanized text above *Nyonin taishū*, the title of the magazine supplement. September 1930. (Courtesy of Waseda University.)

168 Chapter 4

embraced communism (figure 22). As we have seen in previous chapters, women's magazines almost universally made use of cover images gendered feminine, even if only the sprinkling of flowers seen on early *Fujin kōron* covers (see figure 4 on page 35). The early *Nyonin geijutsu* covers were all by women artists, including a couple by non-Japanese artists.[91] A call for cover artwork in the first issue read,

> Requesting submissions for cover art: We are seeking all sorts of cover paintings from our readers: [in particular, we want paintings] whose freshness or vivid symbolism leaves a deep impression, or any other type of powerful or elegant works. We would like to receive works that give some hint at women's lives, will stand out at the newsstand, and still have the artistic appeal to attract more enduring visual interest. We will limit the entrants to women only.... Remuneration: A reasonable fee will be paid for the cover.[92]

Many of the resulting covers did not represent women, although they included such traditionally feminine subjects as flowers and dolls.[93] Those that represented women did not generally represent an idealized reader, as in the case of *Shufu no tomo*. Rather, the figures were abstract, with women part of a scene rather than the entire focal point. We have also seen that most women's magazines made use of portrait-style depiction of women, which suggested certain types: Westernized or Japanese, motherly or maidenly, and so on. These covers, however, did not use a portraiture style. Even the tendency for the subjects to be looking away from the reader did not suggest the same relationships of aspiration or identification that *Shufu no tomo* covers invited.

The complete removal of women and feminine images from the cover that began in September 1929 opened up a more radical distance from the rest of the world of commercial print culture for women (see figure 21). The bold title with the characters for "women" *(nyo-nin)* still forcefully marked the magazine as a women's magazine, yet distinguished it utterly from the rest of the market. More than the category of women, the look of the cover emphasized the associations with Marxist and anarchist politics. The covers' association with political movements and striking appearance are suggested by a reader's recollections: "When the magazine was delivered to my house it was rolled up so no one could tell what it was, because being red it really drew attention to itself."[94]

In the final year of publication, when the dominant forces had become the women who aligned themselves with communism, the covers went back to representing women, but here they were photographic images of Soviet women workers. Previous representations of non-Japanese women showed them in

Literature and Politics in *Women's Arts* 169

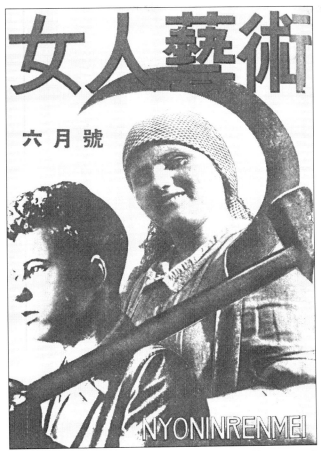

FIGURE 22. Cover. *Nyonin geijutsu*, June 1932. (Courtesy of Waseda University.)

lush surroundings; sexuality was expressed in reproductions of Western nudes. Here instead an international community of women identified as workers became the dominant identification promoted. The medium of photographic reproduction allowed, just as it did for Ozaki Midori and her encounter with Charlie Chaplin, access to people across distances readers would not travel; unlike Ozaki's story, however, the assumption is that the representation is realistic and can be received directly as inspiration to political action by readers rather than causing a sense of distance and alienation.

These final covers made use of the graphic boldness of some commercial advertising art of the period, with sharp lines and bright colors. At the

170 Chapter 4

same time, the representations of women were in no way like the women of cosmetics and fashion advertising; instead, they refused completely the mass-marketing appeal of standardized female beauty while continuing to emphasize identification among a community of women. While the choice to show Soviet rather than Japanese activists may well have been intended to protect the identities of activist Japanese women from police scrutiny, the images may also have created some gap between reader identity and the representation of women on the cover, one that might have been hard to bridge for readers—including proletarian women accustomed to popular women's magazines.

Women Masses *and the Title Debate*

Even before the changes in covers, the magazine made another layout choice to appeal to a readership outside literary circles. A supplement titled *Nyonin taishū* (Women masses) was attached to each issue from late in 1929. Following the pattern of commercial women's magazines, in all the articles in *Nyonin taishū* the Chinese characters were glossed with phonetic pronunciations for ease of reading. The supplement contained some fiction and poetry aimed at an audience with a lower reading level or written by proletarian women, education in basic Marxist ideas, notes on nutrition, Esperanto lessons, and a Children's Newspaper section with features such as "Fairy Tales for Working Children" translated from Russian. Generally there were no advertisements in the supplement, while the regular magazine from the same period carried modernist-style department store advertisements (figure 23). Many of these changes sought to reach a wide audience of women without basing the supplement's appeal or finances on consumer culture at all.

Debate erupted over the title of this supplement when Kawai Akiko wrote a piece titled "My Request to *Nyonin geijutsu*," suggesting that the name of the whole journal be changed to *Nyonin taishū*.[95] The name *Nyonin geijutsu* had come originally from the title of an independent journal run for two months in 1923 by Hasegawa Shigure and Okada Hachio, and many thought it increasingly mismatched to the content of the publication. Kawai writes that this name change was particularly important because "unlike a magazine simply for profit, this is coming to be an organ to help the proletarian movement, and therefore we now need to think about the direction of the journal."[96] She tells of a proletarian education meeting in a rural area where books and magazines were sold after the lecture, and she claims that women's consciousness is raised even by looking at the titles. *Nyonin geijutsu* is a problematic title, she writes, because such women "cannot gain a sense of the content from such a trans-class *(chōkaikyūteki)* title."[97] Some also

FIGURE 23. Advertisement, Mimatsu Department Store. *Nyonin geijutsu*, June 1932, unpaginated. (Courtesy of Waseda University.)

thought that while reconsidering the name, they should change the first part of the title to another more common word for women, such as *josei* (a more common term for "woman" usually used now) or *fujin* (closer to "lady" and more common at the time) because the word *nyonin* was antiquated and "aristocratic"-sounding because of Buddhist associations.

In this period, the word *taishū*, which is usually translated as "mass" or "popular," was used with a variety of inflections, many of which were negotiated by the debaters here. It does not perfectly correspond to either English

term. Sometimes, as when used in *taishū bunka*, it meant "popular culture" in the narrow sense of culture emerging from the people or culture favored by the people. In a sense, the vastness of the category *taishū* meant that, as Miriam Silverberg notes, it "served to gloss over the relationship of class to mass culture."[98] Members of this group, however, liked that *taishū* would refer to the proletariat and either writing by or for them.

This common usage opened up *taishū* as a much more oppositional word than the English "popular" or even "mass." Kawai tries to clarify that she does not refer to "gaining a mass audience" *(taishū kakutoku)*, which she glosses as the "petty bourgeoisie lady masses" *(puchiburu fujin taishū)*.[99] Kawai still advocates the name change by pushing the meaning of *taishū* as a term that can be attached to the proletariat and as potentially antagonistic (in a positive sense) because of its attachment to workers' movements and the culture of nonelites. In short, the Marxist women who were gaining stronger control over the magazine can be seen consciously defining and redirecting this category of *taishū* toward a more politically conscious and less consumer oriented concept.

Author Hirabayashi Taiko described the debate over the name after it had concluded:

> What originally made the name *Nyonin geijutsu* appropriate for this magazine was the editorial aim of exalting and emphasizing the social ability of women in the field of art that had been ignored. In some cases, however, the manifestation of that ability ended up being derailed and, as a result, misused by society or even manifested itself as bourgeois consumption. That derailment has a deep association with the women's rights movement and will always occur when the assertions of women's rights are placed merely in opposition to men's rights. Because of this problem the self-critical discussion [the debate over the name] has developed.[100]

Hirabayashi continues by arguing that the journal should embrace the "intersection of the vertical line of 'women' and the horizontal of 'proletariat'" rather than using "art" as a category to simply promote the "liberal goal of showcasing women's ability" and the "overly vague united front of 'woman.'"[101] This tendency for the magazine to rely for its vision on the category of women was attacked in *Fujin rōdō* (Ladies' labor), the journal run by feminist Oku Mumeo, where a cartoon referred to its hodgepodge of political tendencies as "canned women's liberation" as if the inconsistent politics of the women involved were meaninglessly packed like sardines into the broader category of "women" (figure 24). Hirabayashi, herself active as a fiction writer, felt that changing the name to *taishū* might have clarified the political

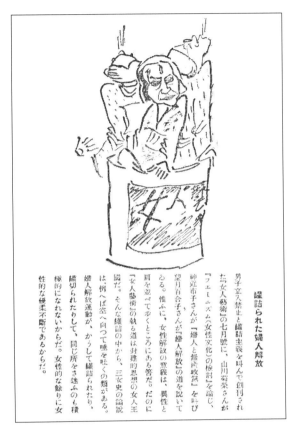

FIGURE 24. Cartoon, "Canned Women's Liberation," by Irimajiri Okuichirō. The container reads "Nyonin gei . . ."; the text discusses the feminist writings by Yamakawa Kikue, Kamichika Ichiko, and Mochizuki Yuriko in *Nyonin geijutsu* and criticizes the magazine for forming a "matriarchy of conservative thought" where "no men are allowed" rather than seeking liberation for women "side by side with men." *Fujin undō*, August 1928.

message of the journal by implicitly acknowledging class politics as they intersected with feminist ones; in doing so, she thought they might have made explicit the difference from other magazines based solely either on female audiences or feminism.

A few who took part in the debate disagreed with changing the name because they felt it denied the importance of literature to political movements: Kitayama Masako wrote, "Political articles are moving because of their fighting spirit, but . . . isn't it the echo of that inspiring fighting spirit out of which art is germinated?"[102] She argues that readers should be given the chance to judge the content politically without invoking a blatantly political name to interpret the material for them. A letter from a Nagoya reader agreed: at first she thought the title meant the magazine was "aestheticist," but after reading it she "clapped and cried out, rejoicing at the feeling of freshness upon seeing that the word 'art' had changed its meaning."[103]

174 Chapter 4

The matter of contention in this debate, however, was not simply whether art could be political or not. It concerned a magazine title and the significance of images and names in print culture. The disagreement then was not so much about what slant the magazine should take but how it should represent that stance to the public. To some, a consistent title to keep the same audience was important; Hasegawa had made a major accomplishment by turning *Nyonin geijutsu* into a famous publication, printing about thirty thousand copies each month. But others said that this "capitalist attachment to name recognition" was no different from any advertising campaign or profit-making magazine marketing technique.[104]

Ultimately, the name was not changed, but the supplement *Nyonin taishū* was enlarged, and the title of the supplement was then printed on the cover of *Nyonin geijutsu* to show the link (see figure 21). Eventually, some aspects of the supplement were also incorporated into the main journal, such as pronunciations for kanji characters. Still, in the supplement, the advertisements are absent, left in the main journal and separated from its texts even though they are still what support it. In both parts of the magazine the amount of literature was vastly reduced during this period.

In looking at the supplements, we see that sometimes an effort to be mass based and nonelitist led to a less critical stance toward other forms of conformity. Although *Nyonin taishū* is aimed at working women, the gender categories are fixed. More than in the early issues of the main journal, it speaks to women as mothers. There is a nod to household sciences, with pieces on topics such as nutrition and child rearing. The Children's Newspaper within the supplement implies that working-class women and children can be placed in the same category of readership, a classic pairing in Meiji-period enlightenment discourses on women and children that seems out of place in this often radical magazine. Advertising and sexual fiction are deemed inappropriate for this supplement for the "masses," but other gender norms are not. The supplement aims at "common people" by appealing to what are judged to be common experiences, such as motherhood, while avoiding the commodified world of urban culture in order to avert its dangers. As a result, the questioning of the nature of womanhood that we saw in the challenging fiction of the "Autobiographical Love Fiction" issue is lost here almost entirely.[105] The commercial reality that the magazine could not survive without accepting the Mitsukoshi department store ads and promoting Hit-and-Run College Baseball Soap is also hidden from the target readers of this supplement, excluding them from the potential questioning of those ads in the context of writings and roundtables that discussed the advertising texts' presumptions about gender and commercial culture. The almost complete

abandonment of fiction in the final issues (in both the supplement and the main magazine) further excludes what had been one of the most powerful ways the publication had explored the complexities of gender and its relationship to class.

The End of *Nyonin geijutsu*

It is worth briefly examining *Nyonin geijutsu*'s ending and a second beginning. In 1932, Hasegawa decided to cease publication of the magazine after several issues were censored because the financial impact of the inability to distribute those copies was too difficult to withstand. Hasegawa also happened to be ill, and she felt that the stress of running the magazine was too much for her. A group led by Yoshiya Nobuko, the popular woman writer who contributed most of her work to *Shufu no tomo* but supported *Nyonin geijutsu* in spirit, gathered late that year to collect money from women in different circles to help recover some of Hasegawa's financial losses.[106] With some of the excess funds from that meeting, the Kagayaku (Shine) Association was formed and began publishing a newsletter in March of 1933, printed in black-and-white newspaper rather than magazine style. It was published until 1941. During its years of print, it quickly shifted from a kind of toned-down version of *Nyonin geijutsu*, which included some famous essays such as Tamura Toshiko's writings about Canada, short fiction, and poetry, into a venue for state propaganda aimed at women, as most women's organizations and publications were disbanded or recruited for the war effort. *Kagayaku* is worthy of a study in itself[107] and highlights some of the problems with the overarching publishing aim—not shared by all participants, as we have seen—of publishing writing exclusively by women, as that goal by itself is unable to prevent such state co-option for propaganda purposes.

Conclusion

At last, we can return to my initial question of what difference it might make to produce a magazine with explicitly political goals and where the process of magazine making is an object of analysis within the magazine itself. *Shufu no tomo*'s construction encouraged readers to feel that the consumption of its advertised products and texts could re-create them into ideal housewives, and the letters from readers implied that they were part of a community of such housewives. I would argue that the open airing of in-house political conflict and diversity of reader experiences made public in *Nyonin geijutsu* would have discouraged any such notion. Certainly, many of the magazine's

176 Chapter 4

contributors hoped that readers would become activists and work to change forces of economic and state oppression. Yet such aspirations, which in some sense parallel the aspirations toward the middle-class urban housewife lifestyle represented in *Shufu no tomo*, were revealed to be not so easily attainable as buying the magazine *Nyonin geijutsu*. Textual traces of censorship helped to demonstrate that becoming a political actor was necessarily mediated by obstacles—ones that would not be transformed by simply reading the texts of the magazine. Meanwhile, those who might read in hopes of becoming literary women would also be reminded of the need for self-censorship. The debates about the title and political direction of the journal also highlighted the fact that such political ideals were always contested.

Rather than being negative qualities of this publication, however, such limitations created a vibrant magazine. Rather than focusing on a random group of texts from which readers might choose liberally for their entertainment or erudition, *Nyonin geijutsu* provided a set of choices that always seemed to have political consequences. That readers and writers did choose, under those obviously difficult circumstances, to take the risk of putting their names to *Nyonin geijutsu* articles or receiving the rolled-up radical-looking magazine at their doorstep is inspiring, not only in a political sense but also a literary one; at its best moments, the quiet drama of their acts of reading and writing are present in the magazine's texts and have aesthetic appeal of their own.

More broadly, we see that a certain disregard for great commercial success allowed texts and images to be printed here that would not have found venues elsewhere. The boldness of their attacks on both gendered categories and economic oppression were not the sort of material that many advertisers were interested in being printed next to, as they did not seem likely to attract large numbers of consumer-readers. In fact, despite the relative fame of the magazine, it was read by less than a tenth as many readers as *Shufu no tomo*, *Fujin kurabu*, or *Fujin kōron* during the same period; at the same time, the letters from readers and interviews with the participants suggest that it was enormously influential for those who read and wrote for it because of its willingness to print contentious pieces, to show a commitment to feminism and socialism, and to take the strong position of being produced solely by women.

Of course, it is important to remember the potential that was also lost by *Nyonin geijutsu* in its inability to tap into the appeal of mass culture or to make full use of the changes in sexual mores, gender categories, and class identities that were created there. The potential for imagining completely different lives, reading about heroines in intense circumstances, and learn-

ing useful information was valuable to women readers whose surroundings might provide neither occasion to think beyond the immediate nor to obtain knowledge useful to maintain their own health. Again, these pros and cons of the *Nyonin geijutsu* effort suggest the ways questions of resistance through consumption of popular culture break down, as they do not account for the divergent, but never unlimited, ways texts can enable resistance or adherence to the status quo.

The almost complete disappearance of literature, in both the main magazine and the supplement, in the final years seemed a negative answer to the question of whether art and politics activism could mix. It may seem disappointing or misguided, but it is not surprising that such a choice would be made in the months around the Manchurian Incident and in the face of rising militarism, when the exigencies of politics may have seemed just too overwhelming. What is surprising is that so many who look back on this publication read it as a broader answer to that question and simply mourn the loss of good writing to political fiction; in doing so, they accept that the two do not mix. The real loss for *Nyonin geijutsu*, though, was not of real art to political art, but of the ability to see the ways that art was in fact useful or necessary for its own political aims. Without dismissing some of the magazine's important criticisms of the literary world, there is a sense that some participants lost track along the way of their own sophisticated understanding of the mediated rather than direct quality of their efforts. Inasmuch as many of the writings became overly literal in their readings of the reality of society and writing about it, they often lost their ability to capture the imaginations of the people they wished to seduce away from mass culture, or from mass mobilization by the state.

Epilogue

A glossy array of periodicals lines the shelves of Japanese bookstores and newsstands today. The women's magazine section presents, together with *Fujin kōron* and *Shufu no tomo*, a magazine for almost every age group and niche market: *Orange Page (Orenji pēji)* for the young woman learning to cook, *An-an* for the young dating scene, *Bagel* for the health-conscious thirty-something, *EGG* for the wild teenager, *Misty* for the girl seeking to have her fortune told.[1] Although not as numerous, titles also target men, including both aficionados of certain hobbies and those seeking niche-market fashion magazines such as *Samurai*, a guide to the skateboarder look. Today, few publications garner the loyal readership that magazines such as *Shufu no tomo* did; titles come and go swiftly as large publishing companies try new markets and attempt to gain market share through the novelty. Faced with such magazines at a newsstand or convenience store in Japan, or their equivalents elsewhere in the world, we might feel greater cynicism about their content than did readers or contributors in the 1920s, when a sense of potential usually accompanied the familiar concerns about commercialization of culture or bad moral influence.

No longer do we see many signs of the idea espoused by *Fujin kōron*'s publishers that there was inherent value, and even marketability, in providing a forum for complex debates on women's issues. The current *Fujin kōron*, like a few others including *Fujin no tomo*, aims to provide high-level cultural features aimed at women, but nothing is at the level of the articles by public intellectuals printed in the prewar era. The idea that a feminine audience might be a politically interested one is now limited primarily to small independent publications, in large part as a result of the demands of advertisers. We see similar trends in the United States, perhaps best observed in the difficulties faced by *Ms. Magazine*'s struggles for financial support and newsstand space.[2] These changes stem primarily from transformations in the

financial structures of the publishing world, but the loss of the aspiration to produce such publications or the ability to imagine that women might be interested in them also plays a role in their demise.

When thinking about what has changed, we might also ask whether anyone would still go to women's magazines to read fiction—or, given the number of pages devoted to advertising and photography, any sort of written text. Yes, many do turn to them for cutting-edge graphics, creative fashions, and design. But for new fiction, the *manga* or comic-book industry, which makes up the bulk of what can be called serialized fiction today and which has its own sets of genres aimed at women consumers, serves just as commonly as the means for publishing new works for those readers. And, of course, television and, more recently, the Internet and cellular phones continue both to increase the types of cultural materials aimed at gendered audiences and to target demographics more finely and through different financial structures. Fiction has a lesser but still important place in magazine culture, primarily the cultural magazines that announce the major fiction prizes and carry interviews with contemporary authors. Literary magazines read by a broad readership such as *Gunzō* and *Bungei shunju* remain successful as the source for works by winners of the established literary prizes, and readers can purchase them not only at high-end bookstores but also on train platforms and local newsstands. Especially since the 1970s, a group of women writers has made its way into such publications as contributors and critics.[3] Popular novelists also have a place in the newspaper, where they place serialized fiction. Meanwhile, the vibrancy of the so-called *mini komi* publications that fill independent bookstores and libraries suggests the continued interest in independent publishing in the style of *Nyonin geijutsu*.[4] Still, the mixed quality of 1920s publications—the "media mix" as one article on *Shufu no tomo* called it—where radical feminists showed up in a housewife's magazine and where established writers such as Tanizaki Jun'ichirō and Satō Haruo were published together with sewing patterns, seems very much of a different time.[5] What do the material conditions of book and magazine publishing and marketing do to the readering of fiction today? What can we make of the major role of telecommunication companies in the dissemination of fiction through e-books and cell-phone serialized novels, and what formal effects will those institutional and media changes have on the fictional forms of the early twenty-first century? One of my central arguments has been that in order to understand serialized fiction and other magazine writings both literarily and historically, it is important to consider the interaction between their production and consumption and to pay close attention to the form that the writings themselves have taken. As we begin to seek methods for thinking

180 Epilogue

about the meaning of the new media that convey literature today and evaluate what we find there, it is worth remembering the mixtures of forms and genres as they interacted with audiences that we have seen in this book.

In discourses on interwar-era audiences, the woman reader was like a "new colony," as Ōya Sōichi put it, financing the production of an increasing volume of magazines and books and often affecting what or how fiction was published.[6] If we were to seek an equivalent group of eager readers today, it might be the so-called *otaku* or zealous fan; the *otaku* fan now provides a seemingly tireless market for *manga*, anime, and video games with related guidebooks and products.[7] Of course, while some of the concerns about the moral character of these readers are the same, the response remains somewhat different. Interwar-era critics often saw the woman reader as being enlightened through her reading, as we saw in the claims made by *Fujin kōron* contributors and editors, and as taking advantage of a skill born from the newly expanded education system; meanwhile, the large number of contemporary readers interested in nontraditional forms such as comics and cartoons invites fear of declining literacy as image seems to displace text. The metaphor of a colony of new consumers of reading material applies less well, as there is a sense that consumers have only been deferred from one reading material—the traditional printed book—to another—the visual book—rather than creating a new frontier. While some embrace *manga* and its reception as a particularly Japanese form dating back to the early-modern period, many also direct fears at such reading. The question posed by the cartoon "Where Will Women's Magazines Lead Them?" (see figure 1 on page 15) comes up in new forms today as reading material comes into play in seeking explanations for troubling behaviors of Japanese youth, be it school violence, high-profile child-murderer cases, or schoolgirl prostitution.[8] In the economic prosperity of the 1980s, increased importance was placed on the strengths of the Japanese education system as a matter of national pride, so comic books or electronically distributed fiction that might be perceived as reflecting a decline in cultural literacy—accurately or otherwise—become a threat to national identity. The similarities to interwar-era anxieties about print culture, social behavior, gender, and Japanese identity are unmistakable.

Also linking contemporary works of fiction and the magazine texts examined in this book is the way texts, media, and genres commingle in the same spaces. The image of the *otaku* readership is that it relishes mixing of media, genres, and high and low culture. Many anime are pastiches that refer in multilayered ways to texts and events from throughout the twentieth century. For example, both the comic book and movie versions of *Akira* refer

Epilogue 181

simultaneously to the A-bomb, *Godzilla*, protests over renewal of the U.S.-Japan security treaty, 1970s and 1980s motorcycle gangs, and drug culture, and could clearly be called postmodern in the ways Fredric Jameson defines the term.[9] The more recent sensation *Neon-Genesis Evangelion* seems to play self-consciously with the obsessive nature of fans, as it overlays the entire series with an excess of references with which to tempt or taunt them.[10] Such celebrations of mixture have origins in more recent structures of both Japanese consumer culture and genre, but the structure and limitations of the miscellaneous or varied *(zatsu)* texts of the interwar magazine are not irrelevant to thinking about contemporary forms. As we have seen, the effects of this variety can be different depending on a publication's aspirations and ideals, formal qualities, and context: the variety of texts found in *Fujin kōron*, *Shufu no tomo*, and *Nyonin geijutsu* differed in both artistic and lived effects. If we look at *Shufu no tomo* during the Pacific War, for example, its format and history allowed more fiction to be published than in less conservative magazines, which had stricter paper rations and had less emphasized the role of entertainment. With its fictional works in wartime, *Shufu no tomo* provided room for both war criticism on the part of some readers and support for it. For example, stories such as Yoshiya Nobuko's novel about a Japanese man and his affair with a Vietnamese woman were found in the context of dry military articles covering military and government policies in the same area.[11] Both fiction and articles tended to support policies of imperial expansion, but some fiction provided an alternative to more dehumanizing views of people in those places, as well as space for levity in the face of increasing didacticism about self-sacrifice for the nation. At the same time, the lack of any information critical of the government in that publication certainly made a difference in whether readers would question government policies; by contrast, for example, *Fujin kōron* articles did contain material that was critical of the war effort.[12]

Parts of *manga* culture celebrate "complexity" and multilayeredness for their own sakes, but they have a different effect on readers' politics and thinking about postwar history than those that do have an agenda, whether left or right. And the habits of readership that such works encourage, such as whether they provide a meaningful substitute for analysis of new stories or simply distract from current events, make a difference, potentially, in their effects on voting, disaffection, or the rise of nationalism among contemporary youths.[13]

I bring up these parallels not as incidental ones, or as proof of some ongoing tendencies in Japanese culture, but to consider what they might tell

Epilogue

us about approaches taken to popular-culture products and literature. First of all, study of contemporary popular culture has often argued for its importance based on the social phenomena to which its works are linked or on the sheer numbers of audience members. On the one hand, this is as it should be: popular culture is no doubt important for those reasons. But often historical and political context dominates analysis of works, particularly those considered to be popular or conveyed in new media, at the expense of analyzing them using literary critical tools. Like interwar serialized fiction, contemporary mass-culture texts also require a more nuanced approach that considers how the works are imbricated in both the literary and cultural landscape (both high and low) and the media and form in which they are disseminated. Their interest as political, sociological, and artistic phenomena all are best understood with some sense of their formal qualities and of how their media are understood by contemporary critics, authors, and audiences.

On the flip side, thinking about common approaches to contemporary works reminds us of the sense in which those approaches can be productive. People easily accept analysis of historical context, audiences, or media for talking about contemporary literature and film—perhaps because the works have not yet crossed over into a canon, or into future categories of popular or high culture. When we turn to earlier fiction, however, the relationship between such analysis and traditional literary critical modes becomes uneasy, and nervousness about "cultural studies" taking over literary criticism quickly arises. Many have assumed that considering historical matters or cultural conditions means somehow turning attention away from literature. The danger in both cases is that literary and historical analysis becomes an either/or choice, as does analysis of visual and written media. As a result, the difficulties of considering the formal qualities of texts, both literary and polemical, together with their historical context and media form, leave the scholar ill-equipped to make sense of them as either art or history.

That the magazines discussed in this book and their world of interwar women's culture continue to attract attention in the form of reading groups, museum exhibits, and new scholarly studies no doubt stems from the continued saliency of the issues that surround them. Just as people wondered where women's magazines would lead them or what made Ayako of Mizoguchi's *Osaka Elegy* follow a life of delinquency on the advice of a magazine column, so too are people intrigued by the influence of contemporary cultural products on their readers. Ultimately, the interest in such texts lies not so much in vague sociological significance, however, as in the compelling

way those stories are told—that Shimokawa's cartoon makes where the modern girl is going look intriguing and that Mizoguchi renders Ayako's story unforgettable through his filmmaking. It also lies in the sense that women readers and viewers of those texts, or of a magazine like *Nyonin geijutsu*, might be "led" somewhere more interesting than many of their contemporaries would have liked.

Notes

Chapter 1: Reading the Production and Consumption of Women's Magazines

1. Mizoguchi Kenji dir., *Naniwa erejii* (sometimes read *Naniwa hika*), 1936. Murai Ayako is played by Yamada Isuzu, known for her role as the equivalent of Lady Macbeth (Washizu Asaji) in Kurosawa Akira's *Throne of Blood* (*Kumonsu jō*, 1957).

2. For one discussion of debates on morality and women's magazines see Takahashi Tomoko, "Shiryō shōkai: Fujin zasshi kaizen ni tsuite," in Kindai Josei Bunkashi Kenkyūkai, eds., *Fujin zasshi ni miru Taishōki: "Fujin kōron" o chūshin ni* (Tokyo: Kindai Josei Bunkashi Kenkyūkai, 1995), 134–142, which introduces a series of articles about improving women's magazines that were primarily printed in the magazines *Kaizō* and *Chūō kōron* in 1925 and 1926.

3. To take one of many examples, a post–World War II editor of *Shufu no tomo* claimed that the term *shufu* (housewife) itself was created and popularized through his magazine. See Imaida Isao in Imaida Isao and Saigusa Saeko, eds., *Henshūchō kara dokusha e: Fujin zasshi no sekai* (Tokyo: Gendai Jānarizumu Shuppankai, 1967), 32. *Shufu no tomo* editors did not in fact create the term, but they did consciously promote and define the meanings of such terms, as will be discussed in chapter 3. A discussion of the origins of the term can be found in Barbara Satō, *The New Japanese Woman: Modernity, Media, and Women in Interwar Japan* (Durham, N.C.: Duke University Press, 2003), 78–79.

4. I am using Louis Althusser's notion of "interpellation." He writes, "I shall then suggest that ideology 'acts' or 'functions' in such a way that it 'recruits' subjects among the individuals (it recruits them all), or 'transforms' the individuals into subjects (it transforms them all) by that very precise operation which I have called *interpellation* or hailing, and which can be imagined along the lines of the most commonplace everyday police (or other) hailing: 'Hey, you there!'" Magazines texts and titles often engaged in a similar process of formally addressing and thus helping to concretize categories of subjects and to transform individual readers. Louis Althusser, "Ideology and Ideological State Apparatuses," in *Lenin and Philosophy, and Other Essays* (New York: Monthly Review Press, 1971), 174.

186 Notes to Pages 4–7

5. Maeda Ai. "Taishō kōki tsūzoku shōsetsu no tenkai: Fujin dokusha no dokusha-sō." *Bungaku*, June and July 1968. My citations throughout this book are from the reprint in *Kindai dokusha no seiritsu* (Tokyo: Iwanami Shoten, 1993). See also Rebecca Copeland's translation as "The Development of Popular Fiction in the Late Taishō Era: Increasing Readership of Women's Magazines," in Maeda Ai, *Text and the City: Essays on Japanese Modernity*, ed. James Fujii (Durham, N.C.: Duke University Press, 2004), 163–219. Rebecca Copeland, *Lost Leaves: Women Writers of Meiji Japan* (Honolulu: University of Hawai'i Press, 2000); Joan Ericson, *Be a Woman: Hayashi Fumiko and Modern Japanese Women's Literature* (Honolulu: University of Hawai'i Press, 1997); Barbara Satō, *The New Japanese Woman*; Jan Bardsley, *The Bluestockings of Japan: Feminist Essays and Fiction from "Seitō," 1911–1916* (Ann Arbor, Mich.: Center for Japanese Studies, 2007).

6. Harry Harootunian, *Overcome by Modernity: History, Culture, and Community in Interwar Japan* (Princeton, N.J.: Princeton University Press, 2000); Barbara Satō, *The New Japanese Woman*; Miriam Silverberg, "Constructing the Japanese Ethnography of Modernity," *Journal of Asian Studies* 51, no. 1 (February 1992): 30–42.

7. It is in large part because of the groundbreaking work by such scholars as Sharon Sievers (see *Flowers in Salt: The Beginnings of Feminist Consciousness in Modern Japan* [Stanford, Calif.: Stanford University Press, 1983]), Copeland, Ericson, and Bardsley that this approach is possible.

8. Publishers did not keep circulation figures very carefully, and censorship department reports are one of the best sources of information. In that government agency's report of 1927, *Shufu no tomo* is estimated at 230,000 copies, *Fujin kōron* at 25,000. Changes in marketing raised *Fujin kōron*'s sales dramatically around 1929. Naimushō Keihōkyoku, "Shinbun zasshi oyobi tsūshinsha ni kansuru chō" (manuscript, 1927), 24. Facsimile edition in *Shinbun zasshisha tokuhi chōsa* (Tokyo: Taishō Shuppan, 1979). The first edition of *Shufu no tomo* that was censored was June 1924. The corporate history describes the editor's state of shock at having to recall the 300,000 copies when forbidden to sell them. Shufunotomosha, ed., *Shufunotomosha no gojū nen* (Tokyo: Shufunotomosha, 1967), 98.

9. Maeda, *Kindai dokusha*, 217. See also Ericson, *Be a Woman*, 42.

10. Naimushō Keihōkyoku, "Shinbun zasshi," 24–26; Nagamine Shigetoshi, *Zasshi to dokusha*, 8.

11. Nagamine, *Zasshi to dokusha*, 163–164.

12. The magazine was founded a year earlier under the name *Jogaku shinshi*, which failed, but was revived the next year as *Jogaku zasshi*. Rebecca Copeland analyzes in depth the ideas of its editors and the role of *Jogaku zasshi* in Meiji-era women's writing in *Lost Leaves*.

13. Produced by the Meiroku society and totaling forty-three issues, the average edition was approximately twenty pages long with a circulation of about 3,200. Some discussion of these texts can be found in Sievers, *Flowers in Salt*, 16–25. For an English translation see *"Meiroku Zasshi": A Journal of Japanese Enlightenment*,

translated and with an introduction by William Reynolds Braisted, assisted by Adachi Yasushi and Kikuchi Yūji (Cambridge: Harvard University Press, 1976).

14. The blank in women's writing between the Heian-period greats, such as Murasaki Shikibu, and the modern period is somewhat of a myth in the literary history of Japan, more a result I think of the quality of early women writers than of the later lack. For example, see Furuya Tomoyoshi, ed., *Edo jidai joryū bungaku zenshū*, 4 vols. (Tokyo: Nihon Tosho Sentā, 1979; original publication, 1919). This area requires considerable further study in English.

15. For an excellent analysis of *koshinbun* in English see Christine Marran, "The Allure of the Poison-Woman in Modern Japanese Literature" (Ph.D. dissertation, University of Washington, 1998), 35–44.

16. In terms of literacy, it has been argued that the shift from a large quantity of kana phonetic writing in the Tokugawa period to more ideographs associated with Meiji-period writing may have lowered the literacy rates for a time in the late nineteenth century; see Hirata Yumi, "Onna no koe o hiro," *Shisō* 845 (1994): 190–191. I would note, however, that by the 1920s a large number of texts provided a pronunciation gloss for all characters.

17. There is a large literature on *genbun'itchi* and modern Japanese literature. For one of the most sophisticated discussions in English see Karatani Kōjin, *The Origins of Modern Japanese Literature*, trans. Brett de Bary (Durham, N.C.: Duke University Press, 1993).

18. Christian and prohibitionist magazines included *Fujin kyōfū zasshi* (Women's reform magazine, 1888–1944), and *Haishō* (Abolition of prostitution, 1890–1891). Magazines about women's education were also common, such as *Fujin kyoiku zasshi* (Women's education magazine, 1888–1892) and *Dai Nihon fujin kyoikukai zasshi* (Great Japanese women's education magazine, 1888–1937), which was edited at one point by Hani Motoko, who went on to form the long-running periodical *Fujin no tomo*.

19. Both publications were stopped during part of World War II, but have since been revived. An excellent close reading of one issue of *Fujin gahō* from 1906 can be found in Jordan Sand, "Was Meiji Taste in Interiors 'Orientalist'?" *Positions* 8, no. 3 (2000): 637–673.

20. Hani's ideas are summarized most concisely in Saitō Michiko, "Hani Motoko no shisō: Kaji kakeiron o chūshin ni," in *Onna tachi no kindai*, ed. Kindai Joseishi Kenkyūkai (Tokyo: Kashiwa Shobō, 1978), 144–170, and at greater length in Saitō Michiko, *Hani Motoko: Shōgai to shisō* (Tokyo: Domesu, 1988). In English, materials available are Hani Motoko, "Stories of My Life," *Japan Interpreter* 12, no. 3–4 (1979): 330–354; Noriko Shimada et al., "Ume Tsuda and Motoko Hani: Echoes of American Cultural Feminism in Japan," in *Remember the Ladies: New Perspectives on Women in American History*, ed. Carol V. R. George (Syracuse, N.Y.: Syracuse University Press, 1975); Chieko Irie Mulhern, "Japan's First Newspaperwoman: Hani Motoko," *Japan Interpreter* 48, no. 1 (1979): 310–329. For discussion of her ideas about the Japanese middle class and family see Mark Alan Jones, "Children as Trea-

188 Notes to Pages 9–12

sures: Childhood and the Middle Class in Early 20th Century Japan" (Ph.D. dissertation, Columbia University, 2001).

21. Copeland, *Lost Leaves*; Sievers, *Flowers in Salt*; Kindai Josei Bunka Kenkyūkai, eds., *Fujin zasshi no yoake* (Tokyo: Ōzorasha, 1989); Horiba Kiyoko, "*Seitō*" *no jidai: Hiratsuka Raichō to atarashii onna tachi* (Tokyo: Iwanami Shinsho, 1988); Katō Keiko, "Josei to jōhō: Meijiki no fujin zasshi kōkoku o tsūjite," *Keiō Gijuku Daigaku Shinbun Kenkyūjo nenpō* 32 (1989): 31–58.

22. Shin Feminizumu Hihyō No Kai, eds., "*Seitō*" *o yomu* (Tokyo: Gakujutsu Shorin, 1998).

23. Bardsley, *The Bluestockings of Japan*.

24. Nihon Zasshi Kōkoku Kyōkai Kinō Kaihatsu Iinkai, *Zasshi kōkoku no riron to jitsumu* (Tokyo: Nihon Zasshi Kōkoku Kyōkai, 1975), 14.

25. Ie-No-Hikari Association, "Nenshi" (Timeline), http://www.ienohikari.or.jp/prof/08.html (accessed July 1, 2004).

26. Yanagida Kunio, "Kairyō wa konnan de nai" (Reform is not difficult), *Ie no hikari* 4, no. 10 (October 1928): 6–10; facsimile edition, Tokyo: Fuji Shuppan, 1994–.

27. *Journal of Business Girls: Fujin to bijinesu*, Founded July 1928, *Fusen*, January 1927–December 1935; facsimile edition, Tokyo: Fuji Shuppan, 1992–1994. Later in its publication, the name *Fusen* was changed to *Josei tenbō* (Women's outlook). These are included in the reprints by Fuji publishers.

28. Yoshiya Nobuko, ed., *Kuroshōbi* 1–8 (January 1925–August 1925): facsimile edition, Tokyo: Fuji Shuppan, 2001.

29. Rebecca Copeland, *Sound of the Wind: The Life and Works of Uno Chiyo* (Honolulu: University of Hawai'i Press, 1992): 55–63.

30. Yahagi Katsumi, "Kindai ni okeru yōranki no shuppan ryūtsū: Meiji shonen–Meiji 20 nendai e," *Shuppan kenkyū* 12 (1981): 113–119. On the related role of the development of railways, see Steven J. Ericson, *The Sound of the Whistle: Railroads and the State in Meiji Japan* (Cambridge: Council on East Asian Studies, Harvard University, 1996); Alisa Freedman, "Tracking Japanese Modernity: Commuter Trains, Streetcars, and Passengers in Tokyo Literature, 1905–1935" (Ph.D. dissertation, University of Chicago, 2002).

31. On use of wooden and metallic movable type see Peter Kornicki, *The Book in Japan: A Cultural History from the Beginnings to the Nineteenth Century* (Honolulu: University of Hawai'i Press, 2001), 165. For a discussion of the history of Japanese newspapers in English see James L. Huffman, *Creating a Public: People and Press in Meiji Japan* (Honolulu: University of Hawai'i Press, 1997).

32. Nagamine, *Zasshi to dokusha*, 11.

33. Unattributed quote, ibid., 12.

34. Nihon Zasshi Kōkoku Kyōkai Kinō Kaihatsu Iinkai, *Zasshi kōkoku no riron to jitsumu*, 13–14.

35. *Gendai Nihon bungaku zenshū* (Anthology of Contemporary Japanese Literature), 63 vols. (Tokyo: Kaizōsha, 1926–1931). See Edward Thomas Mack II, "The

Value of Literature: Cultural Authority in Interwar Japan" (Ph.D. dissertation. Harvard University. 2002).

36. Copeland. *Lost Leaves*. 46–49. 215–225.

37. Gaylyn Studlar. "The Perils of Pleasure? Fan Magazine Discourse as Women's Commodified Culture in the 1920s." *Wide Angle* 13. no. 1 (1991): 7: Jennifer Bean, "Introduction." *A Feminist Reader in Early Cinema* (Durham. N.C.: Duke University Press. 2002). 9.

38. Changes in the mail system and the introduction of a third-class mail rate were also major factors. with cheaper periodical rates allowing for broader circulation of national publications. These increases in advertisements were also enabled by increased circulation itself. since higher rates could be charged for advertising to this larger audience.

39. The terms used are *rajioteki zasshi* and *tōkiteki zasshi*: see Satō Takumi. *Kingu no jidai: Kokumin taishū zasshi no kōkyōsei* (Tokyo: Iwanami. 2002). 199–322. For a discussion of Japanese radio history in English see Gregory Kasza. *The State and the Mass Media in Japan. 1918–1945* (Berkeley: University of California Press. 1988). 72–101. 252–265.

40. Ijima Tadashi. *Eiga no kenkyū* (Film research) (Tokyo: Yumani Shobō. 1995). 59: original publication Tokyo: Kōseikaku Shoten. 1929.

41. The cartoon also mentions Saijō Yaso (1892–1970: poet. professor of French. and author of popular song lyrics): Kume Masao (novelist and critic who wrote many popular novels for women's magazines): "a second Hatano Akiko" (*Fujin kōron* reporter who committed double suicide with writer Arishima Takeo: see chapter 2): Matsuoka Fudeko. Natsume Sōseki's eldest daughter who married writer Matsuoka Yuzuru. a relationship that became the basis for Kume Masao's *Hasen*. serialized in *Shufu no tomo*.

42. The survey response can be found in Kyoto Shiyakusho Shakaika. *Shokugyo fujin ni kansuru chōsa* (Kyoto: Kyoto Shiyakusho. 1927). 59. Similar surveys were taken in Tokyo and provide many comments about reading habits. Examples of reading at work and during a commute abound. One example is an observation by a columnist who sees women reading newspapers and magazines on the train during his commute: see Shimada Seihō. "Bungeiran." *Journal of Business Girls*. August 1927.

43. Miriam Silverberg. "The Modern Girl as Militant." in *Recreating Japanese Women. 1600–1945*. ed. Gail Lee Bernstein (Berkeley: University of California Press. 1991). 239–266: Barbara Hamill Satō. "The *Moga* Sensation: Perceptions of the *Modan Gāru* in Japanese Intellectual Circles during the 1920s." *Gender and History* 5. no. 3 (1993): 363–381.

44. A detailed discussion of the education acts and school facilities can be found in Herbert Passim. *Society and Education in Japan* (New York: Teachers College Press Columbia University. 1965). 62–99. By 1901 each prefecture was required to provide one upper school for girls.

45. Kurosawa Ariko, "Shukkyo suru shōjotachi," in *Taishū no tōjō: Hirō to dokusha no nijū-sanjū nendai*, ed. Ikeda Hiroshi, 70; vol. 2 of *Yomikaeru bungaku shi* (Tokyo: Impakuto Shuppankai, 1998).

46. This was a common practice in mass-market publications until after World War II when the number of kanji characters used was limited and an increased number of simplified characters came into use. But whether a periodical or book did or did not include phonetic markings for all characters was a marker of how wide and educated an audience it targeted. Most literary magazines, for example, did not include full pronunciation, marking only some difficult characters or characters that might have ambiguous readings (such as names). For some statistics on women's primary and secondary education at this time see Ericson, *Be a Woman*, 22–23.

47. A brief but thorough discussion of the history of the Japanese advertising industry is provided in Brian Moeran, *A Japanese Advertising Agency: An Anthropology of Media and Markets* (Honolulu: University of Hawai'i Press, 1996), 5–11; a chronology is provided in the same, 298–305.

48. Useful analysis of the department store in English can be found in Louise Young, "Marketing the Modern: Department Stores, Consumer Culture, and the New Middle Class in Interwar Japan," *International Labor and Working-Class History* 55 (1999): 52–70; also Brian Moeran, "The Birth of the Japanese Department Store," in *Asian Department Stores*, ed. Kerrie L. MacPherson (Honolulu: University of Hawai'i Press, 1998), 141–176.

49. For a thorough history of the "cultured house" and "cultured life" as historical phenomena, see Jordan Sand, *House and Home in Modern Japan: Architecture, Domestic Space, and Bourgeois Culture, 1880–1930* (Cambridge: Harvard University Asia Center, 2003).

50. Available in English as *Naomi*, trans. Anthony Chambers (New York: Knopf, 1985).

51. Minami Hiroshi, ed., *Taishō bunka* (Tokyo: Keisō Shobō, 1965), 13, 50–51.

52. Ann Ardis, ed., *Women's Experience of Modernity, 1875–1945* (Baltimore, Md.: Johns Hopkins University Press, 2003). Two of the seminal works in this area are Rita Felski, *The Gender of Modernity* (Cambridge: Harvard University Press, 1995), and Andreas Huyssen, *After the Great Divide: Modernism, Mass Culture, Postmodernism* (Bloomington: Indiana University Press, 1986).

53. For example, Aono Suekichi, "Josei no bungakuteki yōkyū," in *Tenkanki no bungaku*, Kindai bungei hyōron sōsho (Tokyo: Nihon Tosho Sentā, 1990), 1:312–313 (original publication, Tokyo: Shunjunsha, 1927); Hirabayashi Hatsunosuke, "Bunka no joseika," *Josei*, April 1929, 20–28. These figures are discussed in English in works such as Miriam Silverberg, "The Modern Girl as Militant"; idem, "Constructing a New Cultural History of Prewar Japan," in "Japan in the World," ed. Masao Miyoshi and H. D. Harootunian, special issue, *Boundary* 2, no. 3 (1991): 61–82; Barbara Satō, *The New Japanese Woman*; Harry D. Harootunian, *History's Disquiet: Modernity, Cultural Practice, and the Question of Everyday Life* (New York: Columbia University Press, 2000), and *Overcome by Modernity*.

54. Huyssen, *After the Great Divide*, 52.

55. Felski, *Gender of Modernity*, 21.

56. Huyssen, *After the Great Divide*, 47.

57. Sievers, *Flowers in Salt*, 15. I should note that Miriam Silverberg has also taken an interest in this comment, citing it in "The Modern Girl as Militant," 264.

58. For a general discussion of *joryū bungaku* see Joan E. Ericson, "The Origins of the Concept of 'Women's Literature,'" in *The Woman's Hand: Gender and Theory in Japanese Women's Writing*, ed. Paul Gordon Schalow and Janet A. Walker (Stanford, Calif.: Stanford University Press, 1996), 74–115; and for a discussion of Hayashi's work in particular, Ericson, *Be a Woman*, 92–108. *Hōrōki*'s first installment was in 1928; Hayashi continued to add to the work for several decades, and there are numerous versions as discussed in chapter 4.

59. Of course none of these is actually "Western" in any simple sense, but were often understood as such through what were taken to be markers of these figures in apparently Western-inspired fashions, hairstyles, or behaviors.

60. I am referring to Yoshiya Nobuko, whom I discuss in chapter 3. She once wrote to her partner, Monma Chiyo, "Chiyo-san, I have finally made up my mind, and want to go full speed ahead with my work, my writing. This will be what some people refer to as 'commonplace fiction' *(tsūzoku shōsetsu)*. To put it differently, long works that can provide something for the general populace *(minshū)*. In doing so, I hope to create and reveal something as beautiful and as just *(tadashii)* as I possibly can." In Yoshitake Teruko, *Nyonin Yoshiya Nobuko* (Tokyo: Bungei Shunjū, 1986), 29–30. Some of the words used at the time that might be translated as "mass" or "popular" include *tsūzoku*, *taishū*, and *minshū*.

61. John Guillory, *Cultural Capital: The Problem of Literary Canon Formation* (Chicago: University of Chicago Press, 1993). Guillory's important argument is, of course, inspired by Pierre Bourdieu's writings on cultural, symbolic, and material capital. Guillory focuses on the role of the university and school as the determiners of literary value; I would argue that this was negotiated in periodicals in the interwar era. Edward Mack's dissertation has a much more sustained analysis of modern Japanese literature in these terms; see "The Value of Literature."

62. For discussion of the history of this distinction see Matthew C. Strecher, "Purely Mass or Massively Pure? The Division between 'Pure' and 'Mass' Literature," *Monumenta Nipponica* 51, no. 3 (1996): 357–374.

63. Some recent examples in criticism of Japanese literature include Seiji M. Lippit, *Topographies of Modernism* (New York: Columbia University Press, 2002); William O. Gardner, "Mongrel Modernism: Hayashi Fumiko's *Hōrōki* and Mass Culture," *Journal of Japanese Studies* 29, no. 1 (2003): 69–101; Thomas LaMarre, "The Deformation of the Modern Spectator: Synaesthesia, Cinema, and the Spectre of Race in Tanizaki," *Japan Forum* 11, no. 1 (1999): 23–42; Livia Monnet, "Montage, Cinematic Subjectivity, and Feminism in Ozaki Midori's *Drifting in the World of the Seventh Sense*," *Japan Forum* 11, no. 1 (1999): 57–82.

192 *Notes to Pages 21–26*

64. Part of *Chijin no ai* was printed in *Josei. Tokai no yu'utsu, Sasameyuki,* and *Izu no odoriko* in *Fujin kōron; Hōrōki* in *Nyonin geijutsu.*

65. Lippit. *Topographies,* 27.

66. Ericson. "The Origins of the Concept of 'Women's Literature.'" 91–92.

67. Kobayashi Hideo. "Onna no yūjo" (A female friend). *Bungakkai,* December 1936. Discussed in Kurosawa Ariko. "Shōjotachi no chikadōmei: Yoshiya Nobuko no *Onna no yūjo* o megutte." *New Feminism Review* 2 (May 1991): 81–95.

68. Maeda. *Kindai dokusha,* 211, 214, 228.

69. Felski. *Gender of Modernity,* 121.

70. Nan Enstad. *Ladies of Labor, Girls of Adventure: Working Women, Popular Culture, and Labor Politics at the Turn of the Twentieth Century* (New York: Columbia University Press, 1999). 121.

71. Ibid., 124.

72. A famous example of the effects of emotional literature is a book about factory girls and their songs whose popularity likely has affected thinking about the treatment of workers and labor policy toward women to the present day: Hosoi Wakizō. *Jokō aishi* (The sad history of factory girls) (Tokyo: Kaizōsha, 1925).

73. Silverberg. "The Modern Girl as Militant." 250.

74. Ibid., 264–266.

75. Stephen Heath and Gillian Skirrow. "An Interview with Raymond Williams." in *Studies in Entertainment: Critical Approaches to Mass Culture,* ed. Tania Modleski (Bloomington: Indiana University Press, 1986), 14.

Chapter 2: Serious Reading

1. There is almost no research discussing prewar *Fujin kōron* in English at this time. For a discussion of the magazine in the postwar see Jan Bardsley. "What Women Want: *Fujin Kōron* Tells All in 1956." *U.S.-Japan Women's Journal.* English supplement, no. 19 (2000): 7–48.

2. Advertising insert for *Fujin kōron, Chūō kōron,* December 1916.

3. *"Fujin mondai"* is generally used in the sense of contentious women's issues, and in today's parlance "women's issues" would be a good translation. I have chosen the translation "woman problem" here based on the English from the same period as the original. The question of how best to translate *fujin* is a difficult one as well. As Tani Barlow has shown in her discussion of the same term in China, it implies a woman placed in a set of relationships of family rather than a member of the sex "woman" as the modern term *nuren* (rather equivalent to *josei* in Japanese usage) did. "Lady" can reflect this sense of woman enmeshed in social and familial relationships, as well as the implication that such women were married or of marriageable age. But it is important to remember that the term was also used by many radical feminists even though *josei* was the chosen term for some. Tani E. Barlow. "Theorizing Woman: *Funü, Guojia, Jiating* (Chinese woman, Chinese state, Chinese

family)," in *Body, Subject, and Power in China*, ed. Angela Zito and Tani Barlow (Chicago: University of Chicago Press, 1994), 253–289.

4. Chūō Kōronsha, ed., *"Fujin kōron" no gojū nen* (Tokyo: Chūō Kōronsha, 1965), 149.

5. Simply limiting examples to women's magazines themselves, more visually striking and innovative popular culture materials can be found in the other major magazines of the Taishō period: *Shufu no tomo* (covered in the next chapter), *Fujin kurabu*, *Fujin gahō*, and *Fujin sekai*. In addition, there are wonderful materials to be found among cartoon magazines, advertising posters, and graphic arts magazines. This sort of material is not the primary focus in the argument here, however.

6. Miki Hiroko, *"Fujin kōron* no hakkō jōkyō ni kansuru hito kōsatsu," in *Fujin zasshi ni miru Taishōki: "Fujin kōron" o chūshin ni*, ed. Kindai Josei Bunkashi Kenkyūkai (Tokyo: Kindai Josei Bunkashi Kenkyūkai, 1995), 12–40, shows this through a detailed statistical analysis of contributors by gender. The first woman editor in chief, Saigusa Saeko, was appointed in 1958.

7. The nonitalicized version of Chūō Kōron with *sha* (company) attached refers to the publishing company rather than the magazine *Chūō kōron* itself. The company Chūō Kōronsha publishes *Chūō kōron*, *Fujin kōron*, and, now, a large number of other magazines. It also was and is a major publisher of books. Many compare the new format to that of newsweekly *Aera* and see this as an attempt to create a "women's *Aera*."

8. Even more recently Matsuda has married again. This time she chose a dentist, forcing the disappointed scandal papers to make hay of the relative banality of her choice.

9. *Fujin kōron*, March 1998, 13.

10. Here "younger" refers to women in their late twenties to forties, rather than the forty-plus audience of previous years. Ishimoto Shizue, *Facing Two Ways: The Story of My Life* (New York: Farrar and Rinehart, 1935), 237. Her reference to the magazine as popular suggests her class; although it was more broadly popular in the 1930s when she wrote the article than in the early 1920s, it was most likely to have been widely read among her upper-class and highly educated circle of friends during the whole period than by other classes of women.

11. Shimoda Jirō et al., "Nihon fujin no kekkon tekirei," *Fujin kōron*, January 1916, 36–48; Nitobe Inazō, "Gaikoku fujin o tsuma ni mochite," Ijinrui kekkon no hōmu, *Fujiin kōron*, February 1916, 10–12.

12. The magazine hired a man experienced in marketing women's magazines, Takanobu Kyōsui, who instituted these measures. Chūō Kōronsha, ed., *"Fujin kōron,"* 97.

13. Discussed in Sievers, *Flowers in Salt*, 173–174, and Bardsley, *The Bluestockings of Japan*.

14. Although *atarashii onna* has become the key term for this figure, the contemporary journalists used a variety of phrases—*atarashii josei*, *atarashii fujin*, *shin-*

Notes to Pages 31–32

fujin—which all have slightly different valences. The point is that it is overly limiting to confine histories of the discourse on modern women to a few key terms, such as *atarashii onna* and the later "modern girl" *(modan gāru/moga)*, when this period saw an explosion of new terms for male and female roles and lifestyles.

15. The *Chūō kōron* special issue in 1913 was called "Special Edition on Women's Issues" (Fujin mondai gō tokushū).

16. This tendency is most strongly seen in the sketchier histories of feminism found in textbooks and surveys of modern history. The *Fujin kōron* corporate history does not limit itself to that trajectory completely but does have many references to *Seitō* in its opening pages. Chūō Kōronsha, ed., "*Fujin kōron*," 7. Although she does end with a chapter on *Seitō*, Sharon Sievers, in her groundbreaking history of the early years of the feminist movement, *Flowers in Salt*, shows the multifaceted quality of the women's press. More explicitly, Vera Mackie's recent book does much to dispel the dominant influence of *Seitō* through her thorough analysis of the socialist women's movement at the beginning of the century; see Vera Mackie, *Creating Socialist Women in Japan: Gender, Labor, and Activism, 1900–1937* (Cambridge: Cambridge University Press, 1997).

17. Jon Halliday, *A Political History of Japanese Capitalism* (New York: Monthly Review Press, 1975), 114.

18. Yoneda Sayoko, *Kindai Nihon josei shi* (Tokyo: Shin Nihon Shuppansha, 1972), 129.

19. Murakami Nobuhiko, *Taishōki no shokugyō fujin* (Tokyo: Domesu Shuppan, 1983), 22.

20. "Joshi shokugyō shirabe," *Fujin kōron*, January–December 1916. This feature series in the Chishiki section gave one report each month about such jobs as telephone operator, café waitress, store clerk, actress, and model. Of careers covered, café waitress and geisha were probably those jobs least likely to be pursued by readers of Taishō-era *Fujin kōron*, and the tone of these pieces emphasized tragic situations and degradation, whereas the other articles were focused more on information about the details of the job, the pay, and how to go about being getting hired. Of course, even in these cases there were details and sensationalist comments that played on the voyeurism of some readers about these new occupations. By the mid-1920s, readers of *Fujin kōron* would have been more likely to include café waitresses, both because of the rise in literacy and the popularization of this particular magazine. I have found no information on geisha reading *Fujin kōron* in the prewar era, but it does not seem particularly unlikely to have been read among the top-end geisha, who were often highly literate.

21. Sometani Hiromi, "*Fujin kōron* no shisō: Keiseiki ni okeru," in *Onna tachi no kindai*, ed. Kindai Joseishi Kenkyūkai (Tokyo: Kashiwa Shobō, 1978), 172. For an in-depth discussion of performances of Ibsen in Japan see Ayako Kano, *Acting like a Woman: Theater, Gender, and Nationalism* (New York: Palgrave, 2001), especially 183–218.

22. Shimanaka Yūsaku, *Kaikō go jū nen* (Revising fifty years) (1935), quoted in Sometani, "*Fujin kōron* no shisō," 174.

Notes to Pages 32–38　195

23. Nagamine. *Zasshi to dokusha*, 184.

24. Ibid., 174–176.

25. All circulation figures are taken from the December 1927 report by the police overseeing publishing and censorship: Naimishō Keihōkyoku, ed., *Shinbun zasshi tsūshinsha ni kansuru chōsa*, as compiled in Miki Hiroko, "Taishōki no josei zasshi: Hataraku onna no kikanshi o chūshin ni," in *Taishōki no josei zasshi*, ed. Kindai Josei Bunkashi Kenkyūkai (Tokyo: Ōzorasha, 1996), 8.

26. Nagamine. *Zasshi to dokusha*, 193. One of the most famous girls' magazines was *Shōjo sekai* (Girls' world): an easier magazine to read would be *Shufu no tomo* (see chapter 3).

27. See Moeran, *Japanese Advertising Agency*, 5–11; a chronology is provided in the same, 298–305.

28. The advertisement also promotes books by Yamakawa Kikue and Mushashino Kōji. *Fujin kōron*, October 1919. Arishima's novel is available in translation: *A Certain Woman*, trans. Kenneth Strong.

29. Many discussions of beauty itself, including the writings of Takamure Itsue discussed later in this chapter, dealt with its political implications. Meanwhile, an early contributor, Yūhara Gen'ichi, showed an interest in how beauty was connected to culture, suggesting respectively that Japanese women were less beautiful than Western women because of lack of education and refinement. Yūhara Gen'ichi, "Yōbōbi no fukkyū" (Restoring our good looks). *Fujin kōron*, August 1916, 11–19 (Kōron). Note: pagination for early *Fujin kōron* issues began at one in each section. Therefore my notes will mark the section in parentheses—(Shōsetsu), (Kōron), etc.

30. Guillory, *Cultural Capital*.

31. This analysis will not linger on the Chishiki and Jiron sections. A historian of science or psychology could do an interesting analysis of the articles on women's health, sexology, and psychology in the Chishiki section, but such analysis is outside the purview of this book. The material in Jiron largely overlaps in style and topic with the Kōron section. The title marked these articles (usually one per issue) as closely linked to current events or social trends.

32. I have found no evidence about advertising practices for the magazine so this can only be supposition. Yet in comparison with magazines of similar circulations and content, the small number of advertisements is striking.

33. This was expressed as "low-level interests" *(teikyū naru shumi)* rather than with the term "mass" *(taishū)*, not yet in common use at the time of *Fujin kōron's* founding.

34. Felski, *The Gender of Modernity*, 3.

35. This is the form taken by many of the major texts of Japanese feminism, although the formative role of this publishing practice is often forgotten. Two examples of debates such as this are the motherhood protection debate among Yosano Akiko, Hiratsuka Raichō, Yamakawa Kikue, and Yamada Waka in 1918 and Yamakawa Kikue and Takamure Itsue's love debate in 1928, which was also a debate over socialism and anarchism and will be discussed later in this chapter.

36. Among criticisms, Doi Koge's *Bunmeiron onna daigaku* (Greater learning for women and a theory of civilization) encouraged women to be liberated from the home and to be given freedoms equal to those of men because they were all the same as citizens under the emperor. In *Gakumon no susume* (Invitation to learning), Fukuzawa Yūkichi provided a critique of *Onna daigaku*'s call for women's obedience but was less critical of conventional marriage in his later writings. *Shin onna daigaku hyōron* (New criticism of *Onna daigaku*) and *Shin onna daigaku* (New *Onna daigaku*). Many of these texts are analyzed in Muta Kazue, "Senryaku to shite no onna: Meiji, Taishō no 'Onna no gensetsu' o megutte," *Shisō* 812 (1992): 216–217.

37. One essay per month was published by writers in the following order: Miyake Setsurei, Sawayanagi Masatarō, Ukita Kazutami, Yamaji Aizan, Kamata Eikichi, Inoue Tetsujirō, Takashima Heisaburō, Abe Isō, Naruse Jinzō. *Fujin kōron*, January–September, 1916. Miyake Setsurei (1860–1945) was the husband of author Miyake Kaho and a cultural critic who often weighed in on questions of Westernization. Sawayanagi Masatarō (1865–1927) admitted a woman to Tōhoku Imperial University in 1911 while serving as its president, and while in the Ministry of Education promoted nationalized textbooks and compulsory primary education. Ukita Kazutami (1859–1946) was active as both an educator and a journalist. A graduate of Doshisha University, he studied at Yale (1892–1894) and taught politics and Western history at Doshisha and Waseda universities in Japan; from 1909–1917 he was editor in chief of *Taiyō* magazine and became a major liberal public intellectual. Yamaji Aizan (1864–1917) was a Christian thinker who wrote regularly for *Kokumin no tomo* (Friend of the citizens) in the Meiji period. He became a supporter of imperialism and nationalism and was a cofounder of the Kokkai Shakai party. His translation of *The Courtship of Miles Standish* appeared in *Jogaku zasshi* in 1891–1892. Some of his writings can be found in English in Yamaji et al., *Essays on the Modern Japanese Church* (Ann Arbor: University of Michigan Center for East Asian Studies, 1999). Kamata Eikichi was president of Keiō University for much of the early twentieth century. He also served as minister of education in the early 1920s. Inoue Tetsujirō took courses at Tokyo University with Ernest Fenollossa and was a cofounder of the *Far Eastern Academic Journal* (*Tōyō gakugei zasshi*, 1882–1930). After studying in Germany in the 1880s, he returned to Japan and was active in denouncing Christianity from a nativist perspective. Abe Isō (1865–1949) was a frequent contributor to women's magazines and discussions of women's issues, particularly birth control. He penned the first article printed in *Fujin kōron*, "Gendai fujin no yuku beki michi" (The path that contemporary women should follow), which among other things advocated female suffrage. A professor at Waseda from 1903 to 1927, he was also an active leader in Japanese socialism. Discussed in English in Elise Tipton, "In a House Divided: The Japanese Christian Socialist Abe Isoo," in *Nation and Nationalism in Japan*, ed. Sandra Wilson (London: RoutledgeCurzon, 2002), 81–96. Several of these thinkers are discussed in Kenneth Pyle, *The New Generation in Meiji Japan: Problems of Cultural Identity, 1885–1895* (Stanford, Calif.: Stanford University Press, 1969).

38. The editor is not named, but these articles, like many in this magazine, were introduced by a paragraph or two in small print, presumably written by an employee of the magazine.

39. Kamata, *Fujin kōron*, May 1916, 44 (Kōron).

40. Abe, *Fujin kōron*, August 1916, 48 (Kōron).

41. Yamaji, *Fujin kōron*, April 1916, 40 (Kōron).

42. Inoue, *Fujin kōron*, June 1916, 54 (Kōron).

43. Fukurai Yūkichi, "Hisuterii no hanashi" (A discussion of hysteria), *Fujin kōron*, August 1916, 26–28 (Kōron); Takashima Heisaburō, "'Shitto' no shinrigakuteki kenkyū" (Psychological research on jealousy), *Fujin kōron*, January–May 1916 (Kōron).

44. Yamamura Gunpei, "Onna hanzaisha to furyō shōjo" (Women criminals and delinquent girls), *Fujin kōron*, August 1916, 30–39 (Setsuen); Yamamura Gunpei, "Wakai onna no daraku no keiro," *Fujin kōron*, July 1916, 16–25 (Setsuen).

45. This idea appears in several of the articles and is a major theme in the contribution of Naruse Jinzō, president of Japan Women's University (Nihon joshi daigaku): *Fujin kōron*, September 1916, 51–52 (Kōron).

46. Sawayanagi, *Fujin kōron*, February 1916, 38 (Kōron).

47. Takashima, *Fujin kōron*, July 1916, 35 (Kōron).

48. Ibid., 36.

49. Indeed, presenting such household science and popular psychology in print was the focus of the Chishiki section of *Fujin kōron* and was the central purpose of *Shufu no tomo* (see chapter 3).

50. Abe, *Fujin kōron*, August 1916, 44 (Kōron).

51. Barbara Satō, *The New Japanese Woman*. The Kantō earthquake of 1923 marked a shift in Tokyo urban culture as the rebuilding of the city urged new utopian visions. At the same time, others experienced a great cynicism about the promise of modernity. Triumphs of urban architecture were destroyed, and widespread violence broke out, with political radicals and Korean residents killed in the aftermath of the earthquake. These events are seen by many historians to have marked a shift toward elements of decadent culture, mourning of coherent traditions, and art movements that grew out of this atmosphere. The importance of this earthquake to "Taishō culture" is also a thesis Minami's cultural history of the Taishō period: Minami Hiroshi, ed., *Taishō bunka* (Tokyo: Keisō Shobō, 1965).

52. Inoue, *Fujin kōron*, June 1916, 52 (Kōron).

53. Abe, *Fujin kōron*, August 1916, 31 (Kōron).

54. Inoue, *Fujin kōron*, June 1916, 52 (Kōron).

55. Sawayanagi, *Fujin kōron*, February 1916, 39 (Kōron).

56. Kathy Peiss, *Cheap Amusements: Working Women and Leisure in Turn-of-the-Century New York* (Philadelphia: Temple University Press, 1986).

57. For example, *Fujin kōron*, May 1916, 52 (Kōron).

58. Yamaji, *Fujin kōron*, April 1916, 45 (Kōron).

59. Inoue, *Fujin kōron*, May 1916, 49 (Kōron).

60. Yamaji, *Fujin kōron*, April 1916, 45 (Kōron).

61. Abe, *Fujin kōron*, August 1916, 39 (Kōron).

62. Yamaji, *Fujin kōron*, April 1916, 4 (Kōron).

63. Yamaji, *Fujin kōron*, April 1916, 4 (Kōron).

64. Harootunian, *Overcome by Modernity*, 165–166.

65. Efforts in Meiji, such as the *Meiroku Magazine (Meiroku zasshi)*, also had similar discussions of women's issues, but the goal of reaching a female audience was much stronger in *Fujin kōron* and arguably altered the sense of purpose for the intellectuals writing in it.

66. Yamaji, *Fujin kōron*, April 1916, 44 (Kōron). Each rule is described at greater length in the text.

67. Yamaji, *Fujin kōron*, April 1916, 39 (Kōron).

68. Miki Hiroko, "*Fujin kōron* no hakkō jōkyō," 12–40.

69. *Fujin kōron*, September 1916.

70. Participants in the debate included Yosano Akiko, Hiratsuka Raichō, and Yamakawa Kikue. Yamakawa's September 1928 article "An Argument Against Both Yosano and Hiratsuka" was her first submission to *Fujin kōron*, where she would go on to write countless articles.

71. A discussion of this debate has come out recently in English: E. Patricia Tsurumi, "Visions of Women and the New Society in Conflict: Yamakawa Kikue versus Takamure Itsue," in *Japan's Competing Modernities: Issues in Culture and Democracy, 1900–1930*, ed. Sharon A. Minichiello (Honolulu: University of Hawaiʻi Press, 1998), 335–357. Another related exchange between the women appeared in the journal *Fujin undō* (Women's movement) in 1928: Yamakawa, "Musan fujin undō ni tsuite tachiba wo akiraka ni suru" (Making clear my position on the anarchist women's movement), and Takamure, "Musan kaikyu to fujin—tsutsushinde Yamakawa Kikue joshi ni tatematsuru" (Anarchism and women: A modest offer to Yamakawa Kikue). It focuses on proletarian women and politics and does not involve the topics of beauty and love covered in *Fujin kōron*.

72. "Keihin tsuki tokkahin to shite no onna," *Fujin kōron*, January 1928; reprinted in Yamakawa Kikue, *Yamakawa Kikue shū* (Tokyo: Iwanami, 1982), 5:2 (hereafter, *YK shū*).

73. *YK shū*, 5:2.

74. *YK shū*, 5:7–8.

75. Miriam Silverberg demonstrates that there was both an intellectual and a journalistic discourse creating this concept of the "modern girl" and also the activities of women such as the participants in *Nyonin geijutsu* who in some sense constructed their own meaning of the term through their activities: "The Modern Girl as Militant," 239–266.

76. *YK shū*, 5:5.

77. *YK shū*, 5:5.

78. *YK shū*, 5:6.

79. *YK shū*, 5:8.

80. Takamure Itsue, "Yamakawa Kikue no ren'ai kan o nanzu," *Fujin kōron*, May 1928; reprinted in *Fujin undō no tan'itsu taikei* (Tokyo: Seigabō, 1975), 70–84.

81. In reading Takamure's critique of Marxism it is important to remember that she had not likely read Marx at all. She also seems to misunderstand certain ideas, such as confusing Marxist characterizations of capitalism with Marxist ideas for a postrevolutionary society. She tends to lump all Marxist thinkers and people involved in the Russian Revolution together without much subtlety. Thus, it seems most effective to read her questioning of Marxism not so much as a sustained critique of its theories but as a criticism of certain concepts she has picked out of the general discourse on Marxism to which she has been exposed, though this does not mean that her ideas fail to level interesting critiques at Marxist thinkers.

82. Takamure, "Yamakawa Kikue no ren'ai kan," 82.

83. Ibid., 81.

84. "Ie de no shi," in Patricia Tsurumi, "Feminism and Anarchism in Japan Takamure Itsue, 1894–1964," *Bulletin of Concerned Asian Scholars* 17, no. 2 (1985): 7.

85. Takamure, "Yamakawa Kikue no ren'ai kan," 83.

86. It is not clear who this "famous Marxist" is. My sense is that she is not quoting a Japanese Marxist, and certainly not Yamakawa, although the implication is that as a Marxist she might agree with this.

87. Takamure, "Yamakawa Kikue no ren'ai kan," 83.

88. Takamure Itsue, "Bijin ron: Tokai hiteiron no hitotsu," *Fujin sensen*, October 1930, 19.

89. For example, Akiyama Kiyoshi, *Jiyū onna ronsō: Takamure Itsue no anakizumu* (Tokyo: Shisō no Kagakusha, 1973), 66. He notes that these issues were also pushed aside in the *ana-boru* (anarchist-Bolshevik) debate, which might be seen as a spin-off from Yamakawa and Takamure's debate, in *Nyonin geijutsu*.

90. Takamure Itsue, "Fumareta inu ga hoeru: Futatabi Yamakawa Kikueshi ni," *Fujin kōron*, July 1928; reprinted in *Fujin undō no tan'itsu taikei* (Tokyo: Seigabō, 1975), 85–100.

91. Shimoda Yasaburō, "Takamure Itsuesan ie de no isho" (Takamure Itsue's leaving home note); Miyake Yasuko et al., "Jinbutsu hyōron: Yamakawa Kikue joshi" (Reviews of personalities: Ms. Yamakawa Kikue), *Fujin kōron*, October 1925, 44–52, 143–150 (Shumi).

92. Emphasis in original. The emphasized term is *genron no jiyū* (literally, "freedom of discussion"), which is used broadly to express ideas such as freedom of speech and of the press.

93. "Jizen ka gizen ka" (Philanthopy or philosophy), *Fujin kōron*, November 1919, 34 (Kōron).

94. "Jokyōshi no fungai" (The anger of women teachers), *Fujin kōron*, November 1919, 38–39 (Kōron).

95. Ibid., 39.

96. Advertisement, *Chūō kōron*, December 1916.

97. Strong trans., *A Certain Woman*.

200 *Notes to Pages 57–61*

98. For example, it is mentioned in the 1932 Yoshiya Nobuko novel *Sora no kanata e* (To the yonder edge of the sky), discussed in chapter 3, and more recently the book and television versions of Watanabe Jun'ichi's 1996 novel *Shitsurakuen* (Paradise lost), serialized in *Asahi shinbun*, which placed this suicide as the inspiration for a 1990s couple having a love affair to kill themselves.

99. "Mōshi wake dake ni," in *Ai to sei no jiyū: "Ie" kara no kaihō*, Shisō no umi e, vol. 20, ed. Esashi Akiko (Tokyo: NRK Shuppanbu, 1989), 140; original publication May 1916. All of the letters are republished in the Shisō no umi e volume. The other letters were Kamichika, "Mittsu no koto dake," *Onna no sekai*, May 1916; and Ōsugi Sakae, "Hito jōfu ni ataete nyōbō ni taisuru teishu no shinjō o kataru bun," *Onna no sekai*, June 1916. Original copies of these issues of *Onna no sekai* are difficult to locate.

100. "Jiyū ren'ai no gisei to natta watashi no kokuhaku," *Shufu no tomo*, January 1920. In her essay, she talks about the original appeal of Ōsugi's ideas about free love and her subsequent disillusionment, which she contemplated while in prison for stabbing him. She writes that having turned to her mother for support, she has found a new appreciation for the importance of family and the importance for her of art rather than socialism. *Fujin kōron* also covered Kamichika's imprisonment with an article by a woman reporter who interviewed her in prison soon before her release. Hattori Keiko, "Kamichika Ichiko no shukkoku o demukau no ki," *Fujin kōron*, November 1919, 68–72 (Shumi).

101. Akutagawa Ryunosuke, "Hatano Akikosan no inshō" (Impressions of Hatano Akiko), *Fujin kōron*, August 1923, 103 (Shumi).

102. "Hatano Akikosan no inshō," *Fujin kōron*, August 1923: Murō Saisei, 103; Uno Kōji, 100 (Shumi).

103. "Hatano Akikosan no inshō," *Fujin kōron*, August 1923, 99–100 (Shumi). "Edokko" refers to descendants of early residents of Edo, the present-day city of Tokyo, often associated with various stereotyped characteristics.

104. "Hatano Akikosan no inshō," *Fujin kōron*, August 1923, 124–125 (Shumi).

105. "Hatano Akikoshi no rei ni agete issai o akiraka ni" (Making it all clear in Hatano Akiko's honor), *Fujin kōron*, August 1923, 66–87 (Shumi); reprinted in *Arishima Takeo zenshū* (Tokyo: Chikuma Shōbo, 1988), 16:905–923.

106. Yanagisawa Ken, in "Arishima Takeo shi jōshi jiken hihan" (A criticism of Arishima Takeo's love suicide), *Fujin kōron*, August 1923, 53–55 (Kōron); reprinted as "Arishima-shi no shi ni taisuru sehyō ni tsuite," in *Arishima Takeo zenshū*, 16:899. Yanagisawa had a distinguished career as a diplomat working in the French consulate and as chargé d'affaires to the ambassador to Portugal. Simultaneously he published his poetry and was involved with the journals *Mirai* and *Kuroneko*.

107. Nagamine, *Dokusha to zasshi no kindai*, 195 (table 19).

108. Advertisement, *Chūō kōron*, December 1916.

109. For example, Tokuda Shūsei's short story "Okeshō suki" (She likes makeup), *Fujin kōron*, April 1920, 52–66 (Shōsetsu). This whole special issue was called "Beauties and Cosmetics" and also included many articles on the theme.

Notes to Pages 62–65 201

110. Advertisement, *Chūō kōron*, December 1916.

111. "Fujin no dokusho," *Fujin kōron*, July 1917, 26.

112. For an extended analysis of Miyake's work and publication practices surrounding it see Copeland, *Lost Leaves*, 52–98.

113. Ibid., 98. Interestingly, *Jogaku zasshi*, like *Fujin kōron*, engaged in complex efforts to present writings to audiences according to gender of reader and writer, presenting them in separate spheres, such as the red and white covers of 1892–1893; see ibid., 45–46.

114. Takada Hiroshi, "Musume no yomu beki shomotsu," *Fujin kōron*, July 1917, 40.

115. It is unclear whether *daraku* refers to the decadents, or more generally to fiction the critic sees as debauched and depraved.

116. Noma Gozō in "Musume no yomu beki shomotsu," *Fujin kōron*, July 1917, 43.

117. An English translation of the pair of works was printed as "Gloom in the Country" and "Gloom in the City" in Satō Haruo, *The Sick Rose: A Pastoral Elegy*, trans. Francis B. Tenny (Honolulu: University of Hawai'i Press, 1993). More literally, *den'en* (here "country") can be translated as "garden city" or even "suburb." The publishing history of the first work is complex. At first it was published in the magazine *Kokuchō* in June 1917 under the title *A Sick Rose (Yameru bara)*. In September 1918 a revised version together with a continuation of the story was published in *Chūgai* under the title *Den'en no yu'utsu*. In 1919, Satō wrote a charming comment on the problems he had created by rewriting and renaming the work: "Kaisaku *Den'en no yu'utsu* no ato ni" (After the revised *Melancholy in the Country*), in *Gendai Nihon bungaku zenshū* (Anthology of contemporary Japanese literature) (Tokyo: Kaizōsha, 1927), 29:396–398. Since they are excellent, I will use Tenny's translations except when my own can better explicate a certain point. For an excellent, short introduction to Satō in English see Elaine Gerbert, "Introduction," in Satō Haruo, *Beautiful Town: Stories and Essays by Satō Haruo*, trans. Francis B. Tenny (Honolulu: University of Hawai'i, 1996), 1–30. For a discussion of the "garden city" in the context of women's culture see Mariko Inoue, "Regendering Domestic Space: Modern Housing in Prewar Tokyo," *Monumenta Nipponica* 58, no. 1 (Spring 2003): 84–91. See also Sarah Teasley, "Home-Builder or Homemaker? Reader Presence in Articles on Homebuilding in Commercial Women's Magazines in 1920s Japan," *Journal of Design History* 18, no. 1 (2005): 81–97.

118. Quoted by Suwa Saburō, "Kaisetsu" (Commentary), in *Meiji Taishō Bungaku zenshū* (Anthology of Meiji and Taishō literature), vol. 40 (Tokyo: Shunyūdō, 1929), 606–607.

119. Ibid., 509.

120. Ibid., 508.

121. Ibid.

122. Lippit, *Topographies*, 7.

202 Notes to Pages 66–74

123. Satō. *The Sick Rose*. 137: Japanese in Satō Haruo. *Teihon Satō Haruo zenshū* (Kyoto: Rinsen. 1998). 4:157–158.

124. Miagi Shin'ichi. "Hito odoriko no ochite itta michi." and Andō Fumiko. "Kageki joyū to shite no watashi no seikatsu." *Fujin kōron*. March 1918. 30–37. 54–56 (Shumi).

125. Satō. *The Sick Rose*. 138.

126. Ibid.. 121.

127. Ibid.. 125.

128. My translation. *Gendai bungaku zenshū*. 29:401. Ellipses in original. Cf. Satō. *The Sick Rose*. 124.

129. My translation. *Teihon Satō Haruo zenshū*. 4: 196–197. Cf. Satō. *The Sick Rose*. 183.

130. Satō. *The Sick Rose*. 19. Ellipses in original.

131. Published in *Fujin kōron* September 1917 to June 1918. Citations here are taken from *Tanizaki Jun'ichirō zenshū* (Tokyo: Chūō Kōronsha. 1967). 5:1–160.

132. For a discussion of Meiji-era *katei shōsetsu*. see Ken Itō. "Class and Gender in a Meiji Family Romance: Kikuchi Yuho's *Chikyodai*." *Journal of Japanese Studies* 28. no. 2 (2002): 339–378.

133. For an example of a parallel romance. see the discussion of Yoshiya Nobuko's *Sora no kanata e* in the next chapter.

134. *Tanizaki Jun'ichirō zenshū*. 5:40–44.

135. Ibid.. 5:131.

136. Ibid.. 5:24.

137. See Thomas LaMarre. "The Deformation of the Modern Spectator." 23–42.

138. Takamure Itsue. "Yamakawa Kikue no ren'ai kan o nanzu."

139. *Naomi*. Chambers trans.. 3. Tanizaki himself referred to *A Fool's Lore* as a "kind of *watakushi shōsetsu* [I-novel]." and Ken Itō points out that "the comment drips with irony. for the *watakushi shōsetsu*, or 'I-novel.' the dominant form for serious writing during the twenties. was as different from *Chijin no ai* as any type of fiction could ever be." *Visions of Desire: Tanizaki's Fictional Worlds*. 78.

140. The film version of this novel oddly returns to the *katei shōsetsu* ending with a cheerier result to her search for a husband. The implied love interest between the husband of one sister and another sister also seems to be out of a romance novel that assumes the only reason for not marrying is love of another person. *Sasameyuki* was first serialized in *Chūō kōron* in 1943 but was stopped after three installments by wartime censorship. The novel was completed in 1948 with portions serialized in *Fujin kōron*. It became a best seller.

141. Some of Tanizaki's serialized works were not finished. including *Mermaid* (Kōjin). discussed by Itō. *Visions of Desire*. 65–74.

142. LaMarre. "The Deformation of the Modern Spectator": Joanne Bernardi. "Tanizaki Jun'ichirō's 'The Present and Future of the Moving Pictures.'" in *Currents in Japanese Culture: Translations and Transformations*. ed. Amy Vladeck Heinrich (New York: Columbia University Press. 1997). 291–308.

143. Reprinted in *Hirotsu Kazuo zenshū* (Tokyo: Chūō Kōronsha, 1973–1974), 5:7–242. A sequel called *Kimiyo no maki* was also serialized in *Fujin kōron*.

144. Kōno Kensuke, "Hirotsu Kazuo: Nengetsu no ashioto / zoku nengetsu no ashioto," in Kōno Kensuke, ed., *Hirotsu Kazuo: nengetsu no ashioto*, Sakka no jiden (Tokyo: Nihon Tosho Sentā, 1998), 65:287.

145. Ibid., 151.

146. He makes this claim in an afterword to the book printed in his collected works, Hirotsu Kazuo, *Hirotsu Kazuo chōsakushū* (Tokyo: Tōyō Bunka Kyōkai, 1959), 324. He does not claim that he uses her narrative word-for-word, but writes that it mimics the style of her speech and is directly based on her story.

147. Hirotsu's recollections on *Fujin kōron* and his relationship with Shimanaka can be found in Hirotsu Kazuo, *Hirotsu Kazuo zenshū*, 5:516–519. Those remarks were originally published in *Fujin kōron*, November 1958.

148. See Miriam Silverberg, "Nihon no jokyū wa burūsu o utatta," in *Jyendā no Nihonshi*, vol. 2, ed. Wakita Haruko and Susan B. Hanley (Tokyo: Tokyo University Shuppankai, 1995), 585–606, and in English "The Café Waitress Serving Modern Japan," in *Mirror of Modernity: Invented Traditions of Modern Japan*, ed. Stephen Vlastos (Berkeley: University of California Press, 1998), 208–228; Elise Tipton, "The Café: Contested Space of Modernity in Interwar Japan," in *Being Modern in Japan: Culture and Society from the 1910s to the 1930s*, ed. Elise Tipton and John Clark (Honolulu: University of Hawai'i Press, 2000), 119–136.

149. Mitsuyo Wada-Marciano's analysis of the film suggested this connection to me. Her presentation was at the symposium "Far from Silent," Tufts University, April 22, 2004.

150. Kikuchi, besides being a both popular and well-respected writer, was founder of *Bungei shunju*, a literary magazine still printed today.

151. Hirotsu's account of the matter does not specify the newspaper. There were articles about the dispute by Kikuchi, Hirotsu, and others in *Fujin kōron* itself. The longest description of the events is found in Hirotsu's essay "Kikuchi Kan," in *Hirotsu Kazuo chōsakushū*, 6:94–102.

152. Ibid., 6:96.

153. Hirotsu thinks that Shimanaka did not really mean his statement to be taken literally. He notes that it is very "like Kikuchi" to think that Shimanaka really meant he would risk the company for the case. Ibid., 100.

154. Of course, the question arises whether Hirotsu was still writing during serialization or had finished it before submission. Shibukawa Hiroshi argues that Hirotsu's statement, "I finally fulfilled my promise to Shimanaka to write something for his magazines and took *Jokyū* over to Chūō Kōronsha," means that he wrote the novel in full before submitting it. Really the quote does not prove any such thing, as it does not indicate whether he refers to the first installment or the entire book. Shibukawa's argument is found in his "Kaisetsu," in *Hirotsu Kazuo chōsakushū*, 5:4 (Special insert).

155. Ibid., 4–5. She begins to show "admiration" for Yoshimizu partway through the story; ibid., 5:97.

204 Notes to Pages 77–84

156. Tamura Toshiko, "Tsuyako no ie de," *Fujin kōron*, January 1916, 22–38 (Shōsetsu).

157. Miyamoto Yuriko, *Fujin to bungaku: Kindai Nihon no fujin sakka* (Tokyo: Jitsugyō no Nipponsha, 1947), 7–8. This has been discussed and cited by Ericson, "The Origins of the Concept," 95. The Meiji-period equivalent of this phenomenon is discussed in Copeland, *Lost Leaves*.

158. Ericson, "The Origins of the Concept."

159. Nogami Yaeko in "Musume no yomu beki shobutsu," *Fujin kōron*, July 1917, 54.

160. See chapter 3.

161. For a study of Uno Chiyo, see Copeland, *Sound in the Wind*.

162. Ozaki Midori, *Tei hon Ozaki Midori zenshū* (Authoritative collected works of Ozaki Midori) (Tokyo: Chikuma Shobō, 1998), 2:94–96.

163. Kōno, "Hirotsu Kazuo: Nengetsu no ashioto," 287.

164. The following discussion of this *shashin shōsetsu* is found in a longer form in Sarah Frederick, "Novels You Can Watch/Movies You Can Read: Visual Narrative in 1930s Women's Magazines," *2000 AJLS Annual Proceedings: Acts of Writing: Language and Identities in Japanese Literature*, Fall 2001, 254–274.

165. Okada Saburō, *Pari: Hangyakusha no kokuhaku* (Paris: Confessions of a rebel) (Tokyo: Shinchōsha, 1924), and *Dare ga ichiban baka ka?* (Who is the stupidest?), Modan-ha kessakushū, vol. 2 (Tokyo: Sekiroshobō, 1930). In his humorous preface to the *conte* collection he notes that critics in the newspaper arts section had made fun of his use of this foreign word to mark his writing, but that it had now become all the rage in Japan, even in the same art sections.

166. Okada, "Wakatsuma no yu'utsu," *Fujin kōron*, September 1931, 41.

167. I find useful here Mary Ann Doane's analysis in *The Emergence of Cinematic Time: Modernity, Contingency, and the Archive* (Cambridge: Harvard University Press, 2002) in combination with her discussions of women's film in "The 'Woman's Film': Possession and Address," in *Re-Vision: Essays in Feminist Film Criticism*, ed. Mary Ann Doane, Patricia Mellencamp, and Linda Williams (Frederick, Md.: University Publications of America, 1984), 67–82.

Chapter 3: Writing Home

1. Shufunotomosha, ed., *Shufunotomosha no gojū nen*, 41. The name Takeyoshi is often read as Takemi since that is the most common pronunciation of the characters that make up his name, which was misrecorded on his birth records. Publicly, he came to be known as Takemi, but his official and personal name was read Takeyoshi, and his writings are catalogued that way at the publisher's library. I am basing my romanization on that practice. Both could be considered correct, and there is little consistency among scholars: Barbara Satō uses "Takemi" in *The New Japanese Woman*. I will refer to the magazine by its name *Shufu no tomo* in italics and the

company as Shufunotomosha, its corporate name. They use one word for the romanization when publishing their line of books in English.

2. Today's *Shufu no tomo* magazine is not nearly as successful as it was in its early years: its audience has narrowed to a segment of housewives interested in home budgeting and crafts, and there is more competition from other publishers for this readership. The publisher remains quite successful, however, with its more diversified group of books and magazines aimed at various market segments.

3. Harootunian, *Overcome by Modernity*, 95, 100.

4. Jordan Sand, "The Cultured Life as Contested Space: Dwelling and Discourse in the 1920s," in *Being Modern in Japan: Culture and Society from the 1910s to the 1930s*, ed. Elise K. Tipton and John Clark (Honolulu: University of Hawai'i Press, 2000), 99–118, and *House and Home in Modern Japan: Architecture, Domestic Space, and Bourgeois Culture, 1880–1930* (Cambridge: Harvard University Asia Center, 2003): Silverberg, "Constructing the Japanese Ethnography of Modernity," 30–54: Harootunian, *History's Disquiet*, 11.

5. Benedict Anderson, *Imagined Communities* (New York: Verso, 1983). My description of this community is as one more "anchored" and "congealed" than Anderson's notion of the "imagined community." In a sense the *Shufu no tomo* community too is rather loose, in fact, being geographically and even in gender diverse, but not so much so in ideal.

6. Shiozawa Minobu, "Nihon no shuppankai o ugokasu 12 ka (5) Ishikawa-ka: Media mikusu ni kakeru *Shufu no tomo*," *Chishiki* 77 (May 1988): 160–170.

7. Several recent studies have reflected on the question of what sorts of alternative possibilities and spaces this type of publication might have permitted. Barbara Satō presents a cautiously positive view of the self-awareness, comfort, and escape from social mores that many women found through reading and writing alternative life narratives in this magazine: "An Alternate Informant: Middle-class Women and Mass Magazines in 1920s Japan," in *Being Modern in Japan: Culture and Society from the 1910s to the 1930s*, ed. Elise K. Tipton and John Clark (Honolulu: University of Hawai'i Press, 2000), 137–153. In the same volume, Vera Mackie suggests that the housewife's life was increasingly routinized and delineated along strict gender lines, but that we should also study the "resistance and excess" in art that may tell alternatives stories: "Modern Selves and Modern Spaces," 185–199.

8. Hani Motoko founded *Fujin no tomo* (first under the name *Katei no tomo*) and the Jiyū Gakuen school that remain today. She felt that a woman should manage the household and thus elevate her status: her control over the domestic sphere would be parallel to men's activity in the public sphere. While Hani Motoko's message had been anticommercial, Ishikawa's magazine strove to combine this elevation of the housewife with the editor's enormous ambitions for commercial success. A full-length discussion of Hani Motoko's efforts can be found in Saitō Michiko, *Hani Motoko*.

9. Shufunotomosha, ed., *"Shufu no tomo" no gojūnen*, 18–20, 31–41.

206 *Notes to Pages 87–90*

10. Minami Hiroshi, ed., *Taishō bunka*, 274, describes the way Frederick Winslow Taylor's system of "standardized movement" was incorporated in the textile and other industries to double production between 1918 and 1926.

11. Imai Seiichi, *Nihon no rekishi* (Japanese history), vol. 23, *Taishō demokurashii* (Taishō democracy) (Tokyo: Chūō Kōronsha, 1971), 104, shows the rise in prices clearly in a table format while his text discusses the social and cultural influence of these trends. Yamamura Kozo, "The Japanese Economy, 1911–1930: Concentration, Conflicts, and Crises," in Bernard S. Silberman and H[arry]. D. Harootunian, *Japan in Crisis: Essays on Taisho Democracy* (Princeton, N.J.: Princeton University Press, 1974), 307, demonstrates the dramatic drop in real daily earnings of both men and women in various industries between 1916 and 1919.

12. Sheldon Garon, *Molding Japanese Minds* (Princeton, N.J.: Princeton University Press, 1997), 15; idem, "Women's Groups and the Japanese State: Contending Approaches to Political Integration, 1890–1945," *Journal of Japanese Studies* 19, no. 1 (1993): 5–41.

13. For a discussion of women's role in the 1910s and 1920s economy including the rice riots see Mark Metzler, "Woman's Place in the Great Depression: Reflections on the Moral Economy of Deflation," *Journal of Japanese Studies* 30, no. 2 (2004): 315–352.

14. *Shufu no tomo* texts and images often alluded to the fashionable nature of such architecture, but the magazine generally used the term *bunka jūtaku* to emphasize the rationalization of domestic space. *Bunka jūtaku* has been used elsewhere to describe much less practical set-ups such as that found in Tanizaki's *Chijin no ai*, available in English as Tanizaki Jun'ichirō, *Naomi*, trans. Anthony Chambers (New York: Knopf, 1985). For further discussion of *bunka jūtaku* and women's magazines see Sarah Teasley, "Home-Builder or Homemaker? Reader Presence in Articles on Homebuilding in Commercial Women's Magazines in 1920s Japan," *Journal of Design History* 18, no. 1 (2005): 81–97; Jordan Sand, "The Cultured Life as Contested Space."

15. Shufunotomosha, ed., *Shufunotomosha no gojū nen*, 2. Although this statement was written in 1967 for the fifty-year corporate history, it represents with surprising accuracy the outlook of the publishers during the magazine's first twenty years.

16. Ibid., 33.

17. For example, Shufunotomosha, ed., *Shufunotomosha no gojūnen* and *Shufunotomosha no hachijū nenshi* (Tokyo: Shufunotomosha, 1996). Ishikawa Takeyoshi, *Shinnen no ue ni tatsu: Shufu no Tomosha no keiei* (Tokyo: Shufunotomosha, 1926), and *Fu'un yori kōfuku e* (Tokyo: Shufunotomosha, 1926). Most writings can be found in *Ishikawa Takeyoshi zenshū* (Tokyo: Shufunotomosha, 1980). Ishikawa commonly made comments comparing Japan negatively to other nations particularly over the question of efficiency and domestic science. He often praised the American housewife in this regard.

18. "San nin no kodomo o hakushi to shita mibōjin no kushin," *Shufu no tomo*, March 1917.

19. Hinku no naka ni gonin no danji o sodateta senman chōja no haha. *Shufu no tomo*, September–December 1919.

20. Yosano Akiko touched off the debate by arguing that such support by the state, just like reliance on support by one's husband, constituted a "slave morality" that she termed "dependency-ism" *(iraishugi)* (*Fujin kōron*, March 1918). Although she did accept the value of insurance for women who were ill and unable to work, she insisted throughout that healthy women should focus on developing their own skills in order to support themselves without relying on men or the state (*Yokohama bōeki shinpō*, April 20, 1919). To grant economic support for motherhood alone was to overemphasize this sex-determined role while demeaning a woman's other talents. Hiratsuka Raichō responded that these goals were unrealistic except for exceptionally talented women such as Yosano and that the state should provide economic compensation for mothers (*Fujin kōron*, May 1918). Socialist feminist Yamakawa Kikue criticized both women. She felt that Yosano overstated the potential of "personal effort" to overcome systemic social problems. She wrote, meanwhile, that Hiratsuka's focus on support based on a gender-role difference rather than the overall transformation of the social system was only a temporary solution to the low wages and bad work conditions that women and mothers faced (*Fujin kōron*, September 1918). Yamada Waka, meanwhile, argued that women should focus on being good wives and wise mothers and support their husbands' earning potential rather than seek individual achievement. She felt that "dependency" on the husband or the state was "her right" (*Fujin kōron*, September 1918). One of many summaries and discussions can be found in Barbara Molony, "Equality versus Difference: The Japanese Debate over 'Motherhood Protection,' 1915–50," in Janet Hunter, ed., *Japanese Women Working* (New York and London: Routledge, 1993), 122–148.

21. Minami, ed., *Taishō bunka*, 338.

22. *Ishikawa Takeyoshi zenshū*, 6:337–338.

23. Ishikawa Takeyoshi, "*Shufu no tomo* henshū nikki," in *Ishikawa Takeyoshi zenshū* (Tokyo: Shufunotomosha, 1986), 6:8.

24. For example, *Ishikawa Takeyoshi zenshū*, 6:13; original publication, *Shufu no tomo*, April 1926.

25. *Ishikawa Takeyoshi zenshū*, 6:333.

26. Ibid., 355. The fifteen rules detail such points as how far to stand from the toilet, turning on the light when using the room at night, and how to use a Western toilet. Interestingly, the ladies room at the women-only library run by the company provided a large number of warning signs, such as "Please do not wash your hair in the sink." That library location was closed in 2003 and has been reopened in a different building in the Ochanomizu area.

27. Ibid., 331.

28. Shufunotomosha, ed., *Shufunotomosha no gojū nen*, 41.

29. Naimushō Keihōkyoku, "Shinbun zasshi."

30. Nagamine Shigetoshi, "Senzen no josei dokusho chōsa: Jokō, shokugyō fujin, jogakusei o chūshin ni," *Shuppan kenkyū* 19 (1988): 44–46.

208 *Notes to Pages 94–100*

31. Another group of women who worked for wages is not included in these surveys: *geisha* and prostitutes. I have yet to find statistics on the reading habits of this group. Ibid., 47.

32. Ibid., 43.

33. Today such a strategy would likely be impossible on this scale. There are publications available to target so many of the existing market segments and identities that a single magazine with "housewife" in the title would be unlikely to draw in single college students, for example.

34. Barbara Satō, *The New Japanese Woman*, 114–151.

35. The corporate history notes that their particular printing company, Nisshin Insatsu, owned an especially good set of such movable type. The system was still somewhat labor intensive as a separate stamp was required for each different reading of the same kanji character. Shufunotomosha, ed., *"Shufu no tomo" no gojū nen*, 131.

36. Ibid., 51.

37. For example, the front section of the March 1927 issue of *Shufu no tomo* has a photograph of author Onoe Hachirō sitting in his new house. Other photographs on the same page show various rooms and architectural details of the home. Such examples are innumerable.

38. From a 1921 survey of factory workers in the Tokyo metropolitan area conducted by the Social Bureau of the Tokyo government. Results printed in Nagamine, *Zasshi to dokusha*, 177.

39. Nagamine, "Senzen no josei dokusho chōsa," 44–46.

40. With the one-yen book and pocketbook movements, reading published books also became cheaper. And there seems to have been a common practice of sharing books and selling used books in the countryside and colonies. A thorough discussion of this history can be found in Mack, "The Value of Literature." Still, *Shufu no tomo* usually had installments from at least three serialized novels, short stories, humorous anecdotes, poems, and comic strips in each issue—quite a lot of reading material for the price.

41. The January edition had only Eastern Japan and Western Japan sections: the February edition, a full five sections. The ostensible reason for stopping this practice was that it was against the regulations for third class mail, but it is thought that the real reason was too many returns of unsold copies. Shufunotomo, ed., *Shufunotomosha no gojūnen*, 112–113.

42. One description of Sazanami and the Otogi Club in English is in Nakano Makiko, *Makiko's Diary*, trans. Kazuko Smith (Stanford, Calif.: Stanford University Press, 1995), 52–53.

43. The use of *tomo* in magazine titles was certainly not limited to this case. *Katei no tomo* (Home friend), *Fujin no tomo* (The woman's friend), and *Shōjo no tomo* (Girl's friend) are just a few of the other publications with similar titles. This trend very much corresponds with a move to mass-market publications and to those that provide some form of practical information for women. As in the case of *Shufu no tomo*, such titles reproduced an illusion of intimacy with readers.

44. For a discussion of modernism and the commercial art world see Gennifer Weisenfeld, "Japanese Modernism and Consumerism: Forging the New Artistic Field of *Shōgyō bijutsu*," in *Being Modern in Japan: Culture and Society from the 1910s to the 1930s*, ed. Elise K. Tipton and John Clark (Honolulu: University of Hawai'i Press, 2000), 75–98.

45. Matsuda Tomitaka in Shufunotomosha, ed., *Shufunotomosha no gojū nen*, 224.

46. For a discussion of the development of *Nihonga* see Ellen Conant, Steven Owyoung, and J. Thomas Rimer, *Nihonga, Transcending the Past: Japanese-Style Painting, 1868–1968* (Saint Louis, Mo.: Saint Louis Art Museum, 1995). Although originally at some odds, by the interwar period conflict between the Nihonga and *yōga* schools was not the primary one in the art community. As Gennifer Weisenfeld puts it, "A new antagonism had developed between conservative and progressive forces within each community of painters. This led to mutual support of like-minded artists across *yōga*-Nihonga boundaries." *MAVO: Japanese Artists and the Avant-Garde, 1905–1931* (Berkeley: University of California Press, 2002), 273, n. 36.

47. The Hakubakai, founded in 1896, was the dominant school of oil painting. It was sometimes referred to as the "purple school" (*murasaki ha*), and its adherents were considered "new." Some of their strongest Western influences include Van Gogh and Cézanne, though in general they were unified more by their rejection of certain rules about matters such as uses of color rather than by styles they held in common. One recent study that discusses this group is Satō Dōshin, "*Nihon bijutsu*" *tanjō: Kindai Nihon no "kotoba" to senryaku* (The birth of "Japanese art": The strategies of modern Japanese "language") (Tokyo: Kodansha, 1996), 166–167. Relationships between such schools and commercial art are discussed in Weisenfeld, "Japanese Modernism and Consumerism," 75–98.

48. Shufunotomosha, ed., *Shufunotomosha no hachijū nenshi*, 22.

49. Ibid., 119.

50. "'Donzoku kakei' kara saishuppatsu!! monogatari" (Story of a fresh start!! from a bankrupt family), *Shufu no tomo*, December 2002, 18–23.

51. Anne Friedberg, *Window Shopping: Cinema and the Postmodern* (Berkeley: University of California Press, 1993), 80–81.

52. Just one example is February 1930, with three-line jokes and stories starting in the advertising section and continuing scattered throughout the front portion of the magazine, which was devoted primarily to advertisements and photo essays.

53. Roland Marchand, *Advertising the American Dream: Making Way for Modernity, 1920–1940* (Berkeley: University of California Press, 1985), 140–148.

54. Weisenfeld, "Japanese Modernism and Consumerism."

55. Katō Keiko, "Taishōki ni okeru fujin zasshi kōkoku," *Keiō Gijuku Daigaku Shinbun Kenkyūjo nenpō* 40 (1993): 60. These statistics are originally from Mannensha's *Kōkoku nenpan* for 1927. It began publishing such statistics in 1925.

56. Ibid., 43. All issues in 1925 carried this heading in the index of advertisers. For example, June, 2.

210 Notes to Pages 114–118

57. Ibid., 44. Not only would obviously big-ticket items have been difficult for families with low incomes to afford, but even cosmetics and soap that we might think of as inexpensive would have been out of their price range.

58. The striking cover image for Barbara Satō's book *The New Japanese Woman* is also taken from a light-bulb advertisement.

59. Shufunotomosha, ed., *"Shufu no tomo" no gojū nen*, 65. This also suggests the suspicion the state held toward such enterprises, as indicated also by reports of the Censorship Bureau, which tried to keep track of the nature and use of products (particularly those related in some way to sexuality or contraception) advertised in popular magazines.

60. Rajio reā advertisement, *Shufu no tomo*, September 1920.

61. Elaine S. Abelson, *When Ladies Go A-Thieving: Middle-Class Shoplifters in the Victorian Department Store* (New York: Oxford University Press, 1989), 48–49.

62. Ōya Sōichi, "Bundan girudo no kaitaiki," in *Bungakuteki seijutsu ron* (Tokyo: Chūō Kōronsha, 1930), 303–304. This passage is famously quoted in Maeda Ai's essay on women's magazines and literature, "Taishō kōki tsūzoku shōsetsu no tenkai: fujin zasshi no dokushasō," in *Kindai dokusha no seiritsu*, 151:211–212; original publication, *Bungaku*, June and July 1968. Translations are my own, but I will cite the relevant pages in the published translation for the use of the reader: Maeda Ai, "The Development of Popular Fiction in the Late Taishō Era," 163–219; the quoted passage is translated on page 164.

63. Discussed in Takahashi Tomiko, "Fujin zasshi kaizen mondai ni tsuite," in Kindai Josei Bunkashi Kenkyūkai, eds., *Fujin zasshi ni miru Taishōki*, 143–145.

64. Yamakawa Kikue, "Comumāsharizumu no hitohyōgen," in article series "Fujin zasshi to seiyoku kiji," *Chūō kōron*, June 1928, 75–76. *Comumāsharizumu* (commercialism) would now be written *comāsharuizumu*.

65. Maeda Ai, "Taishō kōki tsūzoku shōsetsu no tenkai." The concept of *tsūzoku bungaku* must not, of course, be simply elided with that of "popular" *(taishū)* literature. *Tsūzoku* to some extent claims to describe the content of the fiction. Although various forces of marketing and common assumption often determine what is called popular fiction, the term literally refers to its large readership. The meanings of the terms overlap in their implications about appeal: the intended audiences of "the populous" or the "common reader" that are also embedded in their meanings.

66. The Japanese equivalent of the dime novel, these inexpensive, one-yen editions of fiction became prevalent during the 1920s. The profits from them transformed the publishing industry and made the fortunes of many writers who were successful in this format.

67. Maeda, "Taishō kōki tsūzoku shōsetsu no tenkai," 228; Copeland trans., 174.

68. Ibid.; Copeland trans., 175.

69. Shufunotomosha, ed., *Shufunotomosha no gojū nen*, 66–67.

70. Ibid. The story was called "Sugi yuku mono" and was published from January to December of that year. A number of his works have been collected in Sasaki Kuni. *Sasaki Kuni zenshū* (Tokyo: Kōdansha, 1974–1975).

71. Shufunotomosha, ed., *Shufunotomosha no hachijū nenshi*, 19.

72. Maeda, "Taishō kōki tsūzoku shōsetsu," 228; Copeland trans., 175.

73. Yamakawa, "Comumāsharizumu no hitohyōgen," 75.

74. Maeda, "Taishō kōki tsūzoku shōsetsu," 213; Copeland trans., 165.

75. Ibid.; Copeland trans., 166.

76. Kume Masao, "Watashi shōsetsu to 'shinkyō' shōsetsu," *Bungei kōza* (January and May 1925); cited in Tomi Suzuki, *Narrating the Self: Fictions of Japanese Modernity* (Stanford, Calif.: Stanford University Press, 1996), 51 (her translation).

77. In Japan this is not the case, and appearing in advertisements conveys the image of current popularity. Hollywood and Japanese movie actors regularly appear in Japanese TV advertisements.

78. Suzuki, *Narrating the Self*, 55.

79. Katakami Noboru, "Sakusha to dokusha" (Authors and readers), *Shinchō*, March 1926, 3.

80. Many modern scholars have continued to overlook this obvious tendency. A thirty-one-volume anthology of Japanese popular literature published well after Maeda's study does not mention a single women's magazine in its extensive lists of "major magazines" in the world of popular fiction publishing. *Taishū bungaku taikei* (Collection of popular fiction) (Tokyo: Kodansha, 1980).

81. Sasaki Kuni, *Sasaki Kuni zenshū*, 8:349. There is a brief discussion of this novel in Maeda Ai, "Taishō kōki tsūzoku shōsetsu," 277–278; Copeland trans., 206.

82. "Warai no pēji: Tomokasegi," *Shufu no tomo*, November 1919, 150–151.

83. "Gofūfu gofuntō" (a married couple's miseries of misunderstanding), *Shufu no tomo*, November 1919, 56–57.

84. Kathleen Uno, "One Day at a Time: Work and Domestic Activities of Urban Lower-Class Women in Early Twentieth-Century Japan," in *Japanese Women Working*, ed. Janet Hunter (New York: Routledge, 1993), 57.

85. "Warai no pēji," *Shufu no tomo*, November 1919, 151.

86. Yoshiya Nobuko, "Tonari no musume," *Shufu no tomo*, November 1932, 273–288.

87. The cast also included Mimura Chiyoko, Takeda Shunrō, and Akita Eiichi.

88. *Shufu no tomo*, January 1925, 62–66. Nikkatsu was Shōchiku's competitor.

89. Satō Takumi, *Kingu no jidai*, 257.

90. Fukiya Kōji, "Hyōchū no kingyo," *Shufu no tomo*, May 1925, 30–39. Charles Baudelaire, "Be Drunk," trans. Louis Simpson, in *Modern Poets of France: A Bilingual Anthology* (Ashland, Ore.: Story Line Press, 1997), 73.

91. Among the many prolific writers taking up this genre were Mikami Otokichi, husband of *Nyonin geijutsu* founder Hasegawa Shigure, and Kikuchi Kan, who also wrote many *katei shōsetsu*.

212 *Notes to Pages 125–128*

92. Aono Suekichi, *Tenkanki no bungaku* (Tokyo: Shinjunsha, 1927), *Fujin kōron*, April 1925; reprinted in Kindai bungei hihyōron zenshū, vol. 1 (Tokyo: Nihon Tosho Sentā, 1990).

93. A version of this section appeared previously as "Sisters and Lovers: Women Magazine Readers and Sexuality in Yoshiya Nobuko's Romance Fiction," *Association for Japanese Literary Studies Proceedings* 5 (Summer 1999): 311–320.

94. Yoshiya Nobuko in fact had some early dealings with *Seitō* and knew many of the women in the group well. See especially Yoshikawa Toyoko, "*Seitō* kara 'taishū shōsetsu' sakka e no michi: Yoshiya Nobuko *Yaneura no nishojo*," in *Feminizumu hihyō e no shōtai*, ed. Iwabuchi Hiroko (Tokyo: Gakugei shorin, 1995), 121–147.

95. Others were found in newspapers and a few in small literary journals, including *Kuroshōbi*, which she created.

96. This work is analyzed in Hiromi Tsuchiya Dollase, "Early Twentieth Century Japanese Girls' Magazine Stories: Examining Shōjo Voice in *Hanamonoagatari* (Flower Tales)," *Journal of Popular Culture* 36, no. 4 (2003): 724–755. Other writings on Yoshiya in English include Jennifer Robertson, "Yoshiya Nobuko: Out and Outspoken in Practice and Prose," in *The Human Tradition in Modern Japan*, ed. Anne Walthall (Wilmington, Del.: Scholarly Resources, 2001), 155–174; Hiromi Tsuchiya Dollase, "Reading Yoshiya Nobuko's 'Yaneura no nishojo': In Search of Literary Possibilities in *Shōjo* Narratives," *U.S.-Japan Women's Journal*, no. 20–21 (2001): 151–178; Michiko Suzuki, "Developing the Female Self: Same-Sex Love, Love Marriage and Maternal Love in Modern Japanese Literature, 1910–39" (Ph.D. dissertation, Stanford University, 2002).

97. Yoshiya Nobuko, "*Sora no kanata e ni tsuite*" (About *Sora no kanata e*), in *Yoshiya Nobuko zenshū* (Tokyo: Shinchōsha, 1975), 2:496. Hereafter, *YN zenshū*. At the time of this publication, the only work published in English outside Japan is "Foxfire" (Onibi), trans. Lawrence Rogers, *The East* 36, no. 1 (May–June 2000): 41–43.

98. Both films had the same title as the book. The first was directed by Tatsumi Takeo, produced by Shōchiku Kamata. The 1939 version was produced by Nikkatsu. *YN zenshū*, 12:578–579. I have been unable to locate a print of either film.

99. While *junan* (the passion) can simply mean suffering, the Christian theme of death and resurrection is clear here and suggests that Yoshiya intends both meanings.

100. *YN zenshū*, 2:276.

101. Ibid., 2:225.

102. Felski, *Gender of Modernity*, 73.

103. Jinno Yuki, *Shumi no tanjō* (The birth of hobbies) (Tokyo: Keisō shobō, 1994).

104. *YN zenshū*, 2:221.

105. In general, *shojo* would not be translated as "virgin," as less explicit usages were in circulation at the time. Its use in this novel connects *shojo* with the Virgin Birth and, less explicitly, to sexual behavior and abstinence; it is this usage that led

me to translate it this way here. For an introduction to the defining discourses surrounding the term see Kawamura Kunimitsu. *Sekushuariti no kindai* (Tokyo: Kōdansha. 1996), 5–12.

106. *YN zenshū*. 2:233.

107. Ibid.. 2:316.

108. Ibid.. 2:308.

109. Ibid.. 2:235; original with censored text in *Shufu no tomo*. May 1927. 12.

110. *Shufu no tomo*. May 1927. 12.

111. Ibid.. November 1927. 17.

112. Ibid.. June 1927. 16.

113. Ibid.. December 1927. 16.

114. Ibid.

115. To what extent readers were aware of this relationship is somewhat unclear. Avid fans are likely to have known about it and had access to her open mention of it in places such as her self-published magazine *Kuroshōbi*, where she was particularly open about her personal life. She did not legally adopt Monma until the postwar period. but many readers would have been aware of their relationship before that and would not necessarily have been aware of the adoption per se.

116. *Shufu no tomo*. September 1927. 16.

117. Ibid.. May 1927. 16.

118. At this time Yoshiya did live in a modern house in Ochiai. a Tokyo suburban neighborhood.

119. *Shufu no tomo*. January 1928.

120. Robertson. "Yoshiya Nobuko." Yoshitake Teruko. *Nyonin Yoshiya Nobuko.*

121. For information in English see Jennifer Robertson. *Takarazuka: Sexual Politics and Popular Culture in Modern Japan* (Berkeley: University of California Press. 1998). esp. 68–69; Suzuki. "Developing the Female Self." 28–39.

122. The Japanese government used the PEN Club of Japan to enlist Japanese authors in promoting the war effort. Its funds were used to send popular and respected writers to the colonies to describe the improvements there in glowing terms and to publish stories inspiring the Japanese people to cooperate with the war effort.

Chapter 4: Women's Art/Women's Masses

1. Translations of Poe's "Morella" (by Ozaki Midori) and Kollontai's *Red Love* appeared in the magazine.

2. For discussions of Japanese proletarian literature in English see Heather Bowen-Struyk. "Rethinking Japanese Proletarian Literature" (Ph.D. dissertation. University of Michigan. 2001); Iwamoto Yoshio. "Aspects of the Proletarian Literary Movement in Japan." in H.D.Harootunian and Bernard S. Silberman. eds., *Japan in Crisis: Essays on Taisho Democracy* (Princeton. N.J.: Princeton University Press. 1970). 156–182; Miriam Silverberg. *Changing Song: The Marxist Manifestos of Nakano Shigeharu* (Princeton. N.J.: Princeton University Press. 1990).

3. Of course, the concern with media was found throughout the proletarian literature movement, particularly in the context of the discussions of popularization (taishūka). Discussed in the context of Tokunaga Sunao by Heather Bowen-Struyk, "Rethinking Japanese Proletarian Literature" (Ph.D. dissertation, University of Michigan, 2001), 121–173.

4. Ogata Akiko, in conversation in 1996. Although I tend to disagree, her statement is not an offhand or dismissive one but based on deep engagement with this magazine and its writings; she deserves the primary credit for its availability in a beautiful reproduction without which my own research might not have begun. Three of Ogata's major works on this topic are "Nyonin geijutsu" no sekai: Hasegawa Shigure to sono shūhen (Tokyo: Domesu Shuppan, 1980); "Nyonin geijutsu" no hitobito (Tokyo: Domesu Shuppan, 1981); "Kagayaku" no jidai: Hasegawa Shigure to sono shūhen (Tokyo: Domesu Shuppan, 1993). She is also active in organizing panel discussions, interviews, and parties (some of which I have attended) with the few women involved in the journal who were still alive in the late 1990s, notably Mochizuki Yuriko, Matsuda Kaiko, and Hirabayashi Eiko. Along with Ogata's work on Nyonin geijutsu, other major resources on the magazine include Asahi Shinbunsha, ed., Hasegawa Shigure to "Nyonin geijutsu": Shōwa o kirihiraita joseitachi ten (Tokyo: Asahi Shinbunsha, 1993); Hasegawa to Nyonin geijutsu Kenkyūkai, eds., Shōwa o ikita joseitachi: "Nyonin geijutsu" no hitobito (Tokyo: Tokyo Josei Zaidan Josei Kenkyū, 1997); Matsuda Tokiko, "Puroretaria sakka dōmei to Nyonin geijutsu," in Kaisō no mori, ed. Matsuda Tokiko (Tokyo: Shin Nihon Shuppansha, 1979), 83–127; Itō Yasuko, "Nyonin geijutsu, Fujin bungei: Nagoya shibu no hito kōsatsu," Chūkyo Joshi Daigaku kiyō 21 (1987): 1–10.

5. There are several common translations of this work's title into English that would highlight different aspects of the tale. Lippit uses Tales of Wandering; Gardner, Fessler, and Ericson, Diary of a Vagabond.

6. Ogata, "Nyonin geijutsu" no sekai.

7. Lippit, Topographies; Gardner, "Mongrel Modernism"; Ericson, Be a Woman; Susanna Fessler, Wandering Heart: The Work and Method of Hayashi Fumiko (Albany: State University of New York Press, 1998).

8. The connection between these publications, so often made, is an obvious one because both magazines were literary magazines run by women, dealing with feminist issues. An exhibit in 1996 at the Setagaya Literary Museum in Tokyo on women writers and journals was framed chronologically and thematically by the two magazines. Setagaya Bungakkan, ed., "Seitō" to "Nyonin geijutsu": Jidai o tsukutta joseitachi ten (Tokyo: Setagaya Bungakkan, 1996). Kanai Keiko recently made an argument closer to mine, which is that if you look at Nyonin geijutsu and Seitō together, you can see the change in media culture between the 1910s and 1930s exhibited on their pages. Kanai Keiko, "Women's Magazines as Community: Seitō and Nyonin geijutsu," lecture, Harvard University, April 13, 2002.

9. Included among those who were Seitō members and connected to Nyonin geijutsu are its founder Hasegawa Shigure; Okada Yachio, a writer of gessaku and

novels; Kamichika Ichiko, journalist and also involved in the Ōsugi Sakae scandal discussed in chapter 2.

10. Yagi Akiko, "*Nyonin geijutsu* ichinen hihankai," roundtable discussion. *Nyonin geijutsu*, June 1929, 8.

11. Ogata, "*Nyonin geijutsu*" *no sekai*, 14. Ogata refers to this as a "famous story." The recollections of Ikuta Hanayo confirm the amount of money coming from Mikami: "[Shigure] said to me 'I want to start up a magazine whose contributors will be only women. And, now I have 20,000 yen in capital that Mikami said I can use as I please. I don't think it's necessary for me to build a house, and I would rather spend it on the women's art world.'" Ikuta Hanayo, *Ichiyo to Shigure* (Tokyo: Chōbunkaku, 1939), 215. Also, in a 1997 compilation of interviews of *Nyonin geijutsu* participants, Hirabayashi Eiko recounts hearing the same story from Hasegawa. Interview as edited in Hasegawa Shigure to Nyonin geijutsu Kenkyūkai, eds., *Shōwa o ikita josei tachi*, 74.

12. For example, Sugawa Kinuko in Ogata Akiko, "*Nyonin geijutsu*" *no sekai*, 27.

13. Ibid. This information is based on an interview of Sugawa by Ogata.

14. Hirabayashi Eiko, interview transcript as edited in Hasegawa Shigure to Nyonin geijutsu Kenkyūkai, eds., *Shōwa o ikita josei tachi*, 79.

15. "Mondai ni natta fujin zasshi," *Nyonin geijutsu*, July 1928, 131. Of course, the assumption that articles about sexual diseases are exploitative of women is misguided. They certainly had some benefit for public health, even when sometimes inaccurate. Many of the criticisms of women's magazines by feminists focused on their sexual content as damaging, but often at the cost of other insights.

16. Ōki Mimiko, "Shakai jihyō" (Current events). *Nyonin geijutsu*, July 1928, 68–70. *Josei* was published from November 1922 to May 1928 by the publisher Puratonsha.

17. Ibid., 69.

18. Ibid.

19. Ibid., 70. The movement for women's suffrage was active in the 1920s, with Ichikawa Fusae as the strongest advocate. Ultimately it was not successful, and women first voted in Japan in 1947.

20. Hasegawa Shigure, "Henshū kōki," *Nyonin geijutsu*, March 1929, 154.

21. Nakamoto Takako, "Suzumushi no mesu," *Nyonin geijutsu*, March 1929, 4–11. Available in translation as "The Female Bell-Cricket," trans. Yukiko Tanaka, in Yukiko Tanaka, ed., *To Live and to Write: Selections by Japanese Women Writers, 1913–1938* (Seattle, Wash.: Seal Press, 1987), 135–144. Ozaki Midori, "Mokusei," *Nyonin geijutsu*, March 1929, 111–114; in English as "Osmanthus," trans. Miriam Silverberg, *Manoa* 3, no. 2 (1991): 187–190.

22. Matsui Teiko, "Dorumen no nazo," *Nyonin geijutsu*, March 1929, 17–22. The meaning of this title is not entirely clear. The dolmen might refer to Stonehenge (and thus the mystery of how it was constructed) though no clue in the story suggests that reference directly. The use of *nazo* (mystery, riddle, or secret) in the story seems to refer to sexual satisfaction that is a mystery when it is not achieved, and perhaps a

stone phallus, but the passage has so many eliminated words that it is difficult to pin down a reading. It is also possible that she is referring to the "riddle of the Sphinx," replacing "sphinx" for what seems to have been a more familiar term at the time, *dorumen*, a word that appears in a literary magazine title during the same era. Matsui Teiko was not well known. She had published in the third issue of *Nyonin geijutsu*. Born in 1902, she worked after graduation as a cashier in her family's rice store in Kyushu like the protagonist of this story. Despite the interest it drew, this was the last story she published in *Nyonin geijutsu*.

23. *Ko* is a diminutive ending common in Japanese women's names.

24. Matsui, "Dorumen no nazo," 20.

25. The history of this practice is described clearly in Kasza, *The State and the Mass Media in Japan*, 37–38, 180–181. In this history of censorship activities in Japan, Kasza demonstrates the effectiveness of blank type placement by editors to continue to convey their meaning. Beginning in the late 1930s the Special Higher Police began to argue against allowing the practice, and starting in 1939 implemented prepublication reviews of galleys and forbidding blank type. In Matsui's story "Dorumen no nazo," the x's are placed in such a way that the meaning of even heavily blocked-out sentences is suggestive, and I would argue that Matsui or a savvy *Nyonin geijutsu* editor is likely to have positioned them. As demonstrated by the frustration of the Special Higher Police in charge of media control toward these x's and o's, their use could even highlight and pique reader interest rather than erase "dangerous thoughts." In general, *zenshū* (collected works) versions, if they exist, fill in the blanks either from manuscripts or the author's own writing (though not necessarily what she wrote originally). See also Jay Rubin, *Injurious to Public Morals: Writers and the Meiji State* (Seattle: University of Washington Press, 1984); and Jonathan Abel, "Archiving the Forbidden: Tracing Exteriors to Graphs of Banned Books," in *Hermeneutical Strategies: Methods of Interpretation in the Study of Japanese Literature*, ed. Michael Marra (West Lafayette, In.: Association for Japanese Literary Studies, 2004), 421–445.

26. Anonymous, in Senryū column, ed. Inoue Nobuko, *Nyonin geijutsu*, September 1931, 147.

27. Bowen-Struyk's discussion of the publication history of one of Miyamoto Yuriko's works demonstrates the complexity of this process and shows that it is misguided to imagine a "pristine, pure text prior to self-censorship." "Revolutionizing the Japanese Family: Miyamoto Yuriko's *The Family of Koiwai*," *Positions* 12, no. 1–2 (July 2004): 479–507.

28. Takamure Itsue, "Bijin ron: Tokai hiteiron no hitotsu," in *Takamure Itsue zenshū* (Tokyo: Rironsha, 1967), 288–295. Originally published in *Fujin sensen* 1, no. 8 (October 1930), 14–21. Another discussion of these issues occurs in Takamure Itsue, *Ren'ai sōsei*, in *Takamure Itsue zenshū*, 7:7–214.

29. Matsui, "Dorumen no nazo," 17.

30. *Takamure Itsue zenshū*, 7:294.

Notes to Pages 146–153 217

31. Charles Rogers was an American actor known for such films as *Wings* (1927)—the first Oscar winner—and *My Best Girl*. *Wings* was also popular in Japan. Rogers married Mary Pickford in 1937 after her divorce from Douglas Fairbanks.

32. Matsui. "Dorumen no nazo." 18–19.

33. Ibid.

34. Ibid., 21.

35. Ibid., 22.

36. Kubokawa Ineko. "Jiko shōkai." *Nyonin geijutsu*, March 1929, 102–105.

37. Ibid., 105.

38. Ibid.

39. For a study of Nakano Shigeharu see Miriam Silverberg. *Changing Song: The Marxist Manifestos of Nakano Shigeharu* (Princeton, N.J.: Princeton University Press, 1990).

40. Hirabayashi Taiko, in "*Nyonin geijutsu* ichinen hihankai." *Nyonin geijutsu*, June 1929, 9.

41. Sata Ineko. *Kurenai*, Shinchō bunko, vol. 280 (Tokyo: Shinchōsha, 1952), 147.

42. The story is translated by Yukiko Tanaka in *To Live and to Write*, 135–144. Unless noted, the translations used here are hers. There are several places where Tanaka's translation fills in what were *x*'s in *Nyonin geijutsu*; such places will be noted.

43. Satō Haruo. *Asahi shinbun*, March 27, 1929. Quoted in Ogata Akiko, "*Nyonin geijutsu*" *no sekai*, 49.

44. *Nyonin geijutsu*, March 1929, 6; my translation.

45. Nakamoto. "The Female Bell-Cricket." Tanaka trans., 137; *Nyonin geijutsu*, March 1929, 6.

46. Nakamoto. "The Female Bell-Cricket." Tanaka trans., 138; *Nyonin geijutsu*, March 1929, 6.

47. My translation from *Nyonin geijutsu*, March 1929, 6. The *x*'s are translated as "pubic hair" by Tanaka, "The Female Bell-Cricket," 137. There is a second printing of the story in book form, but the blanks are not filled in; I have been unable to find the source for Tanaka's filling in of the blanks. The book version is found in Nakamoto Takako, *Asa no burei* (Tokyo: Tenjinsha, 1930), 39–58 (facsimile reprint, Honnotomosha, 2001).

48. Nakamoto. "Suzumushi no mesu." 8.

49. Nakamoto. "The Female Bell-Cricket." Tanaka trans., 142; *Nyonin geijutsu*, March 1929, 9.

50. "Chōsakengakuteki." *Nyonin geijutsu*, January 1930.

51. In Elyssa Faison, "Producing Female Textile Workers in Imperial Japan" (Ph.D. dissertation, University of California Los Angeles, 2001), 188.

52. Ozaki Midori. *Teihon Ozaki Midori zenshū*; idem, "Osmanthus," Silverberg trans.; Livia Monnet, "Montage, Cinematic Subjectivity, and Feminism," 57–82. The

Notes to Pages 153–162

original story is found in *Nyonin geijutsu*, March 1929, and reprinted in *Teihon Ozaki Midori zenshū*, 1:231–236.

53. Ozaki, "Mokusei," in *Teihon Ozaki Midori zenshū*, 1:231–232.

54. Ozaki, "Osmanthus," Silverberg trans., 188; original in *Teihon Ozaki Midori zenshū*, 1:234.

55. Ibid.

56. Ozaki, *Teihon Ozaki Midori zenshū*, 2:94–96.

57. "*Nyonin geijutsu* ichinen hihankai," *Nyonin geijutsu*, June 1929, 9.

58. Ogata Akiko, "*Nyonin geijutsu*" *no sekai* (Tokyo: Domesu Shuppan, 1980), 137.

59. One of the editors, Sugawa Kinugawa, confirms this in the June roundtable when asked if authors submitted the stories with full knowledge of the issue title. She answers, "Of course." Ibid., 6.

60. Yagi Akiko, ibid., 10. Yagi is summarizing the opinions of previous speakers in the roundtable, but herself wants to avoid a "moralizing" position, 11.

61. Imai Kuniko, ibid., 8.

62. Hirabayashi Taiko, ibid., 5.

63. Niizuma Itoko, ibid., 6.

64. Illustrations were for Kamichika Ichiko, "Proletarian Women's Day," *Nyonin geijutsu*, March 1929, 2. The photograph depicts women representing regions of the Soviet Union at a women's May Day meeting in Moscow.

65. "*Nyonin geijutsu* ichinen hihankai," 5. Ellipses in original.

66. Ibid., 9.

67. Ibid.

68. Takeuchi Yukiko, "Musansha shinbun," *Nyonin geijutsu*, June 1930.

69. *Nyonin geijutsu*, December 1930, 55.

70. Aikawa Yō, *Nyonin geijutsu*, October 1930, 112–117.

71. Sudō Toshiko, *Nyonin geijutsu*, October 1930, 90–92.

72. Yase Takako, *Nyonin geijutsu*, October 1930, 82–87.

73. Bowen-Struyk, "Rethinking Proletarian Literature," 33–72.

74. Matsumura Kiyoko, "Kuruwa Nikki," *Nyonin geijutsu*, February 1931, 53–56; quotation from page 55.

75. Gotō Katsuko, "Bakuro jitsuwa sunpyō," *Nyonin geijutsu*, December 1930, 74–77.

76. Ibid., 75.

77. Ibid., 76.

78. Ibid.

79. Ibid., 77.

80. Yama-X X-ko of Chiba, "Kakuchi Repo: *Nyonin geijutsu* ni taisuru yōbō," May 1931, 162–163. All of these expressions mean "it is" (or in the last case, "is it not?"). *Na no desu* and *de arimasu* imply that the speaker might be a woman and of lower status than the listener. In writing it implies some sort of relationship

with the reader. *De aru* and *de wa nai ka?* are in the "plain form" and imply higher or no hierarchical relationship with the reader. In modern writing, they would be considered "stronger" and less marked by gender. Ellipses in quotation marks are in original.

81. Gotō, "Bakuro jitsuwa." 75.

82. Imagawa Hideko, "*Hōrōki*—seisei to sono sekai," in *Hōrōki arubamu*, ed. Nakamura Mitsuo (Tokyo: Haga Shoten, 1996), 65–76; Ericson, *Be a Woman*.

83. Imagawa, "*Hōrōki*," 65–76. The later installments appeared in the magazine *Kaizō*, and the first book version was published by that magazine's publisher Kaizō-sha in 1930.

84. *Nyonin geijutsu*, October 1928, 17; my translation. The same passage is well translated by Ericson, *Be a Woman*, 172. Ellipsis in original.

85. *Hōrōki* (Tokyo: Kaizōsha, 1930), 3; facsimile reprint, 1973. As Gardner has noted, "I am a crossbreed, a mongrel" is deleted from subsequent, and more familiar, versions of the work, including Ericson's translation, because the line was deleted in later Japanese publications of the work. Gardner demonstrates the importance of "mongrel" in understanding Hayashi's modernism (Gardner, "Mongrel Modernism," 69–101). Note that the three lines beginning "I" could be read as capping-verses, a potential that is difficult to see with the third line omitted and (as in Ericson's and other renderings based on later versions) the remaining two laid out like prose.

86. For example, various lovers come and go in the resulting text with no explanation, as do places of employment. This is part of what contributes to the sense of wandering that goes beyond the character's physical changes in location.

87. Joan Ericson has clarified some of the confusion over Hayashi's relationship with *Nyonin geijutsu*, created in part out of Hayashi's misremembering of that history, *Be a Woman*, 52–53. Although Hayashi serialized much of the work there, her recollections of the magazine are negative, probably because of a disagreement with the magazine's political direction and some personal attacks. She even claimed that less of the work was published there than was. Although she was interested in tracking her characters' poverty and struggles, there are clues in her fiction that she resented the Marxist jargon used in *Nyonin geijutsu*. In a passage from *Diary of a Vagabond* the narrator says, "My head made no distinction between Proletarian or Bourgeois. I only wanted to cook and eat one handful of rice. 'Please feed me.'" Ericson, *Be a Woman*, 177. Hayashi recalls being upset at being "lumpen" and said to be writing "a poor girl's graffiti" by other *Nyonin geijutsu* women. Of course, these are Hayashi's recollections (some as early as 1935), but they reflect her memory of alienation during the height of the proletarian literature movement and within this magazine's culture. Ericson, *Be a Woman*, 53.

88. Hasegawa, "Hizakari" (High noon), *Nyonin taishū*, supplement 1931.

89. Enchi Fumiko is known in the postwar era for her erudite use of classical literature in her fiction, and is sometimes criticized for works that seem apolitical;

220 Notes to Pages 166–175

as Masao Miyoshi puts it, she "refused to confront the material historicity of contemporary Japan." *Off Center: Power and Cultural Relations between Japan and the United States* (Cambridge: Harvard University Press, 1991), 210. Ōta Yōko is now best known as a *hibakusha* or A-bomb survivor writer. Her work is discussed at length in John Whittier Treat. *Writing Ground Zero: Japanese Literature and the Bomb* (Chicago: University of Chicago Press, 1995), 199–228.

90. Naimushō Keihōkyoku. *Shuppan Keisatsu gaikan*, reprint edition (Tokyo: Ryūkei Shosha, 1981), 1:271, describes the magazine's turn to the left and the move from "artistic oil paintings" to simple graphics.

91. Sharla Harting, May 1929; Mary Laurenson, July 1929. The names are available only in Japanese orthography and so are difficult to decipher.

92. *Nyonin geijutsu*, July 1928, 64.

93. For example, the still life of fruit and flowers on the first issue in June 1928.

94. Ogata, *"Nyonin geijutsu" no sekai*, 120.

95. Kawai Asako, *"Nyonin geijutsu ni taisuru yokubō"* (What I want from *Nyonin geijutsu*). *Nyonin geijutsu*, February 1931, 67–69.

96. Ibid., 67.

97. Ibid., 69.

98. Silverberg, "Constructing a New Cultural History of Prewar Japan," 68.

99. Kawai Asako, "Futatabi 'Nyogei kaidai' ni tsuite" (Once again, on changing *Nyonin*'s title). *Nyonin geijutsu*, May 1931, 63.

100. Hirabayashi Taiko. "Bungei jikan" (Literary times). *Nyonin geijutsu*, July 1931, 32.

101. Ibid., 33.

102. Kitayama Masako. "Nyonin kaidai ni tsuite shōken" (Considering *Nyonin*'s title change). *Nyonin geijutsu*, April 1931, 112.

103. Sugizaki Toshie. "Dokusha tsūshin" (Reader correspondance). *Nyonin geijutsu*, November 1930, 62.

104. Ibuki Atsushi. "Futatabi, Kawai Asakoshi ni." *Nyonin geijutsu*, May 1931, 776–777.

105. This tendency for Marxists to place feminist concerns below class struggle is part of what sent many of the anarchist participants to split off to form a different magazine. *Fujin sensen*. Although many of them had even more essentialist notions of womanhood, they were resistant to this type of grouping of women, which they saw as no different from state ideology.

106. Yoshiya did not publish fiction in *Nyonin geijutsu*, although there are a few brief references to her, and a photograph of her knitting on her front porch appeared in October 1928. Her words also appear in a roundtable discussion in that issue and one more in April 1932 about Manchuria. "Shin Manshū to wa donna tokoroka?" 24–46.

107. A detailed study has been provided in Ogata Akiko, *"Kagayaku" no jidai*. It is an important publication to consider in any study of wartime literature or women's wartime activities in Japan.

Epilogue

1. Information about many of these contemporary magazines can be found on the Internet. See, for example, *The Orange Page*, http://www.orangepage.net/; Magazine House, http://anan.magazine.co.jp/.

2. *Ms.* began publication as a special insert in *New York Magazine* in 1971, with regular issues starting in the following year. Just as in the case of *Nyonin geijutsu*, there have been discussions about the status of advertising, with the publication running ad free for much of its existence. Its continued publication is impressive and relies on strong support from faithful readers and some feminist groups.

3. Women writers found here tend to be those who have won such prizes as the Akutagawa Prize.

4. At the time of this writing, two examples of the types of locations where such materials might be found include Miss Crayon House bookstore and Tokyo Women's Plaza public library, both in the Aoyama section of Tokyo. *Mini komi* publications are not at all limited to those related to feminism or women, of course, but include a broad range of artistic and political interests. Many library facilities specialize in collecting and preserving such materials, which are generally published using inexpensive printing and materials.

5. Shiozawa Minobu, "Nihon no shuppankai o ugokasu 12 ka (5) Ishikawa-ka: Media mikusu ni kakeru *Shufu no tomo*," *Chishiki* 77 (May 1988): 160–170.

6. Ōya Sōichi, "Bundan girudo no kaitaiki," in *Bungakuteki seijutsu ron*, 303–304. Quoted in Maeda Ai, "Taishō kōki tsūzoku shōsetsu no tenkai: fujin zasshi no dokushasō," in *Kindai dokusha no seiritsu*, 151:211–212.

7. The term *otaku* appeared in the mid-1980s as a derogatory name for obsessive *manga* readers and anime viewers who were sticklers about factual details regarding their favorite series. Gradually the term has taken on a broader meaning, and many identify themselves positively with it.

8. I refer here primarily to the category of behavior referred to as *enjo kōsai* (assisted dating), in which teenagers and other young women enter into relationships with men, often receiving gifts or money in exchange. Fascination with and anxieties about these cases reached a peak in the late 1990s, and a common theory was that the young women's desire for designer goods led them to enter into these relationships. At the same time, media coverage was often such that it piqued the prurient interests of its viewers and itself led to the image of the sexually available schoolgirl. How this type of phenomenon interacted with the world of higher-brow fiction would be worth further study. Writers such as Murakami Ryū set out to depict *enjo kōsai*, while many women writers turned away from the discussion of sexuality altogether, perhaps because of the commodification of the body by the media and even the telecommunications industry that enabled these meetings. Also of interest would be the coincidence of this concern with youth culture with the awarding of the Akutagawa Prize in 2004 to the youngest recipients ever, two young women, Kanehara Hitomi (19) and Wataya Risa (20).

9. The *manga* version of Ōtomo Katsuhiro's *Akira* began in 1983 and continued for over ten years with sequels; the animated version appeared in 1988. Fredric Jameson, *Postmodernism, or the Cultural Logic of Late Capitalism* (Durham, N.C.: Duke University Press, 1992).

10. Gainax, Anno Hideaki, and Andō Ken, dirs., *Shinseiki evangelion (Neon-Genesis Ebangerion)*, 1995.

11. Yoshiya Nobuko, *Tsuki kara kita hito*, serialized in *Shufu no tomo*, January 1942–July 1943.

12. For a discussion of subtle criticisms of the war effort in wartime found in writings from publications such as *Fujin kōron*, see Beth Sara Katzoff, "For the Sake of the Nation, for the Sake of Women: The Pragmatism of Japanese Feminisms in the Asia-Pacific War, 1931–1945" (Ph.D. dissertation, Columbia University, 2000).

13. The most famous example on the right would be Kobayashi Yoshinori's series *Shin-gōmanizumu sengen: Sensōron*, 3 vols. (Tokyo: Gentōsha, 1998–2003). Miyazaki Hayao's works of anime and *manga* can be read as espousing environmentalist and pacifist positions.

Bibliography

Unless noted, sources were original copies. All magazines are monthly:

Fujin gahō (Ladies' pictorial; 1905–present).

Fujin kōron (Ladies' review; 1916–1944; 1946–present).

Fujin kurabu (Ladies' club; 1920–1945).

Fujin mondai (Women's issues; 1918–1919).

Fujin no tomo (Ladies' friend; 1906–present).

Fujin sekai (Ladies' world; 1906–1933).

Fujin sensen (Ladies' front; March 1930–June 1931). Facsimile reprint. 16 issues. Tokyo: Roykuin Shobo.

Josei (Woman; 1922–1928). Facsimile reprint. 9 vols. Tokyo: Nihon Tosho Sentā. 1991.

Josei kaizō (Women's reform; 1922–1924).

Kagayaku (Shine; 1933–1941). Facsimile reprint. 2 vols. Tokyo: Fuji Shuppan. 1988.

Nyonin geijutsu (Women's arts; 1928–1932). Facsimile reprint. 48 issues with supplementary index. Tokyo: Ryukei Shosha. 1981, and Fuji Shuppan. 1987.

Seitō (Bluestocking; 1911–1916). Facsimile reprint. Tokyo: Ryukei Shobo. 1981.

Shinkō fujin (Progressive ladies; 1924–1925).

Shufu no tomo (The housewife's friend; 1917–present).

Japanese-Language Sources

Akiyama Kiyoshi. *Jiyū onna ronsō: Takamure Itsue no anakizumu* (Debate on women's freedom: Takamure Itsue's anarchism). Tokyo: Shisō no Kagakusha. 1973.

Aono Suekichi. *Tenkanki no bungaku* (Literature in transition). Tokyo: Shunjunsha. 1927. Facsimile reprint as vol. 1 of Kindai bungei hyōron sōsho (Anthology of modern literary criticism). Tokyo: Nihon Tosho Sentā. 1990.

Arishima Takeo. *Arishima Takeo zenshū* (Collected works of Arishima Takeo). 6 vols. Tokyo: Chikuma Shobō. 1981–1988.

Chūō Kōronsha. ed. *Chūō Kōronsha shichi jū nen shi* (The seventy-year history of Chūō Kōronsha). Tokyo: Chūō Kōronsha. 1955.

224 Bibliography

————. *"Fujin kōron" no go jū nen* (Fifty years of *Ladies' Review*). Tokyo: Chūō Kōronsha, 1965.

Chūō Shokugyō Shōkai Jimusho. *Tokyo Osaka ryōshi ni okeru shokugyō fujin chōsa: Jokyū* (Survey of working women in the two cities of Tokyo and Osaka: Café waitresses). Tokyo: Chūō Shokugyō Shōkai Jimusho, 1928.

Esashi Akiko, ed. *Ai to sei no jiyū: "Ie" kara no kaihō* (Freedom of love and sex: Liberation from the "family"). Vol. 20 of *Shisō no umi e* (Into the sea of thought). Tokyo: NRK Shuppanbu, 1989.

Furuya Tomoyoshi, ed. *Edo jidai bungaku zenshū* (Collected works of Edo-period women writers). Tokyo: Nihon Tosho Sentā, 1979. Original publication 1919.

Hasegawa Masashi and Kōno Toshirō. *Hasegawa Shigure: Hito to shōgai* (Hasegawa Shigure: The person and her life). Tokyo: Domesu Shuppan, 1982.

Hasegawa Shigure. "Josei to jānarizumu" (Women and journalism). In *Hasegawa Shigure zenshū* (The collected works of Hasegawa Shigure). 4:176–196. Tokyo: Nihon Bunrinsha, 1942.

———— to Nyonin geijutsu Kenkyūkai, eds. *Shōwa o ikita josei tachi: "Nyonin geijutsu" no hitobito* (Women who lived through Shōwa: The people of *Women's Arts*). Tokyo: Tokyo Josei Zaidan Josei Kenkyū, 1997.

Hayashi Fumiko. *Hōrōki* (Diary of a vagabond). Tokyo: Kaizōsha, 1930. Facsimile edition. Tokyo: Tokyo Nihon Kindai Bungakukan, 1969.

Hirabayashi Hatsunosuke. "Bunka no joseika" (The feminization of culture). *Josei*, April 1929, 20–28.

Hirata Yumi. "Onna no koe o hirō" (Recovering women's voices). *Shisō* 845 (1994): 177–192.

Hirotsu Kazuo. *Hirotsu Kazuo chosakushū* (Collected works of Hirotsu Kazuo). 6 vols. Tokyo: Tōyō Bunka Kyōkai, 1950.

————. *Hirotsu Kazuo zenshū* (Complete works of Hirotsu Kazuo). 13 vols. Tokyo: Chūō Kōronsha, 1973–1974.

Horiba Kiyoko. *"Seitō" no jidai: Hiratsuka Raichō to atarashii onna tachi* (The era of *Bluestocking*: Hiratsuka Raichō and the new women). Tokyo: Iwanami Shinsho, 1988.

Horie Toshikazu. "Meiji makki kara Taishō shoki no 'kindaiteki kazokuzō': Fujin zasshi kara mita 'Yamanote seikatsu' no kenkyū" ("Images of the modern family" from late Meiji to early Taishō: Research on "the Yamanote lifestyle" through women's magazines). *Nihon minzokugaku* 186 (1991): 39–73.

Ikuta Hanayo. *Ichiyo to Shigure* (Ichiyo and Shigure). Tokyo: Chōbunkaku, 1939.

Imagawa Hideko. "*Hōrōki*—seisei to sono sekai" (*Diary of a Vagabond*: Its Creation and Its World). In *Hōrōki arubamu*, edited by Nakamura Mitsuo, 65–76. Tokyo: Haga Shoten, 1996.

Imaida Oisamu and Saegusa Saeko. *Henshūchō kara dokusha e: Fujin zasshi no sekai* (From editors to readers: The world of women's magazines). Tokyo: Gendai Jānarizumu Shuppankai, 1967.

Ishikawa Takeyoshi. *Fu'un yori kōfuku e* (From misfortune to happiness). Tokyo: Shufunotomosha, 1929.

———. *Shinnen no ue ni tatsu: Shufu no Tomosha no keiei* (Standing on faith: The management of Shufunotomo Corporation). Tokyo: Shufunotomosha, 1926.

———. *Ishikawa Takeyoshi zenshū* (Collected works of Ishikawa Takeyoshi). Tokyo: Shufunotomosha, 1980.

———. *Waga aisuru seikatsu* (The life I love). Tokyo: Shufunotomosha, 1940.

Itō Yasuko. "*Nyonin geijutsu, Fujin bungei:* Nagoya shibu no hito kōsatsu" (A study of the Nagoya circles of the subscribers of two women's literary magazines: *Women's Arts* and *Ladies' Literary Art*). *Chūkyo Joshi Daigaku kiyō* 21 (1987): 1–10.

Kamichika Ichiko. *Kamichika Ichiko jiden: Waga ai waga arasoi* (Autobiography of Kamichika Ichiko: My love, my struggle). Tokyo: Kōdansha, 1982.

Kaneko Sachiko. "Taishōki *Shufu no tomo* to Ishikawa Takeyoshi no shisō" (*Housewife's Friend* in Taishō and Ishikawa Takeyoshi's thought). *Rekishi hyōron* 42 (1984): 43–61.

Kano Masanao. *Fujin, josei, onna: Joseishi no toi* ("Fujin," "josei," "onna": The question of women's history). Vol. 58 of Iwanami shinsho (Iwanami new books). Tokyo: Iwanami Shoten, 1989.

Katakami Noboru. "Sakusha to dokusha" (Authors and readers). *Shinchō* (March 1926): 2–13.

Katō Keiko. "Josei to jōhō: Meijiki no fujin zasshi kōkoku o tsūjite" (Women and information: Advertisements in Meiji-period ladies' magazines). *Keiō Gijuku Daigaku Shinbun Kenkyūjo nenpō* 32 (1980): 31–58.

———. "Taishōki ni okeru fujin zasshi kōkoku" (Ladies' magazine advertisements in the Taishō period). *Keiō Gijuku Daigaku Shinbun Kenkyūjo nenpō* 40 (1993): 43–70.

Kawamura Kunimitsu. *Sekushuariti no kindai* (The modernity of sexuality). Tokyo: Kōdansha, 1996.

Kimura Kiyoko. "Fujin zasshi no jōhō kūkan to josei taishū dokushasō no seiritsu: Kindai Nihon ni okeru shufu yakuwari no keisei to no kanren de" (The informational space of women's magazines and the establishment of women's mass readership: The formation of the housewife role in modern Japan). *Shisō* 812 (1992): 231–252.

Kindai Josei Bunka Kenkyūkai, eds. *Fujin zasshi no yoake* (The dawn of women's magazines). Tokyo: Ōzorasha, 1989.

Kindai Josei Bunkashi Kenkyūkai, eds. *Fujin zasshi ni miru Taishōki: "Fujin kōron" o chūshin ni* (The Taishō period through women's magazines: *Ladies' Review*). Tokyo: Kindai Josei Bunkashi Kenkyūkai, 1995.

———. Taishōki no josei zasshi (Taishō-era women's magazines). Tokyo: Ōzorasha, 1996.

Komori Yōichi, Kōno Kensuke, and Osamu Takahashi, eds. *Media, hyōshō, ideorogii: Meiji san jū nen dai no bunka kenkyū* (Media, representation, ideology: Cultural studies of the Meiji 1930s). Tokyo: Osawa Shoten, 1997.

Bibliography

Kōno Kensuke, ed. *Hirotsu Kazuo: Nengetsu no ashioto* (The footprints of the years). Sakka no jiden (Autobiographies of authors). vol. 65. Tokyo: Nihon Tosho Sentā, 1998.

Kubokawa Ineko. "Jikoshōkai" (Self-Introduction). *Nyonin geijutsu*, March 1929, 102–105.

Kume Masao. *Hasen* (Shipwrecked). In *Gendai Nihon bungaku zenshū* (Anthology of contemporary Japanese literature). vol. 32. Tokyo: Kaizōsha, 1928.

Kurosawa Ariko. "Shōjotachi no chikadōmei: Yoshiya Nobuko no *Onna no yūjo* o megutte" (The underground alliances of the girl: Yoshiya Nobuko's *A Female Friend*). *New Feminism Review* 2 (May 1991): 81–95.

———. "Shukkyō suru shōjotachi" (Girls' coming to the city). In *Taishū no tōjō: Hīrō to dokusha no nijū-sanjū nendai* (The emergence of the masses: Heroes and readers of the 1930s). edited by Ikeda Hiroshi. Yomikaeru bungaku shi (Rethinking literary history). 2: 78–97. Tokyo: Impakuto Shuppankai, 1998.

Kyoto Shiyakusho Shakaika. *Shokugyō fujin ni kansuru chōsa* (Surveys regarding working women). Kyoto: Kyoto Shiyakusho, 1927.

Maeda Ai. *Kindai dokusha no seiritsu* (The establishment of the modern reader). Tokyo: Iwanami Shoten, 1993. (Original publication. *Bungaku*, June and July 1968.)

Matsuda Tokiko. "Puroretaria sakka dōmei to *Nyonin geijutsu*" (The Proletarian Authors Guild and *Women's Arts*). In *Kaisō no mori* (A forest of memories). edited by Matsuda Tokiko. 83–127. Tokyo: Shin Nihon Shuppansha, 1979.

Matsui Teiko. "Dorumen no nazo" (The riddle of the dolmen). *Nyonin geijutsu*, March 1929, 17–22.

Minami Hiroshi, ed. *Taishō bunka* (Taishō culture). Tokyo: Keisō Shobō, 1965.

——— and Shakai Shinri Kenkyūkai. *Shōwa bunka 1925–1945* (Shōwa culture 1925–1945). Tokyo: Keisō Shobō, 1987.

Miyamoto Yuriko. *Fujin to bungaku: Kindai Nihon no fujin sakka* (Women and literature: Modern Japanese women writers). Tokyo: Jitsugyō no Nippon Sha, 1947.

Murakami Nobuhiko. *Taishōki no shokugyō fujin* (Women workers of the Taishō period). Tokyo: Domesu Shuppan, 1983.

Muta Kazue. "Senryaku to shite no onna: Meiji, Taishō no 'Onna no gensetsu' o megutte" (Woman as strategy: Regarding the "Discourse on woman" in Meiji and Taishō). *Shisō* 812 (1992): 216–217.

Nagamine Shigetoshi. "Senzen no josei dokusho chōsa: Jokō, shokugyō fujin, jogakusei o chūshin ni" (Prewar reader surveys: With a focus on factory girls, working women, and female students). *Shuppan kenkyū* 19 (1988): 32–69.

———. *Zasshi to dokusha no kindai* (The modernity of magazines and readers). Tokyo: Nihon Editāsukūru Shuppanbu, 1997.

Nagatani Ken. "Kindai Nihon ni okeru jōryū kaikyū imēji no henyō: Meijikōki kara Taishōki ni okeru zasshi media no bunseki" (Transformations in images of the upper class in modern Japan: Analysis of magazine media from late Meiji to early Taishō). *Shisō* 812 (1992): 193–230.

Naimushō Keihokyoku. *Shinbun zasshi oyobi tsūshinsha ni kansuru chō* (Surveys of newspapers, magazines, and news agencies). Manuscript 1927. Facsimile edition in *Shinbun zasshisha tokuhi chōsa* (Special survey of newspaper and magazine publishers). Tokyo: Taishō Shuppan, 1979.

———. *Shuppan Keisatsu gaikan* (General survey of the publication police agency). Facsimiles of *Shuppan Keisatsu gaikan*, 1930–1935. 3 vols. Tokyo: Ryūkei Shosha, 1981.

Nakamoto Takako. *Asa no burei* (Morning improprieties). Tokyo: Tenjinsha, 1930. Facsimile reprint. Tokyo: Honnotomosha, 2001.

———. "Suzumushi no mesu" (The female bell-cricket). *Nyonin geijutsu*, March 1929, 4–11.

Nihon Zasshi Kōkoku Kyōkai Kinō Kaihatsu Iinkai. *Zasshi kōkoku no riron to jitsumu* (The logic and business of magazine advertisements). Tokyo: Nihon Zasshi Kōkoku Kyōkai, 1975.

Nishikata Yūmi. "Senji shita ni okeru seiyakuwari kyanpēn no hensen: *Shufu no tomo* no naiyō bunseki o chūshin ni" (Wartime sex-role campaigns through content analysis of *The Housewife's Friend*). *Masu comyunikēshon kenkyū* 47 (1995): 111–126.

Nishikawa Yūko. "Hitotsu no keifu: Hiratsuka Raichō, Takamure Itsue, Ishimure Michiko" (One lineage: Hiratsuka Raichō, Takamure Itsue, and Ishimure Michiko). In *Riron* (Theory). Vol. 3 of *Feminizumu korekushon* (Feminism collection), edited by Kazue Sakamoto, Shūichi Katō, and Kaku Sechiyama, 230–275. Tokyo: Keisō Shobō, 1993.

Ogata Akiko. *"Kagayaku" no jidai: Hasegawa Shigure to sono shūhen* (The *Kagayaku* era: Concerning Hasegawa Shigure). Tokyo: Domesu Shuppan, 1993.

———. *"Nyonin geijutsu" no hitobito* (The people of *Nyonin geijutsu*). Tokyo: Domesu Shuppan, 1981.

———. *"Nyonin geijutsu" no sekai: Hasegawa Shigeru to sono shūhen* (The world of *Nyonin geijutsu*: Concerning Hasegawa Shigeru). Tokyo: Domesu Shuppan, 1980.

Oku Mitsuo. *Fujin zasshi jaanarizumu: Josei kaihō no rekishi totomo ni* (Women's magazines: Journalism and the history of women's liberation). Tokyo: Gendai Jaanarizumu Shuppankai, 1981.

Ōtsuka Meiko. *"Shufu no tomo* ni miru 'Nihongata kindai kazoku' no hendō: Fūfu kankei o chūshin ni" (Transformations in the "Japanese-style family" as seen in *The Housewife's Friend*: With a focus on married relations). *Soshio rogosu* 18 (1994): 243–257.

Ōya Sōichi. *Bungakuteki senjutsu ron* (Essays on literary tactics). Tokyo: Chūō Kōronsha, 1930.

Ozaki Hideki. *Shobutsu no unmei: Kindai no toshobunka no hensen* (The future of published materials: The transformation of modern book culture). Tokyo: Shuppan News, 1991.

Ozaki Midori. *Teihon Ozaki Midori zenshū* (Authoritative collected works of Ozaki Midori). 2 vols. Tokyo: Chikuma Shobō, 1998.

228 Bibliography

Saitō Michiko. *Hani Motoko: Shōgai to shisō* (Hani Motoko: Her life and thought). Tokyo: Domesu, 1988.

———. "Hani Motoko no shisō: Kaji kakeiron o chūshin ni" (Hani Motoko's thought: With a focus on household finances). In *Onna tachi no kindai* (Women's modernity), edited by Kindai Joseishi Kenkyūkai, 144–170. Tokyo: Kashiwa Shobō, 1978.

Sasaki Kuni. *Sasaki Kuni zenshū* (Collected works of Sasaki Kuni). 10 vols. Tokyo: Kōdansha, 1974–1975.

Satō, Barbara Hamill. "Nihonteki modanizumu no shisō: Hirabayashi Hatsunosuke o chūshin to shite" (Japanese-style modernism with a focus on Hirabayashi Hatsunosuke). In *Nihon modanizumu no kenkyū* (Research on Japanese modernism), edited by Minami Hiroshi, 89–114. Tokyo: Burēn Shuppan, 1982.

Satō Haruo. *Den'en no yu'utsu: Kaisaku* (Melancholy in the country: Revised). Tokyo: Shinchōsha, 1919.

———. *Teihon Satō Haruo zenshū* (Authoritative collected works of Satō Haruo). Vols. 3 and 4. Kyoto: Rinsen Shoten, 1998.

———. *Tokai no yu'utsu* (Melancholy in the city). In *Gendai Nihon bungaku zenshū* (Anthology of contemporary Japanese literature). 29:399–475. Tokyo: Kaizōsha, 1927.

Satō Takumi. *"Kingu" no jidai: Kokumin taishū zasshi no kōkyōsei* (The era of *King*: Publicness and a national populist magazine). Tokyo: Iwanami, 2002.

Setagaya Bungakkan, ed. *"Seitō" to "Nyonin geijutsu": Jidai o tsukutta joseitachi ten* (*Bluestocking* and *Women's Arts*: An exhibit of women who made an era). Tokyo: Setagaya Bungakkan, 1999.

Shin Feminizumu Hihyō no Kai, eds. *"Seitō" o yomu* (Reading *Bluestocking*). Tokyo: Gakugei Shorin, 1998.

Shiozawa Minobu. "Nihon no shuppankai o ugokasu 12 ka (5) Ishikawa-ka: Media mikusu ni kakeru *Shufu no Tomo*" (Twelve people who run the Japanese publishing world: Ishikawa betting on media mix with *Shufu no tomo*). *Chishiki* 77 (May 1988): 160–170.

Shufunotomosha, ed. *Shufunotomosha no gojū nen* (Fifty years of the Shufunotomo corporation). Tokyo: Shufunotomosha, 1967.

———. *Shufunotomosha no hachijū nenshi* (Eighty-year history of the Shufunotomo corporation). Tokyo: Shufunotomosha, 1996.

Silverberg, Miriam. "Nihon no jokyū wa burūsu o utatta" (Japanese café waitresses sang the blues). In *Jyendā no Nihonshi* (The history of gender in Japan), edited by Wakita Haruko and Susan B. Hanley, 2:585–606. Tokyo: Tokyo University Shuppankai, 1995.

Sometani Hiromi. *"Fujin kōron* no shisō: Keiseiki ni okeru" (The philosophy of *Ladies' Review*: The formative years). In *Onna tachi no kindai* (Women's modernity), edited by Kindai Joseishi Kenkyūkai, 171–199. Tokyo: Kashiwa Shobō, 1978.

Takamure Itsue. "Bijin ron: Tokai hiteiron no hitotsu" (A theory of feminine beauty: An anticity theory). *Fujin sensen* 1, no. 8 (October 1930): 14–21.

———. *Fujin undō no tan'itsu taikei* (A complete survey of the women's movement). Tokyo: Seigabō, 1975.

———. *Takamure Itsue zenshū* (Collected works of Takamure Itsue). Vol. 7. Tokyo: Rironsha, 1967.

Takasaki Ryūji. *Zasshi media no sensō sekinin* (The war responsibility of magazine media). Tokyo: Dai San Bunmeisha, 1995.

Tanabe Seiko. *Yume haruka Yoshiya Nobuko* (A distant dream: Yoshiya Nobuko). 2 vols. Tokyo: Asahi Shinbunsha, 1999.

Tanizaki Jun'ichirō. *Tanizaki Jun'ichirō zenshū* (Collected works of Tanizaki Jun'ichirō). Vol. 5. Tokyo: Chūō Kōronsha, 1967.

Tokyoshi Shakaikyoku. *Shokugyō fujin ni kansuru chōsa* (Surveys about working women). Tokyo: Tokyoshi Shakaikyoku, 1926.

———. "Josei zasshi ga mita modanizumu" (Modernism through women's magazines). In *Nihon modanizumu no kenkyū* (Research of Japanese modernism), edited by Minami Hiroshi, 115–140. Tokyo: Burēn Shuppan, 1982.

Ueno Chizuko. *Kindai kazoku no seiritsu to shūen* (The rise and fall of the modern family). Tokyo: Iwanami Shoten, 1994.

Wakakuwa Midori. *Sensō ga tsukuru joseizō* (The image of women created by war). Tokyo: Chikuma Shobō, 1995.

Watashi Tachi no Rekishi o Miru Kai. *Fujin zasshi kara mita 1930 nendai* (The 1930s through women's magazines). Tokyo: Dōjidaisha, 1987.

Yahagi Katsumi. "Kindai ni okeru yōranki no shuppan ryūtsū: Meiji shonen—Meiji 20 nendai e" (Modern surveys of publication circulation: Meiji period years 1–20). *Shuppan kenkyū* 12 (1981): 113–110.

———. *Yamakawa Kikue shū* (Collected works of Yamakawa Kikue). 10 vols. Tokyo: Iwanami, 1982.

Yamaki Toshio. *Nihon kōkokushi* (The history of Japanese advertising). Tokyo: Nihon Keizai Shinbunsha, 1992.

———. *Kindai Nihon josei shi* (Modern Japanese women's history). Tokyo: Shin Nihon Shuppansha, 1972.

———, ed. *"Seitō" o manabu hito no tame ni* (For people learning about *Bluestocking*). Kyoto: Sekai Shisōsha, 1999.

Yoshitake Teruko. *Nyonin Yoshiya Nobuko* (The woman Yoshiya Nobuko). Tokyo: Bungei Shunju, 1986.

Yoshiya Nobuko. *Yoshiya Nobuko zenshū* (Collected works of Yoshiya Nobuko). 12 vols. Tokyo: Shinchōsha, 1975.

———, ed. *Kuroshōbi* (Black rose) 1–8 (January 1925–August 1925). Facsimile edition. Tokyo: Fuji Shuppan, 2004.

English-Language Sources

Abelson, Elaine S. *When Ladies Go A-Thieving: Middle-Class Shoplifters in the Victorian Department Store*. New York: Oxford University Press, 1989.

Bibliography

Althusser, Louis. "Ideology and Ideological State Apparatuses." In *Lenin and Philosophy, and Other Essays*, 127–186. Translated by Ben Brewster. New York: Monthly Review Press, 1971.

Ambaras, David R. "Social Knowledge, Cultural Capital, and the New Middle Class in Japan, 1895–1912." *Journal of Japanese Studies* 24, no. 1 (1998): 1–33.

Anderer, Paul. *Other Worlds: Arishima Takeo and the Bounds of Modern Japanese Fiction*. New York: Columbia University Press, 1984.

Anderson, Benedict. *Imagined Communities*. London and New York: Verso, 1983.

Andrew, Nancy. "The Seitōsha: An Early Japanese Women's Organization, 1911–1916." In *Papers on Japan*, 6:45–67. Cambridge: East Asian Research Center, Harvard University, 1972.

Ardis, Ann, ed. *Women's Experience of Modernity, 1875–1945*. Baltimore, Md.: Johns Hopkins University Press, 2003.

Arishima Takeo. *A Certain Woman*. Translated by Kenneth Strong. Tokyo: Tokyo University Press, 1978.

Awaya, Nobuko, and David P. Phillips. "Popular Reading: The Literary World of the Japanese Working Woman." In *Re-Imagining Japanese Women*, edited by Anne E. Imamura, 244–270. Berkeley: University of California Press, 1996.

Banta, Martha. *Taylored Lives: Narrative Productions in the Age of Taylor, Veblen, and Ford*. Chicago: University of Chicago Press, 1993.

Bardsley, Jan. *The Bluestockings of Japan: Feminist Essays and Fiction from "Seitō," 1911–1916*. Ann Arbor: Center for Japanese Studies, University of Michigan, forthcoming.

———. "Feminism's Literary Legacy in Japan: *Seito*, 1911–1916." *Gest Journal* 5, no. 2 (Winter 1992): 87–102.

———. "What Women Want: *Fujin kōron* Tells All in 1956." *U.S.-Japan Women's Journal*, English supplement, no. 19 (2000).

Barlow, Tani E. "Theorizing Woman: *Funü, Guojia, Jiating* (Chinese woman, Chinese state, Chinese family)." In *Body, Subject, and Power in China*, edited by Angela Zito and Tani Barlow, 253–290. Chicago: University of Chicago Press, 1994.

Benjamin, Walter. "The Work of Art in the Age of Mechanical Reproduction." In *Illuminations*, edited by Hannah Arendt, 217–252. New York: Schocken Books, 1968.

Bernardi, Joanne. "The Literary Link: Tanizaki and the Pure Film Movement." *A Tanizaki Feast: The International Symposium in Venice*, edited by Adriana Boscaro and Anthony Hood Chambers, 75–92. Ann Arbor: Center for Japanese Studies, University of Michigan, 1998.

———. "Tanizaki Jun'ichirō's 'The Present and Future of the Moving Pictures'." *Currents in Japanese Culture: Translations and Transformations*, edited by Amy Vladeck Heinrich, 291–308. New York: Columbia University Press, 1997.

———. *Writing in Light: The Silent Scenario and the Japanese Pure Film Movement*. Contemporary Film and Television. Detroit, Mich.: Wayne State University Press, 2001.

Bowen-Struyk, Heather. "Rethinking Japanese Proletarian Literature." Ph.D. dissertation, University of Michigan, 2001.

Bowlby, Rachel. *Just Looking: Consumer Culture in Dreiser, Gissing, and Zola*. New York: Methuen, 1985.

Braisted, William Reynolds, ed. and trans.; assisted by Adachi Yasushi and Kikuchi Yūji. "*Meiroku Zasshi*": *A Journal of Japanese Enlightenment*. Cambridge: Harvard University Press, 1976.

Brooks, Peter. *The Melodramatic Imagination: Balzac, Henry James, Melodrama and the Mode of Excess*. With a new preface by the author. New Haven, Conn.: Yale University Press, 1995.

Brownstein, Michael C. "*Jogaku zasshi* and the Founding of *Bungakkai*." *Monumenta Nipponica* 35, no. 3 (1980): 319–336.

Cook, Haruko Taya, and Theodore F. Cook, eds. *Japan at War: An Oral History*. New York: New Press, 1992.

Copeland, Rebecca. *Lost Leaves: Women Writers of Meiji Japan*. Honolulu: University of Hawai'i Press, 2000.

———. "The Made-Up Author: Writer as Woman in the Works of Uno Chiyo." *Journal of the Association of Teachers of Japanese* 29, no. 1 (1995): 3–25.

———. *Sound of the Wind: The Life and Works of Uno Chiyo*. Honolulu: University of Hawai'i Press, 1992.

de Certeau, Michel. *The Practice of Everyday Life*. Translated by Steven Rendall. Berkeley: University of California Press, 1988.

Doane, Mary Ann. *The Emergence of Cinematic Time: Modernity, Contingency, and the Archive*. Cambridge: Harvard University Press, 2002.

Dollase, Hiromi Tsuchiya. "Early Twentieth Century Japanese Girls' Magazine Stories: Examining Shōjo Voice in *Hanamonogatari* (Flower Tales)." *Journal of Popular Culture* 36, no. 4 (2003): 724–755.

———. "Reading Yoshiya Nobuko's 'Yaneura no nishojo': In Search of Literary Possibilities in *Shōjo* Narratives." *U.S.-Japan Women's Journal*, no. 20–21 (2001): 151–178.

Enstad, Nan. *Ladies of Labor, Girls of Adventure: Working Women, Popular Culture, and Labor Politics at the Turn of the Twentieth Century*. New York: Columbia University Press, 1999.

Enzenberger, Hans Magnus. "Constituents of a Theory of the Media." In *Critical Essays*, 46–76. New York: Continuum, 1982.

Ericson, Joan E. *Be a Woman: Hayashi Fumiko and Modern Japanese Women's Literature*. Honolulu: University of Hawai'i Press, 1997.

———. "The Origins of the Concept of 'Women's Literature.'" In *The Woman's Hand: Gender and Theory in Japanese Women's Writing*, edited by Paul Gordon Schalow and Janet A. Walker, 74–115. Stanford, Calif.: Stanford University Press, 1996.

———. *Captains of Consciousness: Advertising and the Social Roots of the Consumer Culture*. New York: McGraw-Hill, 1976.

Bibliography

Faison, Elyssa. "Producing Female Textile Workers in Imperial Japan." Ph.D. dissertation, University of California, Los Angeles, 2001.

Felski, Rita. *Beyond Feminist Aesthetics: Feminist Literature and Social Change.* Cambridge: Harvard University Press, 1989.

———. *The Gender of Modernity*. Cambridge: Harvard University Press, 1995.

Fessler, Susanna. *Wandering Heart: The Work and Method of Hayashi Fumiko.* Albany: State University of New York Press, 1998.

Fowler, Edward. *The Rhetoric of Confession: Shishōsetsu in Early-Twentieth-Century Japanese Fiction.* Berkeley: University of California Press, 1988.

Fraser, Nancy. "Rethinking the Public Sphere: A Contribution to the Critique of Actually Existing Democracy." In *Habermas and the Public Sphere*, edited by Craig Calhoun, 111–142. Cambridge, Mass.: MIT Press, 1992.

Frederick, Sarah. "Bringing the Colonies 'Home': Yoshiya Nobuko's Popular Fiction and Imperial Japan." In *Across Time and Genre*, edited by Janice Brown and Sonja Arntzen, 61–64. Edmonton: University of Alberta, 2002.

———. "Sisters and Lovers: Women Magazine Readers and Sexuality in Yoshiya Nobuko's Romance Fiction." In *Love and Sexuality in Japanese Literature*, edited by Eiji Sekine, 311–320. West Lafayette, In.: Association for Japanese Literary Studies, 1999.

Freedman, Alisa. "Tracking Japanese Modernity: Commuter Trains, Streetcars, and Passengers in Tokyo Literature, 1905–1935." Ph.D. dissertation, University of Chicago, 2002.

Friedberg, Anne. *Window Shopping: Cinema and the Postmodern.* Berkeley: University of California Press, 1993.

Fujii, James A. *Complicit Fictions: The Subject in the Modern Japanese Prose Narrative.* Berkeley: University of California Press, 1993.

Fujimura-Fanselow, Kumiko, and Atsuko Kameda, eds. *Japanese Women: New Feminist Perspectives on the Past, Present, and Future.* New York: Feminist Press, 1995.

Gardner, William O. "Mongrel Modernism: Hayashi Fumiko's *Hōrōki* and Mass Culture." *Journal of Japanese Studies* 29, no. 1 (2003) 69–101.

Garon, Sheldon. "Fashioning a Culture of Diligence and Thrift: Savings and Frugality Campaigns in Japan, 1900–1931." In *Japan's Competing Modernities*, edited by Sharon A. Minichiello, 312–334. Honolulu: University of Hawai'i Press, 1998.

———. *Molding Japanese Minds.* Princeton, N.J.: Princeton University Press, 1997.

———. "Women's Groups and the Japanese State: Contending Approaches to Political Integration, 1890–1945." *Journal of Japanese Studies* 19, no. 1 (1993): 5–41.

Gerow, Aaron. "The Word before the Image: Criticism, the Screenplay, and the Regulation of Meaning in Prewar Japanese Film Culture." In *Word and Image in Japanese Cinema*, edited by Carole Cavanaugh and Dennis Washburn, 3–35. Cambridge: Cambridge University Press, 2001.

Gordon, Andrew. *The Evolution of Labor Relations in Japan: Labor Relations in Heavy Industry, 1853–1955.* Cambridge, Mass.: Council on East Asian Studies, 1985.

———. "Managing the Japanese Household: The New Life Movement in Postwar Japan." In *Social Politics* (Summer 1997), 245–283.

Guillory, John. *Cultural Capital: The Problem of Literary Canon Formation.* Chicago: University of Chicago Press, 1993.

Hall, Stuart. "Encoding/Decoding." In *Culture, Media, Language: Working Papers in Cultural Studies,* edited by Stuart Hall, 972–979. London: Hutchinson, 1980.

Halliday, Jon. *A Political History of Japanese Capitalism.* New York: Monthly Review Press, 1975.

Hane, Mikiso. *Peasants, Rebels, and Outcasts: The Underside of Modern Japan.* New York: Pantheon, 1982.

Hanes, Jeffrey E. "Advertising Culture in Interwar Japan." *Japan Foundation Newsletter* 13, no. 4 (1994): 8–12.

Hani, Motoko. "Stories of My Life." *Japan Interpreter* 12, no. 3–4 (1979): 330–354.

Harada Kazue. "Lesbianism and the Writing of Yoshiya Nobuko in the Taisho Period." In *Across Time and Genre,* edited by Janice Brown and Sonja Arntzen, 65–68. Edmonton: University of Alberta, 2002.

Harootunian, Harry D. *History's Disquiet: Modernity, Cultural Practice, and the Question of Everyday Life.* New York: Columbia University Press, 2000.

———. "Overcome by Modernity: Fantasizing Everyday Life and the Discourse on the Social in Interwar Japan." *Parallax* 2 (1997): 77–88.

———. *Overcome by Modernity: History, Culture, and Community in Interwar Japan.* Princeton, N.J.: Princeton University Press, 2000.

Havens, Thomas R. H. *Valley of Darkness: The Japanese People and World War II.* New York: W. H. Norton, 1978.

Honey, Maureen. *Creating Rosie the Riveter: Class, Gender, and Propaganda During World War II.* Amherst: University of Massachusetts Press, 1984.

Huffman, James. *Creating a Public: People and Press in Meiji Japan.* Honolulu: University of Hawai'i Press, 1997.

Hunter, Janet, ed. *Japanese Women Working.* New York: Routledge, 1993.

Huyssen, Andreas. *After the Great Divide: Modernism, Mass Culture, Postmodernism.* Bloomington: Indiana University Press, 1986.

Imamura, Anne E., ed. *Re-Imagining Japanese Women.* Berkeley: University of California Press, 1996.

Inoue, Mariko. "Regendering Domestic Space: Modern Housing in Prewar Tokyo." *Monumenta Nipponica* 58, no. 1 (Spring 2003): 84–91.

Ishimoto Shizue. *Facing Two Ways: The Story of My Life.* New York: Farrar and Rinehart, 1935.

Itō, Ken. "Class and Gender in a Meiji Family Romance: Kikuchi Yūhō's *Chikyōdai.*" *Journal of Japanese Studies* 28, no. 2 (2002): 339–378.

———. *Visions of Desire: Tanizaki's Fictional Worlds.* Stanford, Calif.: Stanford University Press, 1991.

Ivy, Marilyn. "Formations of Mass Culture." In *Postwar Japan As History,* edited by Andrew Gordon, 239–258. Berkeley: University of California Press, 1993.

Bibliography

Jameson, Fredric. *The Political Unconscious: Narrative as a Socially Symbolic Act.* Ithaca, N.Y.: Cornell University Press, 1981.

Jones, Mark Alan. "Children as Treasures: Childhood and the Middle Class in Early Twentieth-Century Japan." Ph.D. dissertation, Columbia University, 2001.

Kano, Ayako. *Acting like a Woman in Modern Japan: Theater, Gender, and Nationalism.* New York: Palgrave, 2001.

Karatani, Kōjin. *The Origins of Modern Japanese Literature.* Translated by Brett de Bary. Durham, N.C.: Duke University Press, 1993.

Kasza, Gregory. *The State and the Mass Media in Japan, 1918–1945.* Berkeley: University of California Press, 1988.

Kornicki, Peter. *The Book in Japan: A Cultural History from the Beginnings to the Nineteenth Century.* Honolulu: University of Hawai'i Press, 2001.

LaMarre, Thomas. "The Deformation of the Modern Spectator: Synaesthesia, Cinema, and the Spectre of Race in Tanizaki." *Japan Forum* 11, no. 1 (1999): 23–42.

Lefebvre, Henri. *Critique of Everyday Life.* Translated by John Moore. London and New York: Verso, 1991.

Lippit, Noriko Mizuta. "*Seitō* and the Literary Roots of Japanese Feminism." *International Journal* 2, no. 2 (1979): 153–163.

Lippit, Seiji M. *Topographies of Modernism.* New York: Columbia University Press, 2002.

Mack, Edward Thomas II. "The Value of Literature: Cultural Authority in Interwar Japan." Ph.D. dissertation, Harvard University, 2002.

Mackie, Vera. *Creating Socialist Women in Japan: Gender, Labor, and Activism, 1900–1937.* Cambridge: Cambridge University Press, 1997.

Maeda Ai. *Text and the City: Essays on Japanese Modernity.* Edited by James Fujii. Durham, N.C.: Duke University Press, 2004.

Marchand, Roland. *Advertising the American Dream: Making Way for Modernity, 1920–1940.* Berkeley: University of California Press, 1985.

Marek, Jayne E. *Women Editing Modernism: "Little" Magazines and Literary History.* Lexington: University of Kentucky Press, 1995.

Marran, Christine. "The Allure of the Poison-Woman in Modern Japanese Literature." Ph.D. dissertation, University of Washington, 1998.

Masao, Miyoshi. *Off Center: Power and Cultural Relations between Japan and the United States.* Cambridge: Harvard University Press, 1991.

Matsugu Miho. "Why Does Uiko Die? The Invisible Lesbian and Patriarchy in Yoshiya Nobuko's *The Woman's Classroom.*" In *Across Time and Genre,* edited by Janice Brown and Sonja Arntzen, 56–60. Edmonton: University of Alberta Press, 2002.

Menzies, Jackie. *Modern Girl, Modern Boy: Modernity in Japanese Art.* Sydney: Art Gallery of New South Wales, 1998.

Minichiello, Sharon A., ed. *Japan's Competing Modernities: Issues in Culture and Democracy, 1900–1930.* Honolulu: University of Hawai'i Press, 1998.

Mitchell, W. J. T., ed. *Art and the Public Sphere*. Chicago: University of Chicago Press, 1990.

Miyamoto, Ken. "Itō Noe and the Bluestockings." *Japan Interpreter* 10, no. 1 (1975): 190–204.

Modleski, Tania. *Loving with a Vengeance: Mass-Produced Fantasies for Women*. New York and London: Methuen, 1982.

———, ed. *Studies in Entertainment: Critical Approaches to Mass Culture*. Bloomington: Indiana University Press, 1986.

Monnet, Livia. "Montage, Cinematic Subjectivity, and Feminism in Ozaki Midori's *Drifting in the World of the Seventh Sense*." *Japan Forum* 11, no. 1 (1999): 57–82.

Moeran, Brian. "The Birth of the Japanese Department Store." In *Asian Department Stores*, edited by Kerrie L. MacPherson, 141–176. Honolulu: University of Hawai'i Press, 1998.

———. *A Japanese Advertising Agency: An Anthropology of Media and Markets*. ConsumAsiaN Book Series. Honolulu: University of Hawai'i Press, 1996.

———. "In Pursuit of Perfection: The Discourse of Cars and Transposition of Signs in Two Advertising Campaigns." In *Contemporary Japan and Popular Culture*, edited by John Whittier Treat, 41–68. Honolulu: University of Hawai'i Press, 1996.

Mori, Barbara Lynne Rowland. "The Traditional Arts as Leisure Activities for Contemporary Japanese Women." In *Re-Imagining Japanese Women*, edited by Anne E. Imamura, 117–134. Berkeley: University of California Press, 1996.

Mulhern, Chieko Irie. "Japan's First Newspaperwoman: Hani Motoko." *Japan Interpreter* 48, no. 1 (1979): 310–320.

Nakamoto Takako. "The Female Bell-Cricket." Translated by Yukiko Tanaka. In *To Live and to Write: Selections by Japanese Women Writers, 1913–1938*, edited by Yukiko Tanaka, 135–144. Seattle, Wash.: Seal Press, 1987.

Orbaugh, Sharalyn. "The Body in Contemporary Japanese Women's Fiction." In *The Woman's Hand*, edited by Paul Schalow and Janet Walker, 119–164. Stanford, Calif.: Stanford University Press, 1996.

Ozaki Midori. "Osmanthus" (Mokusei). Translated by Miriam Silverberg. *Manoa* 3, no. 2 (1991): 187–190.

Passim, Herbert. *Society and Education in Japan*. New York: Teachers College Press Columbia University, 1965.

Peiss, Kathy. *Cheap Amusements: Working Women and Leisure in Turn-of-the-Century New York*. Philadelphia: Temple University Press, 1986.

Petro, Patrice. *Joyless Streets: Women and Melodramatic Representation in Weimar Germany*. Princeton, N.J.: Princeton University Press, 1989.

Pumphrey, Martin. "The Flapper, the Housewife, and the Making of Modernity." *Cultural Studies* 1, no. 2 (1987): 179–194.

Pyle, Kenneth. *The New Generation in Meiji Japan: Problems of Cultural Identity, 1885–1895*. Stanford, Calif.: Stanford University Press, 1969.

Bibliography

Radway, Janice. *Reading the Romance: Women, Patriarchy, and Popular Literature.* London: Verso, 1987.

Reich, Pauline C. "Japan's Literary Feminists: The Seitō Group." *Signs* 2, no. 1 (1976): 280–291.

Robertson, Jennifer. "Gender-bending in Paradise: Doing 'Female' and 'Male' in Japan." *Genders*, no. 5 (1989): 50–69.

———. *Takarazuka: Sexual Politics and Popular Culture in Modern Japan.* Berkeley: University of California Press, 1998.

———. "Yoshiya Nobuko: Out and Outspoken in Practice and Prose." In *The Human Tradition in Modern Japan*, edited by Anne Walthall, 57–104. The Human Tradition around the World, no. 3. Wilmington, Del.: Scholarly Resources, 2001.

Roden, Donald. "Taishō Culture and the Problem of Gender Ambivalence." In *Culture and Identity: Japanese Intellectuals during the Interwar Years*, edited by J. Thomas Rimer, 37–55. Princeton, N.J.: Princeton University Press, 1990.

Rosenberger, Nancy R. "Fragile Resistance, Signs of Status: Women between State and Media in Japan." In *Re-Imagining Japanese Women*, edited by Anne E. Imamura, 12–45. Berkeley: University of California Press, 1996.

Rubin, Jay. *Injurious to Public Morals: Writers and the Meiji State.* Seattle: University of Washington Press, 1984.

Sakaki, Atsuko. *Recontextualizing Texts: Narrative Performance in Modern Japanese Fiction.* Cambridge: Harvard University Asia Center, 1999.

Sand, Jordan. "The Cultured Life as Contested Space: Dwelling and Discourse in the 1920s." In *Being Modern in Japan: Culture and Society from the 1910s to the 1930s*, edited by Elise K. Tipton and John Clark, 99–118. Honolulu: University of Hawai'i Press, 2000.

———. *House and Home in Modern Japan: Architecture, Domestic Space, and Bourgeois Culture, 1880–1930.* Cambridge: Harvard University Press, 2003.

———. "Was Meiji Taste in Interiors 'Orientalist'?" *Positions* 8, no. 3 (2000): 637–673.

Satō, Barbara Hamill. "An Alternate Informant: Middle-Class Women and Mass Magazines in 1920s Japan." In *Being Modern in Japan: Culture and Society from the 1910s to the 1930s*, edited by Elise K. Tipton and John Clark, 137–153. Honolulu: University of Hawai'i Press, 2000.

———. "The *Moga* Sensation: Perceptions of the *Modan Gāru* in Japanese Intellectual Circles during the 1920s." *Gender and History* 5, no. 3 (1993): 363–381.

———. *The New Japanese Woman: Modernity, Media, and Women in Interwar Japan.* Durham, N.C.: Duke University Press, 2003.

Satō, Haruo. *Beautiful Town.* Translated by Francis B. Tenny. Honolulu: University of Hawai'i Press, 1996.

———. *The Sick Rose: A Pastoral Elegy.* Translated by Francis B. Tenny. Honolulu: University of Hawai'i Press, 1993.

Scanlon, Jennifer. *Inarticulate Longings: "The Ladies' Home Journal," Gender, and the Promises of Consumer Culture.* New York: Routledge, 1995.

Schalow, Paul Gordon, and Janet A. Walker, eds. *The Woman's Hand: Gender and Theory in Japanese Women's Writing*. Stanford, Calif.: Stanford University Press, 1996.

Scott, Joan. *Gender and the Politics of History*. New York: Columbia University Press, 1988.

Setouchi, Harumi. *Beauty in Disarray*. Translated by Sanford Goldstein and Kazuji Ninomiya. Rutland, Vt.: Tuttle, 1993.

Shimada Noriko, Takamura Hiroko, Iino Masako, and Ito Hisako. "Ume Tsuda and Motoko Hani: Echoes of American Cultural Feminism in Japan." In *Remember the Ladies: New Perspectives on Women in American History*, edited by Carol V. R. George. Syracuse, N.Y.: Syracuse University Press, 1975.

Sievers, Sharon L. *Flowers in Salt: The Beginnings of Feminist Consciousness in Modern Japan*. Stanford, Calif.: Stanford University Press, 1983.

Silberman, Bernard S., and H. D. Harootunian, eds. *Japan in Crisis: Essays on Taisho Democracy*. Princeton, N.J.: Princeton University Press, 1974.

Silverberg, Miriam. "Advertising Every Body: Images from the Japanese Modern Years." In *Choreographing History*, edited by Susan Leigh Foster, 129–148. Bloomington: Indiana University Press, 1995.

———. "The Café Waitress Serving Modern Japan." In *Mirror of Modernity: Invented Traditions of Modern Japan*, edited by Stephen Vlastos, 208–228. Berkeley: University of California Press, 1998.

———. *Changing Song: The Marxist Manifestos of Nakano Shigeharu*. Princeton, N.J.: Princeton University Press, 1990.

———. "Constructing the Japanese Ethnography of Modernity." *Journal of Asian Studies* 51, no. 1 (February 1992): 30–42.

———. "Constructing a New Cultural History of Prewar Japan." In "Japan in the World," edited by Miyoshi Masao and H. D. Harootunian. Special issue, *Boundary 2*, 61–89.

———. "The Modern Girl as Militant." In *Recreating Japanese Women, 1600–1945*, edited by Gail Lee Bernstein, 239–266. Berkeley: University of California Press, 1991.

Skov, Lise, and Brian Moeran, eds. *Women Media and Consumption in Japan*. Edited by Brian Moeran and Lise Skov. ConsumAsiaN Book Series. Honolulu: University of Hawai'i Press, 1995.

Stanley, Thomas. *Ōsugi Sakae, Anarchist in Taishō Japan: The Creativity of the Ego*. Cambridge: Council on East Asian Studies, Harvard University, 1982.

Strecher, Matthew C. "Purely Mass or Massively Pure? The Division between 'Pure' and 'Mass' Literature." *Monumenta Nipponica* 51, no. 3 (1996): 357–374.

Studlar, Gaylyn. "The Perils of Pleasure? Fan Magazine Discourse as Women's Commodified Culture in the 1920s." *Wide Angle* 13, no. 1 (1991): 7.

Suzuki, Michiko. "Developing the Female Self: Same-Sex Love, Love Marriage, and Maternal Love in Modern Japanese Literature, 1910–39." Ph.D. dissertation, Stanford University, 2002.

———. "Love and Marriage, Sisters and Mothers: Yoshiya Nobuko Rereads Ellen Key." In *Across Time and Genre*, edited by Janice Brown and Sonja Arntzen, 52–56. Edmonton: University of Alberta Press, 2002.

Suzuki, Tomi. *Narrating the Self: Fictions of Japanese Modernity*. Stanford, Calif.: Stanford University Press, 1996.

Tanaka, Yukiko, ed. *To Live and to Write: Selections by Japanese Women Writers, 1913–1938*. Seattle, Wash.: Seal Press, 1987.

———. *Women Writers of Meiji and Taishō Japan: Their Lives, Works, and Critical Reception, 1868–1926*. Jefferson, N.C.: McFarland, 2000.

Tanizaki Jun'ichirō. *Naomi*. Translated by Anthony Chambers. New York: Knopf, 1985.

Teasley, Sarah. "Home-Builder or Homemaker? Reader Presence in Articles on Homebuilding in Commercial Women's Magazines in 1920s Japan." *Journal of Design History* 18, no. 1 (2005): 81–97.

Tipton, Elise. "In a House Divided: The Japanese Christian Socialist Abe Isoo." In *Nation and Nationalism in Japan*, edited by Sandra Wilson, 81–96. London: Routledge Curzon, 2002.

———, and John Clark, eds. *Being Modern in Japan: Culture and Society from the 1910s to the 1930s*. Honolulu: University of Hawai'i Press, 2000.

Treat, John Whittier. "Yoshimoto Banana Writes Home: The Shōjo in Japanese Popular Culture." In *Contemporary Japan and Popular Culture*, edited by John Whittier Treat, 275–308. Honolulu: University of Hawai'i Press, 1996.

———. *Writing Ground Zero: Japanese Literature and the Bomb*. Chicago: University of Chicago Press, 1995.

Tsurumi, Patricia. *Factory Girls: Women in the Thread Mills of Meiji Japan*. Princeton, N.J.: Princeton University Press, 1990.

———. "Feminism and Anarchism in Japan: Takamure Itsue, 1894–1964." *Bulletin of Concerned Asian Scholars* 17, no. 2 (1985): 2–19.

Ueno, Chizuko. "Seibu Department Store and Image Marketing." In *Asian Department Stores*, edited by Kerrie L. MacPherson, 177–203. Honolulu: University of Hawai'i, 1998.

Uno, Kathleen S. "One Day at a Time: Work and Domestic Activities of Urban Lower-Class Women in Early Twentieth-Century Japan." In *Japanese Women Working*, edited by Janet Hunter, 37–68. New York: Routledge, 1993.

———. *Passages to Modernity: Motherhood, Childhood, and Social Reform in Early Twentieth-Century Japan*. Honolulu: University of Hawai'i Press, 1999.

Vernon, Victoria. *Daughters of the Moon: Wish, Will and Social Constraint in Fiction by Modern Japanese Women*. Berkeley: Institute of East Asian Studies, University of California, 1988.

Vlastos, Stephen, ed. *Mirror of Modernity: Invented Traditions of Modern Japan*. Berkeley: University of California Press, 1998.

Weisenfeld, Gennifer S. "Japanese Modernism and Consumerism: Forging the New Artistic Field of *Shōgyō bijutsu.*" In *Being Modern in Japan: Culture and Society from the 1910s to the 1930s,* edited by Elise K. Tipton and John Clark, 75–98. Honolulu: University of Hawai'i Press, 2000.

———. *MAVO: Japanese Artists and the Avant-Garde, 1905–1931.* Berkeley: University of California Press, 2002.

———. *Decoding Advertisements: Ideology and Meaning in Advertising.* London: Marion Boyars, 1978.

Winship, Janice. *Inside Women's Magazines.* London and New York: Pandora Press, 1987.

Wöhr, Ulrike, et al., eds. *Gender and Modernity: Rereading Japanese Women's Magazines.* Kyoto: International Research Center for Japanese Studies, 1998.

Young, Louise. *Japan's Total Empire: Manchuria and the Culture of Wartime Imperialism.* Berkeley: University of California Press, 1999.

———. "Marketing the Modern: Department Stores, Consumer Culture, and the New Middle Class in Interwar Japan." *International Labor and Working-class History* 55 (1999): 52–70.

Index

Abe Isō, 40, 42–45, 196n. 36
actresses, 77, 79, 83, 109, 124
advertisements, 6, 12, 17–18; audiences and, 94; beauty and, 52; fiction and, 3, 11, 61–62, 76; in *Fujin kōron*, 33, 37, 79; image of West in, 78; as information, 114–115; Mannensha, 17; marriage and, 49; in *Nyonin geijutsu*, 170, 174; in *Shufu no tomo*, 89, 94, 100, 111–117
Akira, 180–181
Akutagawa Prize, 221n. 8
Akutagawa Ryūnosuke, 10, 58–59
America, Japanese magazine readers in, 99–100
An-An, 178
anarchism: feminism and, 48, 51–53; Ōsugi Sakae and, 57–58
anime, 180–181; Miyazaki Hayao, 222n. 13
Aono Suekichi, 19, 125, 135
architecture, 18, 88, 132–133
Arishima Takeo: *Aru onna*, 33, 57; suicide with Hatano Akiko, 56–60, 61, 134, 149
Aru onna (A certain woman). *See* Arishima Takeo
autobiography: "Autobiographical Love Fiction" Issue of *Nyonin geijutsu* and, 143–158; *Hōrōki* as 164–166

Bagel, 178
Bardsley, Jan, 4, 9, 186n. 7
beauty, 106, 146; covers and, 170; intellectual discourse on, 49–54, 195n. 20
birth control, 39, 100
Blake, William, 63

books, 179; consumption and, 62; contemporary, 180; magazines and, 37. *See also enpon*
Bourdieu, Pierre, 36
Bowen-Struyk, Heather, 146, 160, 213n. 2
Brazil, 11, 99
bundan (literary establishment), 119–120; *Shufu no tomo* and, 117–121
Bungei kurabu (Literary club), 12
bunka (culture), 18. *See also* cultured house; cultured life; culture village
Bunshō kurabu (Composition club), 141

Café waitress (Jokyū). *See* Hirotsu Kazuo
café waitress *(jokyū)*, 75, 85; Korean, 130. *See also* Hirotsu Kazuo
capitalism, viii, 125; everyday life and, 92; Japanese, 143; literature and, 22; publishing and, 84; women and, 6, 19, 49–53, 85, 117
cellular phones: literature and, 179
censorship, 11, 22, 131, 141, 144–147, 151, 161, 175, 216n. 25; *Nyonin geijutsu* and, 163; office of, 6, 166, 195n. 25; *Shufu no tomo* and, 163
Chaplin, Charlie, 153–155, 169
Chijin no ai (A fool's love). *See* Tanizaki Jun'ichirō
children, 44, 174; newspaper for, 170; as readers, 124, 126
Chūō kōron (Central review), 26, 28, 30–33, 76, 78; covers of, 34; *Fujin kōron* and, 30–33, 46; "Woman Problem" Issue (Fujin mondai gō), 31–32

241

242 Index

circulation of magazines, 7, 119, 186n. 8;
 Fujin kōron, 6, 32–33, 93; *Fujin kurabu*,
 32, 93; *Fujin no tomo*, 33; *Fujokai*, 93; *Ie
 no hikari*, 11; *Josei*, 32; return of unsold
 copies, 89; *Shufu no tomo*, 6, 32, 85, 89,
 93, 98
class: conflict, 160, 162; feminism and,
 38, 51–54; gender and, 40, 128, 137, 172,
 175–176; magazine readership and, 32,
 93; mass culture and, 172
colonies, 129; readership in, 99; Yoshiya
 Nobuko and, 134, 181
comics. See *manga*
commercial art, viii, 101–110, 112–113, 169.
 See also advertisements; covers, of
 magazines
commercialism: art and, 121; literature
 and, vii–viii, 117–121; women and, 158
commuting, 16, 121–122
confession (*kokuhaku*), 16, 55, 86, 98, 116,
 131
consumption: advertising and, 111;
 femininity and, 107; marriage and, 43,
 130; pleasure of, 129–132; as rational,
 100; reading and, 100–101; resistance
 and, 177; *Shufu no tomo* and, 94;
 taishū (mass) and, 172; women and, 1–2,
 36, 102, 128, 221n. 8; women writers'
 representations of, 7–9, 128–132
Copeland, Rebecca, 4, 7, 12, 62,
 186nn. 7, 12
corporate culture: and home culture,
 89–92
cosmetics, 15, 33, 37, 112–113; Club, 10;
 Yamakawa Kikue and Takamure Itsue
 on, 50–53
covers, of magazines, viii, 13; *Fujin kōron*,
 28, 33–35, 79; *Nyonin geijutsu*, 137, 144,
 145, 155, 166–170; print quality of, 101; of
 Shufu no tomo, 101–110
cultural studies, 5, 182
cultured house (bunka jūtaku), 89, 133
cultured life (bunka seikatsu), 18, 82–83,
 89, 98, 114
culture village (bunka mura): in literature,
 121–122

debate: in *Fujin kōron*, 36, 38, 83; in
 Nyonin geijutsu, 163, 170–175; in *Shufu
 no tomo*, 88, 100
delinquent girl (*furyō shōjo*), 1, 16, 86
Den'en no yu'utsu (Melancholy in the
 country). *See* Satō Haruo
department stores, 14, 18, 62, 127–128;
 advertising and, 33, 37, 116–117, 174;
 parallel to magazines, 111, 116
diaries, women's, 62
Diary of a Vagabond (Hōrōki). *See*
 Hayashi Fumiko
domestic novels. *See* *katei shōsetsu*
domesticity, 38, 129–131; consumption,
 and, 18; contrast to office culture,
 89–92; entertainment and, 96, 135;
 rationalization of, 85–86, 114; and
 women's education, 42
"Dorumen no nazo" (Riddle of the
 dolmen). *See* Matsui Teiko

Earthquake, Great Kantō, of 1923, 42, 89,
 106–107, 126–127
editors, of women's magazines:
 contributors and, 76; influence of, 2–4,
 6, 21, 57–58, 74–77, 87–94, 175–177;
 literary value and, 22, 27; women as, 9,
 141; women readers and, 54–55. *See also*
 Hani Motoko (*Fujin no tomo*); Hasegawa
 Shigure (*Nyonin geijutsu*); Hiratsuka
 Raichō (*Seitō*); Ishikawa Takeyoshi
 (*Shufu no tomo*); Itō Noe (*Seitō*);
 Shimanaka Yūsaku (*Fujin kōron*)
education of women, 8–9, 17, 39–45, 180;
 magazine reading and, 93, 96–97;
 marriage and, 40
efficiency. *See* time management
EGG, 178
Enchi Fumiko, 137, 166
enjo kōsai (compensated dating), 1–2, 180,
 221n. 8
enpon (one-yen books), 12, 20, 118, 141
Enstad, Nan, 23
entertainment, 98, 135; advertising
 and, 111; fiction and, 3, 121, 135–136;
 information and, 36–37; media and,

121–124, 151–152; as social criticism, 123–124; wartime and, 181; women's magazines and, 11–14, 16, 55–56, 88, 92, 100

Ericson, Joan, 4, 20, 22, 78, 140, 164, 186n. 7

Esperanto, 170

eugenics, 38, 53

everyday life, 123; advertising and, 114–116; popular literature and, 135; women and, viii, 28

extended family, decline of, 85

factory girls. *See joko*

Felski, Rita, 19, 23, 38, 128

"The Female Bell-Cricket" (*Suzumushi no mesu*). *See* Nakamoto Takako

femininity: consumption and, 107, 128–132; cover images and, 102, 168; education and, 41; language and, 163; modernity and, 45; nation and, 44; as performance in Tanizaki, 72; politics and, 147–148; popular culture and, 120; public activity and, 134; reading and, 36–38; work and, 96; Yamakawa Kikue and Takamure Itsue on, 49–53

feminism, 23–25, 127–128, 172; debates and, 37, 46; Marxism and, 48–54, 147; *Nyonin geijutsu* and, vii–viii, 173; proletarian movement and, 148; socialism and, 137; translations of Western, 9–10; women's magazines and, vii–viii, 2, 5; World War II and, 134; Yoshiya Nobuko and, 126, 133

Fessler, Susanna, 140

film: actors, 13, 16, 81–83, 162; adaptation into, 118, 127, 202n. 140; image in literature, 152; in print culture, 13, 98, 107–109; scriptwriting contests, 123–124; technology, 154

free love, 58

frugality, 100–102, 117, 122–123; femininity and, 129–132; *Shufu no tomo* and, 88–92, 110

Fujin gahō (Ladies' pictorial), vii, 8–9, 93, 110, 187n. 19

Fujin kōron (Ladies' review), 3, 84–85; advertising in, 33, 37; *bosei hogo ronsō* (motherhood protection debates) in, 46, 48, 90; categorization of texts in, 26, 35–38, 53–56, 83, 111, 156; circulation of, 32–33, 93; commercialism and, 30; covers, 27–29, 33–35, 79; debate in, 27, 36–39, 60–62, 88, 100, 178; editorial changes in, 30, 79–83; enlightenment of women and, 26–28, 56–57; founding of, 26–28, 30–33; as *fujin zasshi*, vii; gender of contributors, 27; Hirotsu Kazuo in, 74–77; *Jiyū rondan* (Free discussion column), 54–55; literature in, 36–38, 60–79, 111; men as readers of, 33; Miyamoto Yuriko and, 77–78; readership of, 27–28, 31–34; Renewal Issue (1998), 28–30, 79; Satō Haruo in, 63–70; *Shufu no tomo* and, 87; Taishō shin *Onna daigaku* series, 39–47; Takamure Itsue in, 48–54; Tamura Toshiko in, 77; Tanizaki Jun'ichirō in, 21, 59, 70–74, 78; women writers and, 47–55, 77–79; working women in, 31, 156; Yamakawa Kikue in, 48–54

Fujin kurabu (Ladies' club), vii; competition with *Shufu no tomo*, 10, 94, 113

fujin mondai. See woman problem

Fujin no tomo (Ladies' friend), 9, 33, 87, 205n. 8

Fujin rōdō (Ladies' labor), 172

Fujin sekai (Ladies' world), 79, 97

Fujin sensen (Ladies' front), 166

Fujin undō (Ladies' movement), 173

fujin zasshi (ladies' magazine): *Fujin kōron* as, 79; *kaizen undō* (movement to reform), 118; as publishing category, vii. *See also* women's magazines

Fuji Publishing Company: magazine reprints and, 11

Fujishima Takeji, 105

Fujokai (Women's world), 87–89

Fujo zasshi (Women's magazine), 8

Fukuzawa Kōko, 167

Fukuzawa Yūkichi, 7

Index

furigana, 170; print technology and, 96
Fusen (Women's suffrage), 11
Fusen kakudoku dōmei (Women's suffrage league), 11

Gardner, William O., 140, 165
geisha, 8, 32
genbun itchi (unification of speech and writing), 8
gender: ambivalence, 72; class and, 137, 151; consumption and, 174; nature and, 41; race and, 71–73; roles, 6; media and, 2, 86, 91, 174, 176
general interest magazine (*sōgō zasshi*), 5, 96
genre, 70–74, 78, 125, 180; gender and, 3–4; in women's magazines, 26
girl. See *shōjo*
Godzilla, 181
Good Housekeeping Seal, 116
Gotō Katsuko, 161–163
Guillory, John, 20, 35–36

Hakubakai, 105
Hakubunkan, 8
Hanabusa Yuriko, 124
Hanamonogatari (Flower stories). See Yoshiya Nobuko
Hani Motoko, 9, 32–33, 87, 205n. 7
Hani Yoshikazu, 87
Harootunian, Harry, 4, 19, 85–86
Hasegawa Noburu, *104*
Hasegawa Shigure, 137, 141, 143–144, 170, 214n. 9; "Hizakari" (High noon), 166
Hasen (Shipwreck). See Kume Masao
Hatano Akiko, double suicide with Arishima Takeo, *15*, 56–60, *61*, 134, 149

Hayama Yoshiki: "The Prostitute" (*Inbaifu*), 160
Hayashi Fumiko, vii, 75, 137, 142–143, 155; *Hōrōki* (Diary of a vagabond), 20, 140, 164–166, 219nn. 85, 87
Hirabayashi, Hatsunosuke, 10, 19
Hirabayashi Eiko, 214n. 4
Hirabayashi Taiko, 149, 155–157, 172
Hirasawa Seiji, 64

Hirata Yumi, 8
Hiratsuka Raichō (Haruko), 9, 31, 41, 47, 56, 198n. 70, 207n. 20
Hirotsu Kazuo, 63; *Café waitress (Jokyū)*, 74–77, 81
historical fiction, 125
home economics and management, 93, 106–109, 117
Horiba Kiyoko, 188n. 21
Hori Yasuko, 57–58
Hōrōki (Diary of a vagabond). See Hayashi Fumiko
household account book (*kakeibo*), 88–89, 96
household appliances, 114–116, *115*
housewife (*shufu*), viii, 2, 16, 32; American, 92; cultured life and, 83; everyday life of, 62; as Japanese, 92, 100; magazine covers and, 101; modernity and, 114; as reader of fiction, 62; as readers and consumers, 117; *Shufu no tomo* and, 85–86, 89–95, 97, 110
Huyssen, Andreas, 19
hygiene, 114
hysteria, 41

Ibsen, Henrik, 32, 66
Ichikawa Fusae, 11
Ie no hikari (The light of the family), 10–11
Ikuta Chōsuke, 118
Ikuta Hanayo, 141, 214n. 11
Imagawa, Hideko, 164
independent magazines, 11, 78, 178
Inoue Tetsujirō, 40–41, 43–44
I-novel (*watakushi shōsetsu, shi-shōsetsu*), 5, 21–22, 69–70, 73, 119–120
Ishii Tekisui, 104
Ishikawa Takeyoshi (Takemi), 84–136, 86, 121; American magazines and, 116; contributors and, 97, 118; cover images and, 103; editorial aims of, 84, 87–94, 136; Editor's Diary, 91, 94, 98; on title of *Shufu no tomo*, 93
Ishimoto Shizue, 30
Itō Noe, 57–59, 134
Iwamoto Yoshiharu, 7
Iwaya Sazanami, 8, 99

Izu no odoriko (The Izu dancer), 21
Izumi, 59–60, *61*
Izumi Kyōka, 10

Jameson, Fredric, 181
Japan Women's University (Nihon Joshidai), 40
Japanese Business Girls, 11
Jinno Yuki, 128
jitsuwa (true stories), 149, 158–163
jogakusei (women students), 7
Jogaku sekai (Women's education world), 8
Jogaku zasshi (Women's education magazine), 7–8, 12, 62
jokō (factory girls), 6, 15–16, 23, 94, 97, 160; as readers of *Shufu no tomo*, 97
Jokyū (Café waitress). *See* Hirotsu Kazuo
Josei (Women), 10, 113, 142–143; *Chijin no ai* in, 70; circulation of, 32
josei ron, 8
journalism: criticisms of, 142–143; relationship with fiction, viii, 3; women in, 9, 56–60, 91
jun bungaku (pure literature), 20. *See also* popular literature

Kagayaku (Shine), 175
Kaibara Ekken, 39
Kamata Eikichi, 40, 196n. 37
Kamichika Ichiko, 10, 57–58, *173*, 214n. 9
Kanai Keiko, 214n. 8
katei shōsetsu (domestic novel), 71–74, 125
Katō Shizue. *See* Ishimoto Shizue
Katzoff, Beth, 222n. 12
Kawabata Yasunari, 152; *Izu no odoriko* (The Izu dancer), 21
Key, Ellen, 63, 127
Kikuchi Kan, 76
Kingu (King), 7, 13–14, 98, 124
Kinoshita Takanori, 109
Kishida Toshiko, 7
Kitamura Tōkoku, 7
Kitayama Masako, 173
Kobayashi Hideo, 22
Kobayashi Yoshinori, 222n. 13
Kōdan kurabu (Story club), 98

Kōkoku nenkan (Advertisers' annual), 17
Kollontai, Alexandra, 137
Kondō Kenzō, 7
Kōno Kensuke, 74, 81
Kon Wajirō, 19
Korea, 99, 129–130
koshinbun (small newspapers), 8
Kume Masao, *15*; *Hasen* (Shipwreck), 96, 118, 189n. 41
Kurenai (Scarlet), 149
Kuroshōbi (Black rose), 11

labor movement, 172; women and, 152–153, 156, 158–159; writers and, 119
labor, women's. *See* working women
layout, 86, 101, 141; categorizing texts through, 6, 35–38, 53–56; *Fujin kōron* and, 26; *Nyonin geijutsu* and, 138; *Shufu no tomo*, 111–112
Lefebvre, Henri, 1, 5
Lettuce Club, 109–110
Life Reform Movement *(Seikatsu kaizen undō)*, 88
Lippit, Seiji, 21, 140
literacy, 8–9, 17, 187n. 16; compulsory education and, 96; *manga* and, 93, 180; standardized language and, 99
literary criticism, 2, 5–6, 21–23; analysis of popular culture and, 182–183
literary establishment. *See bundan*
literary magazines, 21–22, 74, 78, 96, 119; *Bungei shunju*, 179; *Gunzō*, 179
literary value, 4, 20–22, 27; consumption and, 61–62; politics and, 147–148; sexuality and, 147–148
literature: censorship, 163; commercialism and, 11, 120; consumption and, 21–25; mass culture and, 36, 60; in *Nyonin geijutsu*, 177; politics and, 21–25, 125, 147–148, 173–175; selection of, by magazines, 70; social change and, 158; truth and, 156–166; in women's magazines, 33, 36, 179. *See also* serialized fiction
love: class and, 155–156; debates on, 48–54; fiction and, 61, 63; representation of, 155–156

246　Index

Mack, Edward, 12

Mackie, Vera, 205n. 7

Maeda Ai, 3–6, 22, 118–120

magazines: effects on women readers, 28; financial backing for, 37, 141–143, 170; methods for analyzing, vii–viii, 5–6. *See also* women's magazines

The Makioka Sisters. See Sasameyuki

Manchuria, 99

manga, 99, 122, 124, 179–181

Marran, Christine, 187n. 15

marriage, viii, *15*, 16, 30, 94–96, 98, 134; debate on, 39, 48–54; love *(ren'ai kekkon)*, 49–53; in *Nyonin geijutsu*, 149; readership of *Shufu no tomo* and, 98

Marxism: feminism and, 48–55, 147, 149; in *Nyonin geijutsu*, 139, 146, 152, 161

Masamune Hakuchō, 62

masculinity, 128, 135

mass culture, 60; *Fujin kōron* and, 83; Hayashi Fumiko, 165; literature and, 79, 119; *Nyonin geijutsu* and, 142, 176; politics and, 137–139; Tanizaki Jun'ichirō and, 74; women and, 19–20. *See also* popular culture; *taishū*

Matsuda Kaiko, 214n. 4

Matsuda Seiko, 28–30, 79

Matsui Teiko: "Dorumen no nazo" (Riddle of the dolmen), 144–147

media, 80–83; fiction and, 179–181; *Nyonin geijutsu* and, 138; politics and, 177; truth and, 163

Meiroku zasshi (Meiji six journal), 7, 38

Melancholy in the City (Tokai no yu'utsu). *See* Satō Haruo

Melancholy in the Country (Den'en no yu'utsu). *See* Satō Haruo

melodrama, 23, 88, 131

men: *bundan* writers, 141–142; magazines for, 178; as readers of women's magazines, 33, 92; as writers for women's magazines, 27, 39–47

middle class, 9, 16, 18, 24, 83–84, 93, 110, 123, 125

Mikami Otokichi, 118, 141, 164

Minami Hiroshi, 18, 91

mini komi (minicommunications), 11, 179, 221n. 4

Misty, 178

Miyake Kahō, 39, 62

Miyake Setsurei, 39

Miyamoto Saburō, *108*

Miyamoto Yuriko, 77–78

Miyazaki Hayao, 222n. 13

Mizoguchi Kenji, 1, 24–25, 182

Mochizuki Yuriko, 166, *173*, 214n. 4

modern girl, 14, *15*, 16, 19–20, 28, 44, 73, 78, 85–86, 88, 101, 114, 125; scholars and, viii, 24–25; Yamakawa and Takamure debate and, 49

modernism: commercial art and, 112–114; Hayashi Fumiko and, 20, 140, 164–165; illustrations and, 124; mass culture and, 21, 121; politics and, 138; women writers and, 19, 153

modernity: gender and, 26–28, 41; housewife and, 101–102; scandal and, 30; women and, 19, 22, 38–39, 41–42, 113, 136; women writers and, 77–79

"Mokusei" (Osmanthus). *See* Ozaki Midori

Monma Chiyo, 133

Monnet, Livia, 153

Mori Arinori, 7

Morita Hisashi, *103*

motherhood, viii, 41–42, 94, 99; frugality and, 110; protection debate *(bosei hogo ronsō)*, 46, 48, 90, 207n. 20; in *Shufu no tomo*, 89–91

Ms. Magazine, 178

Murakami Nobuko, 31

Murō Saisei, 59

Nagai Kafū, 10

naishoku (piecework), 122–123

Nakahira Fumiko, 14, *15*

Nakamoto Takako: "Suzumushi no mesu" (The female bell-cricket), 143, 150–153

Nakamura Murao, 119–120

Naomi. See Tanizaki Jun'ichirō, *Chijin no ai*

Naruse Mikiyo, 40, 124

The Nation, 142

national identity. 27. 38. 43–46. 81.
 180–181; class and. 159–160; domesticity
 and. 130; magazine covers and. 170;
 reader letters and. 99; women's status
 and. 2. 22–30. 92
Natsume Sōseki. 15. 118
Neon-Genesis Evangelion. 181
newspapers: scandal and. 56; women
 writers in. 78
new woman *(atarashii onna)*. 2. 19–20.
 26. 31. 40–41. 44. 52. 78. 85; terms for.
 1930. 14
Nihonga. 101–106
Nihonjin. 39
Nihon no jogaku (Japanese women's
 education). 8
Nishikawa Fumiko. 47
Nitobe Inazō. 30
Nogami Yaeko. 78
Noma Gozō. 63
nuclear family. 93. 129
Nyonin geijutsu (Women's arts). vii–viii. 3.
 24. 37; "Autobiographical Love Fiction"
 Issue. 143–144. 165. 174; categorization of
 texts. 163; commercial magazines and.
 138; covers of. 137. 166–170; debate over
 title. 170–175; end of. 175; founding of.
 140–143; Hayashi Fumiko and. 137. 140.
 142–143. 155. 164–166; Matsui Teiko in.
 144–147; Mikami Otokichi and. 118. 141.
 164; Nakamoto Takako in. 143. 150–153;
 Nyonin taishū supplement. 170. 174–175;
 Ozaki Midori. 44. 153–155. 169; proletar-
 ian literature in. 158–163; readership of.
 170–171; Sata Ineko in. 137. 143. 148–149.
 152; self-criticism in. 155–158; socialism
 and. 166; women writers and. 137–144.
 See also Hasegawa Shigure
Nyonin geijutsu dōmei (Women's arts
 league). 13
Nyonin shinsei (The sacred woman). *See*
 Tanizaki Jun'ichirō

Ōba Sōkichi. 7
Ogata Akiko. 139. 154
Okada Hachirō. 179

Okada Saburō: *Pari* (Paris). 81–82;
 "Wakatsuma no yu'utsu" (The young
 wife's melancholy). 81–83
Okada Saburōsuke. 105–106
Okamoto Kanoko. 78
Okamoto Kidō. 118
Oku Mumeo. 172
Okuzawa Jirō. 107
Onna no sekai (Women's world). 58
Orange Page. 109–110. 178
Osaka Elegy (Naniwa eregii). 1
"Osmanthus" (Mokusei). *See* Ozaki Midori
Ōsugi Sakae. 57–58. 134
otaku. 180–181
Ōta Yōko. 166
Ōya Sōichi. 117. 180
Ozaki Midori. 78–79. 169; "Osmanthus"
 (Mokusei). 44. 153–155; "Random
 Jottings on Film" (Eiga mansō). 154
Ozu Yasujirō. 75

Pari (Paris). 81–82
Peiss, Kathy. 43
PEN. 134
photography. 13. 79–83. 99. 162.
 168–169; *shashin shōsetsu* (photographic
 fiction). 81–83. 123; *Shufu no tomo*
 covers and. 109
politics: art and. 137–138. 172–177; emotions
 and. 37; femininity and. 38; literature
 and. vii–viii. 4. 135–136. 173–175. 177;
 love and. 69; mass culture and. 79;
 representation and. 169; sexuality and.
 60; women's magazines and. 2. 54.
 100–101. 125. 176
popular culture. 18. 172; approaches to.
 3–6. 20–25. 181–183; effects on readers
 of. 86; highbrow culture and. 27. 37;
 politics in. 139; women's magazines as.
 27. *See also* mass culture; *taishū*
popular literature. 61. 125; approaches to.
 viii. 2; gender and. 120; proletarian liter-
 ature and. 22. 60; politics and. 22–23;
 and "pure literature" *(jun bungaku)*.
 4. 70. 119–120; by Sasaki Kuni. 118–119.
 121–122; in *Shufu no tomo*. 117–121;

248 *Index*

in *Tokai no yu'utsu*, 69; women readers and, 27; by Yoshiya Nobuko, 126–136

postal system: distribution of periodicals, 12, 189n. 38

print culture: literature and, 21; other media and, 80–83; movable type, 12; professional writers and, 74; women as market for, 27

print technology, 11–12; changes in, viii; *Shufu no tomo* and, 101, 104, 116–117

professional writers, 60, 101, 116; amateurs and, 97–101, 154–155; fiction and, 22; Hirotsu Kazuo as, 74–77; woman readers and, 69–70

prohibition, 8; magazines, 187n. 18

proletarian literature, 22, 96, 145–147, 152–155, 166; feminism and, 158; Hayashi Fumiko and, 164–165; mass culture and, 119; *Nyonin geijutsu* and, 137–139; women writers and, 79

prostitution, 46, 151, 160–161, 180; anti- movement, 8

public discourse: *Fujin kōron* and, 27–28, 36–37, 100–101; *Shufu no tomo* and, 100–101; women in, 9, 54–55; women's issues in, 8

public intellectuals: in labor movement, 159; women as, 47–60, 85–86; writings on women by, 39–47

publishers: role of, 6; effects on fictional works of, 76–77. *See also* editors, of women's magazines

radio, 13

readers: class of, 5; colonial, 130; cultured life and, 82–83; education level and, 93; and fiction writers, 2–6, 60; *Fujin kōron* and, 26–28, 32, 56; Hatano Akiko as, *15*, 59–60, *61*; housewives as, 86, 90–91; identification and, 101–103, 169–170; *jogakusei* (women students) as, 7; *jokō* (factory girls) as, 6, 16; letters from, 98, 132, 135; men as, 5, 8, 46; middle-class, 134; mothers as, 122; national identity and, 8, 92; *Nyonin geijutsu* and, 173; politics and, 24–25, 101, 135–136, 176; popular literature

and, 27, 117–121; regional differences in, viii, 5, 10, 14–15, 22, 92, 94, 96; *Shufu no tomo* and, 85, 92–101; *shokugyō fujin* (working women) as, 6–7, 32, 95, 194n. 20; submissions by, 54–55, 74, 97–101, 119, 158–166, 168; surveys of, 33, 94–96; *Tokai no yu'utsu* and, 69–70; women as, viii, 1–2, 18, 28, 35, 75, 101, 175–177, 180; women writers and, 26, 78–79; writing style and, 47; Yoshiya Nobuko and, 126–136

recipes, 89

rhetoric, 39, 90; in *Fujin kōron*, 26; proletarian literature and, 161–163; reader letters and, 54–55; *Shufu no tomo* and, 97, 101

rice riots, 88

"Riddle of the Dolmen" (Dorumen no nazo). *See* Matsui Teiko

Rōnō (Worker and farmer), 142

royalties, 36, 74, 117–119

rural areas: *Nyonin geijutsu* and, 170; women's magazines and, 99. *See also* readers

ryōsai kenbo (good wife, wise mother), 40

The Sacred Woman (Nyonin shinsei). *See* Tanizaki Jun'ichirō

Saijō Yaso, *15*, 189n. 41

Sakai Toshihiko, 33

Sakuma Ryōko, 109

same-sex love, 23, 113; Yoshiya Nobuko and, 133

Samurai, 178

Sand, Jordan, 187n. 19

Sasaki Kuni, 118–119, 121–122

Sasameyuki (Spring snow). *See* Tanizaki Jun'ichirō

Sata Ineko, 137, 143; "Jikoshōkai" (Self-Introduction), 148–149, 152; *Kurenai* (Scarlet), 149; *Kyarameru kōjō kara* (Caramel Factory), 149

Satō, Barbara, 4, 16, 19, 42, 95–96

Satō Haruo: *Den'en no yu'utsu* (Melancholy in the country), 69–70; on Nakamoto Takako, 150; *Tokai no yu'utsu* (Melancholy in the city), 63–70

Index 249

Sawayanagi Masatarō, 40, 41, 43–44

scandals, 55–60; literary figures in, 120; Matsuda Seiko and, 28–30; *Seitō* and, 26, 31; in serialized fiction, 125; women's magazines and, 155; women writers and, 149

schoolgirls *(jogakusei)*: as readers, 32

Schreiner, Olive, 127

Seitō (Bluestocking), 7–9, 41, 56, 77, 141; *Fujin kōron*, 26, 47; Itō Noe and, 57; scandals and, 31

Senki, 161

sensation, media and, 139, 151–152, 154

serialization, effects on fiction of, 74–77

serialized fiction, viii, 1, 2, 4–5, 98, 119; in *Fujin kōron*, 61–70; gender roles in, 134–136; *manga* as, 179–181; popular literature and, 134–136; selection of, 75; in *Shufu no tomo*, 118–136; women readers and, 96; women in, 86; in women's magazines, 33

sewing, 95, 106

sexuality, 14; articles on, 100, 142, 156; consumption and, 131, 221n. 8; in *Fujin kōron*, 38–39; in literature, 73, 144, 151–152, 156; political effects of, 147, 151–152; popular literature and, 134; in Yoshiya Nobuko, 133–134

Shimamura Hōgetsu, 32

Shimanaka Yūsaku, 32, 75–76, 79; on Hatano-Arishima suicide, 59

Shimazaki Tōson, 69

Shimizu Shikin, 7

Shimokawa Ōten, 15

Shinchōsha, 141

shinkankaku-ha (new sensation school), 10, 152

Shin shin fujin (The new true woman), 9

shōjo (girl) 21, 22; magazines for, 32, 61, 99, 126, 178

Shōjo sekai (Girls' world), 99

shokugyō fujin, 6–7, 16, 127; as readers, 16

Shōnen sekai (Boys' world), 99

shufu, 24; as defined by *Shufu no tomo*, 85, 91, 110, 185n. 3. *See also* housewife

Shufu no tomo (The housewife's friend), 3; advertising in, 111–117; architecture and, 88; circulation of, 6, 85, 89, 93, 98; covers of, 34, 101–110; editorial stance of, 84, 87–94, 97; factory girls *(jokō)* in, 156; fiction in, 117–121; founding of, 84–93; frugality and, 88–92; as *fujin zasshi*, vii; household accounting *(kakeibo)* and, 88–89; Kamichika Ichiko in, 58; Kume Masao in, 96, 118; literacy and, 17; marriage and, 84; *Nyonin geijutsu* as alternative to, 138; photography in, 83; print technology and, 12; reader community and, 89, 92, 97, 100–101, 110, 133; reader contributions in, 98–101, 119; reader letters in, 54; readership of, 92–101; Sasaki Kuni in, 118–119, 121–122; scholarly interest in, 84; success stories in, 89–91, 98–99; title of, 93, 102; true stories *(jitsuwa)* in, 155, 158; World War II and, viii, 181; Yoshiya Nobuko in, 126–136

Shufunotomosha (Shufunotomo Corporation): contemporary publishing activities, 109–110; marketing practices, 99; publications on thrift, 89

Shumi (Taste), 18

shūyō (cultivation), 95–96

Sievers, Sharon, 19, 186nn. 7, 13

Silverberg, Miriam, 4, 16, 19, 24, 144, 172

socialism: feminism and, 54, 58

Sora no kanata e (To the yonder edge of the sky). *See* Yoshiya Nobuko

sound: in women's magazines, 13, 80

suburbs, 121–122

suffrage, women's, 8, 11, 88, 143

Sugawa Kinuko, 141

suicide, 56–60, 76, 134

Sutairu (Style), 11

Suzuki, Tomi, 120

"Suzumushi no mesu" (The female bell-cricket). *See* Nakamoto Takako

taishū, 20, 171–172, 210n. 65. *See also* mass culture; popular culture

Takamure Itsue, vii, 73, 143, 166; *Bijinron*, 146; debate with Yamakawa Kikue, 48–54; *Ie de no shi* (The leaving home poem), 51, 53

Takanobu Kyōsui, 79
Takashima Heisaburō, 42
Takehisa Yumeji, 14
Tamura Toshiko: "Tsuyako no ie de"
 (Tsuyako runs away from home), 77;
 writings from Canada, 175
Tanizaki Jun'ichirō, 10, 18, 32, 78; *Chijin
 no ai* (A fool's love *or* Naomi), 10, 18, 32,
 70, 73; on Hatano-Arishima suicide, 59;
 Nyonin shinsei (Sacred woman), 70–74;
 race and gender in, 72–73; *Sasameyuki*
 (Spring snow *or* The Makioka sisters),
 21, 73; in *Shufu no tomo*, 118
Tayama Katai, 61
television, 170
textile industry, 31. See also *jokō*
time management, 89–92, 96, 100, 106,
 124–125
Tōgō Seiji, *34*
Tokai no yu'utsu (Melancholy in the city).
 See Satō Haruo
Tokuda, Shūsei, 14, 61
Tolstoy, Leo, 63, 127; *Resurrection*, 66
Tōyō Muslin Factory, 152–153
tuberculosis, 98
Tsutomi Takeo, 124
tsūzoku shōsetsu (commonplace fiction),
 21, 118–120, 210n. 65. *See also* popular
 literature; serialized fiction

Ukita Kazutami, 196n. 37
United States: women of, 40, 43
U.S.-Japan Security Treaty Revision, 181
Uno Chiyo, 11, 78
Uno, Kathleen, 122
Uno Kōji, 59
urbanization, 4
urban life, viii, 70, 92, 125; magazine
 reading and, 99; and rural life, 45;
 women and, 14

video games, 180–181
virginity, 128–129, 131–132, 136
visuality, 13–14, 17; in women's magazines,
 116–117, 168, 179–180; written texts and,
 79–83, 86

Wakamatsu Shizuko, 7
Waseda University, 32, 75
Watanabe Katei, 118
Weisenfeld, Gennifer, 113
Western style, 18, 81
Williams, Raymond, 24
Woman of Tokyo (Tokyo no onna), 75
woman problem *(fujin mondai)*, 26–27,
 31–32, 38–40, 46; in *Fujin kōron*,
 48–55; translation of term, 192n. 3
women: as commodities, 48–54, 79,
 179; enlightenment of, 80; financial
 independence and, 49–53; as market,
 27, 77
Women's Arts League (Nyonin geijutsu
 dōmei), 140
women's magazines: American, 116; beauty
 and, 52; circulation of, 6–7, 32–33;
 contemporary, 178; debates over, 1;
 everyday life and, 5; growth of, 2, 10–17;
 as lowbrow reading material, 117–118;
 marketing and, 168; Meiji period, 7–9;
 methods for analyzing, 3–6, 35; modern
 life and, vii–viii; political effects of,
 vii–viii, 6; profitability of, 26; as
 publishing category, 2, 10; role of in
 modern literature, 3–6, 21–22, 36; social
 effects of, 1, 14–17, 175–177; women
 writers and, 77. See also *fujin zasshi*
women writers, vii, 5, 9, 20, 153–154, 179;
 contemporary, 221n. 8; Edo period, 7–8,
 187n. 14; *Fujin kōron*, 27, 47, 77–79;
 joryū (feminine) style and, 77–78, 126;
 Nyonin geijutsu and, 137–144; readers
 as, 158–166; scandals and, 56; Yoshiya
 Nobuko exclusion from study of, 126,
 175
working women, 14–17, 31–32, 40, 122;
 consumption, 142; cultivation *(shūyō)*
 and, 42; image of, 88; leisure and, 43;
 marriage and, 42–43, 50–53, 95–96;
 proletarian literature and, 137; as
 readers, 170, 194n. 20; sexual difference
 and, 43; *shokugyō fujin*, 31–32, 94; in
 textile industry, 31; in *Tokai no yu'utsu*,
 69; wages of, 136; as writers, 158–160.

See also café waitress; housewife; *jokō*; motherhood

World War II: economic effects of, 31, 87–88, 107–109; *Shufu no tomo* and, 181; women and, 134

writers: limitations on, viii, 176; professionalization of, 12, 54–55

Yagi Akiko, 157–158, 166

Yamada Junko, 14, *15*

Yamada Waka, 47, 90, 198n. 70, 207n. 20

Yamaji Aizan, 40–41, 44–46, 196n. 37

Yamakawa Kikue, 118, *173*; debates in *Fujin kōron*, 48–54, 198n. 70, 207n. 20; on women's magazines, 119

Yanagida Kunio, 11

Yanagisawa Ken, 59

Yasunari Jirō, 58

Yōga (Western-style painting), 105–106

Yokomitsu Ri'ichi, 10, 152

Yomiuri, 28

Yosano Akiko, 90, 198n. 70, 207n. 20

Yoshimura Jirō, 105

Yoshiya Nobuko, 11, 22, 78, 123, 191n. 60; *Hana monogatari* (Flower stories), 126, 133; *Sora no kanata e* (To the yonder edge of the sky), 126–136; *Tsuki kara kita otoko* (The man from the moon), 181

Yūaikai (Friendship society), 31

Yukiko Tanaka, 143

zenshū (collected works), 20, 23, 61, 77, 146; *Gendai bungaku zenshū* (Anthology of contemporary Japanese literature), 12

Zola, Émile: *Au bonheur des dames*, 128

About the Author

Sarah Frederick is associate professor at Boston University, where she teaches Japanese literature, film, and popular culture. She is also the translator of *Yellow Rose* by Yoshiya Nobuko.